# The New York Times Magazine

# The New York Times Magazine

preface by gerald marzorati
photographs and notes by 140 photographers

**aperture**

# photographs

edited and with a foreword by kathy ryan

# contents

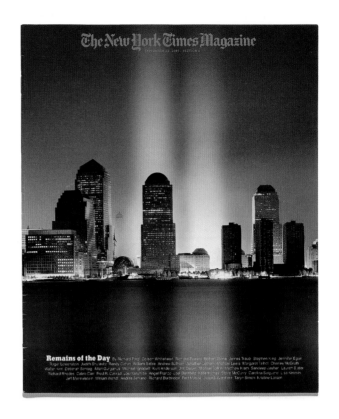

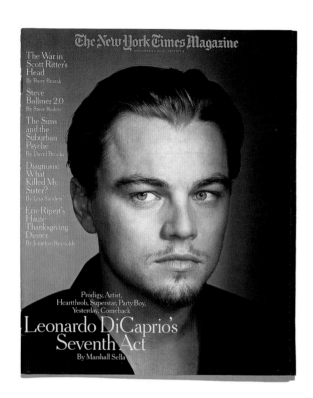

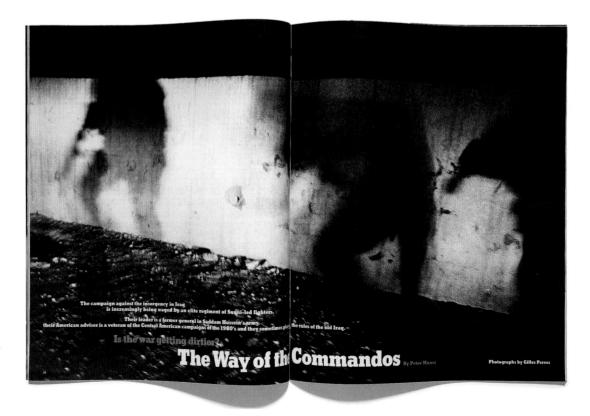

# preface

## BY GERALD MARZORATI

**I. Slowness**

There never really was a Golden Age of Magazine Photography. *Life* and the other large-format photo-magazines thrived in the Golden Age of Motion Pictures. A generation later, when photography, including photojournalism, celebrity portraiture, and fashion spreads, became (for no immediately apparent reason) the focus of searching cultural criticism—think of Susan Sontag's *On Photography*, Roland Barthes's *Camera Lucida*, John Berger's *Another Way of Telling*, Janet Malcolm's *Diana & Nikon*—it was generally understood that America's public imagination (or, anyway, its gaze) was in the thrall of television far more than of still pictures. Today, with video-streaming, JumboTrons, and photo-sharing via smartphones, magazine photographs seem almost to belong to another epoch altogether. And yet many of the pictures that begin their lives in the pages of the *New York Times Magazine*—one of the last wide-circulation print outlets in America for ambitious photography—tend to wind up, and soon, on the walls of galleries, where they may fetch thousands of dollars from museums or private collectors assured that what they are seeing is art (or *something*) in a way that all the nonstop digital imagery of our time is not.

What continues to give such pictures their currency?

The project of magazine photography, today as for the past fifty, sixty years, is to reveal to us that which can be seen only when time is arrested. Photographs—great ones, especially—slow things down and particularize. They advance *oneness*. It has been suggested that a photographer's intentions do not necessarily determine the meaning of a photograph. Fair enough. It is nevertheless true that the intention of the editors of the *Magazine* (I was associated with the publication for three decades, and was its editor from 2003 to 2010) is to publish, week in and week out, along with long-form reportage and speculative essays, the kinds of photographs that do not simply document or deliver "news" but—by capturing *that* light, *that* gesture, *that* moment—halt time, and, then, the eye of the *Magazine*'s reader: slow her down, invite him to look. Look hard. Look again.

Think about this: is there anything as brimming with meaning yet as hard to see and fix in the mind as the look or glance of another? But take note throughout this book of how frequently magazine photography is drawn to eyes, how it still looks and glances. Regard, for example, the eyes of all those young, head-scarved women in suddenly post-revolutionary Iran—young women looking out warily from their radically, severely new selves, so precisely framed and shot by Gilles Peress (pages 336–37); or the stolen, sideways glance toward her aged husband provided by an uncomprehending (and incomprehensibly young) Afghani child-bride, captured by Stephanie Sinclair (pages 204–5); or the resigned watchfulness in the searchlight-reflecting eyes of a Haitian refugee set sail on a dark sea in a small, rickety boat, hoping to reach the Florida coast, photographed by Christopher Anderson (pages 176–77); or Sean Penn's eye-roll of smoldering impatience with life and his place in it, caught by Richard Burbridge (page 45); or Joan Didion's grieving stare, quietly observed by Eugene Richards (page 69).

In these photographs, as throughout this book, we are seeing what only magazine photography sees. And, in order to

do so, we have slowed down—and been rewarded not only with *information* (the importance of which is conferred by including a photograph in any publication that reaches millions of readers); not only with *feeling* (consequential photographs delight, enrage, sadden, jar); but also with *consciousness*: spending time with pictures like these, we are made aware of the difference between watching and *seeing*.

## II. Promiscuity

War photography, haute-couture confections, studio portraiture, conceptual photographs, documentary essays, landscape pictures, artists' portfolios: the *New York Times Magazine* today ranges across photographic genres as very few other magazines have ever done. Any given issue of the *Magazine* is a pictorial mélange, with gritty black-and-white commingling with high-keyed color, and strobe-lit close-ups a page away from vast, long-exposure vistas. The *Magazine*'s continued utilization of the slow-printing rotogravure process lends the photographs printed in it an ink-saturated richness, despite the relatively light (for a magazine) paper stock. The *Magazine*'s decision, made in the mid-1990s, to make the printing of color available on every page of the publication, along with a marked increase in the budget for photography, expanded the boundaries of the possible. In its way, the *Magazine* became (along with everything else it is) a modern-day photo-journal.

Of course, it took people to bring the *Magazine* into this new era, and no one more crucial than Kathy Ryan, the *Magazine*'s longtime photo-editor (who, it should be said, is as cherished out in the international photography world as she is in the *Magazine*'s New York offices). With daily input from her talented staff, and in collaboration with the *Magazine*'s art department and other editors, Kathy ponders and decides what kind of photographic approach best suits a given story as soon as that story is assigned. (Except in the case of a purely photographic project, be it a fashion shoot or a photo-essay, it generally starts with the story.) The point, however, is never simply to illustrate a story but to have photographers make meaning *their* way, and the array of photographers Kathy and her editors have cultivated and can draw upon to send off on stories is astonishing—a testament to the *Magazine*'s place in contemporary photography's ferment and to the photo-editors whose care and daring (from assigning through helping to shape concepts to editing) have forged that reputation.

Collected in this volume is the work of the best war photographers of our time: among them, Susan Meiselas in Nicaragua, Gilles Peress in Bosnia and Iraq, Paolo Pellegrin in Lebanon, Darfur, and Libya, and Lynsey Addario in Darfur and Afghanistan. There are memorable celebrity portraits by photographers (themselves celebrated) such as Dan Winters, Platon, Robert Maxwell, and the duo Inez van Lamsweerde and Vinoodh Matadin. The artist Andres Serrano has, over the years, realized a number of disturbingly transgressive conceptual photographs for the *Magazine*—pictures meant to capture not a visage or an event but an idea (torture, for example, or sainthood). Serrano does most of his work at a certain art-world remove from weekly journalism, and it is in luring him, and others of his caliber, to the *Magazine*'s pages that Kathy reveals her discerningly promiscuous eye—playful *and* discriminating—as it alights upon the most striking (but completely logical if you know your stuff, as she does) pairings of photographer and subject. Nan Goldin, renowned photo-biographer of the sex-and-drugs East Village demimonde, documenting the fast-lane downtown life of the teenage fashion model James King (pages 38–39); the celebrated German artist Thomas Struth doing a family sitting of the painter Gerhard Richter and his wife and children (pages 52–53); the great street-shooter Lee Friedlander, backstage at a New York fashion show (pages 322–23).

What makes photography so interesting just now is how unself-consciously it probes the restless border that Art still patrols against whatever isn't. Kathy Ryan has made herself at home on that permeable border, and, as a result, the *Magazine* has found a home there of sorts as well.

### III. Beauty

The *New York Times Magazine* is an entertainment, a recreation, in the sense those words would have carried in the New York of Edith Wharton—that is, the New York in which the *Magazine* was launched, in 1896, as a pictorial supplement devoted to fashion and "society." The *Magazine*'s subject matter has broadened to include more or less anything of our time that captures the interest of the editors, but the point is still to captivate, fascinate, illuminate. A magazine like this one—down to its very bones: design, format, pacing, and, yes, even upscale real-estate advertising—is meant to impart pleasure. Photography's role in this is crucial. It is not too much, I think, to say that photography makes the *New York Times Magazine* beautiful.

And I do not mean simply the weekly fashion portfolios or portraits of actors and actresses or Ryan McGinley's dreamy Olympic athletes (pages 398–407) or Sebastião Salgado's otherworldly oil-field firefighters in Kuwait (pages 358–63). I mean also Simon Norfolk's picture of a newly constructed refugee camp in Chad (pages 190–91), and Gary Schneider's of a morbidly obese man (pages 260–61), and Thomas Demand's reconstruction of a Times Square massage parlor (page 280–81), and Lynsey Addario's image of a burnt-out village in Darfur (pages 202–3).

The now near-ubiquitous use of color is one factor in this. For much of its history, photojournalism eschewed color as "prettifying." (The Vietnam War was the first large conflict enterprisingly shot in color; and color photographs of rural American poverty taken under the auspices of the Works Progress Administration during the 1930s have only recently been given their due.) Even today, magazines have a tendency to show, for instance, Africa and its dire sufferings in stoic, mournful black and white (a choice not without problematic assumptions, perhaps). But am I any less saddened and maddened by Simon Norfolk's photograph (pages 190–91) of poverty-stricken African villagers displaced by senseless warring because the light in the image happens to be so warmly, seductively roseate—or because the light somehow echoes and enhances the pink robe of the bicyclist in the foreground? Or does the play of color and light against the red-dun earth *complicate* the picture, complicate my reaction to it, make me linger with it, and so with my thoughts and feelings?

What I would call the self-consciousness, or art-consciousness, of today's photographers is, with color's pervasiveness, the other chief factor in magazine photography's embrace of the beautiful. Photographers of this era, compared to those of a generation or two ago, are much more likely to have passed through art school, or a graduate fine-arts program, immersing themselves in art's canon and aesthetic theories—and no less importantly, the younger history of photography itself. Some employ old photo-technologies (a tripod-mounted box camera, or a camera obscura) to achieve lovely detail and textures. Others place a premium on graphic rigor and formal invention, and they tend to be sly with their references to earlier pictures, be they paintings or photographs. One example: Brenda Ann Kenneally's photograph of children on a sofa in a FEMA trailer (pages 210–11), from her Hurricane Katrina–anniversary photo-essay "Children of the Storm" (to which an entire issue of the *Magazine* was devoted in August 2006) is inventively composed as well as steeped in Walker Evans. Together, these qualities make the picture work. It's unanticipated and timeless—like a force of nature.

It isn't so much the *consolation* of beauty that these pictures are after (the fear behind the fear of "prettiness"). It's the possibility of permanence, or something like it—*maybe this picture will continue to haunt you after you put the magazine down*—that beauty has always promised. And this yearning for permanence? Perhaps it is born of a fear among photographers that we viewers, in our sped-up lives, even on a lazy Sunday morning with a magazine in hand, will not or cannot be slowed down, our gaze arrested, by even the best of photographs.

This book is an argument against that.

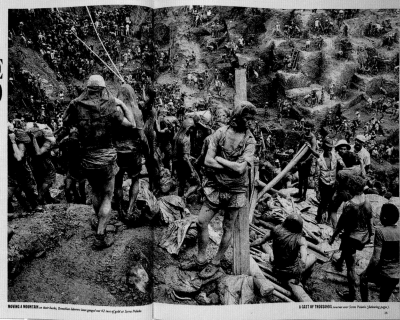

# AN EPIC STRUGGLE FOR GOLD

**I**t is a staggering scene, seeming to belong in a time in which slaves built monumental works for pharaohs and kings. The ancient, frenzied dream of gold has drawn 400,000 people across the wilderness of Brazil. Digging in the Amazon forests, diving into rivers and gnawing at mountainsides, they move with the rainy season and rumors of new sites. Serra Pelada, in the northern state of Pará, is the largest and richest of these impoverished mines. Since a peasant found the first nuggets there in 1980, a mountain has been reduced to a hollow 600 feet deep and half a mile wide. It has yielded 42 tons of gold. Bars, brothels and stores have sprung up nearby; 100,000 people now live alongside the pit. On the following pages, photographer Sebastião Salgado provides stunning images of Serra Pelada, where fortune-seekers have moved a mountain on their backs.

Portfolio by Sebastião Salgado
Text by Marlise Simons

**MOVING A MOUNTAIN** on their backs, Brazilian laborers have gouged out 42 tons of gold at Serra Pelada.

**A CAST OF THOUSANDS** swarms over Serra Pelada (following pages).

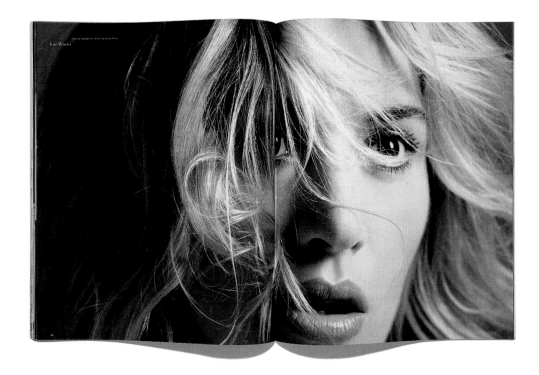

**CLOCKWISE FROM TOP LEFT:** SEBASTIÃO SALGADO, June 7, 1987; JACK PIERSON, May 18, 1997; INEZ VAN LAMSWEERDE AND VINOODH MATADIN, February 27, 2005.

# editor's foreword

BY KATHY RYAN

IT USUALLY STARTS WITH AN IDEAS MEETING. Or perhaps an editor clips an item from the newspaper. Or a writer calls his story editor with a pitch and an article gets assigned that needs photography to go with it. Sometimes the magazine's editor challenges the team to come up with ideas related to a particular subject. Occasionally a newsworthy subject cries out for a visual treatment in the form of a photo-essay. Sometimes a phone call from a photographer far afield lights the fuse.

Each of the photographs in this book began with an idea. The ideas came from all quarters—editors, writers, photo-editors, art directors, and of course the photographers themselves. The majority of the images in this book were made on assignment for the *New York Times Magazine*. Some of them were brought to the *Magazine* as completed projects by the photographers.

A weekly magazine is perpetually hungry for ideas that are timely, newsworthy, and original. This hunger has to be satisfied continuously and at tremendous speed. It is hard to overstate the tempo at a weekly magazine. There is no time for reflection. It is always forward motion. Deadlines can be the worst part of a working at a magazine—mostly, they are the best part. You launch a project into orbit without second-guessing yourself, because you have to get it done. You take chances on the issue you are constructing, knowing that if you fail there is another issue right behind it.

The rigorous pace keeps you on your toes and demands a rapid-fire process of decision making. Whether matching a photographer to an assignment, committing to a creative approach, or brainstorming about a cover concept, you have to cut to the chase. This can be liberating. The adrenaline-fueled atmosphere helps with the crystallization of ideas. Given that there's not much time for pondering, the tricky part is figuring out how to carve out the nebulous, untethered space necessary for creative thinking. That part requires discipline.

Making a magazine is a team sport, with the editor of the magazine calling the plays. Creative decisions are often arrived at in a "group think"—editor, photo-editor, art director, perhaps the photographer. One person takes the first leap with an idea. Another builds on it, and then another, until the idea is clear enough to send off the photographer, who will capture the idea in colors, shadows, and edges. Some assignments and photographers are made for each other; in those cases, you present the concept or problem to the photographer and wait to see how he or she solves it.

The process often begins with the question: "How do we reinvent ourselves this week?" The news of the world tends to repeat itself: every year brings earthquakes, wars, famines, and elections. How do you get readers to take sharp notice when a subject—though tragic or otherwise momentous—is so familiar?

It has long been recognized that documentary photography is not purely objective. Of course it delivers the facts of a situation, but the photographer's interpretation of those facts makes a world of difference. The documentary photographers in these pages bring a highly nuanced and personalized point of view to their reportage. Some are truth seekers who create fresh visual reporting by peering more intently, by peeling away the extra layer. Some move outside the traditional

boundaries of photojournalism and embrace art history for their inspiration, reinventing a hardcore news story by seeing it, for example, through the eyes of an eighteenth-century landscape painter. An intensely human story can be told through pictures devoid of people. A contemporary scene can seem biblical. A massive, complex machine can be rendered a painterly abstraction.

The Academy Awards come around every year; the Olympics every two years; the U.S. presidential elections every four years. Reinventing these events, along with the myriad other stories we cover on a weekly basis, is a challenge. Drawing on artists, photojournalists, portraitists, and fashion photographers across the spectrum enables us to bring new visual insights and interpretations to our coverage. Why not send a veteran war photographer to photograph the Oscar-worthy actors one year? Or commission a gallery of Olympians by an artist with a very personal iconography, rather than by a sports photographer? "Cross-assigning" is a signature of this magazine, an approach that came clearly into focus with the publication of the "Times Square" issue in May 1997—an issue devoted entirely to images by a group of photographers working within all genres of photography.

All this requires faith. You can't know how something will turn out when you set the elements in motion. Each photo-assignment follows an arc, from the nugget of an idea, proceeding to an accelerated period of conceptualizing, strategizing, and producing, and ultimately resulting in the arrival of the images.

One of the most invigorating parts of photo-editing is the mental tug of war that goes on when weighing the pros and cons of one photographer versus another for a particular assignment. It can be an interior dialogue or one shared in a robust back-and-forth with other members of the *Magazine*'s photography department or art director. The pairing of photographer and subject is the most critical part of the process. Some photographers are adept at reading character in the subtlest gesture, posture, and expression. Others elicit a sitter's most beautiful side. Some literally shape the subject into a memorably elegant portrait. Still others deliver appraisals of their sitters' personalities that are concerned exclusively with truth and not at all with beauty. Of course, given how subjectively we experience photography, it is impossible to predict exactly what a reader will perceive in the end.

A key factor guiding the commissioning of cover portraits is what the *Magazine*'s editor wants in terms of mood and purpose. The editor and the photo-editor speak in shorthand. The word *attitude* comes up often in cover discussions. As in: What is the attitude we want the sitter to project? Are we looking for a spirited playful cover, a serious cover, or a provocative cover? Is it a pop-culture moment that we want to be "over the top"? (*Over the top* is another often-used phrase, denoting a little crazy—and therefore attention-grabbing.)

When you assign a photographer to a documentary story, you are sending out a witness. If you are placing a photojournalist in a community in crisis or a combat situation, you need someone with a heart big enough to handle the assignment and the courage necessary to get it done. Sometimes you are counting on the photographer's sense of outrage. Other times you want a poetic point of view—someone who will transform the scene unfolding into a more impressionistic and metaphorical kind of imagery. Always you are looking to make the reader sit up and pay attention. You are hoping for pictures that *freeze time* and thus command a sustained look from the viewer.

In the thirty-three years covered in this book, everything has changed in terms of technology. A lot of words are dying as I write this—*film, Kodachrome, contact sheet, light table, darkroom, enlarger, fixer, manual, developing tray*. They have been replaced by *digital, Photoshop, files, hard drives, cloud, iPhone, jpeg, apps, memory cards*, and *gigabytes*. We never used the phrase *post-production* in the first decade covered in this book. Now we use it regularly. We never had to worry about whether

readers would believe the photographic document. Now we wrangle with their skepticism. We have to clearly differentiate between documentary photojournalism—in which digital alteration is unacceptable—and imaginative photo-illustration, where digital conjuring is very welcome. The digital age has introduced all kinds of new picture-making possibilities, enriching our pages with new creative approaches to classic editorial problem solving. Most of the photographers represented here have switched from film to digital in the time period covered in this book. Some continue to use film for part of or all their picture making, holding onto it for the nuances of color and grain that film offers but, they believe, digital imagery lacks.

The advent of digital technology has transformed the way documentary photographers make and transmit their work. Thirty years ago, photographers in the field had to get rolls of film (or negatives or prints) to the *Magazine*'s offices in New York from wherever they were working. Now, of course, images can reach us within seconds of their making via new technologies.

The *Magazine*'s online presence is becoming increasingly vital and important, and very often videos are featured as a component of our stories. Nowadays, we regularly develop cinematic ideas and seek film directors in tandem with our photographic assigning. When we conceptualize a major portfolio project today, the brainstorming for the video we will commission as part of it often drives the conversation. Sometimes one person fills the role of both photographer and videographer; other times we split the billing. Motion and sound come into play. It is a thrilling new addition to the *Magazine*.

We hardly bother trying to imagine what the future holds—the life of media is clearly in a time of great transformation—although I hope there will always be a print magazine that we can hold in our hands.

In this book, you will hear the voices of the photographers, editors, photo-editors, art directors, and style directors involved in the making of the pictures. Occasionally you will hear from the subjects of the photographs themselves. It is hoped that these anecdotes, behind-the-scenes details, and philosophical insights will shed some light on how the images came into being, how they can be read, and why I think these photographs are ones for the ages.

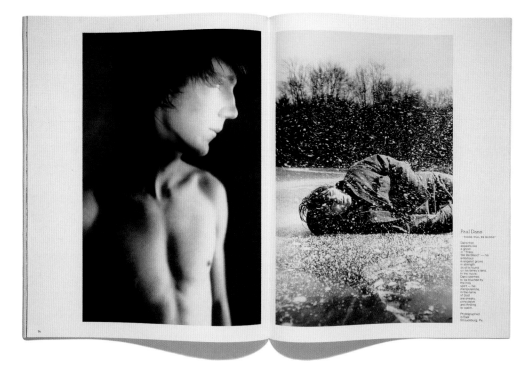

# portraits

WHAT MAKES A PORTRAIT MEANINGFUL TO VIEWERS? The subject's recognizability or relevance to current events. Outstanding beauty; intense expressiveness. An innovative or provocative formal composition. A palpable sense of life and genuine communicativeness, conveyed in the still point of a gesture or glance. The great portrait photographer is attuned to every one of these elements and will use all his or her skills to capitalize upon them and distill them into a galvanizing image.

The *New York Times Magazine* has over the course of its history published thousands of portraits of newsmakers (the cover of its very first issue, September 6, 1896, featured a story about the 1860 presidential campaign, with photographic portraits of contenders Stephen A. Douglas and John Bell looking stern and well-starched). In each of these images, the photographer makes a mercurial connection with the subject—a link that is impossible to formulate: the people on either side of the lens may be strangers or longtime friends, or there may be friction or even serious antipathy between them. Some portraitists work in intense sessions that last only minutes; others go at a slower pace, over the course of days or weeks—sometimes years—studying the subject.

This connection is a complicated matter, and it is generally initiated by the commissioning photo-editor, who determines what tone might be most effective for a particular subject and is then responsible for putting the photographer together with that person, which sets off the chemical reaction. Though it may be risky, the photo-editor can create combustion by mixing modes in a surprising way: pairing a gruff sports figure with a photographer who specializes in soft, classical depictions, or a "ready-for-my-close-up" movie star with a steeled photojournalist.

There are occasions when a bit of creative power-struggle between sitter and photographer can be beneficial to the result: when painters, film directors, and other image-makers are being photographed, they often can't resist making aesthetic or conceptual suggestions to the person with the camera (filmmaker Spike Jonze calls it "backseat driving"). Politicians, for their part, don't necessarily wish to look "interesting" or overly glamorous—that may not serve their political purposes—but neither, of course, do they want to be depicted with warts and all. As for performers and models, it can be difficult to portray them in a way that is "true," because they are used to being the masters of how they appear. Occasionally, though—as the photographs in this chapter reveal—even performers sometimes let down their guard (or at least appear to do so).

Divas, murderers, orphans, heroes, geniuses. Cooperative and reluctant. Grieving and rejoicing. Ugly and beautiful. Here is a selection of some of the most powerful portraits published in the *New York Times Magazine* over the past three decades.

---

The majority of the photographs in this volume are accompanied by notes, whether from the photographer, the subject, Kathy Ryan (K.R.), or other *New York Times Magazine* staff involved in the production of the images. (A list of *Magazine* staff members, specifying their roles at the publication, appears on page 439.) These notes—which range from behind-the-scenes anecdotes to philosophical insights about photography—have been culled for the most part from interviews or correspondence conducted for this volume; some, however, are from the issues of the *Magazine* in which the corresponding photographs originally appeared. Each comment is attributed to its author; unless otherwise indicated, all are from 2011.

**LIZZIE HIMMEL**

Artist Jean-Michel Basquiat in his New York studio. From "The Marketing of an American Artist," published February 10, 1985 (cover image).

I was very nervous, because this was my first commissioned *Times* portrait—and for a cover. I got there, and Basquiat was in bed, totally out of it. We had to drag him out of bed and dress him. He doesn't have shoes on because I was so pissed off that he was not really there that I decided not to put his shoes on.

He didn't talk at all during our shoot, but he did what I said. There was no collaboration, but I didn't demand that he do anything that wasn't characteristic of him. I was upset that I wasn't getting any cooperation, because I needed more from him. I needed to know who this guy was. Even though I was angry, I felt he was an important artist—and I didn't want him to look like a schmuck. I mean, I knew he was a complete workaholic, but I wanted him not to be the drugged-out kid that he was. I could have taken advantage of that and shot him in his bed, as I'd found him—that would have been somebody else's choice. I didn't want to do that.

But he was definitely stylish. Oh, absolutely. He designed a whole style downtown. —LIZZIE HIMMEL

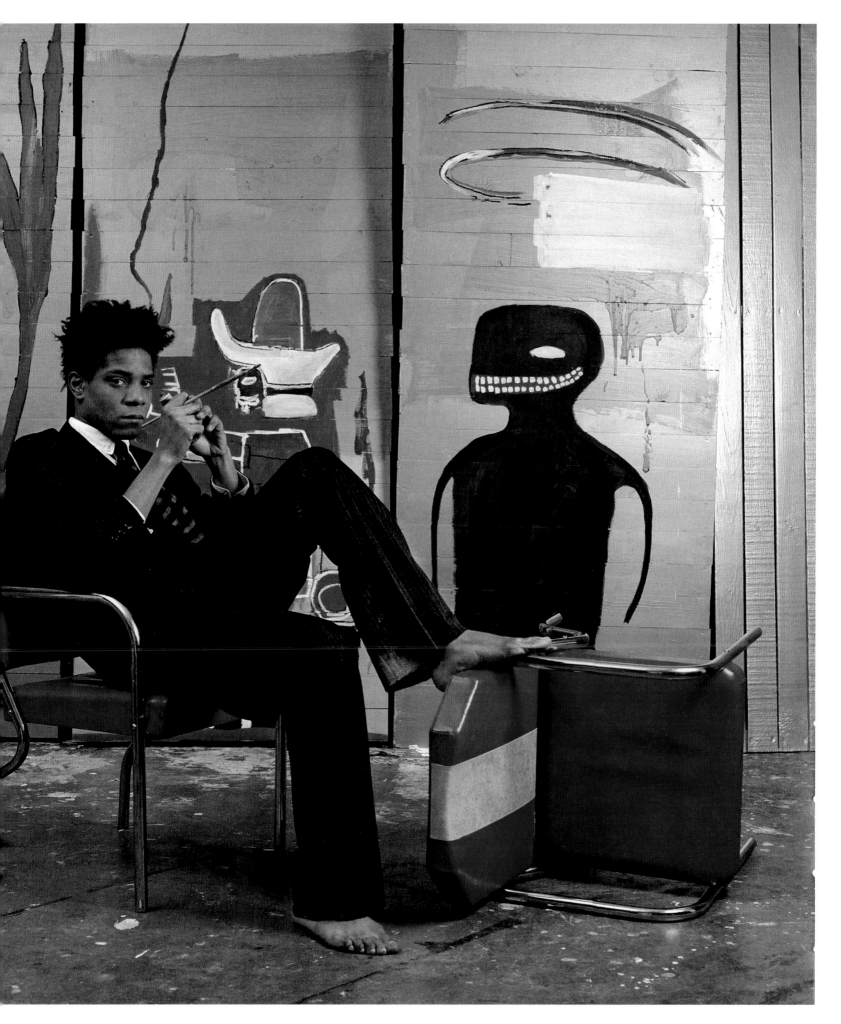

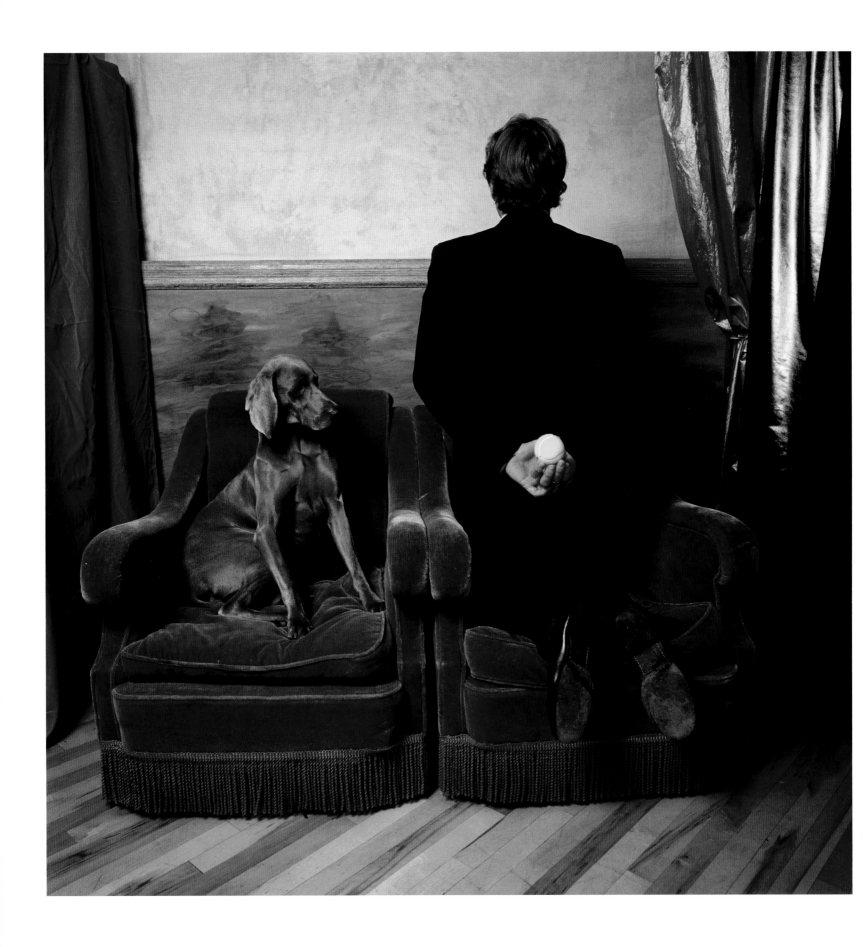

## KAREN KUEHN

Filmmaker Spike Lee. From "Spike Lee's Gotta Have It," published August 9, 1987.

I was a young journalist and conceptual photographer when I made this picture. Meeting Spike Lee was part of an awakening to the world at large and its injustices. Spike's visual voice had a huge impact on the film industry and society, and his ideas about making a difference were an inspiration. —KAREN KUEHN

**OPPOSITE:** Photographer William Wegman with his canine model Fay Ray. From "William Wegman: The Artist and His Dog," published November 29, 1987.

The best thing about Fay isn't visible in a photo. It's her voice. You say: "Fay, speak," and she sounds like a distant thunderstorm. —WILLIAM WEGMAN, 1987

**ANTHONY BARBOZA**

Jazz trumpet player Miles Davis. From "Miles Davis," published June 16, 1985.

That look! Is it a sinister look or a childlike look? Miles's complex personality always came down to which mood he was in that day. In our relationship of twenty years, Miles always trusted me and did whatever I asked without question. . . . I say it's childlike. —ANTHONY BARBOZA

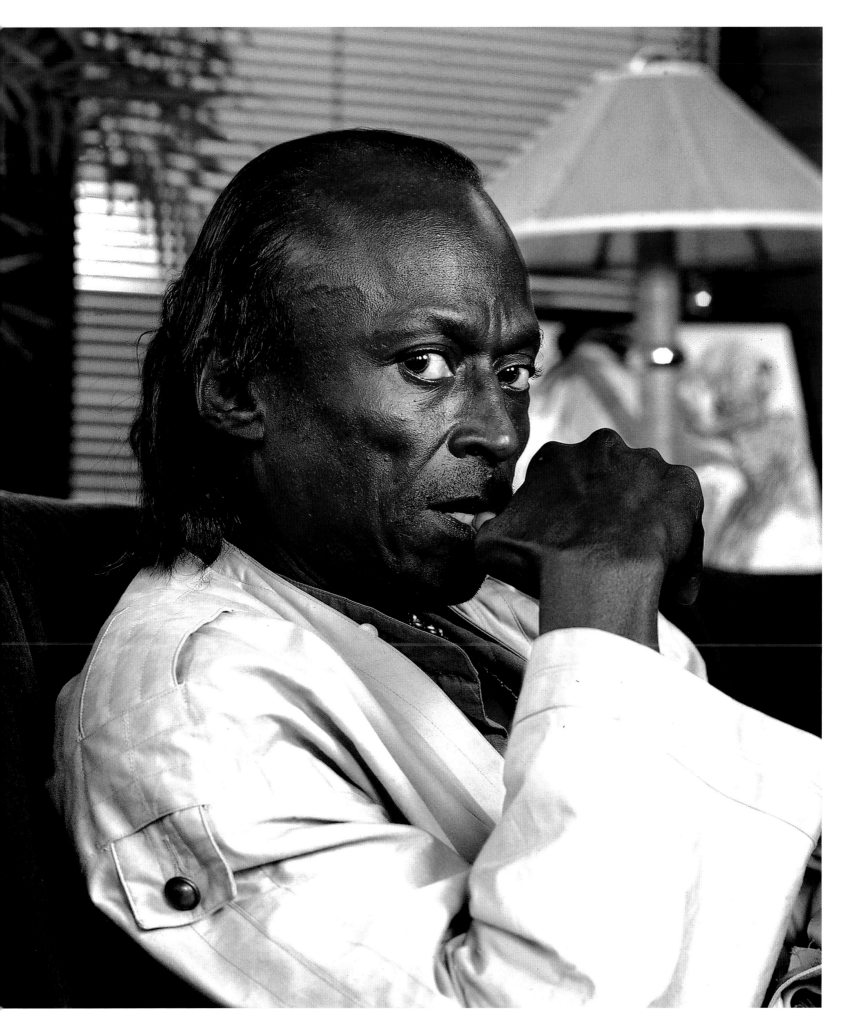

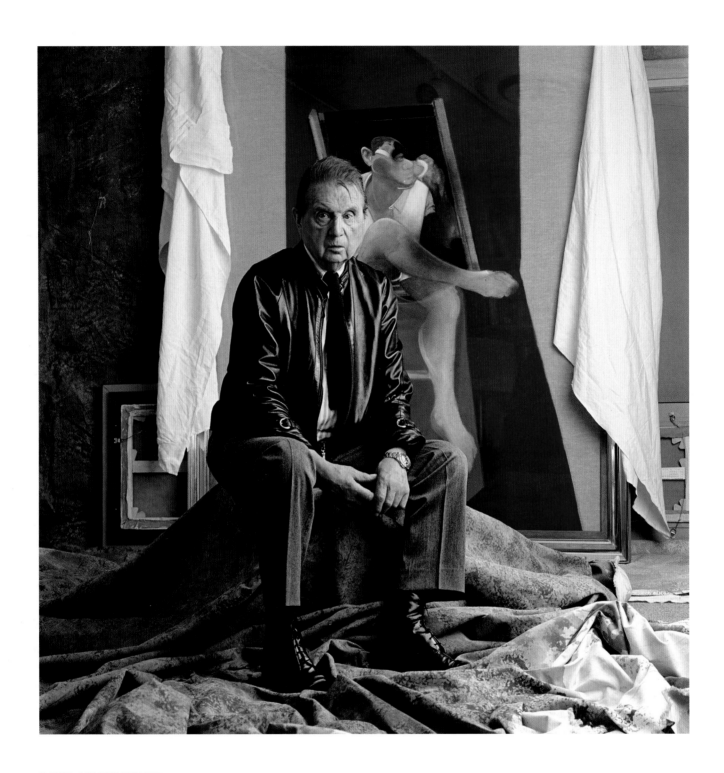

## DAVID MONTGOMERY

Painter Francis Bacon, in front of his painting *Study for Portrait of John Edwards*. From "Francis Bacon at 80," published August 20, 1989 (cover image).

I thought I had about a one percent chance that Francis Bacon would stay for this portrait. A photographer friend had put together a book on him and spent a year shooting him, and then Francis told him: "Well, you can't publish it." But we took this picture without any incident—in fact, Francis really loved having his picture taken. He was quite a vain guy. —DAVID MONTGOMERY

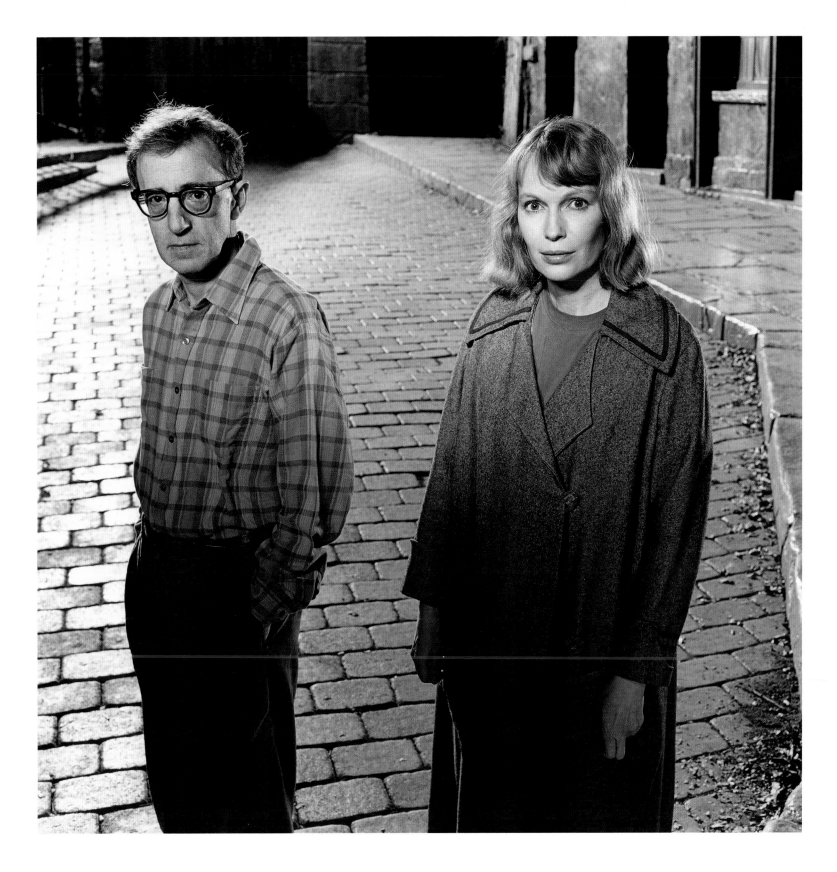

## MARY ELLEN MARK

Woody Allen and Mia Farrow on the set of Allen's 1991 film *Shadows and Fog,* in Astoria, Queens. From "Woody and Mia: A New York Story," published February 24, 1991 (cover image).

Woody Allen insisted on the negative space in this photograph. He said: "I'll do the picture with Mia, but we cannot touch." I thought: "That is the weirdest request, but if that's what he wants, it makes a better picture." We set up all these lights, and at the last minute, one of the lights failed—but it made the picture more powerful because it emphasized the distance between them. —MARY ELLEN MARK

## GILLES PERESS

Novelist Cormac McCarthy in a pool hall in El Paso, Texas. From "Cormac McCarthy's Venomous Fiction," published April 19, 1992.

I met Cormac McCarthy in El Paso. He was very Anglo-Saxon, very reserved, proper, mysterious—the way the legend goes.

I asked him if he played pool. He said: "Absolutely." So we went to a pool hall and started to play.

And he became a different man— very loose, suddenly comfortable. It was another self, one that was not *prepared* and literary and mysterious. Clearly, this was something that he had done early in life and very well. He was beating me consistently. I shot the picture as we were playing pool.

The afternoon light comes across very quickly and disappears very quickly. But when the moment is perfect, it goes very slowly. —GILLES PERESS

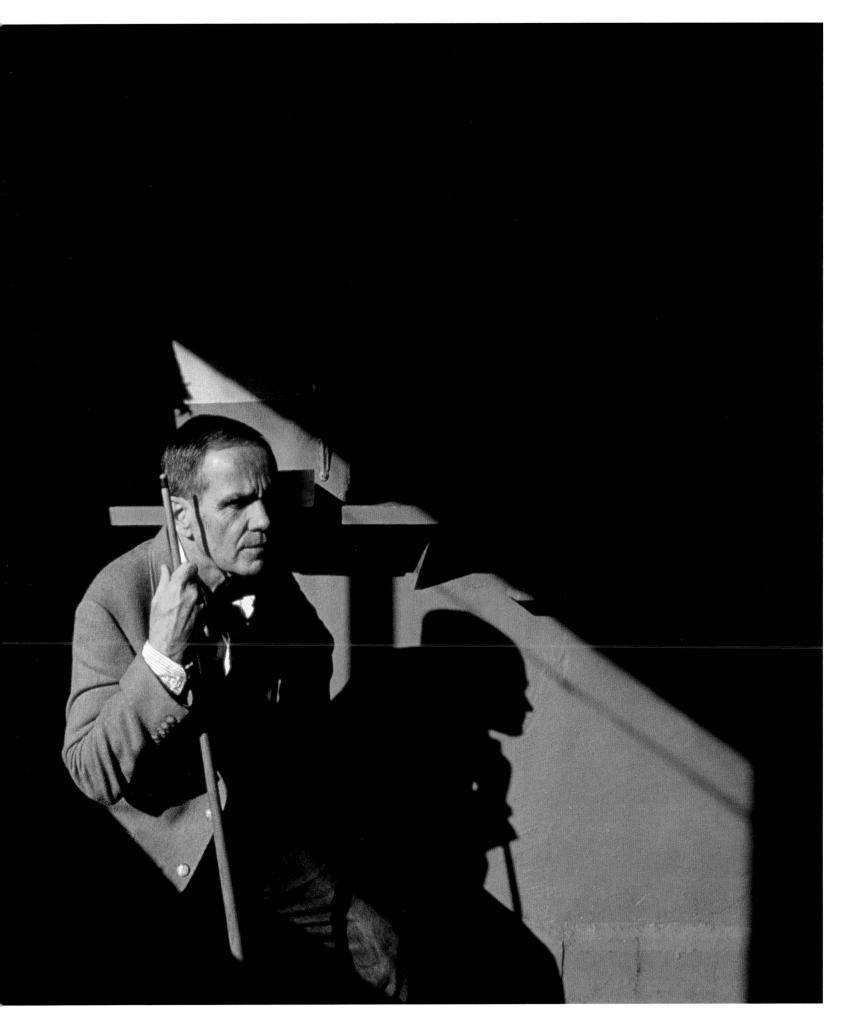

**MICHAEL O'NEILL**

Actress Natasha Richardson. From "Natasha Richardson and the Redgrave Dynasty," published June 6, 1993 (cover image).

Natasha Richardson was stunning. But today, of course, we have the knowledge that she died an untimely death almost fifteen years after this picture was made. Time moves on and different layers of meaning come onto pictures. I can't imagine anyone looking at this now and just seeing a moment of youthfulness. Instead, we look at it and feel sadness. —K.R.

OPPOSITE:
**DAN WINTERS**

Actor Denzel Washington. From "Playing with Fire: Bringing Malcolm X to the Screen," published October 25, 1992.

Green has always been my favorite color; they say it has a calming effect on people. I thought it would be cool to make an environment like the back room of some pool hall—and so I started the day before and built the whole thing, and created that kind of odd perspective. —DAN WINTERS

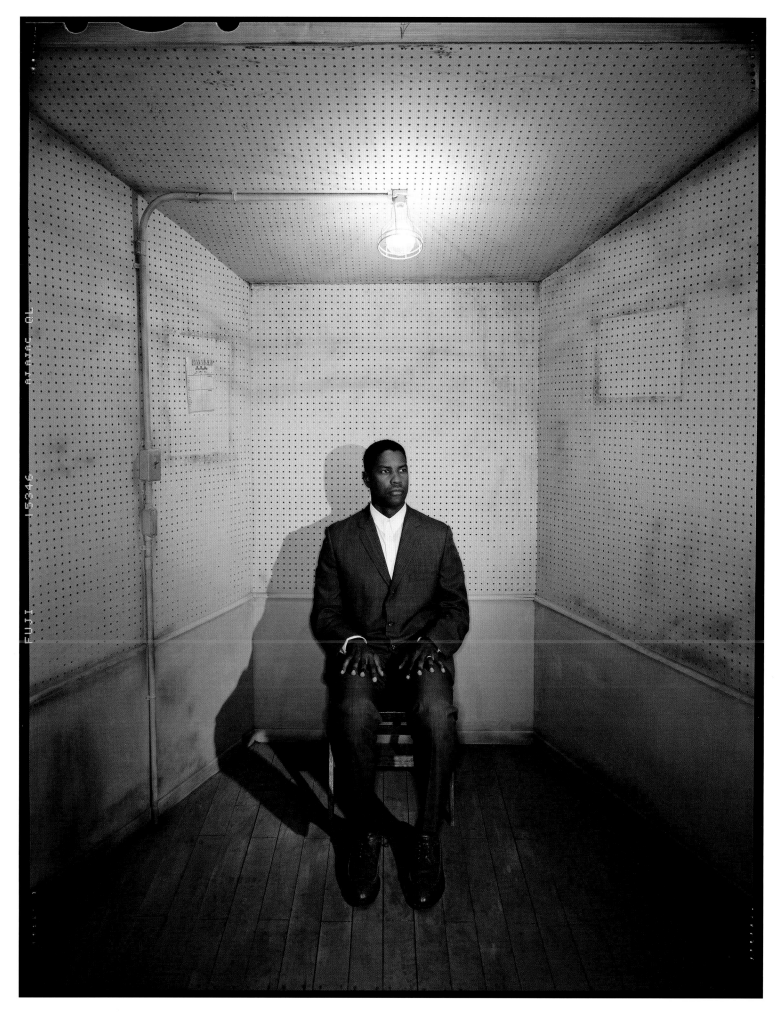

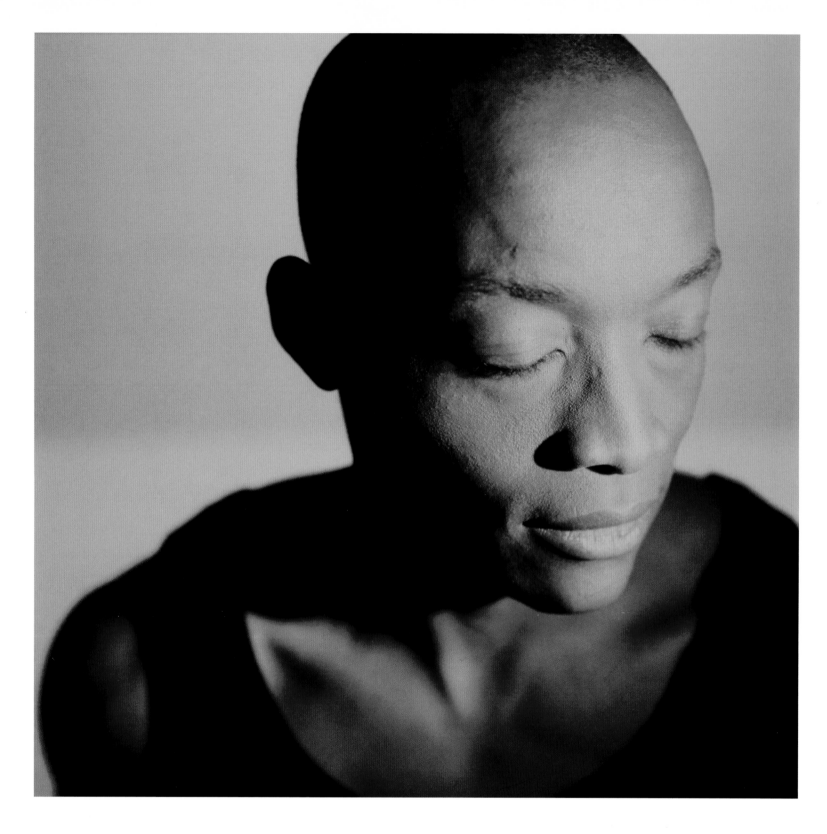

**BARRON CLAIBORNE**

Dancer Bill T. Jones. From "Bill T. Jones: Shifting Identities, Moods and Partners, the Choreographer Dances Against Time," published March 6, 1994.

I guess most people would shoot a dancer's body, but I wanted to show his face. He told me about his illness [Jones learned he was HIV-positive in 1985], and I had this urge to make him warm. He was tired, so I told him to stay calm and close his eyes if he wanted. —BARRON CLAIBORNE, 1996

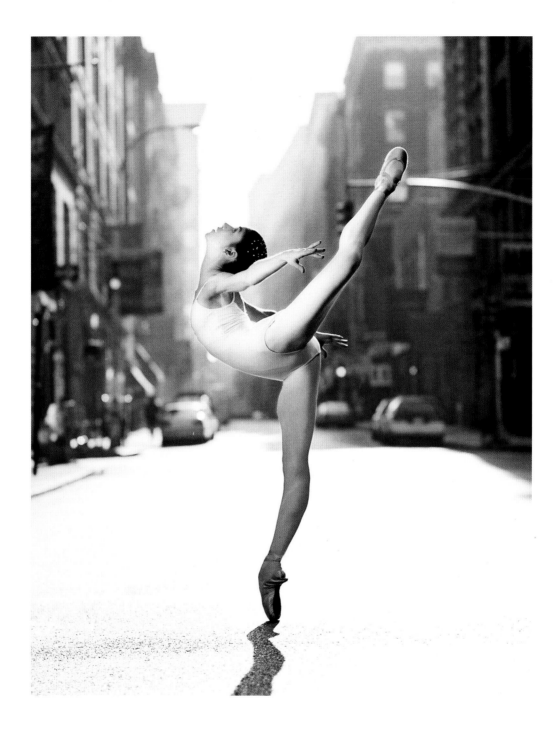

**MICHAEL O'NEILL**

Dancer Paloma Herrera, of the American Ballet Theater, on Manhattan's Spring Street. From "If You Dropped a Bomb on These Pages. . . : Presenting 30 Artists, 30 and Under," published November 20, 1994 (cover image).

This was the first shoot I was ever on. It was very early in the morning, because we had to get the picture when there was no traffic in SoHo. It was freezing out, and Paloma Herrera was very brave—what she was doing was actually very difficult in that cold weather.

　　All the things that make this picture great, I didn't see at the time. I had a different image in my head: I saw the emptiness of the street and the ownership that an artist could take of it. But what makes this a wonderful picture is the framing, the focus, the light. —ADAM MOSS

## MATUSCHKA

Self-portrait by Matuschka, New York artist and member of WHAM (Women's Health and Action Mobilization). From "The Anguished Politics of Breast Cancer," published August 15, 1993 (cover image).

The *Magazine*'s art director, Janet Froelich, was looking through the visual research material gathered for Susan Ferraro's article and was struck by the image of Matuschka, which was on a four-by-six-inch postcard distributed by a political organization. I contacted the organization and found Matuschka, photographer, activist, and breast-cancer survivor. A former lingerie model, Matuschka had had a radical mastectomy that left a jagged scar on her chest. "This could become a very important cover," Janet said. This image would not illustrate the intellectual content of the essay; rather, it was the emotional truth of the essay delivered by a subject of the essay. —SARAH HARBUTT

What I remember vividly is the impression that this picture burned into my mind. I had just read Susan Ferraro's manuscript for the cover article. That Matuschka was willing, even eager, for us to publish so startling a portrait made precisely the central point, subsequently expressed in the issue's cover line: "You Can't Look Away Anymore."

At the time, I was especially sensitive to the subject because just that week, my wife and I were trying to be supportive of a dear friend about to go to the hospital for a mastectomy.

As we anticipated, the cover offended many readers. It stirred up more reaction than any illustration I can remember. But I was pleased, thrilled, that two-thirds of the responders said they approved. On the day the issue came off the press, I took a copy to our friend in the hospital. She said that this was "a turning point" against all the prevalent denial and secrecy about the topic. Joseph Lelyveld summarized the episode with a single word. This brave photo is, he said, "demystifying." —JACK ROSENTHAL

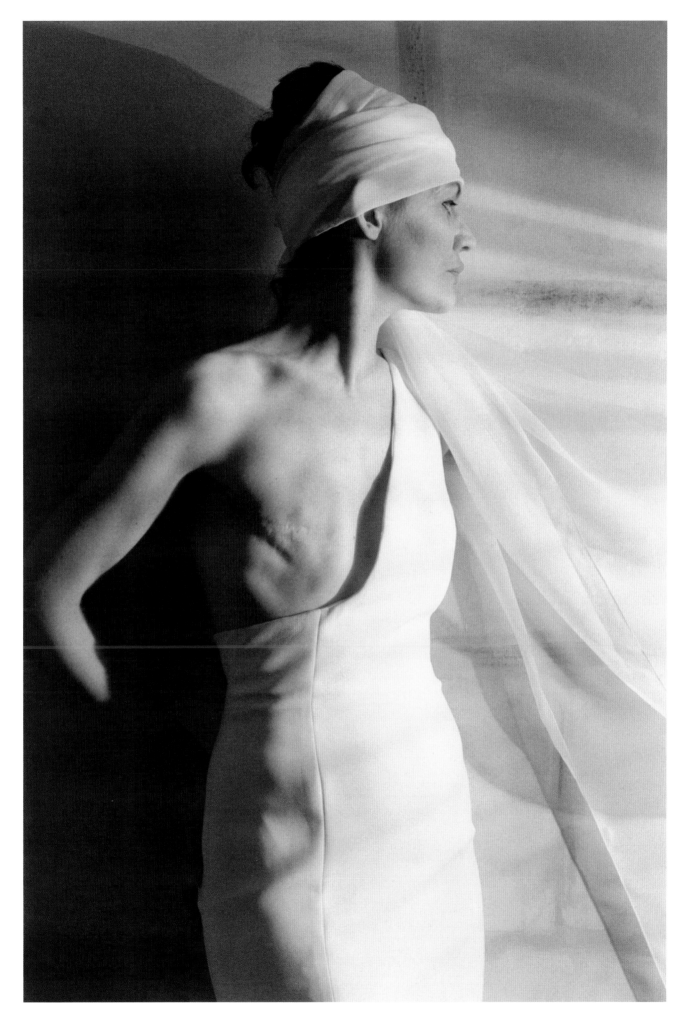

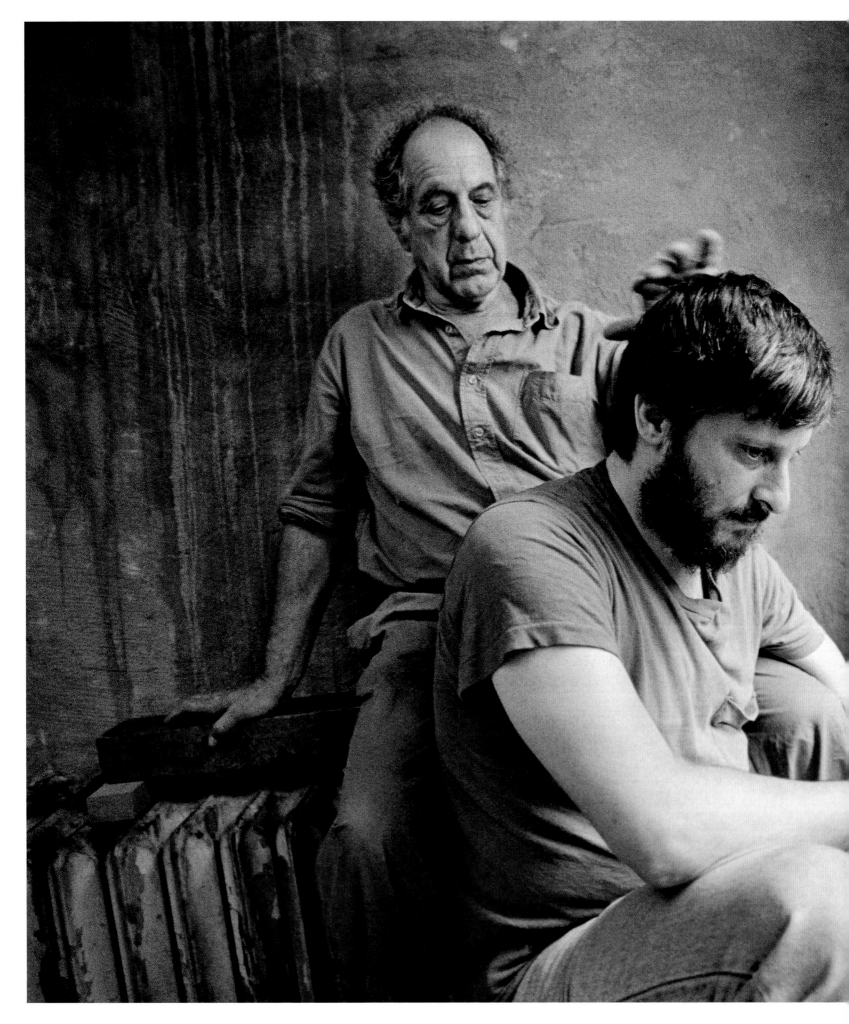

## EUGENE RICHARDS

Photographer Robert Frank and his son, Pablo. From "Where Have You Gone, Robert Frank?," published September 4, 1994.

Robert Frank didn't really want anyone to photograph him—I think he said yes to me only because he figured I wouldn't bother him. . . . So I spent a few hours with him, and then Kathy asked if I would go back a second day. Which I really hated, I confess, because I didn't want to impose on him. But I went back, and that's when this moment happened with his son.

It was at the end of my time with Robert when Pablo came out of the back room, kind of upset-looking and I didn't have any idea why. But this is the gesture, when you have a child or loved one, where you don't dare really reach them or stop them—but you almost do: you try, but you stop just at that point of contact. It's that moment of uncertainty. You almost want to transfer your feelings to them, but you can't, and you don't really want to try because you might make things worse. There's no doubt about it: this was Robert Frank trying to reach Pablo—without really doing so.

As a photographer, I wanted to be there when Frank was really himself. But until that moment, he wasn't. The portraits I'd made of him up until then were kind of formal, okay—but they didn't reveal anything that I knew of him except for his physical presence. This was the only moment we had when he became who he is. It's an indefinable thing. —EUGENE RICHARDS

## RICHARD BURBRIDGE

**THIS PAGE:** Amy Fisher, who in 1992 shot and wounded Mary Jo Buttafuoco, the wife of her lover Joey Buttafuoco. From "Amy Fisher's Time," published July 21, 1996. **OPPOSITE:** Musician Wynton Marsalis. From "Stop Nitpicking a Genius," published June 25, 1995 (cover image).

I found a language with photography that I didn't think other people knew existed. I can "edit" a moment in photography that can't be "fixed" otherwise—we can only see it if we stop moving. Only if you freeze-frame a film or take a still photograph can you see it.

What I love about photography is the essence of what it is. I can use it as a tool to create an image that is sharper than what we can experience. —RICHARD BURBRIDGE

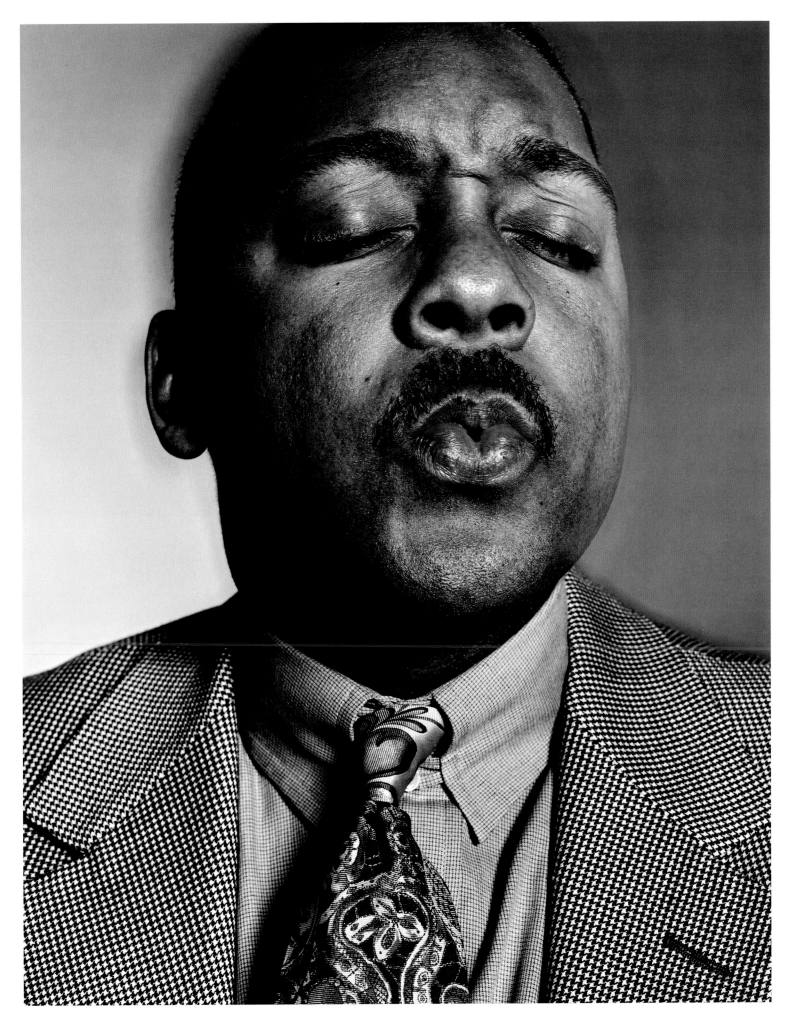

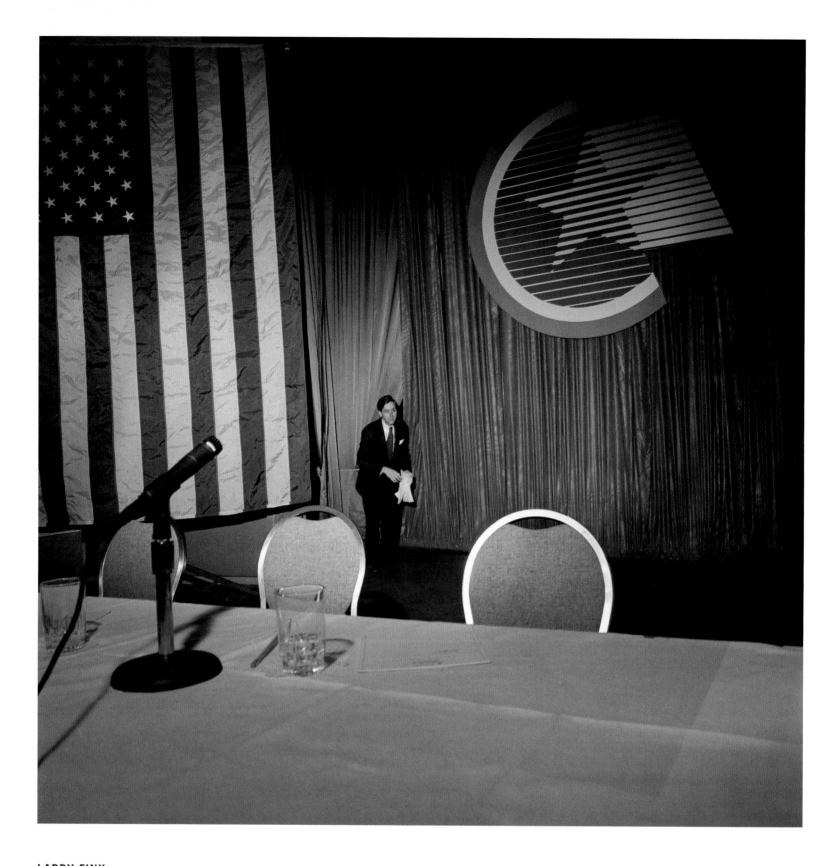

**LARRY FINK**

Political activist Ralph Reed at a Christian Coalition conference. From "Life Beyond God," published October 16, 1994.

My assignment was to photograph a conference of the Christian Coalition—me, the deep leftist, with the *New York Times*! I went into the auditorium and waited for the energy to create its own theater. The curtain was thrown back and Ralph Reed was thrust into the room, to hold the audience spellbound with his high, mincing voice. And then I noticed the stunning similarity of the Christian Coalition logo to the one used by the Soviet Union. —LARRY FINK

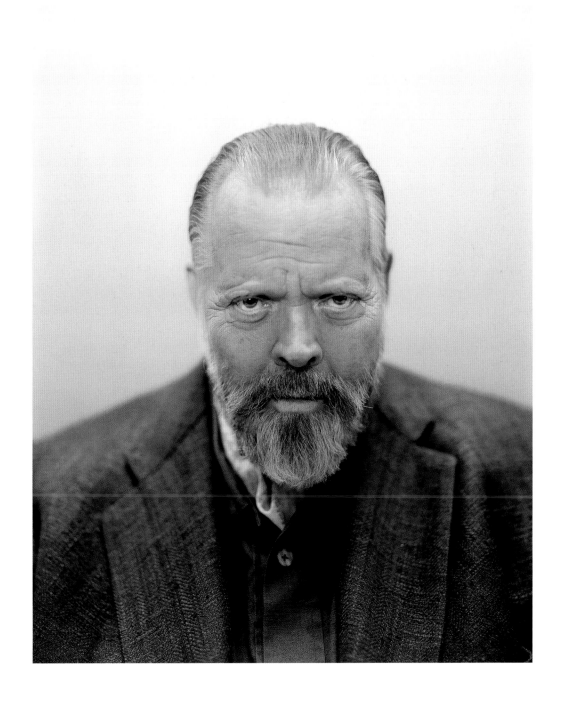

**MICHAEL O'NEILL**

Filmmaker and actor Orson Welles. From "Orson Welles: The Unfulfilled Promise," published July 14, 1985 (cover image).

This is one of the last photographs made of Orson before he died. He loved my camera—I was using a gigantic Deardorff—and he decided that he had to direct me and tell me where to put the light. So even in his last days, he was performing his directorial role perfectly, and bossing me around. Which was precious. —MICHAEL O'NEILL

## NAN GOLDIN

Model James King backstage at a Karl Lagerfeld show. From "At 16, A Model's Life," published February 4, 1996 (cover image).

When I first met James, I had been asked to do something I didn't know how to do: photograph strangers. I was scared.

What was I looking for? Obviously, beauty. But less of the superficial beauty, less of the posing—more trying to break through to something that went beyond that.

James and I connected very quickly. I understood her, in some ways, because of my own youth and history. She was very self-destructive—I don't think she liked being a model. I had this kind of caring for her as if she were my child, and I really wanted to help her. I don't know how effective that was, but at least she could confide in me. —NAN GOLDIN

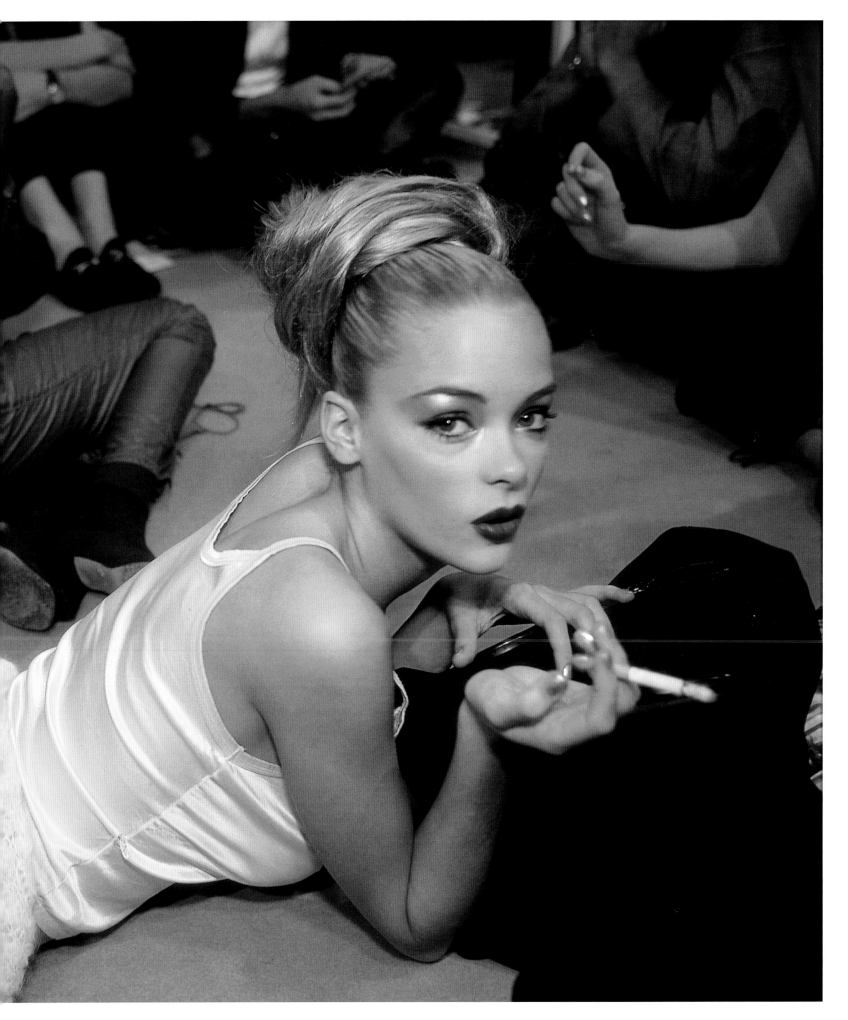

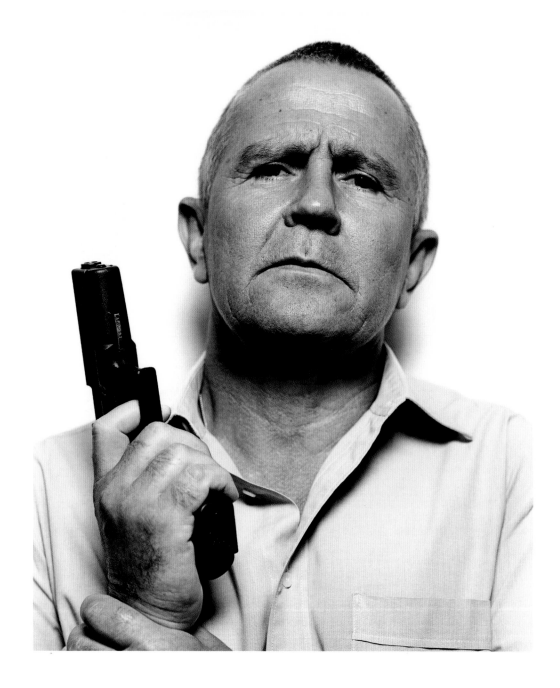

## JILLIAN EDELSTEIN

**THIS PAGE:** Dirk Coetzee, commander of the Vlakplaas police squad.

Dirk Coetzee, the commander of a covert "counterinsurgency" police squad in Vlakplaas, had ordered the deaths of many African National Congress activists. He was granted amnesty by South Africa's Truth and Reconciliation Commission in 1997. When I visited him at his home, he served me English Breakfast tea. I saw that wherever he went—even when he was serving tea—a little leather purse hung off his wrist. "It contains my gun," he told me. "I take it everywhere, even when I go to the toilet."

**OPPOSITE:** Thembinkosi Tshabe and Mxolisa Goboza, who testified before South Africa's Truth and Reconciliation Commission. Both photographs from "The Witnesses," published June 22, 1997.

These boys, Thembinkosi Tshabe (left) and Mxolisa Goboza, were two of the youngest victims to appear before the Truth and Reconciliation Commission. They had both been shot by police, who opened fire with pellets and tear gas on a Congress of South African Students demonstration in 1993. Tshabe was fifteen at the time; Goboza was eleven. Here you can see their wounds. —JILLIAN EDELSTEIN

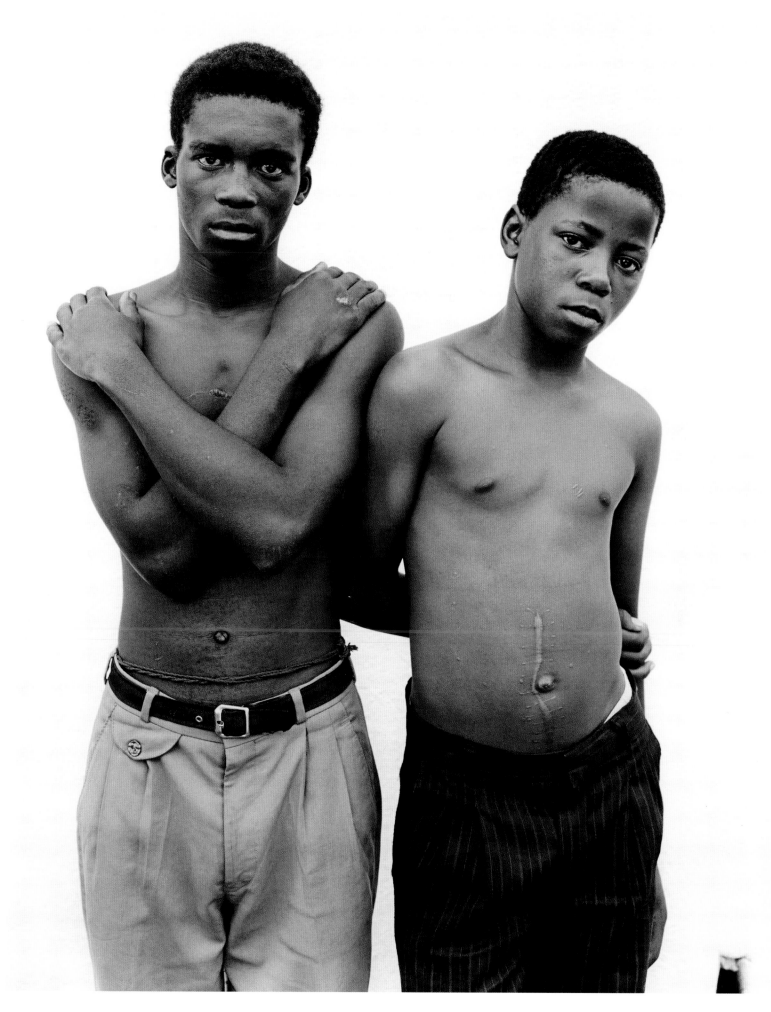

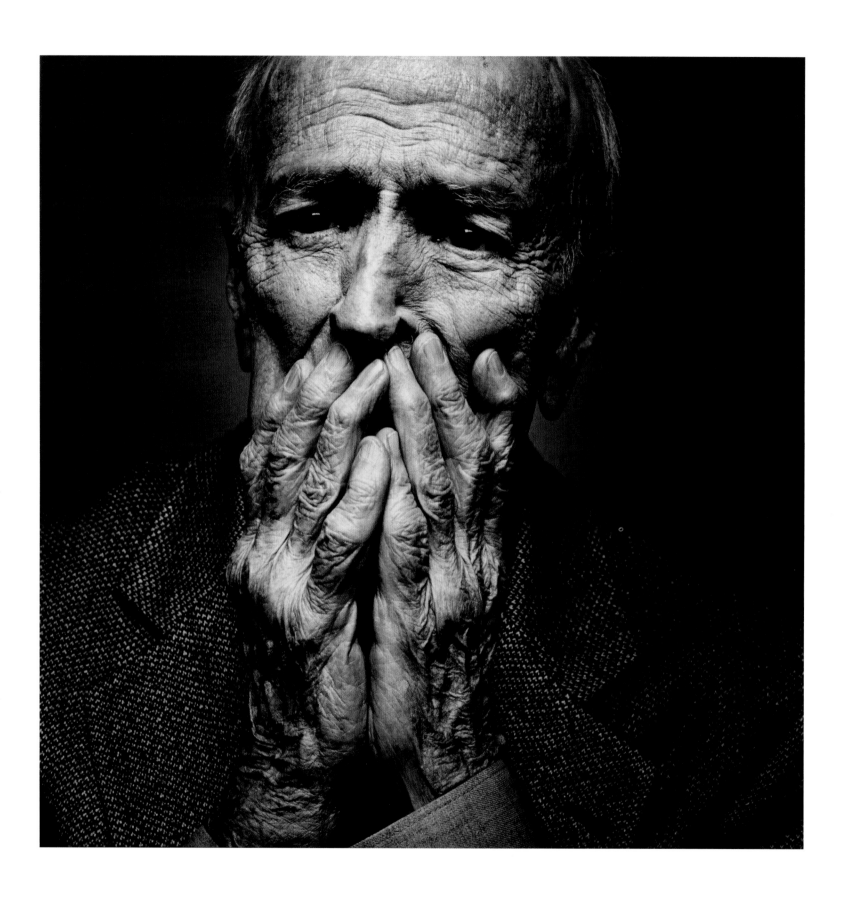

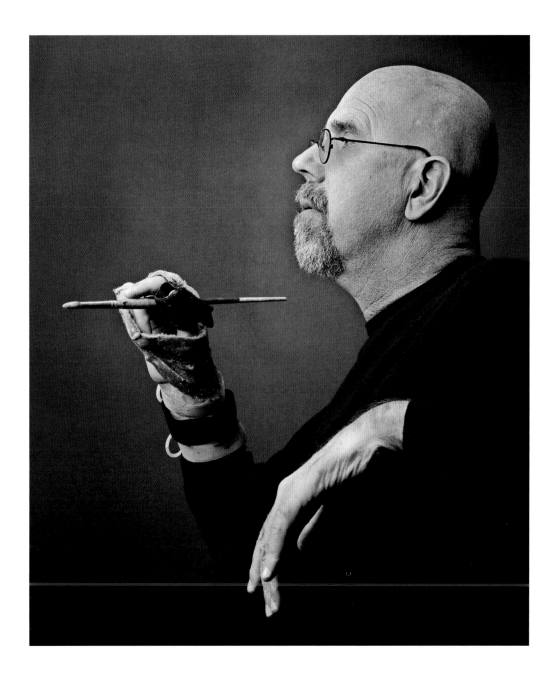

**MICHAEL O'NEILL**
Artist Chuck Close. From "Portraitist for the Information Age," published February 1, 1998 (cover image).

OPPOSITE:
**NIGEL PARRY**
Author William Maxwell. From "Nearing 90," published March 9, 1997.

Maxwell was quite spirited, even for his age; I find that a very endearing quality. The shoot started with him sitting down with a cat in a corner, almost behind a door; I moved closer and closer, and finally I got so close that I saw that his hands looked sort of like crumpled paper or crumpled metal. I asked him to lift his hands up to his face, and he just did that. —NIGEL PARRY

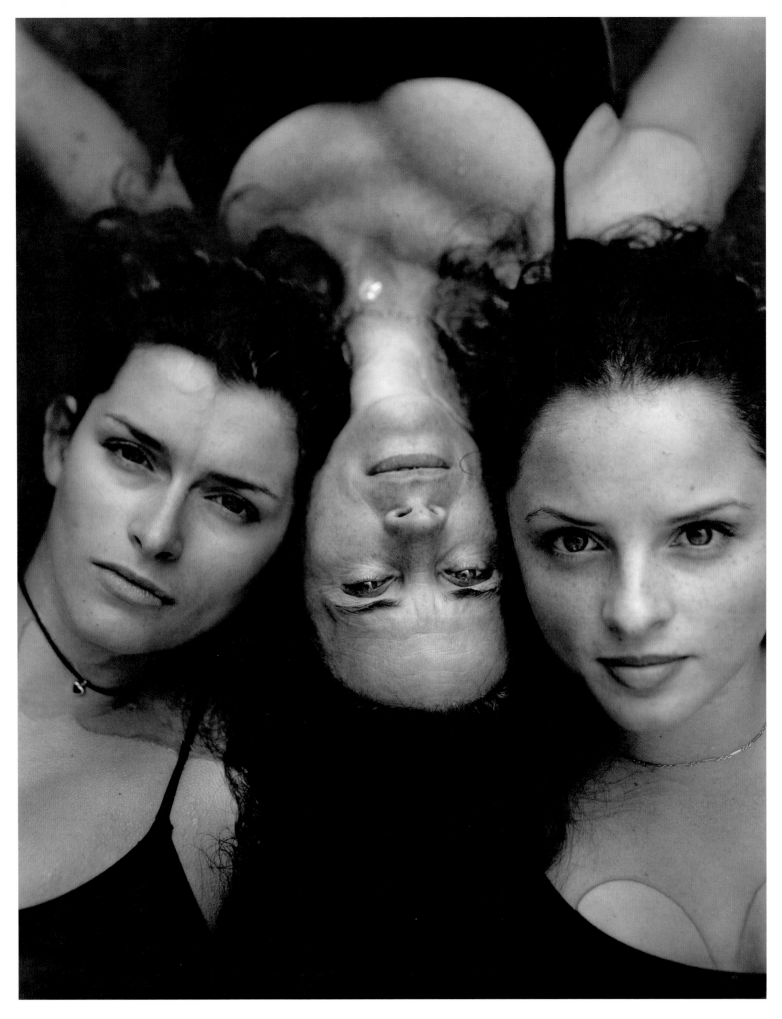

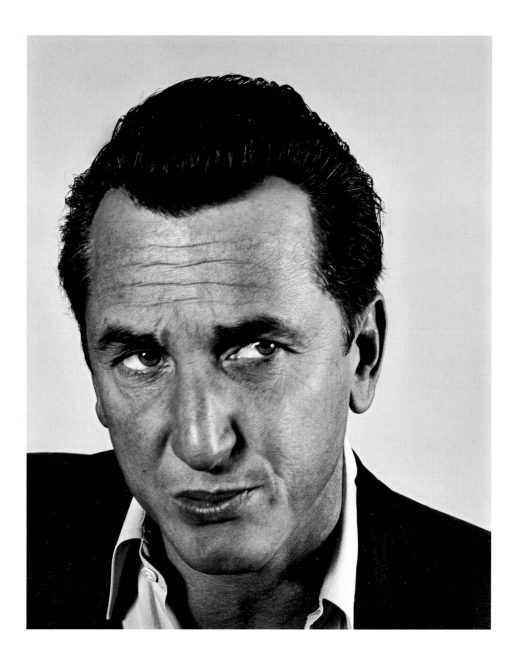

## RICHARD BURBRIDGE

Actor Sean Penn. From "What's Sean Penn Angry About Now?," published December 27, 1998 (cover image).

I saw that Penn was adopting an expression that I didn't want, and I found it really hard to break it. I felt like it was the expression that I've always seen with him. I think I finally did it by allowing him to smoke a cigarette, and by talking to him. When I saw the picture, I was thrilled that I had overcome the control that he posed. —RICHARD BURBRIDGE

Celebrity portraiture can risk being all too often homogenous and non-distinct. At the *Magazine*, we always felt it was our duty to do the exact opposite whenever we had these opportunities—to make a memorable and singular portrait of these iconic actors. —JODY QUON

OPPOSITE:
## SALLY MANN

Photographer Sally Mann (center) with her daughters Jessie (left) and Virginia. From "Women Looking at Women: An Exploration in Pictures of Power and Its Opposite," published September 9, 2001 (cover image).

For this image [created especially for the cover of an issue devoted to women photographers], my daughters and I were lying in three inches of water by the edge of the river. I had recently taken a picture of my daughters on the teeter-totter—sort of a relative-weight idea: it was about a shifting of relationships, the shifting of weight—about how children eventually overtake you as their mother. This picture has the same theme. I mean, they are so present and so strong, and they absolutely take the picture over. —SALLY MANN

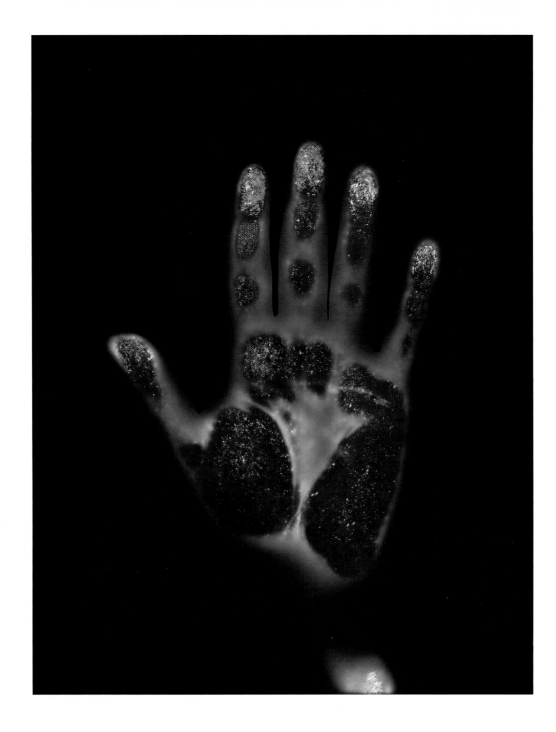

### GARY SCHNEIDER

Self-portrait: The photographer's hand. From "Inside Out," published October 17, 1999.

For this image, I placed my hand in contact with the emulsion of the film, which absorbs the humidity and heat from the skin. In the process, the emulsion accumulates biological information: it is damaged by the acids and the humidity in the hand. It all takes place under an enlarger, and I flash a photogram outline of the hand to "enclose" all that information, and then the film gets processed. Scientists were actually making all these experiments early in photography, so there is a precedent for my process in history. To me, it's just a portrait. —GARY SCHNEIDER

OPPOSITE:
### TARYN SIMON

Walter McMillian, Alabama. Convicted of murder 1988, exonerated and released from jail 1993. From "Life After Death Row," published December 10, 2000.

Taryn Simon is a photographer who works with a resolute, fully formed idea of what she wants to do, and once she has an idea, she remains committed to it. She was so compelled by the subject of wrongfully convicted people who had been exonerated that she spent several years of her life traveling across the United States, making portraits of them for her project titled *The Innocents*. —K.R.

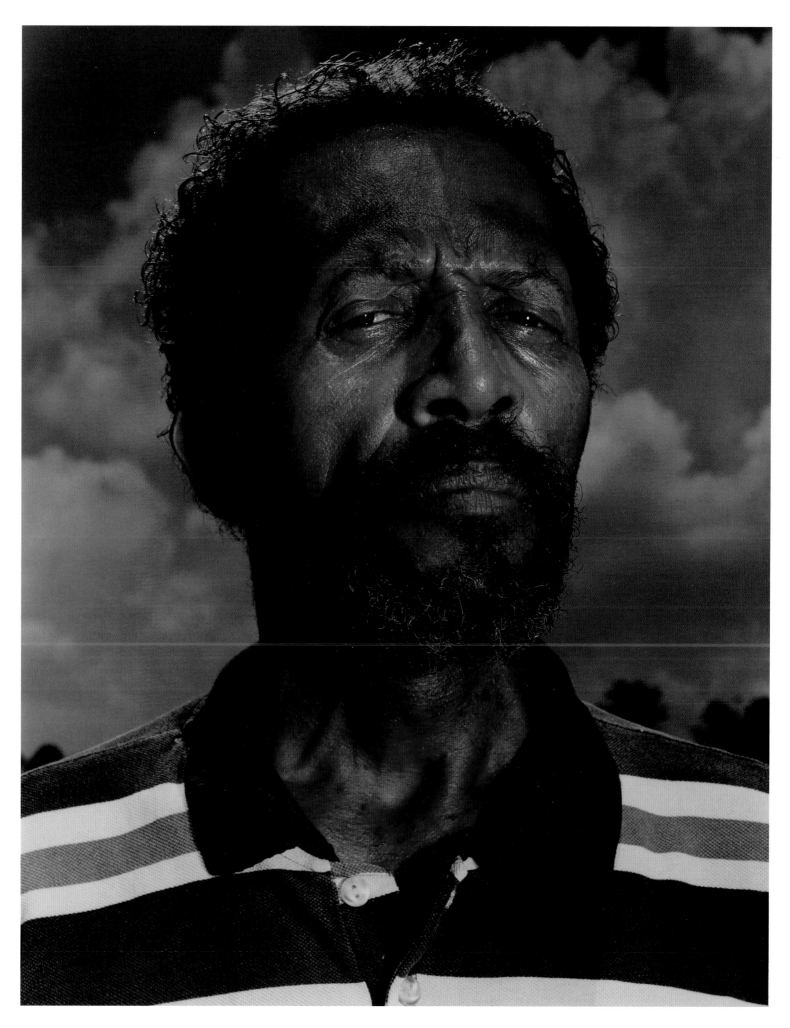

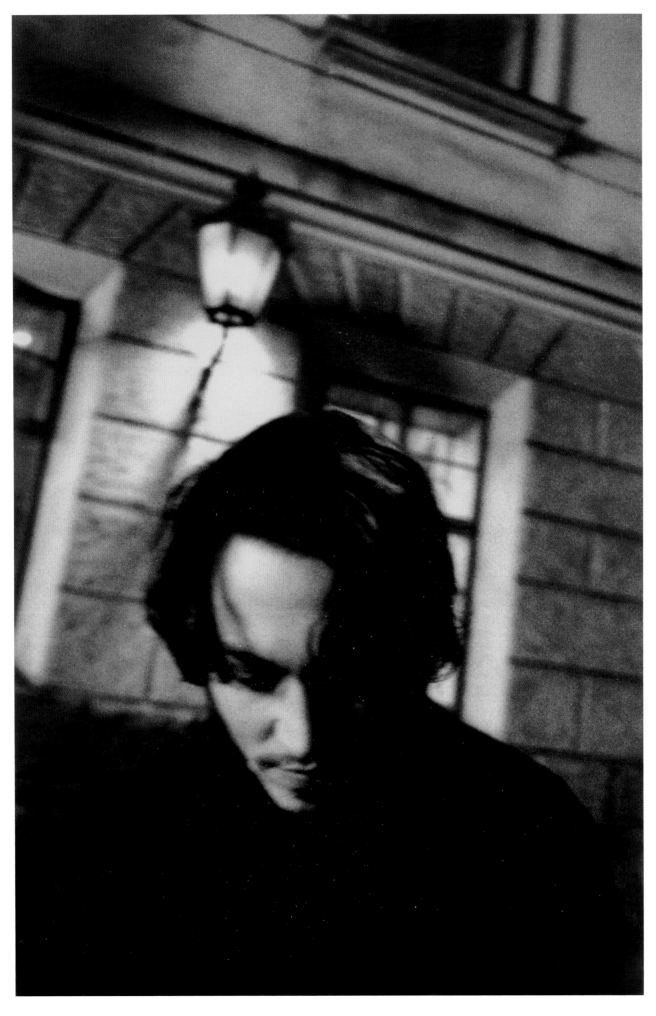

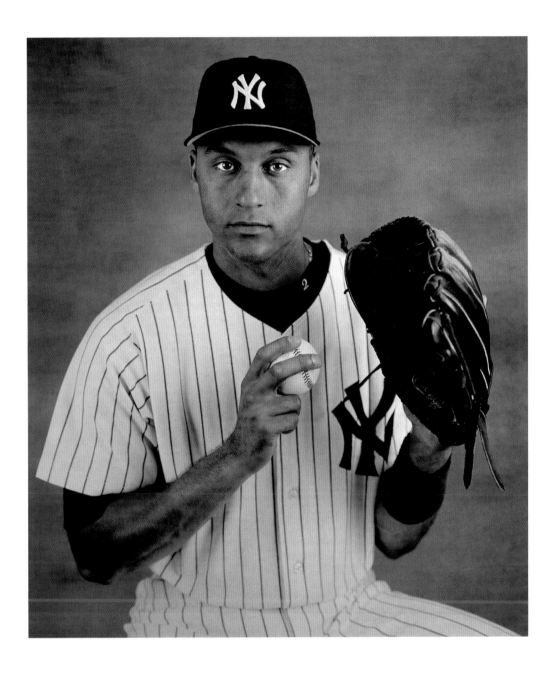

**JOYCE TENNESON**

New York Yankees shortstop Derek Jeter. From "The Team That George Built: A Portfolio of the 1998 Yankees," published September 27, 1998.

We asked Joyce Tenneson to create sepia-toned baseball-card images of the New York Yankees. At the stadium, there was a kind of nervousness and awe around the team—even their own handlers treat them like gods. But that didn't mean anything to Joyce—she'd go up and tug on a superstar player's pants, or adjust somebody's shirt as if they were just anybody off the street. —K.R.

OPPOSITE:
**ANTONIN KRATOCHVIL**

Actor Johnny Depp on the set of Allen and Albert Hughes's 2001 film *From Hell*. From "The Piece Period," published November 12, 2000 (cover image).

Antonin Kratochvil is Czech, and his photographs are fueled, I think, by the restlessness and yearning of a longtime expatriate. He loves to tilt the camera and keep everything off-kilter and moving. His work is thrilling to edit. No contact sheet has the same picture twice. That restless energy is always there. —K.R.

## KATY GRANNAN

Audrey Wilbur in her room in Woodstock, New York. From "The Invisible Poor," published March 19, 2000 (cover image).

This was my first commission for the *Magazine*. And it was a tough assignment: we were asked to go photograph "poverty" in unexpected places around the country. But no contacts had been set up beforehand—so I went through social services in Woodstock, New York, and a few other communities, and they put me in touch with a couple of families.

This particular situation was pretty shocking, I thought, for a neighborhood in upstate New York. The people were very, very poor: the clothes looked like rags; the kids looked like they hadn't bathed, and it seemed as though they all lived in one big room together. But there was this little girl who was incredibly sweet and didn't seem to have any real awareness of her circumstances, but just was bouncing on the bed with her sister—really kind of joyful. Here, she was doing what little girls do: playing dress-up, trying on different clothes. It's amazing how kids, despite any circumstance, find a way to play. And I thought that was enough. I didn't want to be patronizing or didactic; I just thought, I want to make a portrait. I didn't want to make a picture of "poverty." I wanted it to be more a photograph of *her* than I wanted to illustrate poverty.

This is the way photography can be cruel, though, in the sense that it describes everything, even the things we are not necessarily aware that we're revealing. —KATY GRANNAN

An artist like Katy Grannan is able to formalize and essentialize a situation so that the very specific is elevated to a larger level and becomes timeless. She uses a 4-by-5 camera, which means that all the details are here: the cracked radiator, the girl's tattered dress—and because of these details there is nothing anonymous or "archetypical" about this image. —K.R.

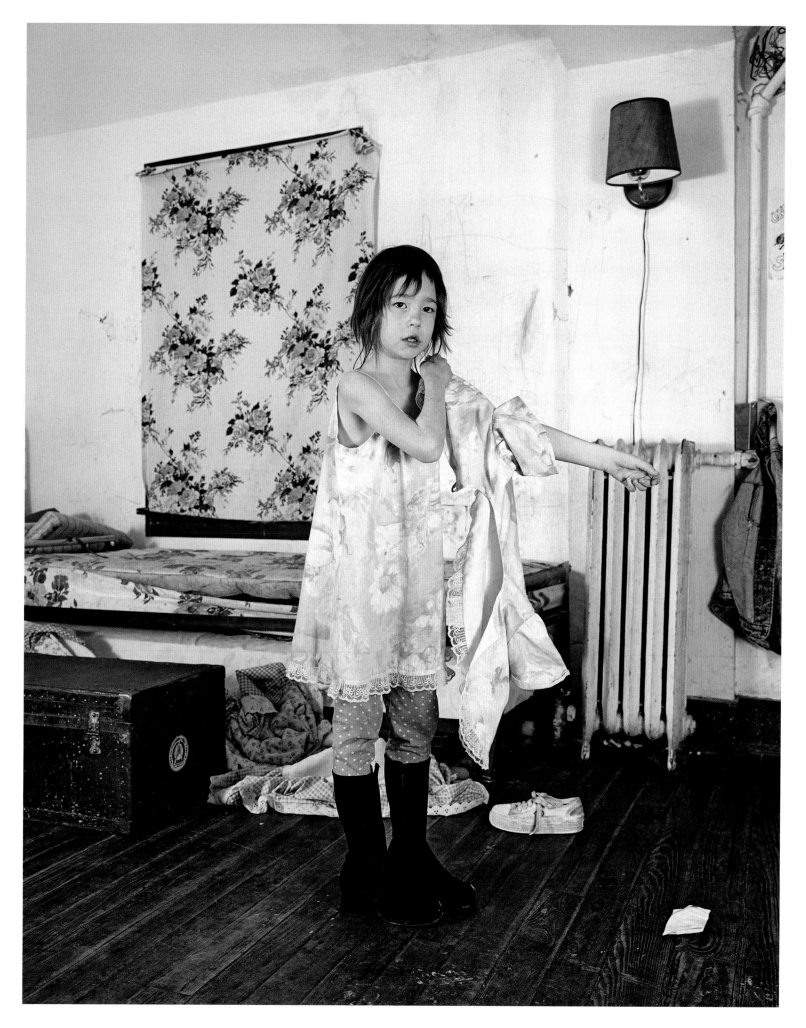

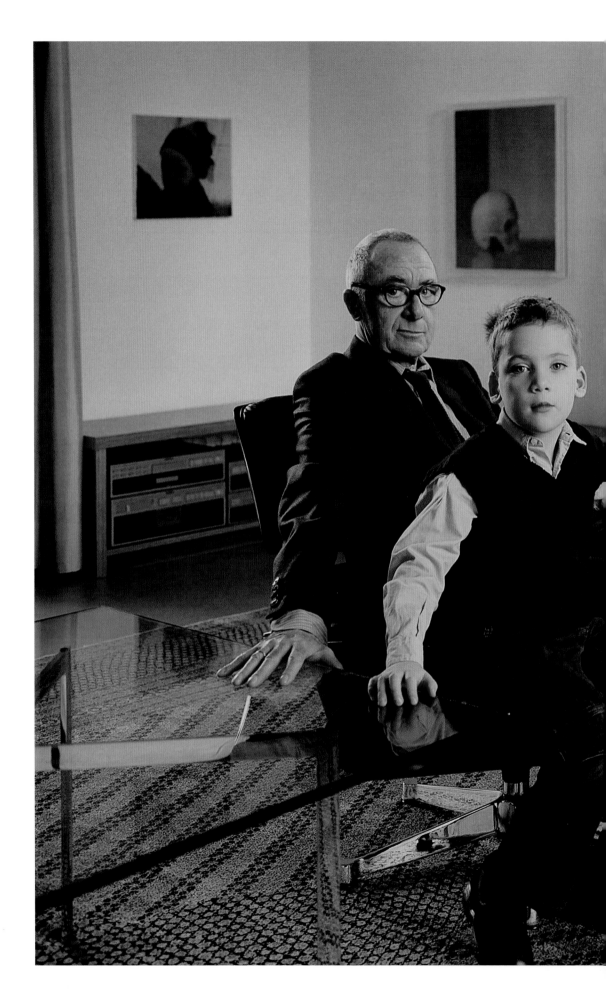

## THOMAS STRUTH

Artist Gerhard Richter, his wife, Sabine, and their two children, Moritz and Ella. From "An Artist Beyond Isms," published January 27, 2002.

I generally let sitters choose their position, because I know they will "slip" into a posture and position within the family, which represents how they feel in this particular moment. However, I have to be able to read the narrative. In the case of the Richters, I knew that the two chairs would make them have to choose. They are at home, which makes them feel comfortable. The white lilies, the paintings (especially the skull), the classic modern and conventional furniture all fit into the artist's realm. I only took down a few pieces of stereo system in the back, which had nothing to do with the ingredients I thought to be necessary for the picture. —THOMAS STRUTH

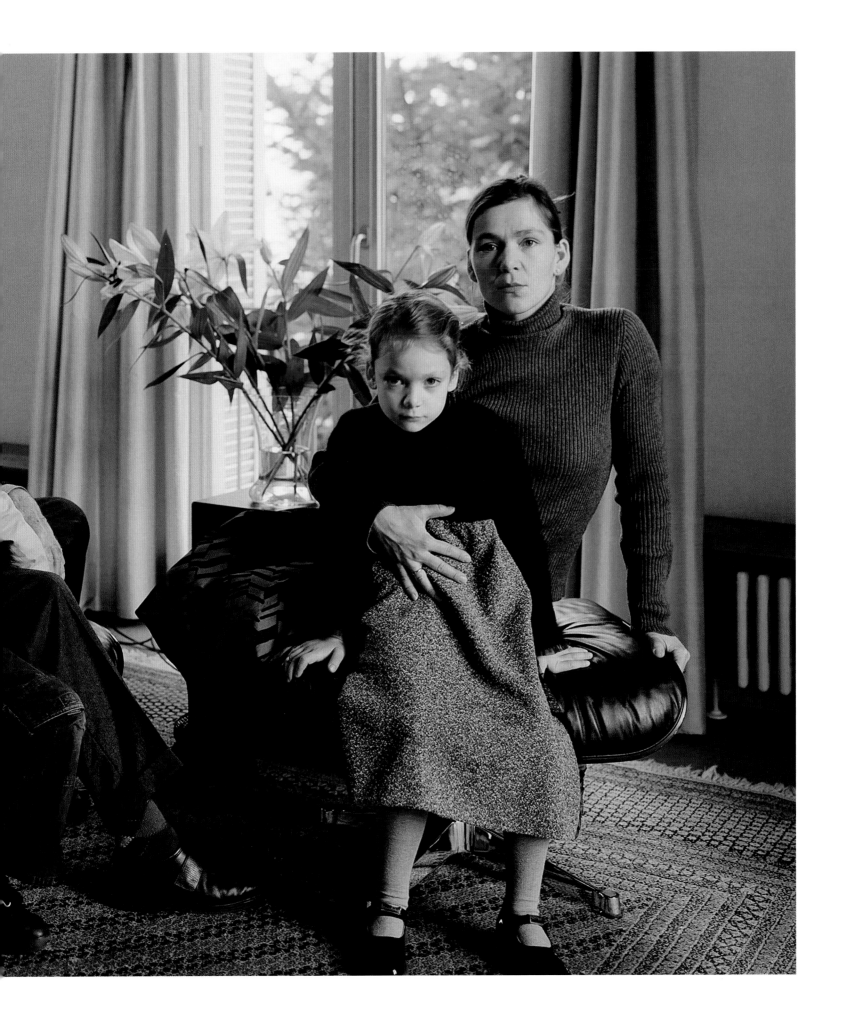

**ROBERT MAXWELL**
Dancer Alexandra Beller. From "Amazing Grace," published April 28, 2002.

In every frame I shot that day, it looks as if she is floating in water. She had such grace, such power. —ROBERT MAXWELL

As I recall, at the *Magazine* we were talking about Irving Penn and his nude studies of the dancer Alexandra Beller. Her body, which was proportioned differently from conventional dancers, was the focus of a show of Mr. Penn's work at the Whitney Museum, and the *Magazine* was doing a story on Beller's feelings about her body and that show. But the story was all about the photograph.

Robert Maxwell's image of Alexandra Beller is completely different from Penn's. It shows light and lift, where Penn's is focused on the beauty of sheer weight and mass. Penn's work, which has such power and balance, was difficult to compete with, but Maxwell's image succeeded in becoming an iconic, memorable image of movement and grace. —JANET FROELICH

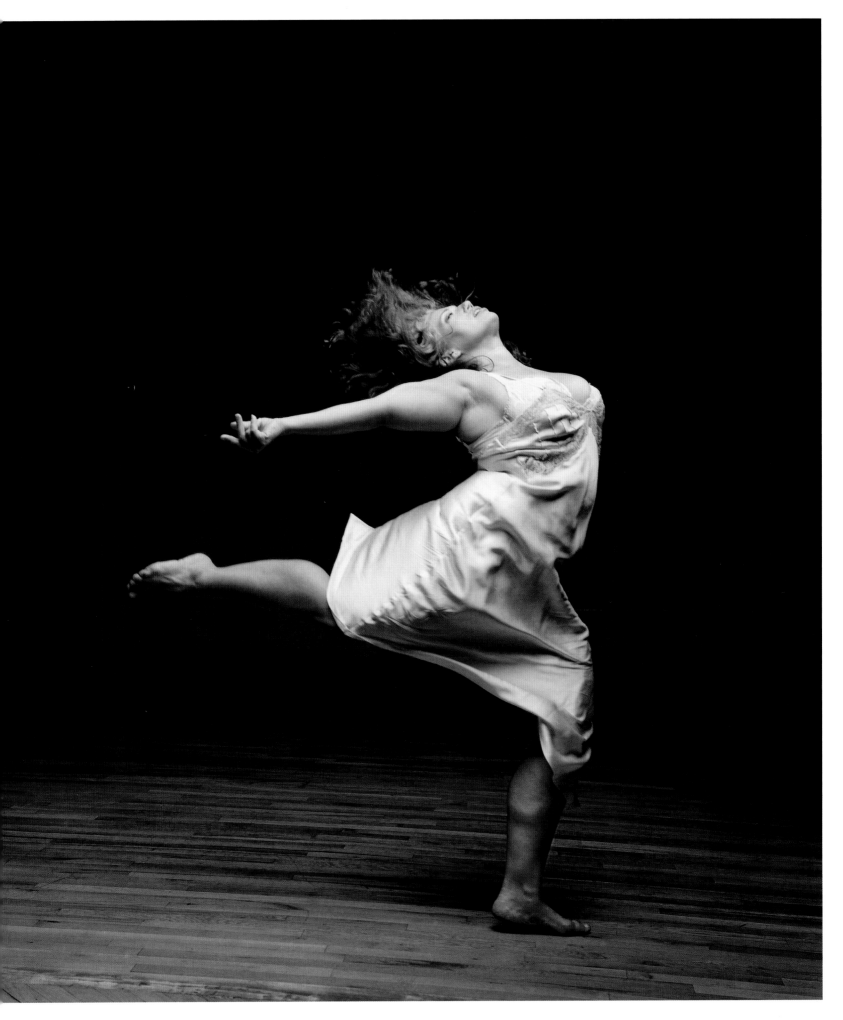

**BRIGITTE LACOMBE**
Actress Emily Watson. From "40th Reunion: An Ensemble Cast from the First Four Decades of the New York Film Festival," published September 22, 2002.

OPPOSITE:
**DAN WINTERS**
Actor Leonardo DiCaprio. From "The Kid Stays in the Pictures," published November 24, 2002.

Often, when you're photographing big movie stars, there's a whole production that goes on, but when there are only a few people involved, there's a much more relaxed vibe. Here, I just let him get into his zone. I think Irving Penn is my biggest influence—with regard to what a portrait can do, and the idea that the quietness of an individual often speaks so loudly. —DAN WINTERS

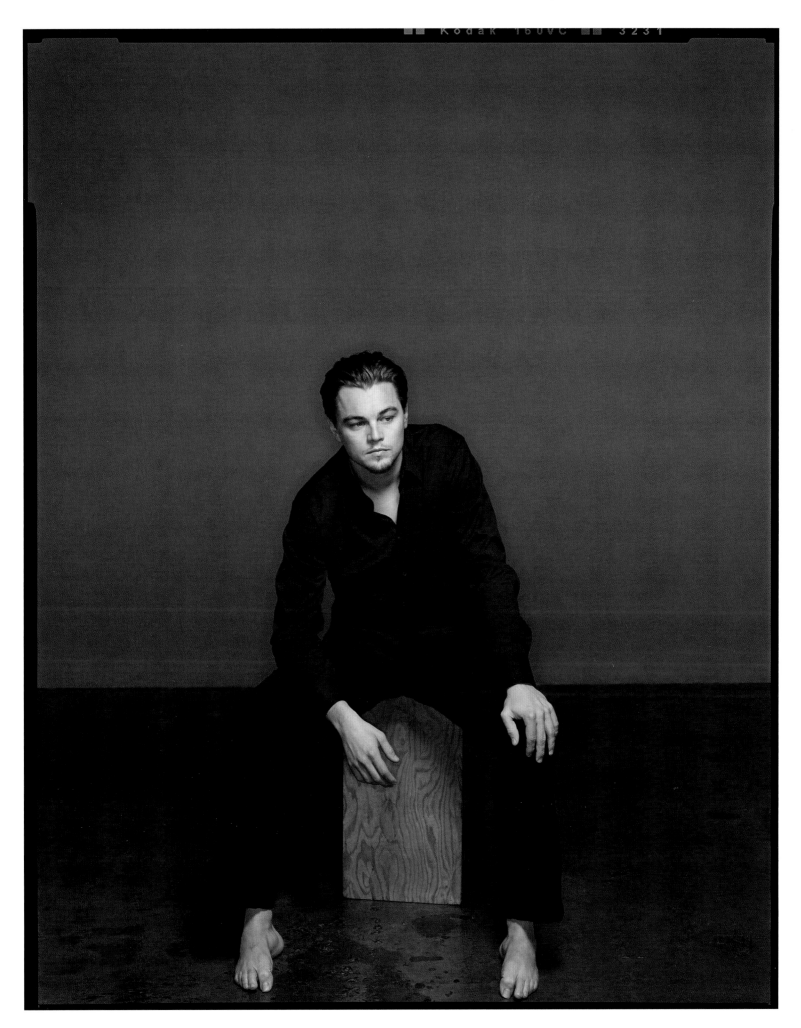

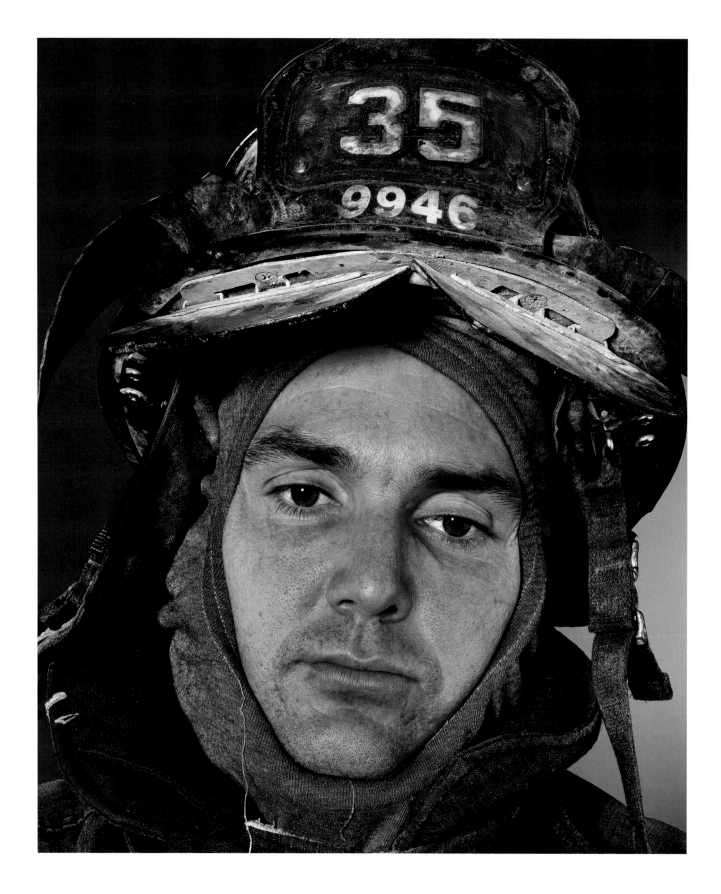

**RICHARD BURBRIDGE**

Firefighter Kevin Shea, September 11 survivor. From "Which Way Did He Run?," published January 13, 2002.

I was there to communicate a story beyond my own. I felt Burbridge was looking to demonstrate that I was troubled over 9/11—an injured survivor, contemplating the event and his place in it. Apparently I had some amnesia about what had happened. When I saw the published image I thought it was powerful— more powerful than the photo of the finance guy [Treasury Secretary Paul O'Neill] that ran on the cover of the issue. —KEVIN SHEA

**ROBERT MAXWELL**
Musician Norah Jones. From "The Anti-Diva," published January 25, 2004.

This was my second time working with Robert, so I felt more comfortable than I usually do at photo-shoots. At the time this photograph was taken I was in the middle of promoting my second record, which was a fun but very stressful time. I think he captured a little fear in my eyes. —NORAH JONES

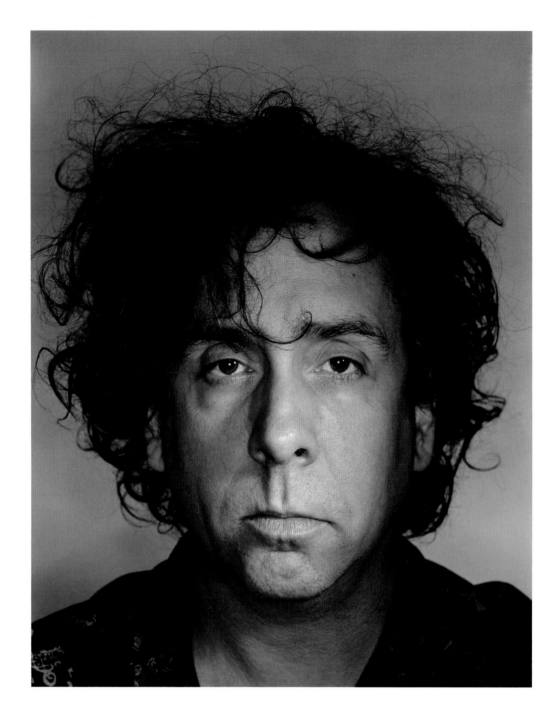

## DAN WINTERS

**THIS PAGE:** Filmmaker Tim Burton. From "Drawn to Narrative," published November 9, 2003.

Tim Burton's visual aesthetic really resembles his physical self: he looks like his work. When I made this picture, he was editing *Big Fish* and had been in the editing bay for months, so he was *white*. It was clear that he hadn't seen the sun in quite a while. We did the photograph in maybe twenty minutes, and then he went back to work. —DAN WINTERS

**OPPOSITE:** Filmmaker Spike Jonze. From "Spike Jonze's Wild Ride," published September 2, 2009 (cover image).

I have to say, Dan was pretty patient with my backseat driving. I definitely had opinions on what the photos should be. I think he has an ego as a photographer, in that he wants to make something he is connected to, but not so much so that he doesn't also want the photo to represent the person. —SPIKE JONZE

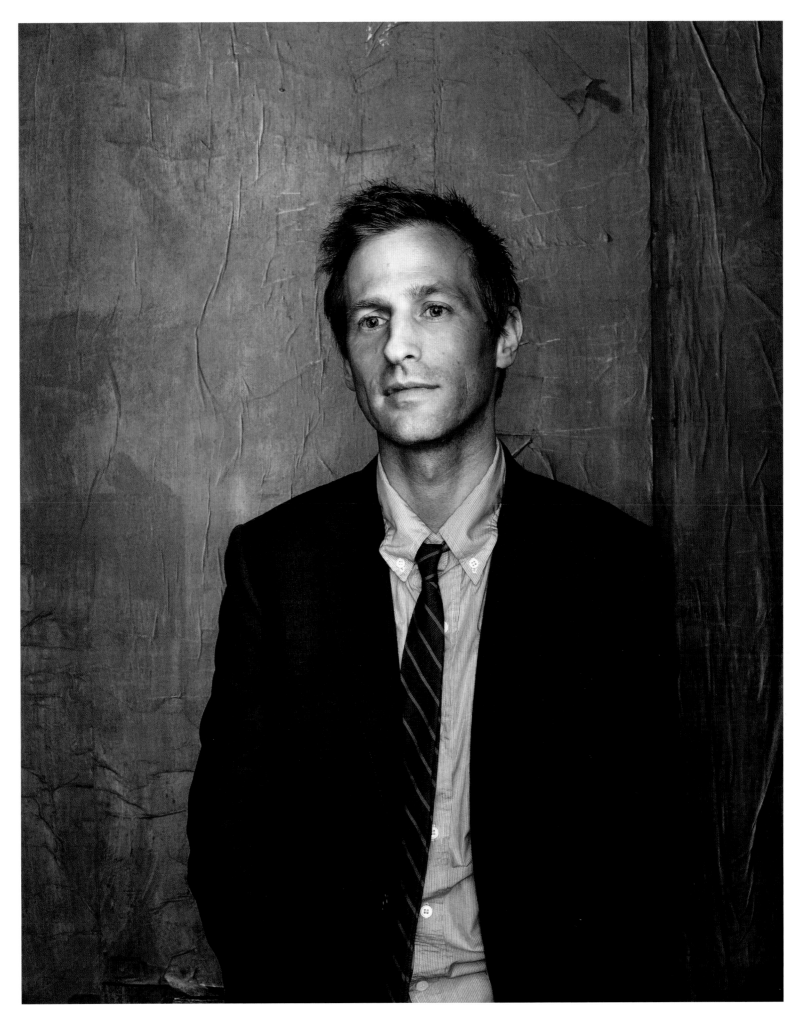

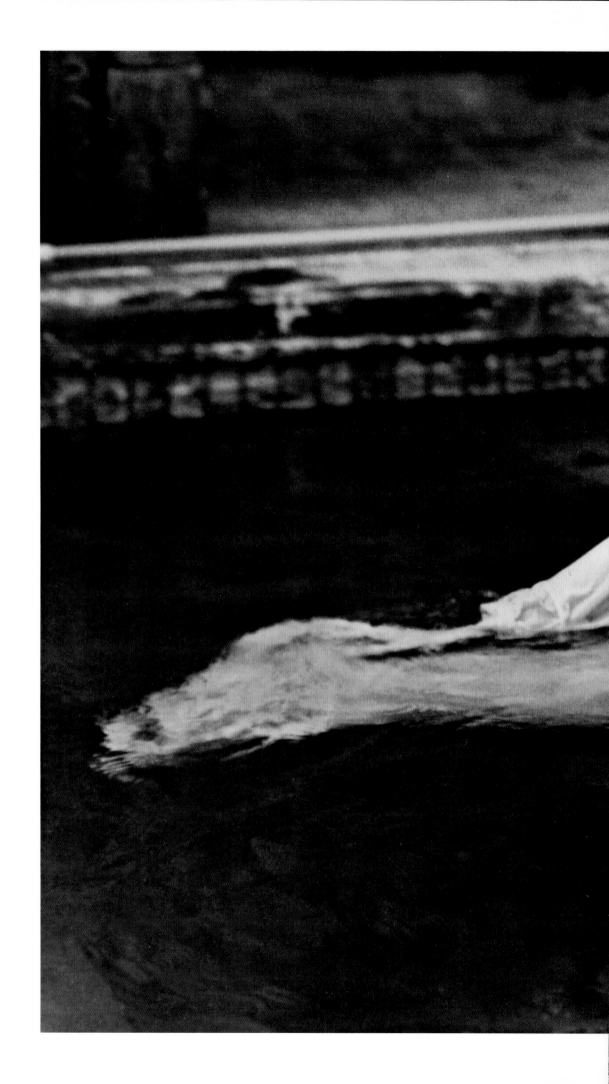

**DEBORAH TURBEVILLE**
Actress Julia Roberts. From "Transporting Beauty," published November 14, 2004.

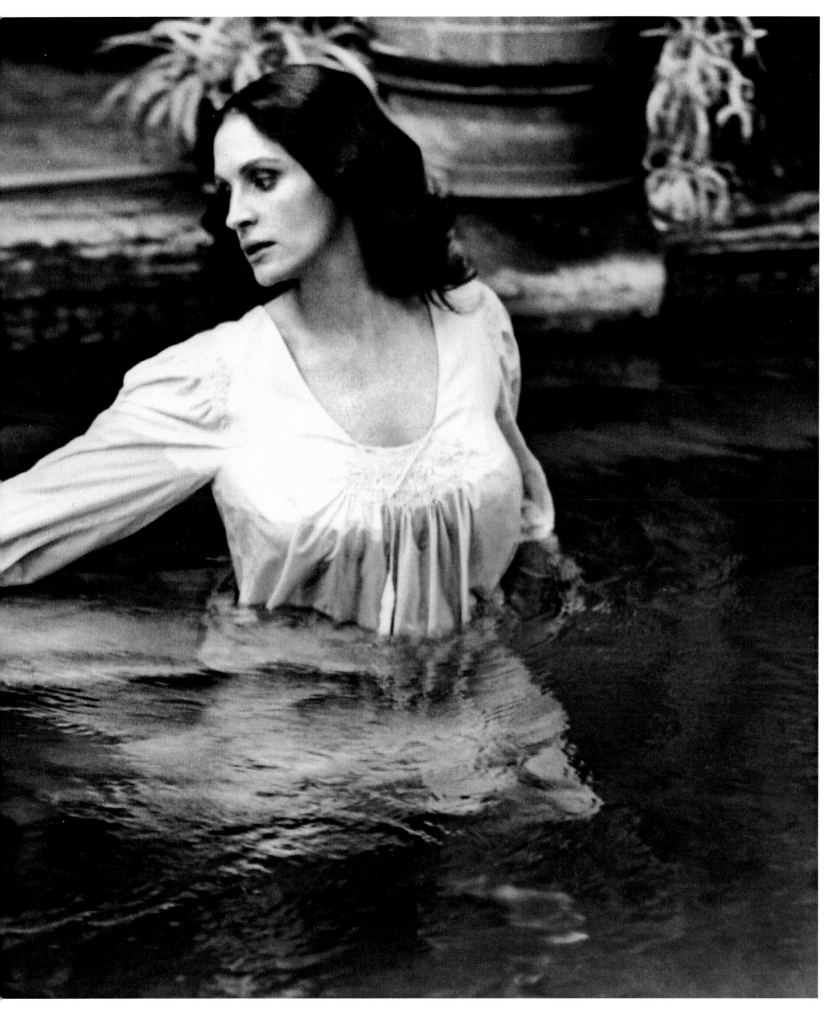

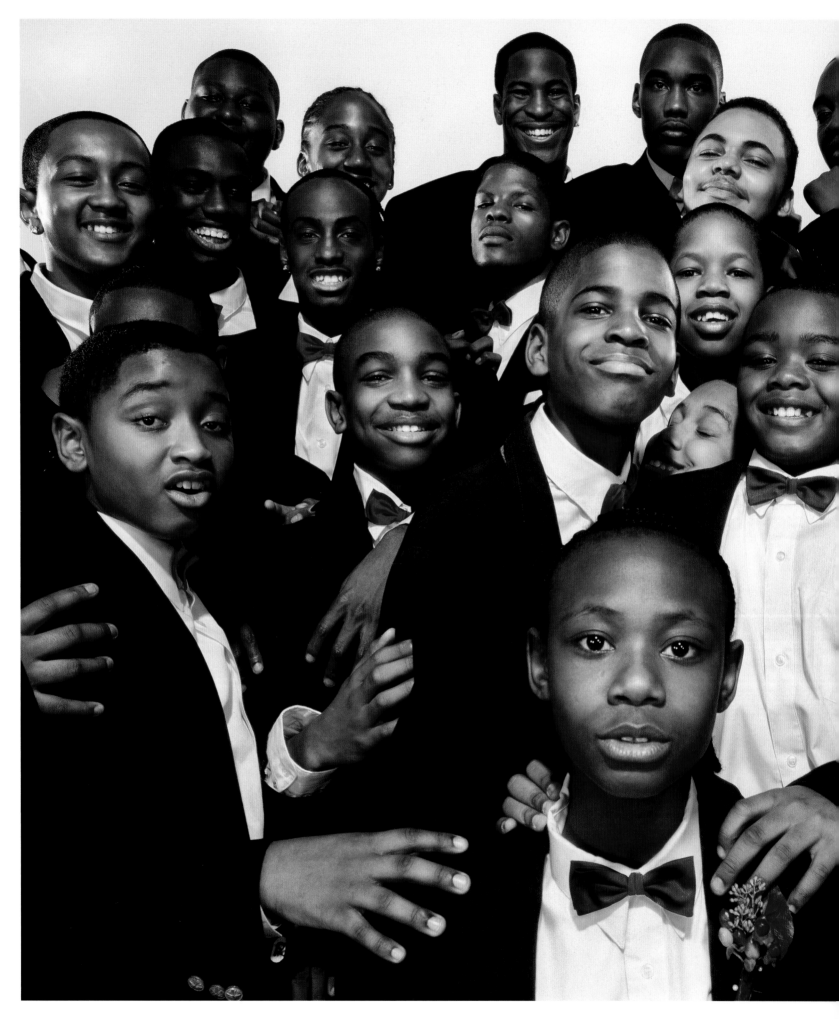

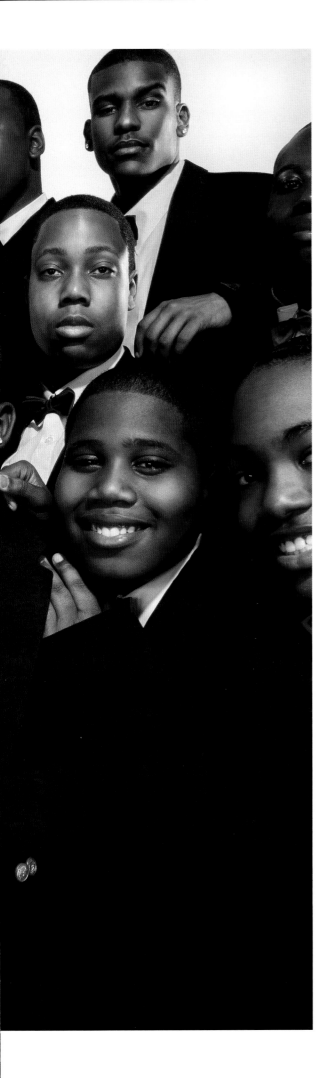

## OLAF BLECKER

The Boys Choir of Harlem. From "Jazzing Things Up: Style Portfolio," published December 5, 2004.

This image is all about the bowties. The color code of the image is pretty much black and white and red, which I think is an outstanding combination.

You might think that it is difficult to photograph a group of faces—but in the end, this one really wasn't. I am quite easygoing with big groups. I just tell the people: "Listen, guys, if you can't see me, I probably will not see you, so please make sure that you see the camera."

Still, it all happened under kind of a lucky star: everything came out well, almost by itself. —OLAF BLECKER

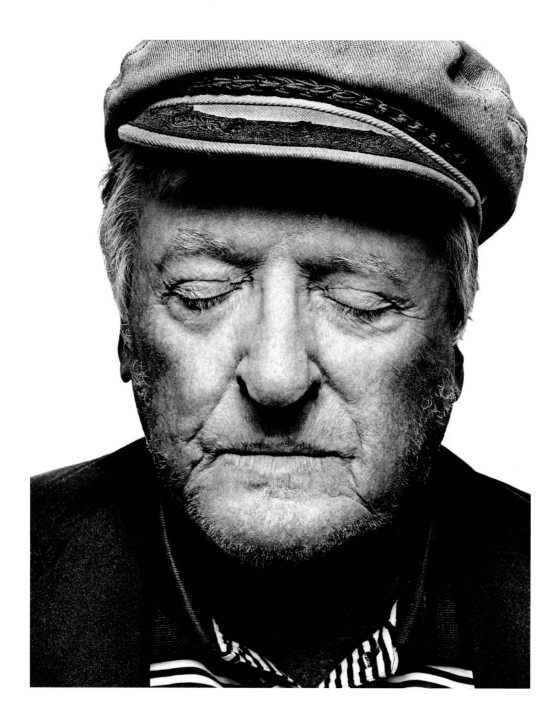

## PLATON
William F. Buckley Jr. From "How William F. Buckley's '65 Run for Mayor Changed America," published October 2, 2005 (cover image).

To really connect with someone, ask them to close their eyes in front of you. It's quite a vulnerable position to be in, not a comfortable position—and it quickly breaks down a barrier between the sitter and me. When they open their eyes again, I push them a bit—and now they know I have the confidence to push them, so there's less tension between us after that moment.

I remember saying to Buckley: "When you die, what should they put on your gravestone?" He said: "That's easy—'That was a half-assed effort.'" —PLATON

OPPOSITE:
## RICHARD BURBRIDGE
Author Tom Wolfe. From "Wolfe's World," published October 31, 2004.

For me, Tom Wolfe's eccentricity is wonderfully expressed in this picture, by that crazy smile. He was charming. I think that, above else, Tom Wolfe is absolutely charming. And when I was equally charming, he was *more* charming.

I like a portrait session to last ten minutes. When it goes past ten minutes, I'm in trouble, or something strange is happening. Because my photo-shoots are uncomfortable for most people. —RICHARD BURBRIDGE

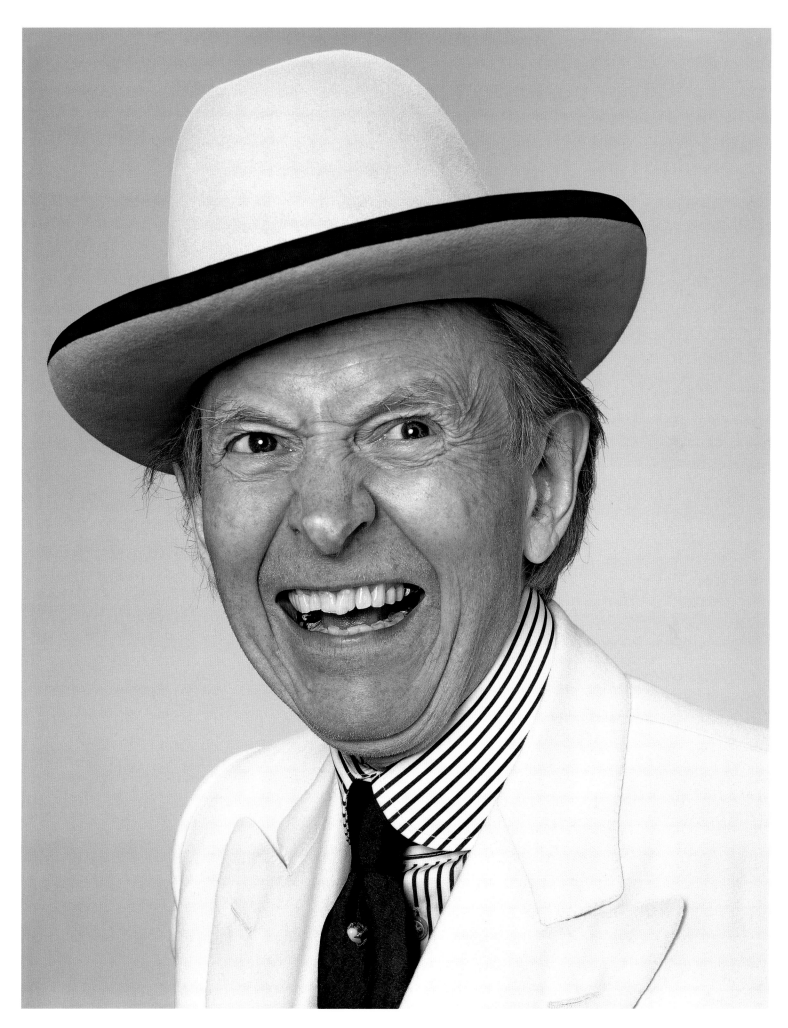

## EUGENE RICHARDS

Author Joan Didion. From "After Life, by Joan Didion," published September 25, 2005 (cover image).

I was curious about Joan Didion, because I think she's so brilliant.

The first thing I wanted to do was get a sense of her late husband and what had happened. On the first day of shooting, I photographed only the place, the table where he died. Because . . . when you think about someone passing away, it's usually in a hospital room, it's not right there, sitting there at the table. So that stopped me.

When I went back, I wanted to see, left to her own devices, what she would do by herself, so it would be kind of natural. I was probably a little intimidated.

I never want to hurry the process. I want to see what people are about. It's kind of the one chance you have. She's not a person who gives a lot up; she's not overtly sentimental. But you don't point to the table where it happened without it being a very emotional moment. And the fact that she didn't mention it emotionally made it feel even more emotional, ironically. That's the way she was.

So I sat there. Which I'm used to doing; that's not unusual. People have things to do, and I know enough to know that if you intrude . . . that's when it's gone. They become a "subject": something that is not themselves. They'll start to give you something that you might "want." It's like a performance, I guess. Then I start searching around for something to break down the formality. And it works, sometimes.

It took a while. She actually made me lunch, and went into another room to write for some time when I was there.

There were two chairs where she and her husband used to sit. I asked her which was her husband's chair—because I kept feeling his presence there. And she told me his chair was the one up against the mantelpiece, the beautiful mantelpiece. Then she went and sat in her own chair.

I set up a camera, and we just chatted for a while. I was waiting for her to relax. And she barely did. Frame after frame after frame, with a few exceptions, she was watching me. It was very curious: she was really watching me. She had that habit of putting a finger against her mouth—someone who's really concentrating. Like, when people go to a museum and they watch a piece of art, that's how she was watching me. I think there are only maybe three frames from the whole time in which she *isn't* watching me. That's what I was waiting for: for her to go into that place where she was thinking about something else. Of course, her husband—because that's why we're there. And she did, I think. When it happened, it wasn't brain surgery. It was only a few frames, but massively different. She was a different person. —EUGENE RICHARDS

What I mostly remember is the arm, discussing the arm, with Kathy Ryan and Katherine Bouton, our deputy editor—Joan's bare left arm, so thin and weathered and weary. Of course, the arm was attached to the rest of her, that neck and that gaze, and also to all these questions, some of them spoken, some not: How old is too old for a magazine cover, especially (let's be ruthless here; and editors can be ruthless) if the subject is a woman? How intimate is grief, and how close is profound grief to depression, madness, the death that is being grieved? And did we, in a sense, have her permission to publish this photograph on our cover? She had agreed, after all, to the shoot with the magazine, and with Gene. But that made it trickier somehow. We did have other pictures.

And for me, there was this: while I was not close to her—I knew her from a lunch here, a dinner there—I had this feeling about Joan that others tend to have (because she is small, and quiet, and a little anxious) of wanting to protect her. (She has written, cannily, of how this has served as a journalistic weapon for her, as a way to get people to talk honestly.) And, finally, this: She had been a hero. I'd read her in the '60s (she so stylishly petite then, so full of life, so young), read her in magazines like the *Saturday Evening Post* in my high-school library, read her and Gay Talese and Tom Wolfe and the rest. I was editing a magazine now, in no small part, because of the work she did.

That I—that we—couldn't stop worrying the picture convinced me, in the end, to make a cover of it. —GERALD MARZORATI

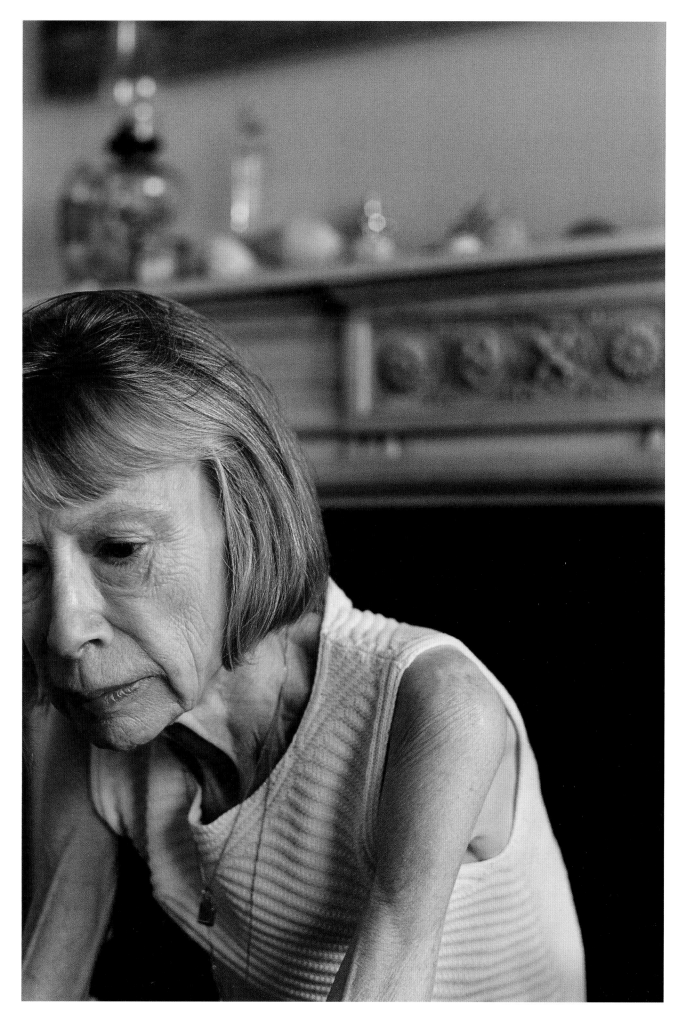

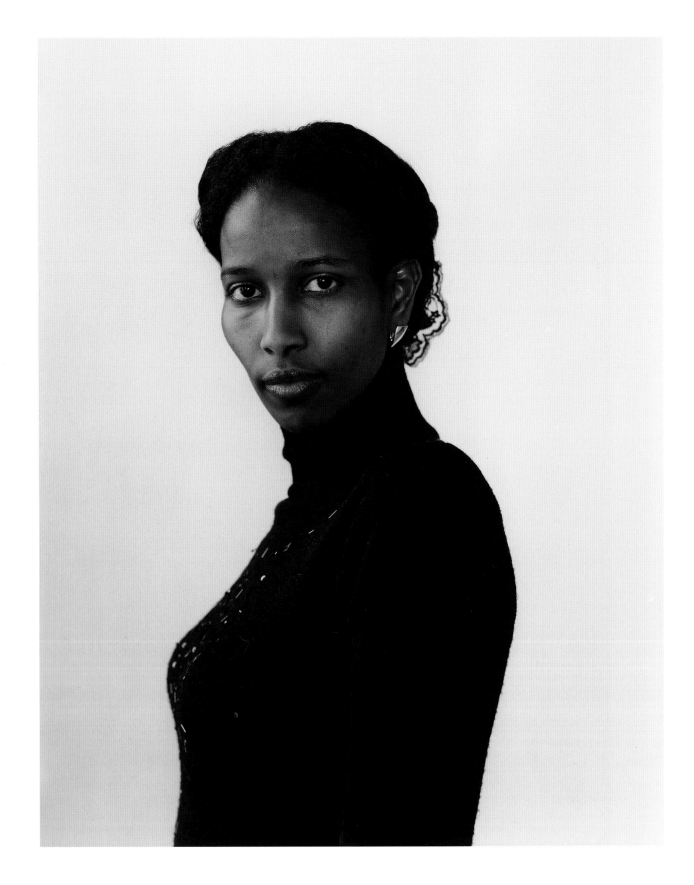

**RINEKE DIJKSTRA**

Activist and author Ayaan Hirsi Ali. From "Daughter of the Enlightenment," published April 3, 2003.

I admire Hirsi Ali's spirit, so I was dying to meet her. This shot happened at my home in Holland, although first her security guards had to come check the place out. I photographed her in my bedroom, because I have the best light there. She was so at ease—the opposite of the security guards!—she totally trusted me. I really think this is a powerful portrait of her. She's so beautiful, almost like a goddess. —RINEKE DIJKSTRA

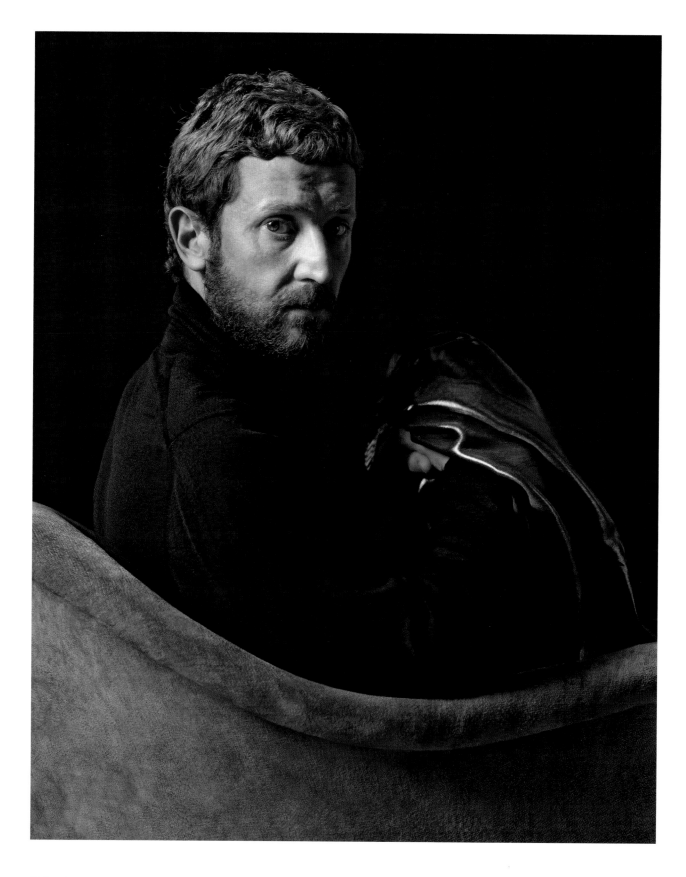

## HENDRIK KERSTENS

Designer Stefano Pilati. From "The Tastemaker," published August 31, 2008.

Stefano Pilati, with his mysterious gaze, seemed to be in a territory of intense silence, like those in Flemish primitive paintings. Posing him in that chair fixed the moment in time, making it clear that there is really nothing to hold on to. Life goes on. —HENDRIK KERSTENS

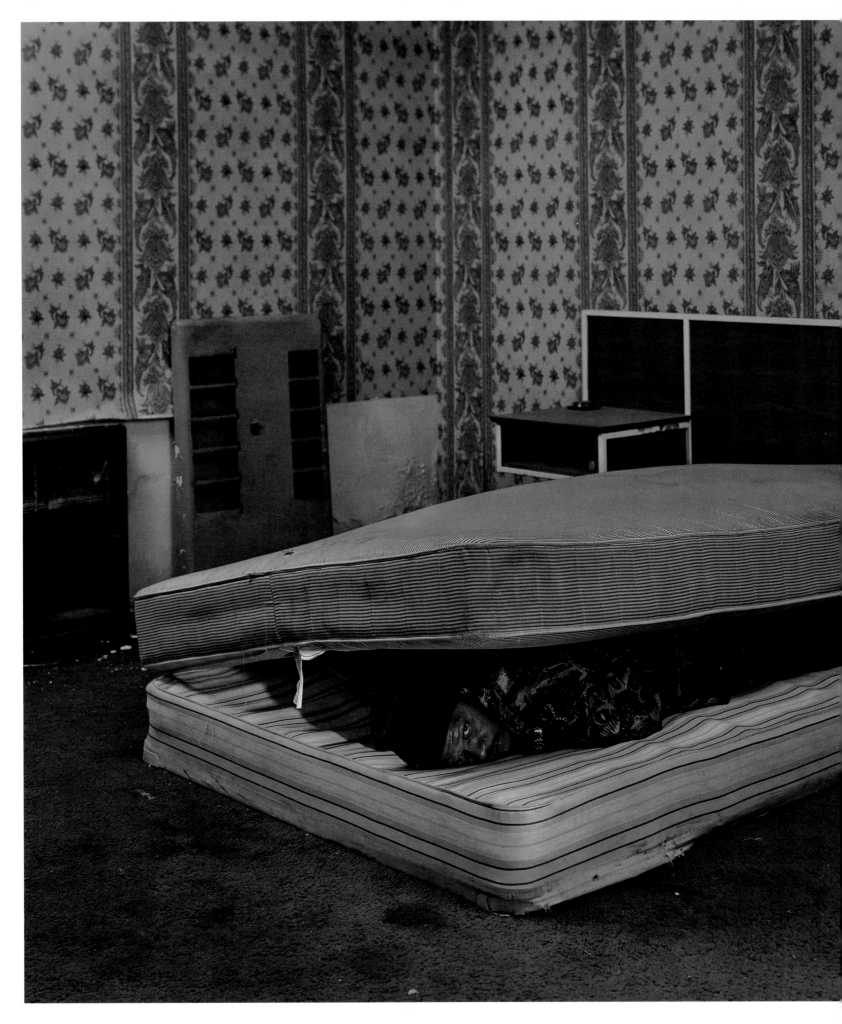

## TARYN SIMON

Larry Mayes, who served 18.5 years of an 80-year sentence for rape, robbery, and "unlawful deviate conduct" before his exoneration and release from jail. From "Freedom Row," published January 26, 2003.

*The Innocents* is a series of photographs, produced over a three-year period, that documents the stories of individuals who were misidentified and served time in prison for violent crimes they did not commit. At issue was the question of photography's function as a credible eyewitness and arbiter of justice. The *Times Magazine* published some of the photographs from this personal project.

I photographed Larry Mayes at the scene of his arrest. He had been identified by the victim from an array of photographs (although she had failed to identify Mayes in two live lineups).

In the cases of *The Innocents*, photography offered the criminal-justice system a tool that transformed innocent citizens into criminals. Photographs assisted officers in obtaining eyewitness identifications and aided prosecutors in securing convictions.

I photographed the subjects of *The Innocents* at sites that had particular significance to their illegitimate convictions: the location of misidentification or of the arrest, or the scene of the crime or of the alibi. These locations hold contradictory meanings for the subjects, and highlight photography's ability to blur truth and fiction—an ambiguity that can have severe, even lethal consequences. —TARYN SIMON

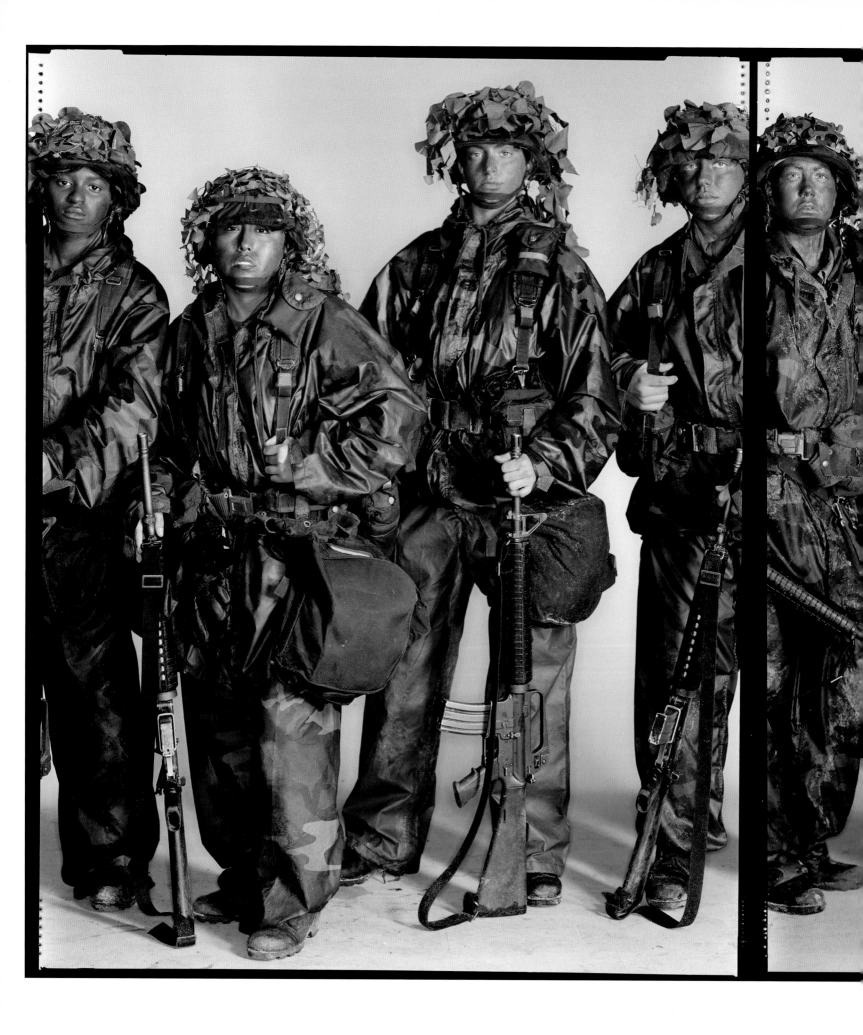

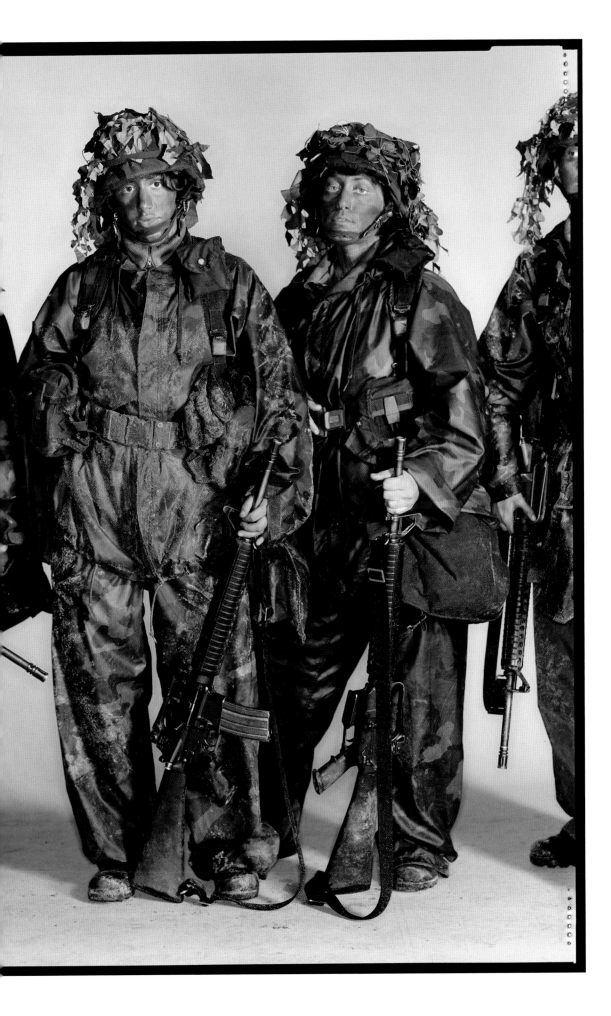

## DAN WINTERS

**LEFT TO RIGHT:** Privates Lorraine Cason, eighteen; Rose Angela Lopez, twenty-one; Jennifer Rudick, twenty-four; Christie Zimmermann, eighteen; Private First Class Viki Aldridge, eighteen; Private Heidi Shenk, twenty-one; Private Bobbie Jo Pearson, thirty; Private Jacquelyn Flores, twenty, at Fort Jackson army base, South Carolina. From "Warrior Women," published February 16, 2003.

Our call time on this shoot was 3 A.M.; we started photographing at 6:30. The soldiers had been on a live-fire range and in a forest bivouacking overnight. By six o'clock, they were thrilled to get off that range. It had rained all night, so they were soaking wet and hadn't slept in over twenty-four hours. We drove them fifteen minutes from the range, and I put them in the shot; there was no time lag at all. It was very organic. It didn't feel like anything was styled or affected. That's what I loved about it most. —DAN WINTERS

We had a lot of backlash about this portfolio. Readers felt that by decontextualizing these soldiers and putting them against a white seamless backdrop, we were somehow trivializing them. I was fascinated by the response: for average readers this image said "fashion photography," and it made them furious. —K.R.

## GILLIAN LAUB

Kinneret Bussany, twenty-five, who survived a terrorist explosion at the Tel Aviv coffee shop where she worked. From "The Maimed," published July 18, 2004.

I began photographing in Israel in 2002 after the second Intifada began. It was a particularly violent time. After spending a few months there, I began visiting hospitals and rehabilitation clinics.

I felt an immediate connection with Kinneret Bussany. She kept saying she felt *lucky* to be alive. I wondered how this could be possible, this beautiful young girl with her whole life in front of her, now burned from head to toe. She had been working as a waitress at a Tel Aviv coffee shop in order to pay for college when the suicide bomber came in—and in one second her entire future was altered. Everyone has a strong opinion about the situation in the Middle East, and here was this young woman who had been maimed by it, and yet she had compassion and forgiveness in her heart . . . there was something so large to be learned from that.

Kinneret was so badly injured I had no idea how I would photograph her—I didn't want the image to be just about her injuries. I hoped to make an image where her strength and beauty were more visible than her scars. This photograph was taken in her bedroom in Tel Aviv, about three A.M. Because of her severe burns, she couldn't be out in daylight, so her waking hours began after sundown. After I made this image, I remember, I was shaking—we had shared a very intimate, indescribable moment.

The support of the *Magazine* was important to this project; it enabled me to spend time in the West Bank and meet Palestinian families and individuals who were also injured during the second Intifada. After the piece was published I sent a copy to everyone who sat for a photograph. The greatest pleasure was hearing from the families that it helped them to see the conflict in a different way; it opened up a dialogue between two sides.

I continued with the project; it would later became a book published by Aperture titled *Testimony*. —GILLIAN LAUB

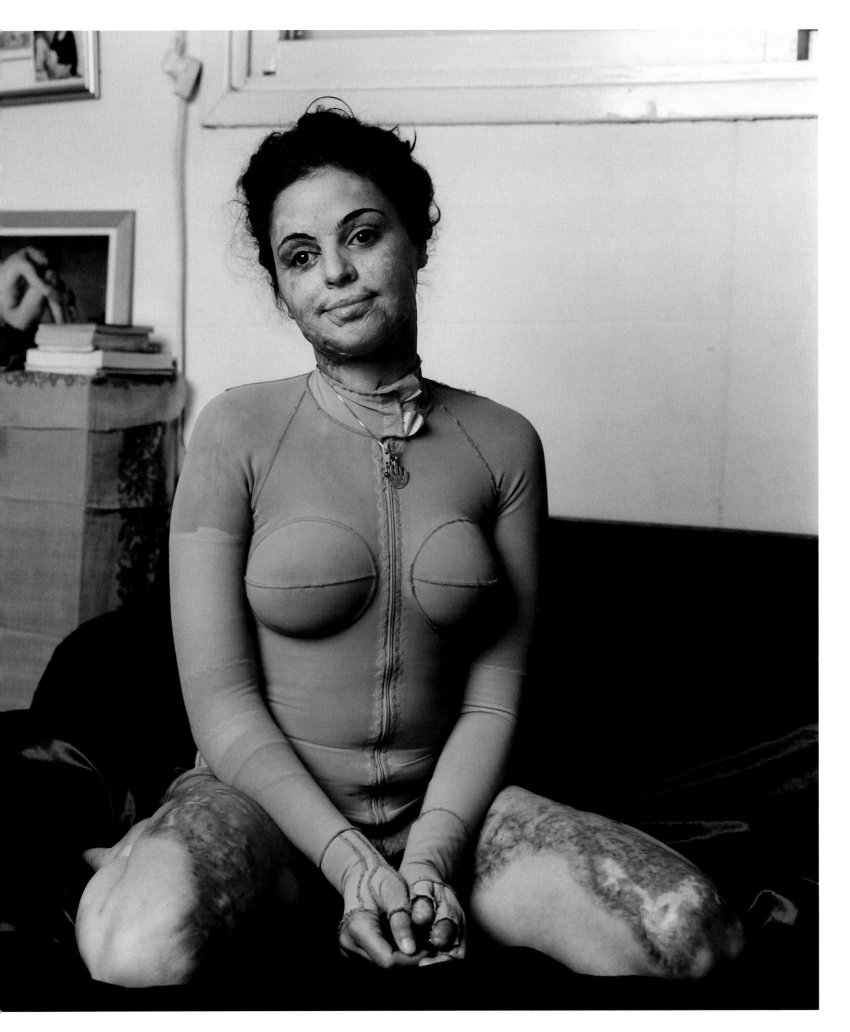

**TARYN SIMON**

Fisherman Jaloe in the Aceh River, Sumatra, Indonesia. From "The Day the Sea Came," published November 27, 2005.

In 2005 the *Magazine* told the stories of six people who lived through the tsunami that had devastated Indonesia the previous year. Taryn Simon went over to photograph the subjects in environments that spoke to their experience with the tsunami. She photographed this fisherman in the same body of water where he had survived, by turning his boat into the waves—as his grandfather had taught him to do. —K.R.

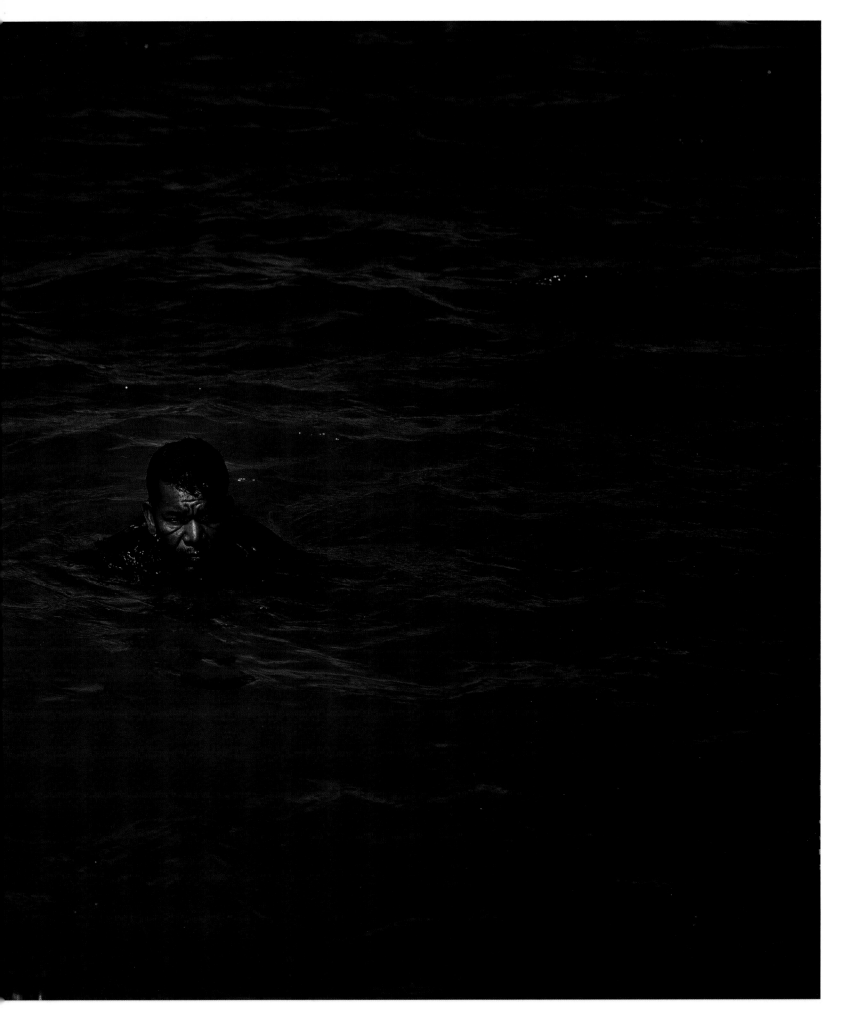

**TIERNEY GEARON**

Actress Diane Keaton. From "Another Woman," published October 23, 2005.

A lot of actors don't like having their photos taken. When Diane Keaton arrived at my house for this shoot she was wearing a hat. As soon as we began, she took the hat off and started hiding behind it. I think she was surprised that I said: "Okay, then, if you want to hide your face let's just do it *all the way* instead of this peek-a-boo thing."

I asked her to lie on the ground in this alley and put her hat over her face. A man on the street saw us and shouted: "Hi, Diane Keaton!"—he recognized her just from the hat! —TIERNEY GEARON

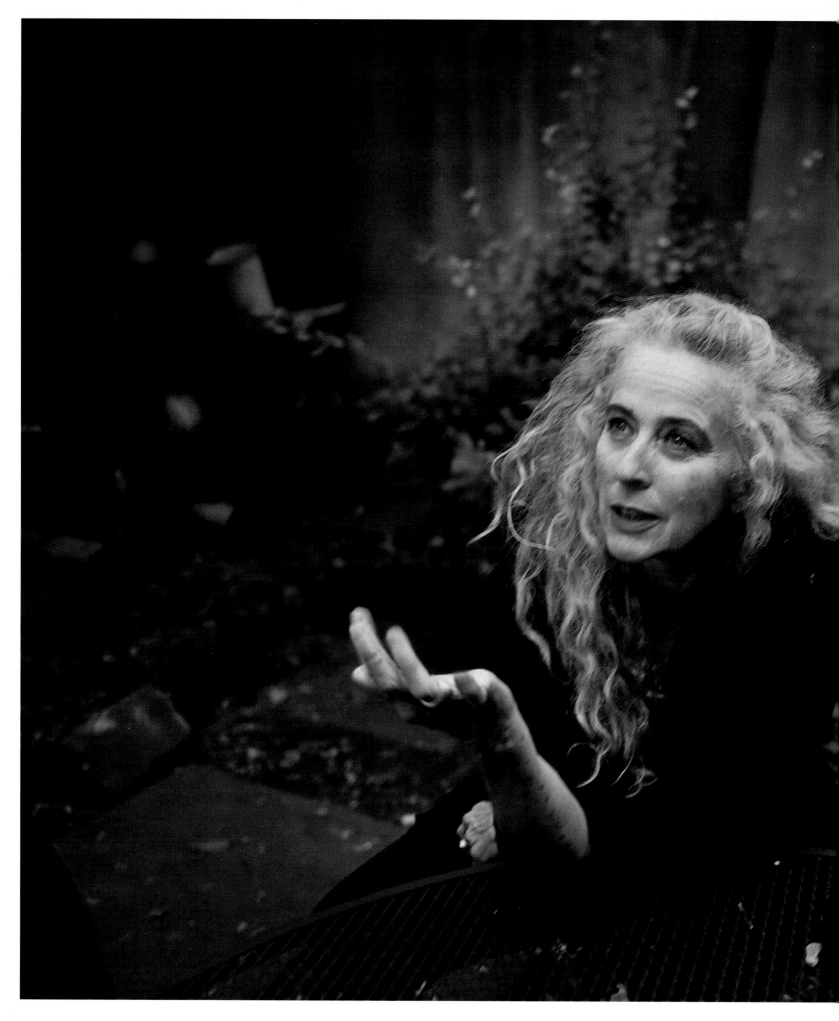

## NAN GOLDIN

Artist Kiki Smith. From "The Intuitionist," published November 5, 2006.

I've known Kiki Smith for many years, and have always had great respect for her, but I haven't been close to her personally in some time. So at first, the pictures were awkward. We began to really communicate when the issue of AIDS came up. I knew her sister, Bebe, who died of AIDS. Kiki started to speak very emotionally—and that's when the feeling of the shoot changed.

Kiki can speak a language that I don't speak. It's more artistic, more vague; it's almost made up of amorphous material—whereas I speak in a very solid, kind of blunt way. So it was wonderful to catch this moment when we were speaking the same language, and when you could see the intensity of Kiki not just talking about her work, but talking about her life, and something that had affected her so deeply.

So this was the picture that broke through. Because it's not just a portrait of, you know, "Kiki Smith." It's the real Kiki. —NAN GOLDIN

Sometimes the slightly out-of-focus image is the one to go with. To me, this image is absolutely alive. It just breathes. And that celestial blue light brings to mind the hues and spirituality of Giotto. Goldin is a defining photographer of our time, who skips back a couple of centuries for her inspiration. —K.R.

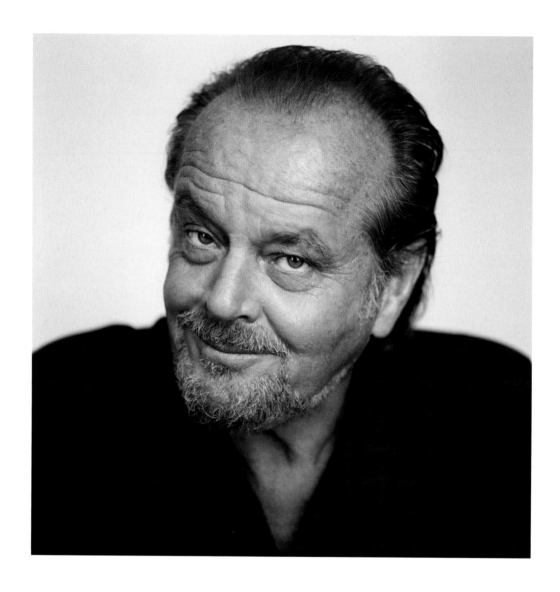

**BRIGITTE LACOMBE**
Actor Jack Nicholson. From "40th Reunion: An Ensemble Cast from the First Four Decades of the New York Film Festival," published September 22, 2002.

OPPOSITE:
**RUVEN AFANADOR**
Dancer and choreographer Twyla Tharp. From "To Dance Beneath the Diamond Skies," published October 22, 2006.

Ruven Afanador sets out to create a *shape* with the human form in his pictures, which of course works beautifully on the page. Part of the success of this image is also due to Twyla Tharp's way of holding herself, with enormous self-containment and elegance—something only a dancer can do. —K.R.

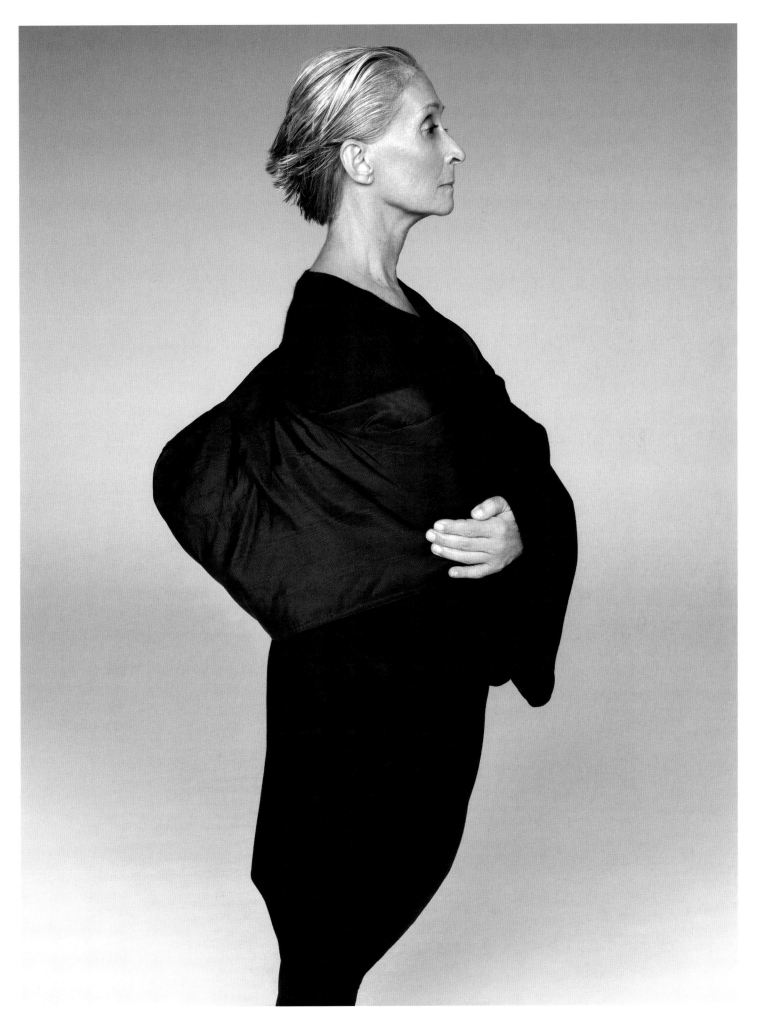

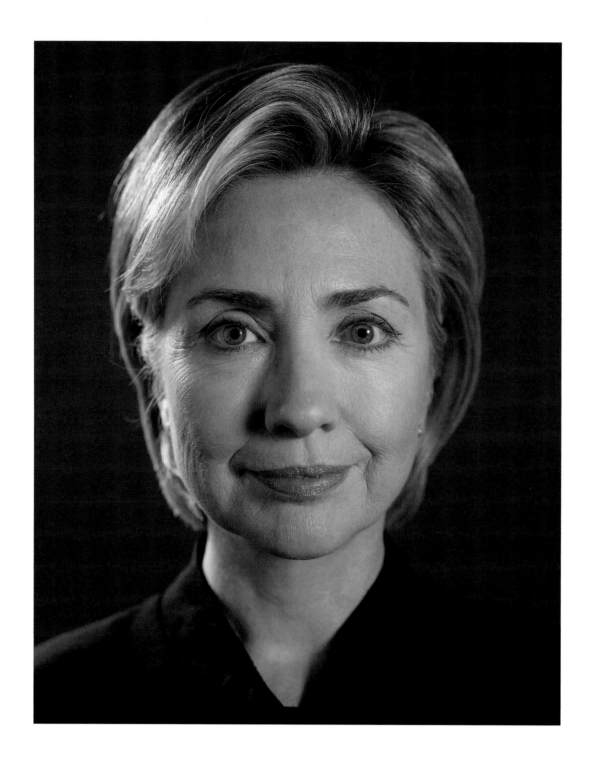

## CHUCK CLOSE

Hillary Clinton. From "Hillary, Herself," published May 30, 1999 (cover image).

My work is not necessarily known to be flattering—so I was concerned whether Hillary Clinton would be pleased. But she seemed very pleased with the images. I would say that she displayed virtually no vanity. Later, she used prints of those images for fundraisers during her election. We became pretty good friends. —CHUCK CLOSE

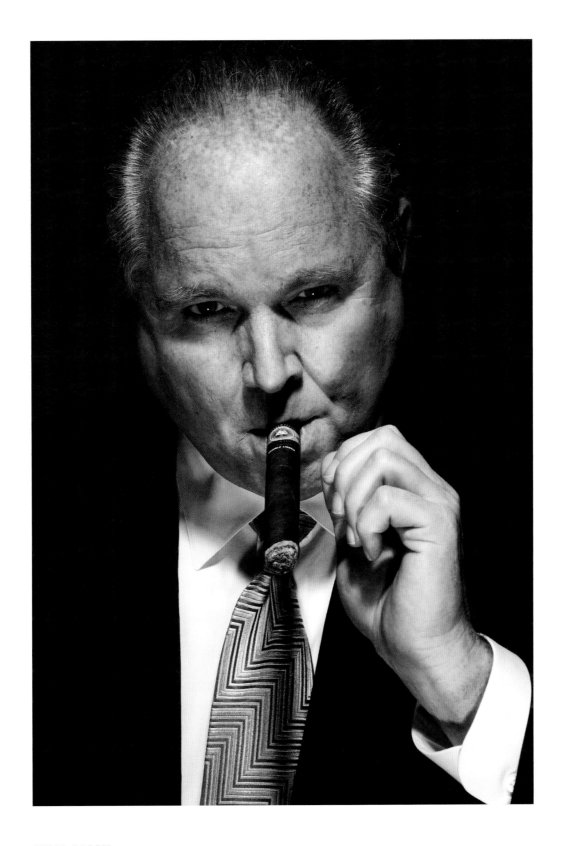

**NIGEL PARRY**
Radio commentator Rush Limbaugh. From "Rush Is Just Getting Warmed Up," published July 6, 2008 (cover image).

I asked Rush Limbaugh why he was sitting for a publication that wasn't necessarily on his side. He said that he believed that he'd managed to convince the writer that his ideas were *good*. I said: "That's very interesting. Just dip your head down and pop your cigar in, will you?" I thought there's something slightly Churchillian about him—his size, or the shape of his head, or the way he carries himself. . . . He lit his cigar ten or twenty times. He was very happy to keep the flames coming. —NIGEL PARRY

**KATY GRANNAN**

Army reservist Keli Frasier and her son. From "The Women's War," published March 18, 2007.

We traveled to a lot of different towns across the United States for this project, but each time we arrived somewhere new, it seemed as though we'd been there before: big-box chains, housing developments, trailer parks. But then every time I walked into a new home, I was struck by the uniqueness of each person and every situation. Their stories were remarkable and difficult, and most, like Keli, were so young.

When we arrived at Keli's home, it was late in the day and the light was quickly going down. We walked to the small playground nearby and I asked her to sit on the swing with her son. What I remember most of all was the stillness, the silence around us. —KATY GRANNAN

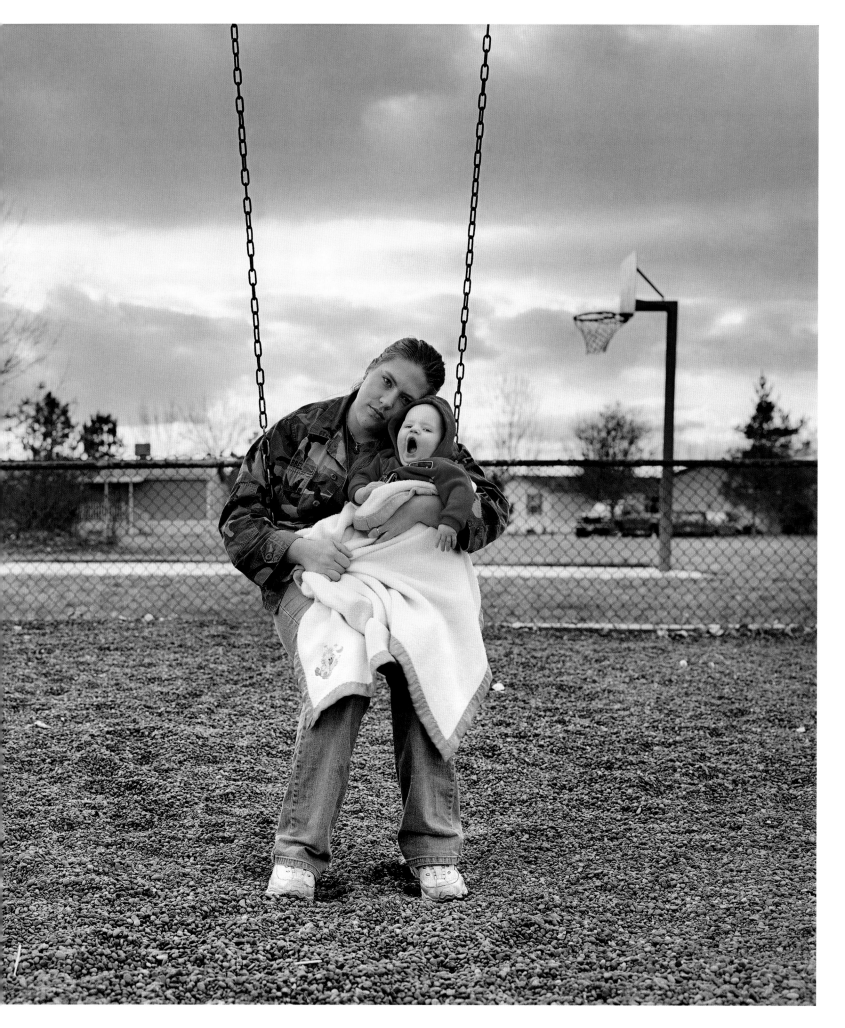

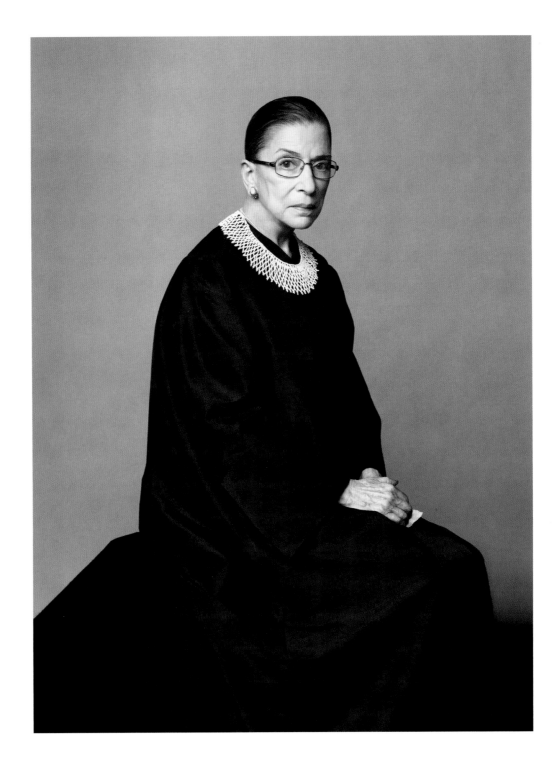

**RUVEN AFANADOR**
U.S. Supreme Court Justice Ruth Bader Ginsburg. From "The Place of Women on the Court: An Interview with Justice Ruth Bader Ginsburg," published July 12, 2009.

OPPOSITE:
**NADAV KANDER**
President Barack Obama. From "After the Great Recession: An Interview with President Obama," published May 3, 2009 (cover image).

This was one of the toughest shoots we ever did. Obama was not going to give a portrait sitting, but I pleaded, and finally got the press folks to let us into the Oval Office with one photographer, one assistant, and a hand-held light during the start of an interview. To Nadav's credit, he made this extraordinary picture in five minutes. It was intense: this image was made during an instant when Obama was listening to a question. —K.R.

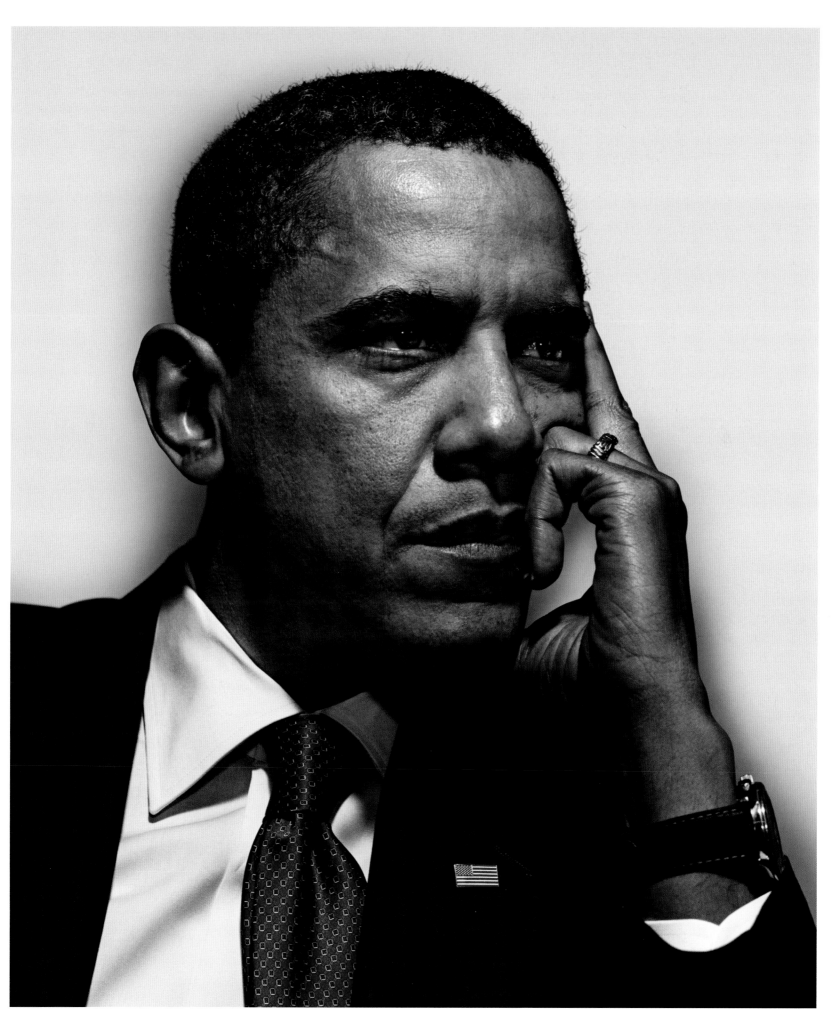

**GUEORGUI PINKHASSOV**
Actor Gael García Bernal. From "Great Performers,"
published February 11, 2007.

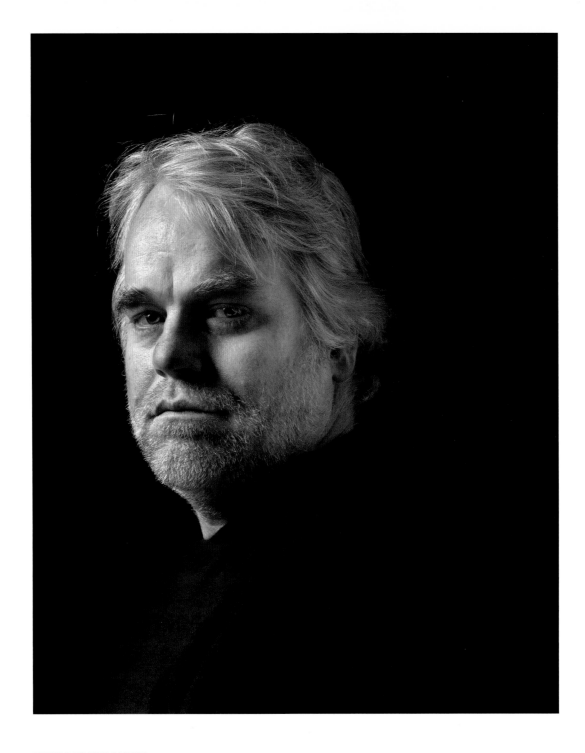

### HENDRIK KERSTENS

Actor Philip Seymour Hoffman. From "A Higher Calling: How Philip Seymour Hoffman Has Worked Himself into the Greatest Character Actor of Our Time," published December 21, 2008 (cover image).

What photography achieves in portraiture is not a reproduction, but a translation from one dimension to another. That is why the portrait is not always the person we think to know. Are we looking at the actor or at Hoffman?

In some way, I think of this as a self-portrait of Hoffman. I was there, but I was just *looking*. —HENDRIK KERSTENS

OPPOSITE:
### RINEKE DIJKSTRA

Actress Cate Blanchett. From "Great Performers," published February 11, 2007.

I don't normally photograph famous people, so I was nervous with Cate Blanchett. But she was so nice—she really put me at ease, instead of the other way around. I like her form here very much, the way she's holding her hands. They seem to mirror her expression, which shows both arrogance, in a way, and also hesitation, or doubt. They start to live somehow; they express something. There's life in those hands. —RINEKE DIJKSTRA

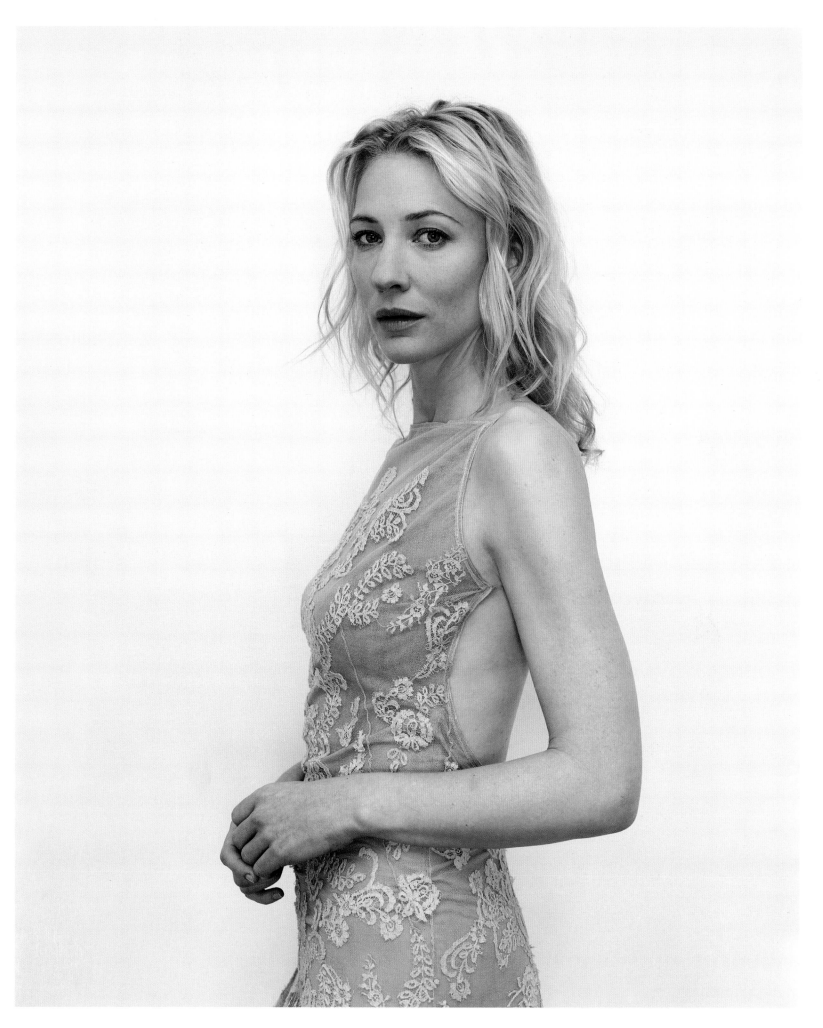

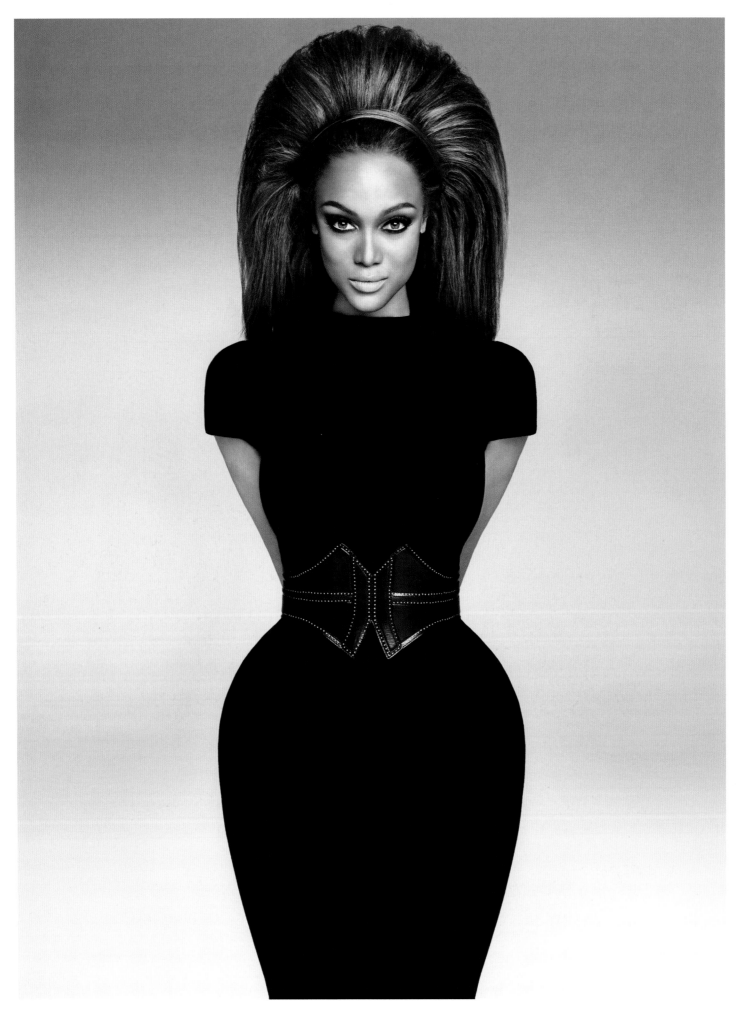

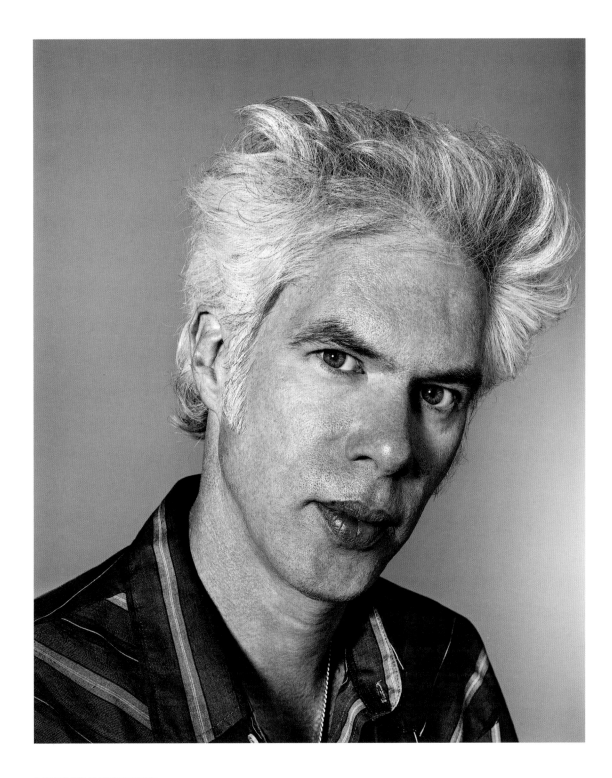

### RICHARD BURBRIDGE
Filmmaker Jim Jarmusch. From "The Last of the Indies," published July 31, 2005.

Jim Jarmusch is slightly skewy in this picture: his shoulders are twisted. I saw him doing that and corrected him and told him he'd look better sitting up straight. Then he went back to that position, and I decided that there was something about him in that position: he felt more comfortable than sitting up straight. —RICHARD BURBRIDGE

OPPOSITE:
### RUVEN AFANADOR
Model Tyra Banks. From "Banksable: How Tyra Banks Turned Herself—Fiercely—into a Brand," published June 1, 2008 (cover image).

This is an intentionally *loud* picture, which ran on the cover of the *Magazine*. Tyra Banks knew exactly how she wanted to look here, the clothing, the big hair. She boasted to the reporter Lynn Hirschberg that she had a repertoire of 275 smiles. —K.R.

## ERWIN OLAF

Paul McLoughlin (left) and Jason Shumaker at their home in Waltham, Massachusetts. From "Young Gay Rites," published April 27, 2008 (cover image).

This was a very interesting assignment. We knew we wanted to convey a sense of 1950s-style happiness. But there was a restriction: we were allowed to do some grooming, but we had to use the subjects' interiors and wardrobes. So in this image it's their barbecue and their garden, but we added the red-and-white checkered tablecloth, and—very important—the blossoming branch. After we explained the idea to the subjects, they jumped into it, and were really completely professional. But if you look carefully, you see the joy in their eyes as well. They loved the joke we were making. I think this added an extra quality to the pictures. —ERWIN OLAF

This photograph is an interesting hybrid of "straight" documentary and heightened effects. The subjects are real, the house is their actual house—but it's fictionalized in the sense that Erwin exaggerated it: styling it with the tablecloth, the perfectly colored food, the branch. —K.R.

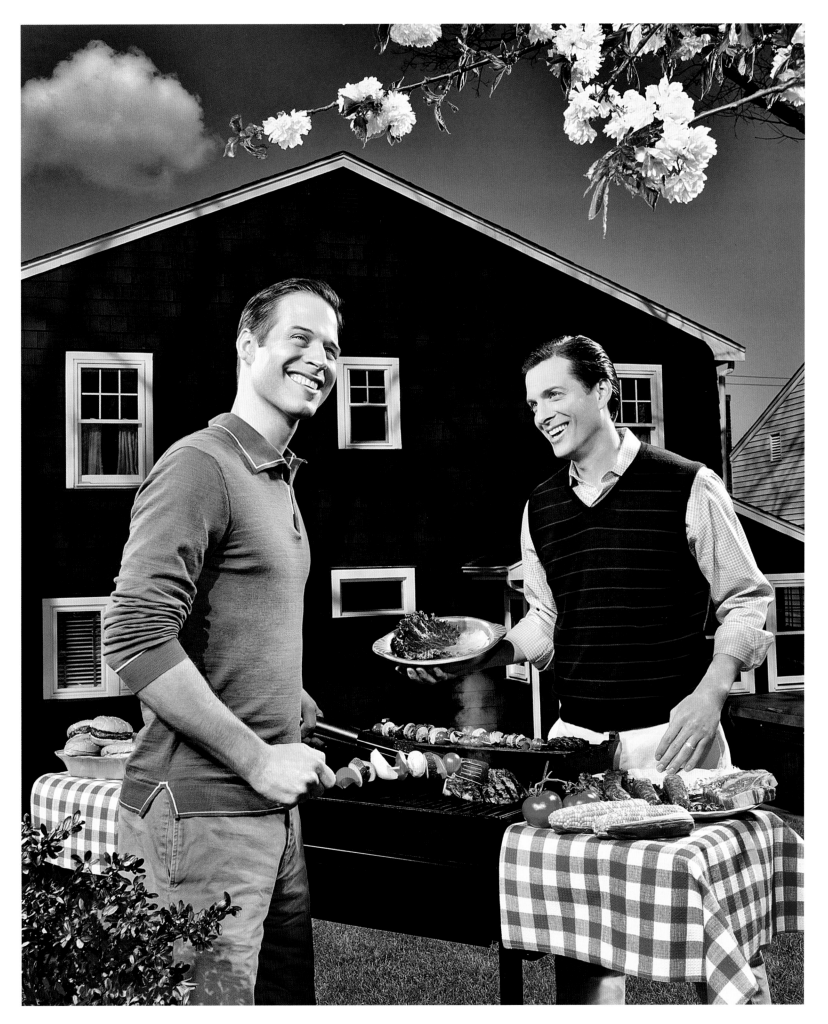

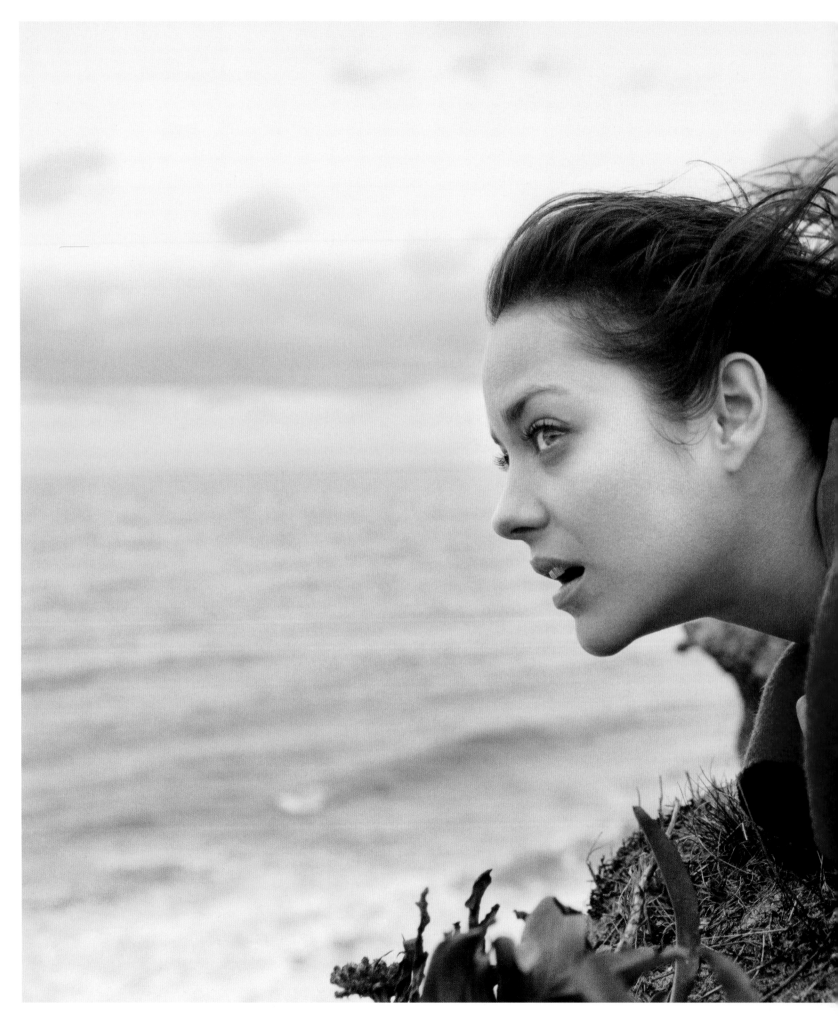

**RYAN McGINLEY**

Actress Marion Cotillard. From "Breaking Through: Fifteen Film Actors Whose Performances in 2007 Marked a Career-Defining Moment," published February 10, 2008.

We shot Marion Cotillard in Montauk, New York. She was up for an Oscar for *La Vie en Rose.*

An assistant was holding my legs while I made this photograph—I was hanging off a cliff. Looking at the photograph, you feel like you're there, like you're at the edge of that cliff. You can taste the wind, and you can smell the ocean. You can see in her eyes how windy it was, you can feel it in her hair; you can see how cold it is by the red blanket wrapped around her. All the elements of nature are in this photograph, plus her sincerity and her beauty. —RYAN McGINLEY

## RYAN McGINLEY

**THIS PAGE:** Actress Jennifer Jason Leigh.

This photograph of Jennifer Jason Leigh was made in Cold Spring, New York. Just by good luck, we scheduled the shoot on the day of an ice storm. And Ryan McGinley knew exactly how to take advantage of this good fortune. —K.R.

**OPPOSITE:** Actor Paul Dano. Both photographs from "Breaking Through: Fifteen Film Actors Whose Performances in 2007 Marked a Career-Defining Moment," published February 10, 2008.

I was shooting Paul Dano on the ice at his father's house, and at one point he fell through into the water—or his arm and shoulder went in. I said: "Let's get you inside, so you don't get cold." So we went up to the house, and as he was taking off his wet shirt, I said: "I want to make a photo of you without your shirt." I photographed him next to a window. The contrast between his body and that glowing, golden face is really interesting. It is as though he is disembodied; the two parts of the picture are almost battling. —RYAN McGINLEY

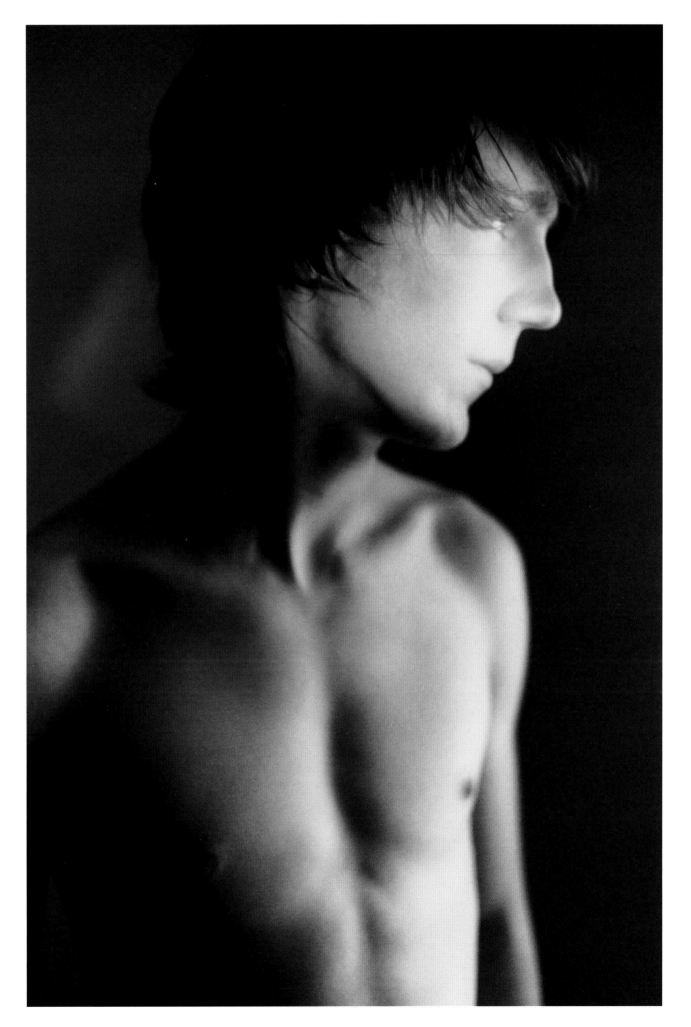

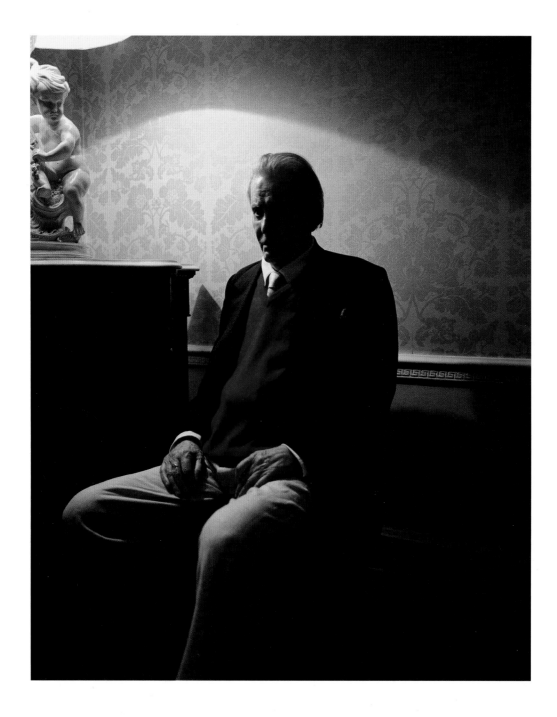

### GARETH McCONNELL

Actor Peter O'Toole. From "Great Performers," published February 11, 2007.

Peter O'Toole came into the room at the Connaught Hotel, crooned "Hello, darlings!," chatted about photography, sang us a sea shanty, and recited a Shakespeare sonnet. This took up approximately half our scheduled forty-five minutes.

   This was the final shot of our session; it's lit simply by a hotel-room lamp and took just a couple of minutes. I liked the idea of this mischievous cherub coming through the aging and unrepentant decadent. —GARETH McCONNELL

OPPOSITE:
### INEZ VAN LAMSWEERDE AND VINOODH MATADIN

Actor Mickey Rourke. From "His Fists Are Up and His Guard Is Down: Mickey Rourke Gets His Career Off the Mat with *The Wrestler*," published November 30, 2008.

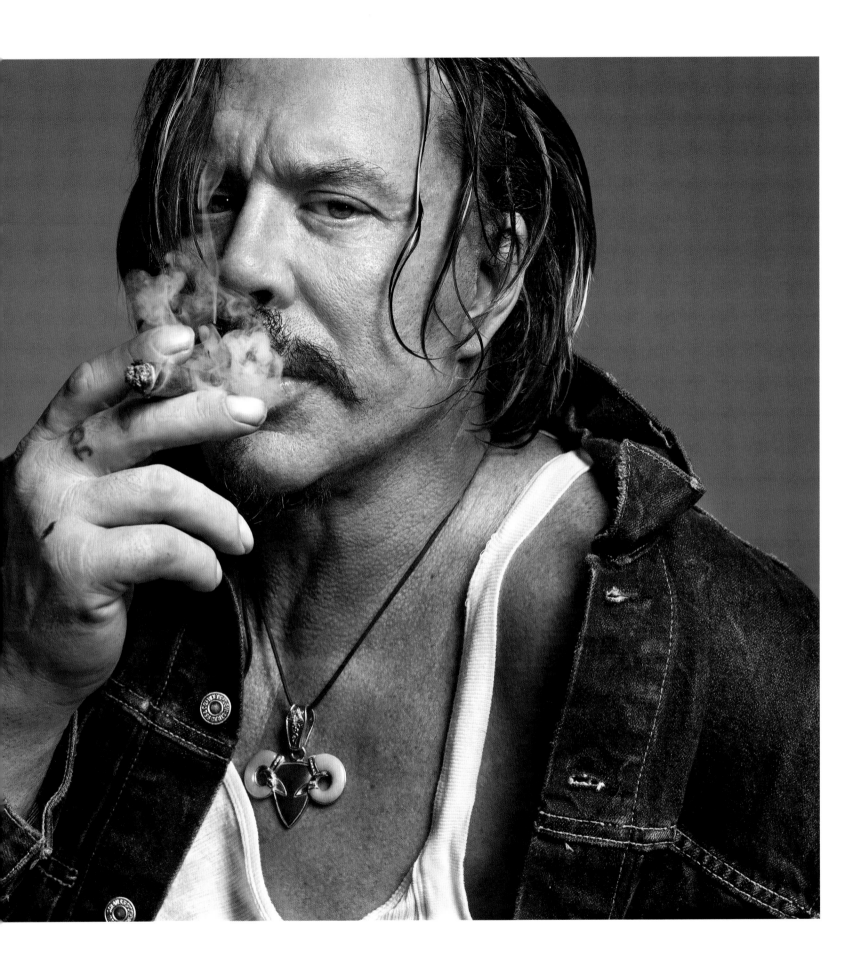

**HELLEN VAN MEENE**

Actress Gabourey Sidibe. From "The Secret Lives of Girls," published February 21, 2010.

In 2009 several important films were released that had young women in starring roles. We asked Hellen van Meene to photograph five of them for the *Magazine*. For this portrait, we took Gabourey Sidibe, who'd been nominated for an Academy Award for her performance in the movie *Precious*, to a strange old house that seemed frozen in time—with 1970s furnishings and wallpaper—and we worked there over the course of several days.

So much of the photographic act is about framing—look at how Sidibe is framed in the doorway here. And how strong a reduced palette can be—all the beautiful greens and yellows.

But in the end, Gabourey's attitude is what really defines this picture. —K.R.

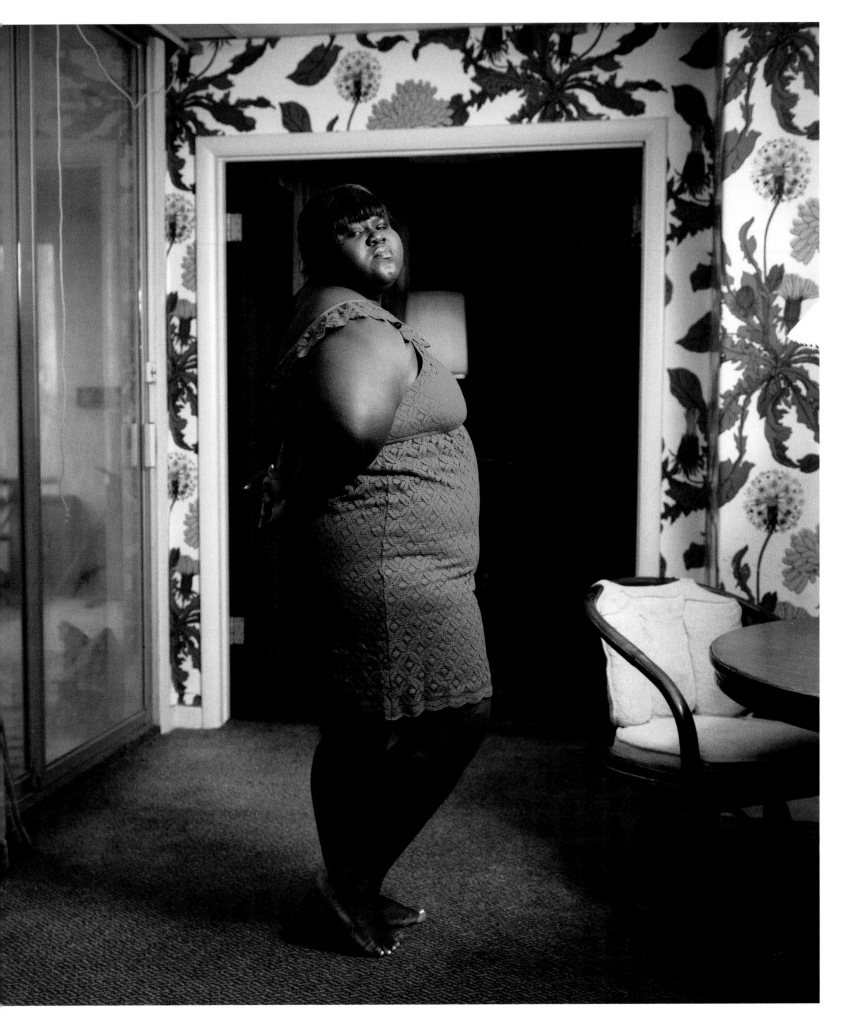

## RYAN McGINLEY

Musician Maya Arulpragasam (M.I.A.). From "Maya Takes to the Streets," published May 30, 2010.

We had to basically rig a truss for this swing; it was a major production to make sure that it was safe. And I would never let anyone do anything without doing it myself first—so I tried it out. It was fun. It was an amazing feeling to swing out over New York City and see the Empire State Building. I was in heaven! Or as close to heaven as possible.

It was a complicated photo logistically: How high does the rig have to be? How high does the swing have to be? How far out is the swing going to go? And it was risky in the sense that Maya might not have done it after we'd rigged all this stuff. She might have gotten there and said: "I'm not doing this; this is too crazy." But she came out and got on and just started swinging like it was something normal. I asked her: "Are you okay with this? Do you need some time to warm up?" She said: "No, this is cool." And I remember her saying: "If I'm going to go out, this is an *awesome* way to go." —RYAN McGINLEY

To this day, I think the single scariest moment in my career was arriving at this shoot and seeing Ryan swinging way out over the edge of the building—he was trying it out, and he was in ecstasy. I could not believe it. He was fully harnessed in by the special-effects crew, but there was a thirty-story drop! I had them move the swing back before we shot Maya. I just had to. I remember thinking: "Ryan McGinley's not going out on my watch!"

Maya was incredibly giving. We had two creative people working together on this shoot, and Maya really was willing to give Ryan whatever it took to make the image. —K.R.

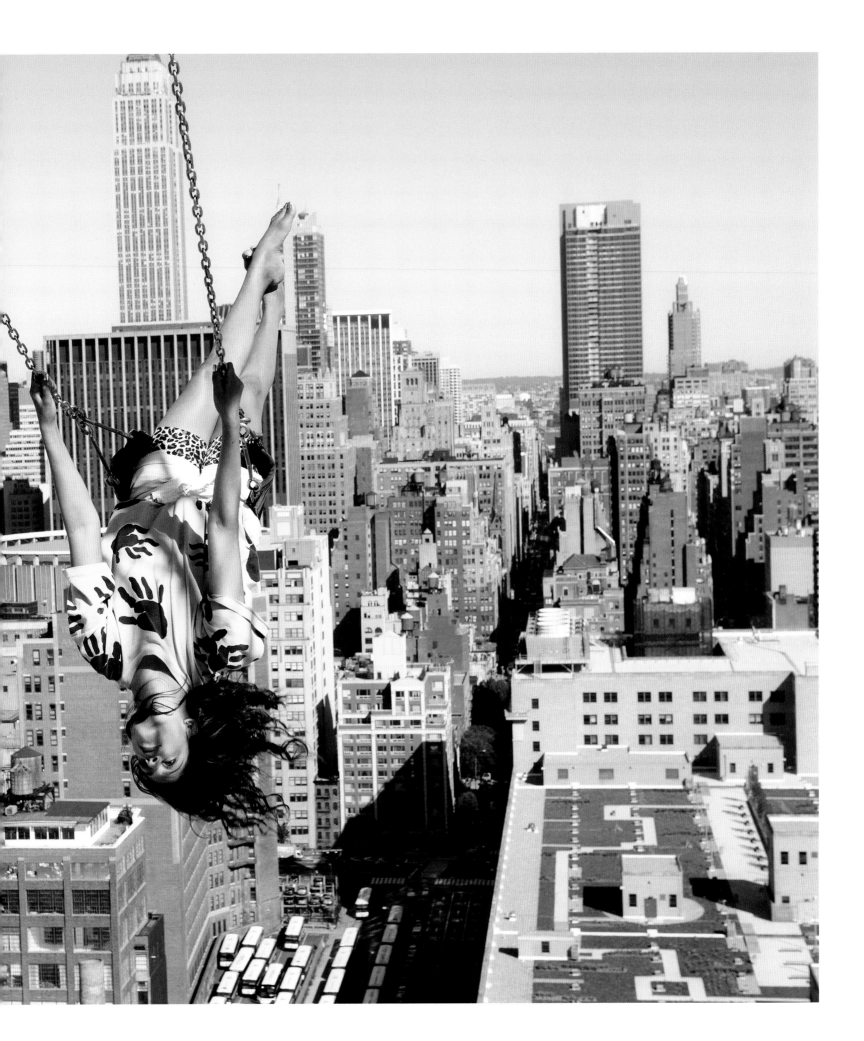

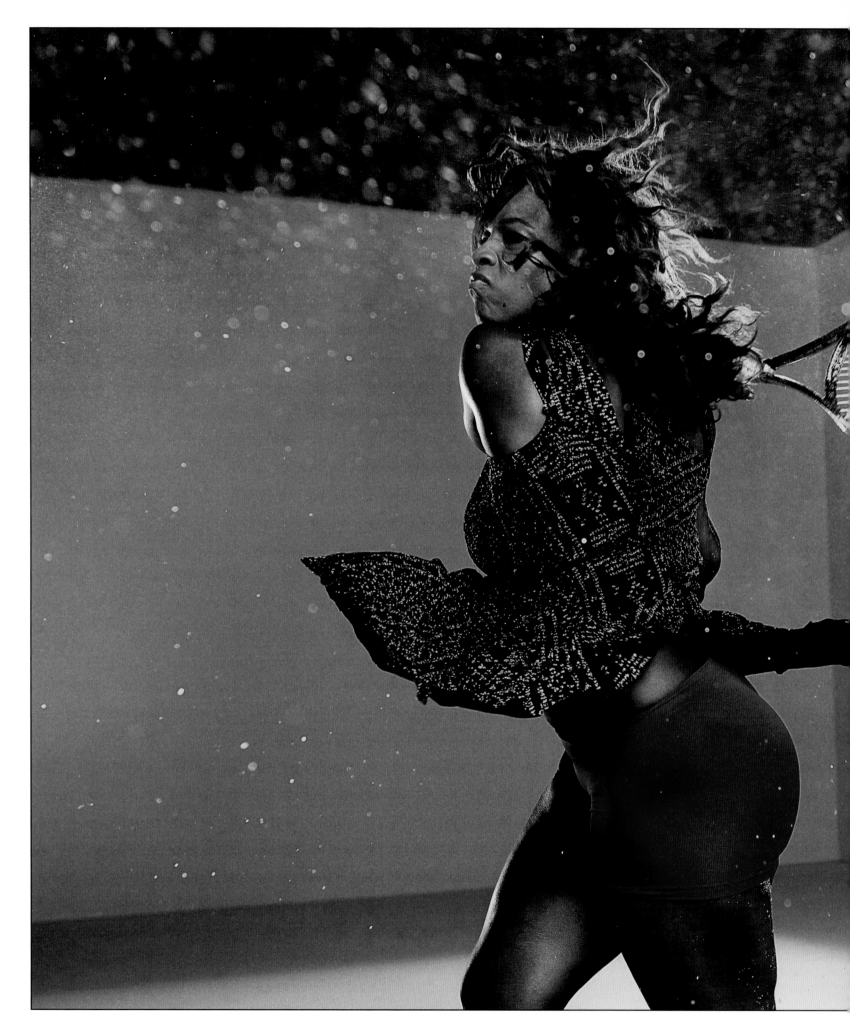

## DEWEY NICKS

Tennis champion Serena Williams. From "Power Games: Women Who Hit Very Hard," published August 20, 2010.

The *Magazine* now regularly commissions videos as part of its editorial mission. In this case, we decided to create a series of videos and a print portfolio featuring the world's best women tennis players. The editorial concept can be boiled down to two words, *power* and *beauty*. My idea was to capture the women in slow motion, emphasizing their tremendous athleticism as they hit the tennis balls, while styling them in an unexpectedly glamorous and sexy way. We engaged the wonderfully creative Dewey Nicks to do the film and portfolio, and Susan Winget to style the women. There was much talk about dance as we brainstormed the shoot, and we looked at photographs ranging from Alexey Brodovitch's grainy black-and-white ballet images from 1945 to pictures of Robert Wilson performances for our inspiration. We transformed a tennis club into a makeshift studio over several days. Lots of chalk dust, glitter, smoke bombs, and dramatic lighting were enlisted to give the air physical presence as the balls sliced through it. The tennis players generously gave of themselves, whacking the tennis balls over and over. The unexpected juxtaposition of the hard-hitting women and the beautiful styling electrified these images, and produced mesmerizing videos that were made even more unusual by the haunting original music composed for each piece by Pamela Chen, who was brought into the project by our online editor Miki Meek. —K.R.

Serena Williams, then ranked the number one women's tennis player in the world, was originally going to be the *Magazine*'s cover subject. But around 4:30 in the afternoon on the day the issue was being shipped to the printers, the *Magazine*'s editor, Gerry Marzorati, came over to the photo-department and told us that he had just Googled Williams's name before going home: she was pulling out of the U.S. Open with a foot injury. Immediately we replaced Williams on the cover with a picture of Kim Clijsters—who went on to win her second consecutive Open two weeks later. —STACEY BAKER

The New York Times Magazine

The U.N. is not going to
stop the genocide in Darfur.
The African Union is not going to
stop the genocide in Darfur.
The U.S. is not going to
stop the genocide in Darfur.
NATO is not going to
stop the genocide in Darfur.
The European Union is not going to
stop the genocide in Darfur.

But someday, Luis Moreno-Ocampo
is going to bring those who committed
the genocide to justice.

The Prosecutor of the World's Worst
By Elizabeth Rubin

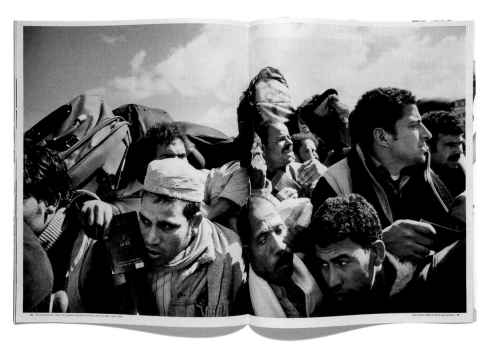

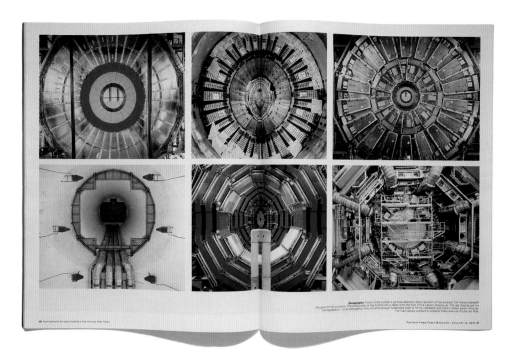

**CLOCKWISE FROM TOP RIGHT:** LYNSEY ADDARIO, April 2, 2006; SIMON NORFOLK, January 14, 2007; PAOLO PELLEGRIN, March 13, 2011.

# documentary

THE CELEBRATED DOCUMENTARIAN Berenice Abbott made a seminal comment in the 1951 *Universal Photo Almanac*: "I have yet to see a fine photograph which is not a good document." More than half a century later, Abbott's point still holds, although today it is almost a given that there *will* be a camera in the right place at the right time, and that a perfectly good document will ensue.

But what sets a good document apart as a *great photograph*?

The great photograph stops viewers and makes them look and think, because of *how* it shows what it shows. It may lead them to a surprising understanding, or to the revelation of a new kind of pain or joy; it may even incite them to take action against injustice. The great photograph has an intrinsic, timeless power that will not diminish with the passing of years—indeed, sometimes its strength increases as the baffling reality of the moment becomes more distant, more carefully examined, and more intricately woven into the fabric of history.

In contrast to the daily *New York Times* newspaper, the weekly *Magazine* plans its content weeks or months in advance of publication. The final batch of editorial materials must be sent to the printer at least ten days before publication. The documentary coverage is thus not immediate, and its narrative criteria are different from those of the daily paper. The

photojournalism in the pages of the *Magazine* has the leeway to be interpretive and essayistic; to tell a story either in electrifying, singular, *big* images or in nuanced series that accrue strength in number or episodic sequence. The photographs may be part of image-driven photo-essays or serve as illuminating illustrations with major text articles. Stories—whether they originate with the *Magazine*'s editors, or with a writer, or with the photographer him- or herself—are proposed and commissioned with all these possibilities in view. But no matter what the ultimate setting for the photographs may be, each is under the onus to function with the utmost efficiency: to convey a maximum amount of information and impact so as to make the best possible use of the *Magazine*'s limited number of pages.

The *New York Times Magazine* is one of the few remaining major print outlets for this type of considered photoreportage. It showcases images both by the most esteemed photographers of our time and by emerging talents, on subjects ranging from explosive world crises to intimate personal dilemmas, from moments of human inanity to visions of unspeakable tragedy. It is a forum with enormous visibility and agency for these artists, who in turn produce images that serve to help make the *Magazine* so compelling and so necessary to its audience.

## SUSAN MEISELAS

Masked Nicaraguan rebels arm themselves with homemade bombs. From "National Mutiny in Nicaragua," published July 30, 1978 (cover image).

The launch of Nicaragua in my consciousness began with an extended article I read in the *New York Times* in January 1978, about the assassination of Pedro Joaquín Chamorro, editor of the newspaper *La Prensa*, highly opposed to Somoza. That article took up just enough space in the paper for me to take note—you know, you don't feel the importance of space in digital the way you do in a printed newspaper, where you turn that huge page and there is some new information, staring at you.

Over the next months I continued to notice little snippets of events evolving in Nicaragua—student demonstrations, the closure of a factory, protests of one kind or another—which kept my interest perked. And then I began to do some research, to see if anybody *else* knew about Nicaragua. I thought I should go with a journalist, because I had never done this kind of reporting before. This was after my project *Carnival Strippers* (which came out in 1976), and it was a big shift in my practice to go into the field. I mean, what do you do? How do you figure out how to build a visual narrative?

But I went on my own. The *Magazine* didn't send me; I didn't have the right track record: I'd done pictures of *strippers*—how would that get me launched into Nicaragua? I don't think so. And they didn't either. That first trip to Nicaragua was about six weeks long—and of course the visual narrative evolved. And that's what kept me there, probably, the sense that every day something different was an added dimension, and trying to figure out the various forces at play.

Alan Riding was writing a piece on Nicaragua, which led to this image being published on the cover. We had not been in the field together—but he definitely knew Nicaragua better than anyone at that time. It was coincidental that Alan was working on an article that allowed the simultaneity of the pictures and text to come together.

I went to Nicaragua June 1 and came back mid-July, and the issue came out July 30, so you can imagine the time pressure—the *Magazine* was ready to roll the second I got back: that film needed to *move* because no one else had film from Nicaragua so there was a lot of pressure on the delivery. It was the *Magazine*'s art director, Ruth Ansel, who found this picture and the photographs that ran in the interior. I came back from Nicaragua with film, but Ruth really discovered the pictures.

The other curiosity about this particular issue is that it came out just before the famous press strike of 1978. It was the last magazine before that hiatus. I remember that the issue stayed around for a long time—it was the last magazine people had. So it had extra presence, a longer-than-usual lifetime. —SUSAN MEISELAS

I am always fascinated by intense photographers with intense feelings about their subject. I feel that the camera in the hands of a dedicated photojournalist gives us permission to *stare*, and that's a thing I really believe in when it comes to photography. Sometimes we stare at extreme beauty, as in fashion magazines, and sometimes we stare at extreme cruelty—the dark side of humanity. Which is where some of Susan's work fits in.

Before the Nicaragua project, I had only seen Susan's work in her *Carnival Strippers* book—but I was in love with her daring ability to pursue a taboo subject. I recall that she was very anxious to go to Nicaragua: she clearly had a real curiosity. The *Magazine* was not a fancy operation back then. There were no computers; there was no communication. When someone was out in the field, they were on their own. And this was a new way of working for Susan: she had not done any photojournalistic work like this before.

When her photographs came in, I remember being absolutely knocked out by this image of three boys in masks. And thinking: "She is fearless!" Because where the hell *was* she with her camera? They were looming right over her.

I recall that this picture wasn't so easy to sell to the *Magazine* editors—because it was ambiguous. I think the reason it is so memorable is that there is something both menacing and poetic about it—and you usually don't get those two things in one photojournalistic picture. That's why it stood out as an image, and certainly as a cover of a national magazine like the *Times Magazine*. —RUTH ANSEL

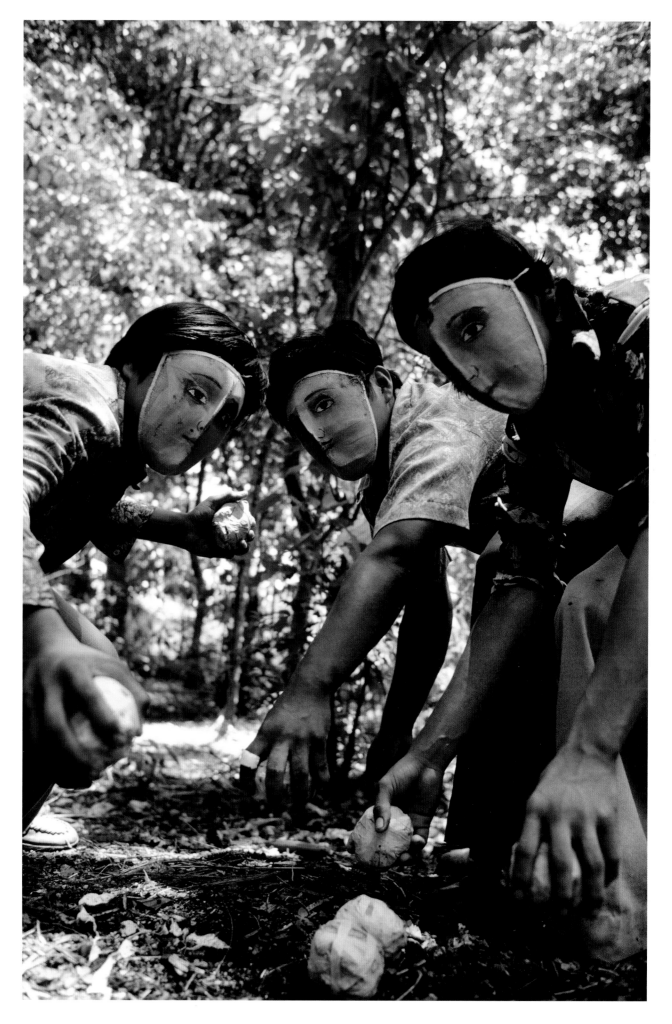

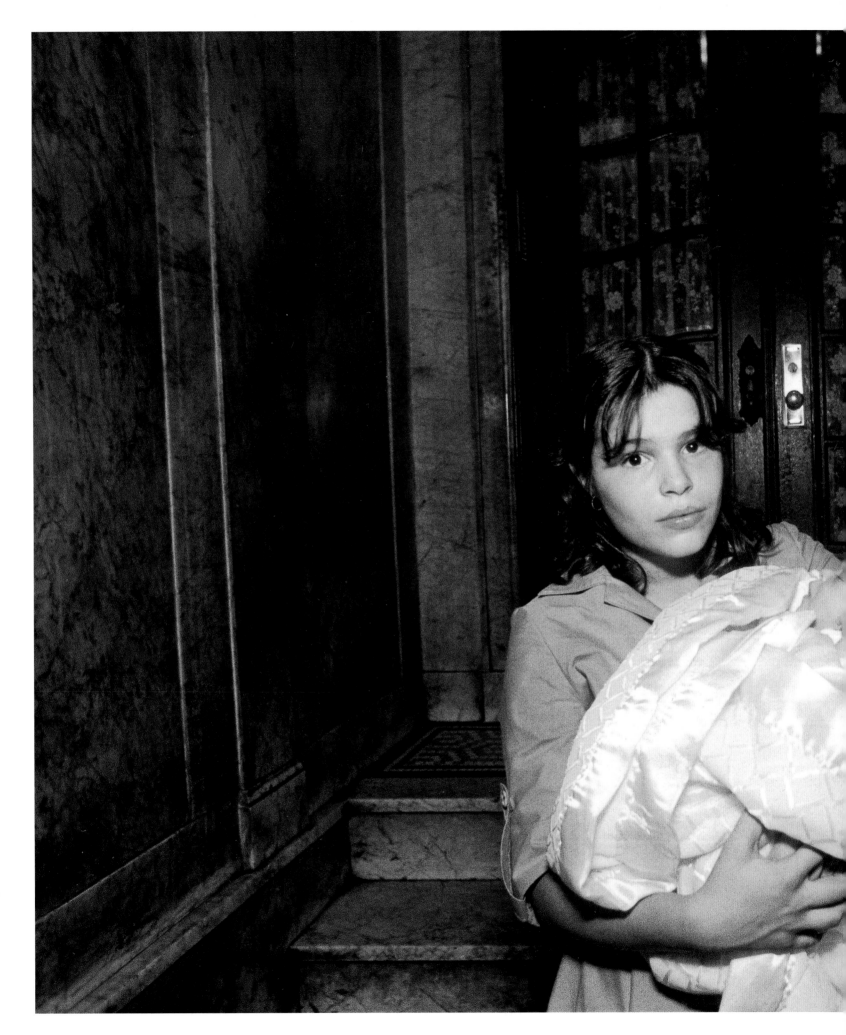

**MARY ELLEN MARK**

Jeanette Alejandro, fifteen, and her daughter Chastity. From "Children of Desire," published September 30, 1979.

I met Mary Ellen in Central Park, at the Puerto Rican Day Parade. I was fifteen and pregnant: I was going to give birth the following month. She took a picture of me, and then another, and then she came over and spoke with me for a little bit. I thought she was just a nice woman who liked to take pictures, and that was it. Then she mailed me the photos. She was always so kind to us back then, and still is.

She was with me all the way . . . she was there when Chastity was born.

The odds were really against me. But I managed to survive, and made a life for myself and got my home. I moved out of New York City; I raised three successful children. That whole experience with Mary Ellen always follows me around, throughout my life. —JEANETTE ALEJANDRO

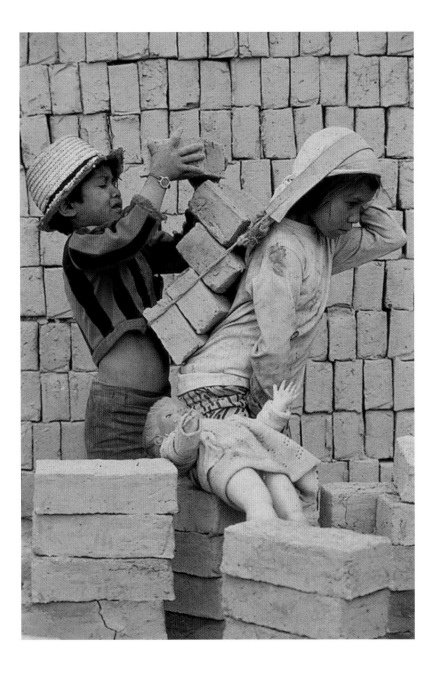

**JEAN-PIERRE LAFFONT**
Children working at a brick factory in Colombia. From "Child Labor: The Shame of Nations," published September 23, 1979.

When I was working in Pakistan in 1977, a four-year-old boy followed me for hours during the riots against Ali Bhutto, carrying two bottles of Coca-Cola. I asked a local journalist why the kid was following me. He told me: "He is waiting until you are thirsty to sell them to you." It touched me deeply. I recalled all the working children I had met during my travels around the world. And that was when I decided to do something about this essential issue of child labor. By exposing the tragedy of these children's lives, I was glad to be able to grab the world's attention and reveal the unacceptable situation. —JEAN-PIERRE LAFFONT

**OPPOSITE:**
**LEONARD FREED**
Incident in New York City's Ninth Precinct. From "The Ninth Precinct Blues," published January 21, 1979.

Leonard Freed struck me as a moral man with a camera, a humanist. He also had a kind of laser intensity—that Weegee ability to look at something shocking and fearlessly drive the camera right into the middle of the action to capture unguarded moments. When the Ninth Precinct story came up, I thought: "This is just right for him." He immediately went about embedding himself with the cops, and spent months cruising the streets at night looking for trouble with them. This was not at all typical—you don't usually have time to work that way. But he did it. In fact, he was so intense that the cops, I remember, made a phone call to the *Magazine*'s editor to say: "Can you get this guy off our back?" But he just went right on, sticking to them like glue until he got the pictures that he wanted. That was Leonard. —RUTH ANSEL

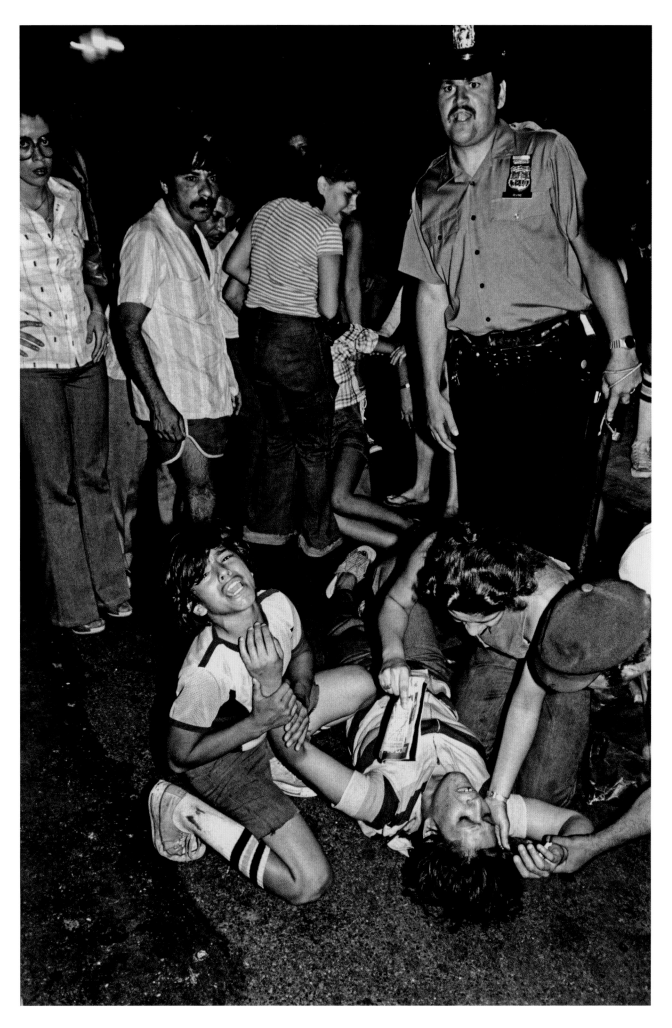

## FRANCO ZECCHIN AND LETIZIA BATTAGLIA

Benedetto Grado's wife and daughters at the scene of his slaying. From "Sicily and the Mafia," published May 18, 1986.

When Letizia Battaglia and Franco Zecchin were documenting the murderous activities of Cosa Nostra, anyone who opposed the Mafia was at risk of being killed. Judges and prosecutors traveled surrounded by armed guards to protect them in an environment of intimidation and revenge. These security measures were by no means infallible, but were better than none—and none is exactly what the two photographers had. The work they produced made a tangible difference when used in evidence in cases brought against several powerful and dangerous mafiosi, but they are also extraordinary images in their own right. They are evidential not just of specific crimes but of the darker side of the human condition, and their portrayal of violence and grief transcend any particular time or location. —PETER HOWE

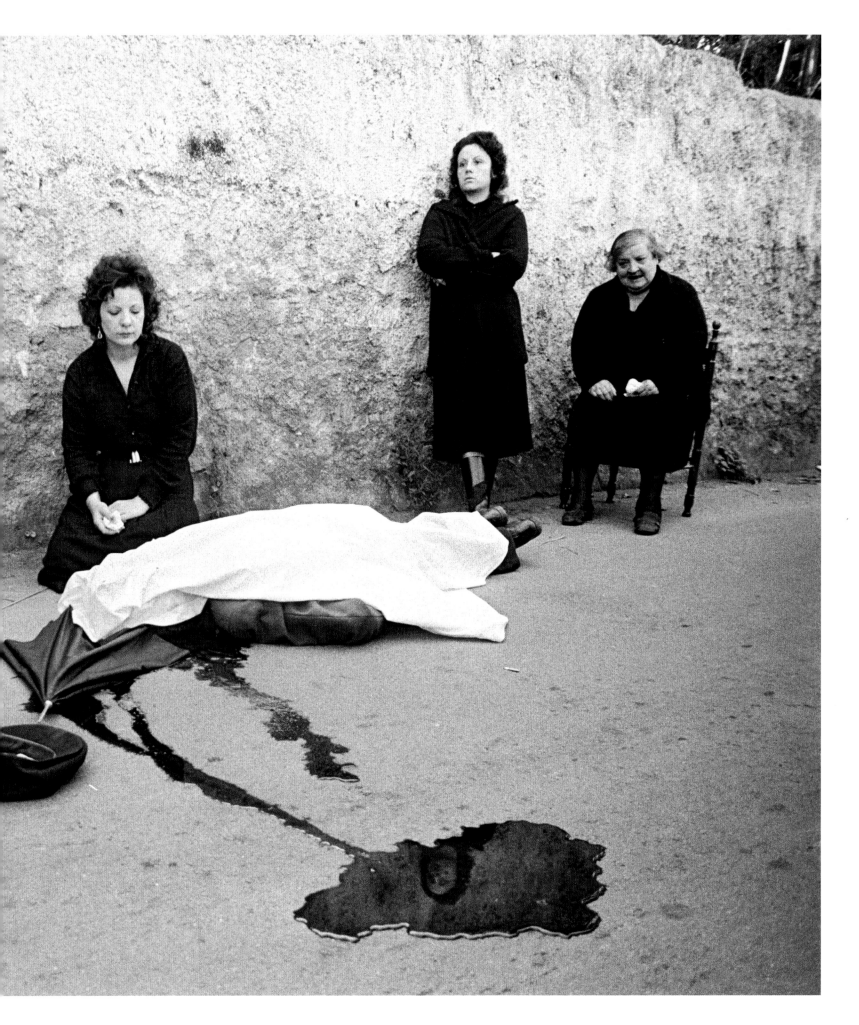

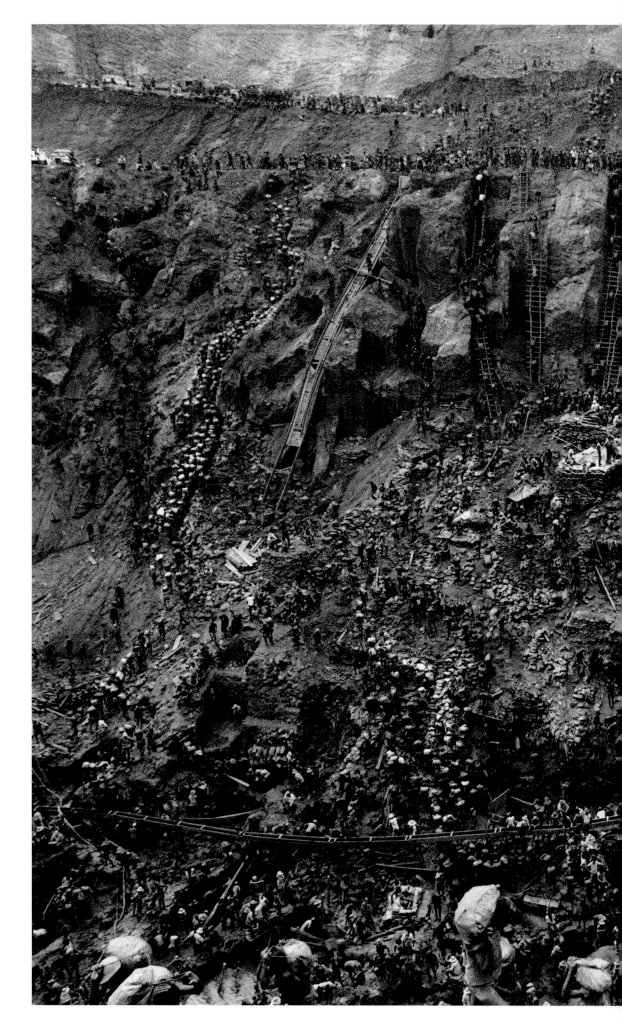

## SEBASTIÃO SALGADO

Thousands of workers swarm over the Serra Pelada gold mine. From "An Epic Struggle for Gold," published June 7, 1987.

This majestic panorama of human struggle hangs in my office today to serve as a daily reminder of my privileged existence. It is a truly epic image, worthy of D. W. Griffith—except, of course, that Griffith had control over his crowds that Salgado didn't. When I showed all the photographs in the Serra Pelada shoot to Ed Klein, who was then the *Times Magazine* editor, he was with the then–deputy editor, Marty Arnold. The two men looked at the photographs silently for some time before Arnold broke the silence. "You just knocked one out of the park," he said. Of course he was wrong. It was Sebastião who got the home run, and he would go on to hit this mark again and again over many long and far-reaching projects. —PETER HOWE

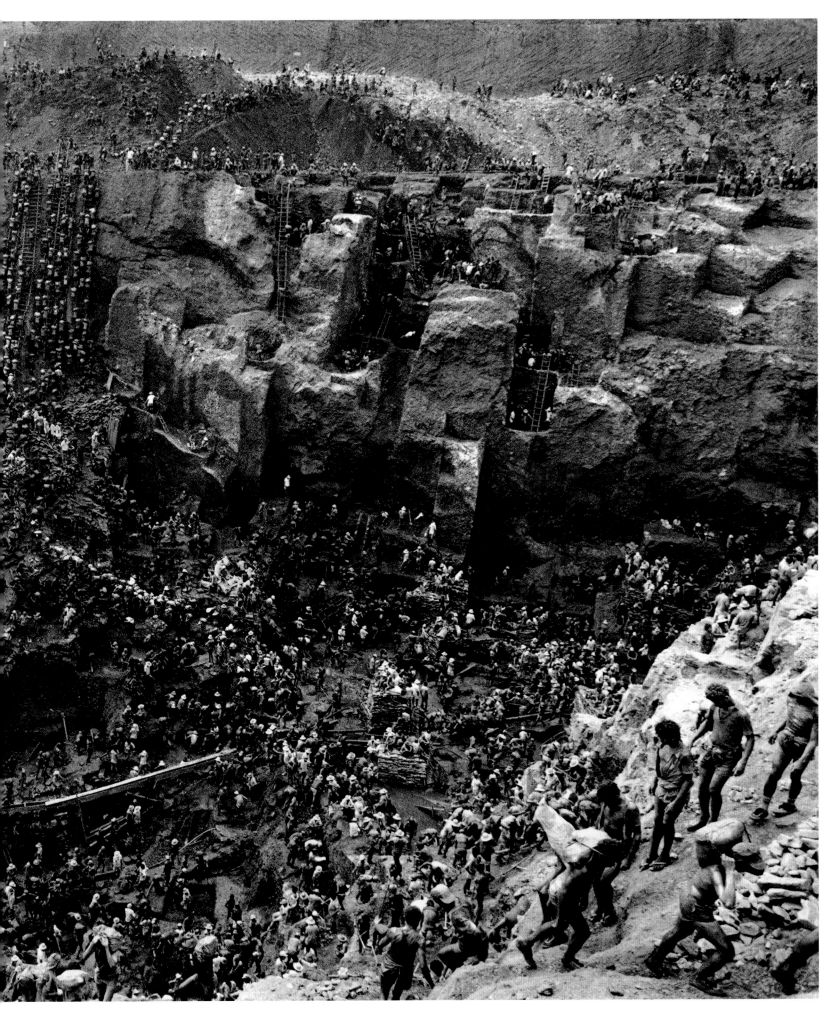

## ANTONIN KRATOCHVIL

Dimitri Iliescu, a resident of Copsa-Mica, Romania, where soot from factories blackens the air. From "The Polluted Lands," published April 29, 1990.

This man was a gardener: he was planting something in his little garden in this completely poisoned environment.

For this project, I looked for the most polluted places, because I wanted to explore and photograph what was happening. People were getting really sick. And I got sick sometimes, too; at one point I fell into water that was so polluted that I developed a problem with severe eczema on my leg, and I had headaches.

But this photograph is about humanity, how people—even in such a bad environment—go about their business and try to live a normal life. It reinforces my belief in humanity, because they can continue, despite everything.
—ANTONIN KRATOCHVIL

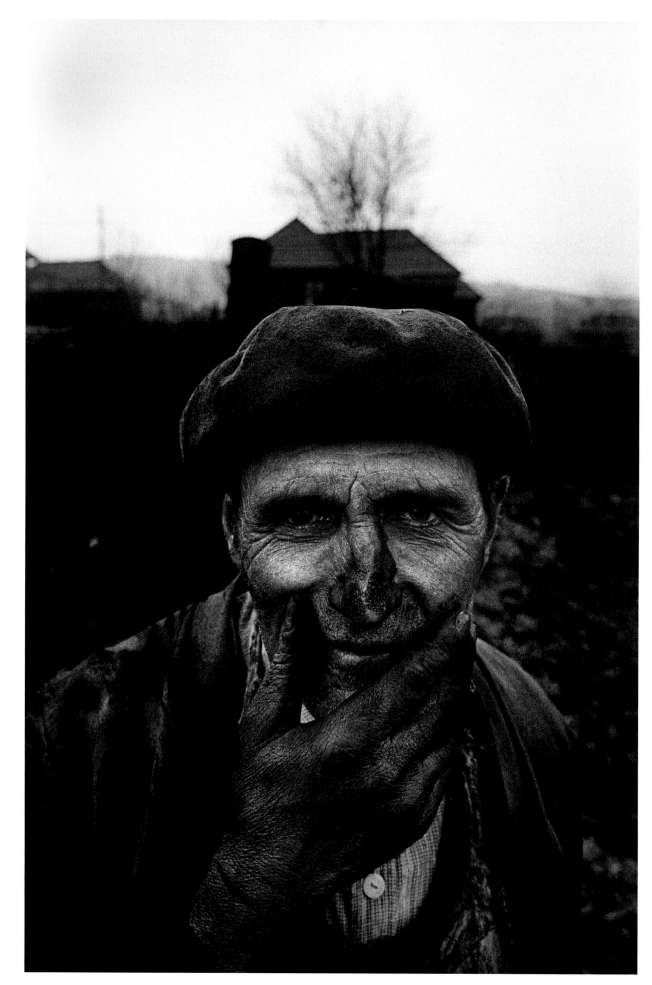

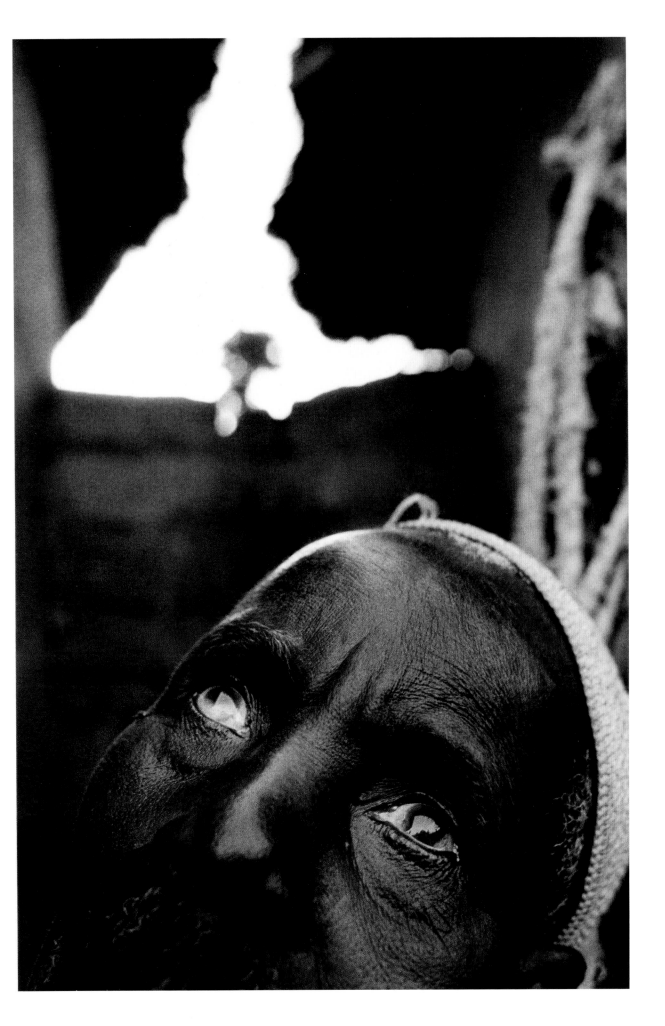

### EUGENE RICHARDS

In 1989 more than three hundred thousand people in West Africa had fallen victim to river blindness, including this man in Guinea. From "River Blindness: Conquering an Ancient Scourge," published January 8, 1989.

At the time of this photograph, I believed in imposing a lot on the viewer. I can't help myself. I tell myself it's not cool anymore and people are perceiving photography differently and questioning the veracity of images like this that are highly emotional. It is an imposition in a way. It doesn't give anybody a whole lot of translation room. They're face-to-face with a sightless person in a world of light. —EUGENE RICHARDS

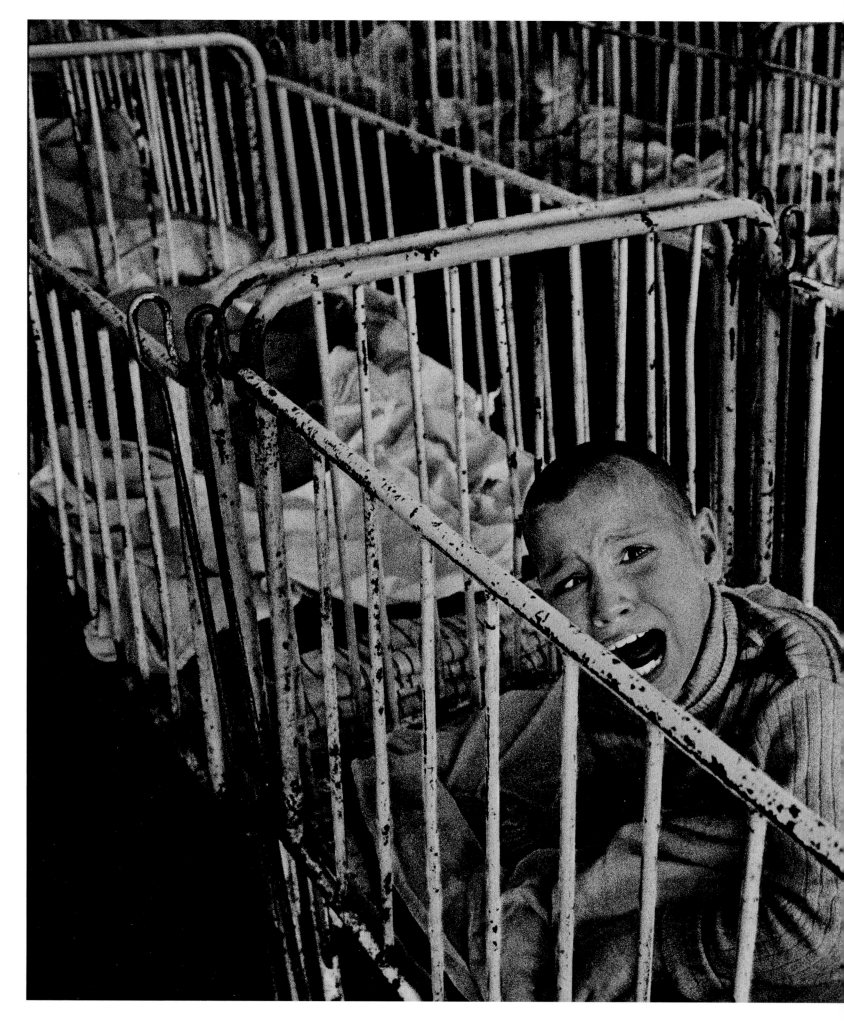

**JAMES NACHTWEY**

Children at a psychiatric hospital in Sacsa, Romania. From "Romania's Lost Children," published June 24, 1990.

When Ceaucescu was overthrown in 1989, Romania suddenly became accessible to journalists from the West for the first time in decades. I went to Bucharest, where I learned about an AIDS epidemic in the country's orphanages.

These children were being kept in medieval conditions: beds without blankets; sometimes they had no clothes, poor nutrition, virtually no medical care. Indeed, there was a lot of AIDS in the orphanages, and it was caused by injecting the children with adult blood—the belief was that adult blood would make them stronger. Well, sometimes the blood was infected with HIV, and often a single syringe would be used for many children. So this was another horror on top of the horrors they were already experiencing.

In my career up to that point, I had been involved in a lot of wars and conflicts, and I had seen some terrible things in the world. But nothing prepared me for what these children were experiencing. It was institutionalized cruelty, and I considered it a crime against humanity. It really shook my faith in humanity. The only thing that kept driving me was the thought that if we shed some light on this, the rest of the world would respond, which they did. —JAMES NACHTWEY

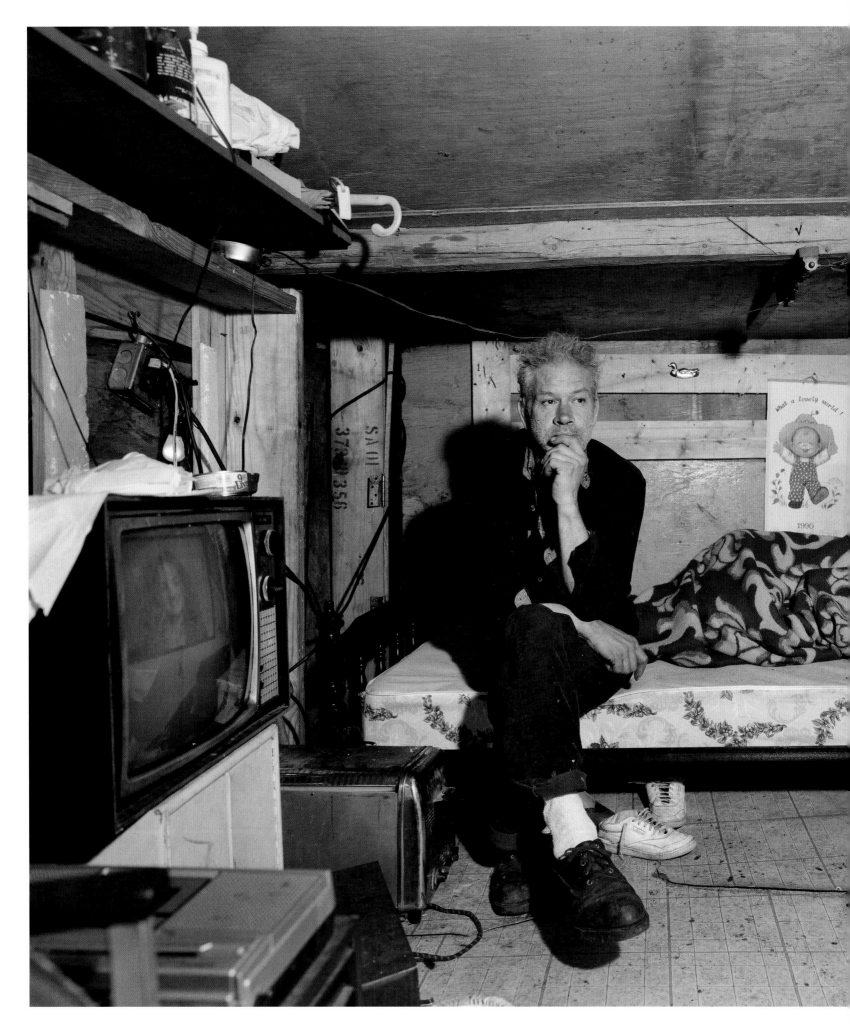

## FRED R. CONRAD

Shantytown, Manhattan Bridge Plaza, near Canal Street. From "New York in the Nineties," published September 29, 1991.

The idea behind this story was to consider New York City in the 1990s as Jacob Riis had done in his eye-opening *How the Other Half Lives* a century earlier. Fred Conrad captured the feel of the city's squalor and deprivation. It seemed that many things hadn't changed in that hundred years. —K.R.

This man had built a shelter beneath the highway between the Manhattan Bridge and the Brooklyn Bridge. He was very handy and had tapped into a nearby light pole for power—he had a TV and an electric heater. I used a wooden 4-by-5 camera to create a look similar to the Riis photographs. So I was able to get more detail with the big negative, but the process also allowed me to spend more time with the people I photographed. Often I heard several of their stories. This man was pretty quiet, but revealed much about himself by the home he created from discarded materials. —FRED R. CONRAD

## MARC ASNIN

Menachem Schneerson, grand rabbi of the ultra-orthodox Lubavitcher sect, addresses followers in Crown Heights, Brooklyn. From "The Oracle of Crown Heights," published March 15, 1992.

Moments before, the rebbe was in quiet contemplation, praying alone by the wall. Anticipation filled the room with an undeniable charge. Immersed in an expanse of black, constricted on all sides by the weight of a thousand others, I felt the tide suddenly pulling me, as the masses began to move. I looked up to see what had set this migration in motion.

The rebbe moved quietly toward the center of the room. As he did, the mass began to rotate around him. Men took up their positions—every space was filled with men, from the elderly to young yeshiva boys, all hanging on the rebbe's every word. His intensity fueled the passion of the crowd, and in turn the passion of the crowd inspired greater intensity from him. They were in harmony, a reciprocity resulting in greater and greater amplification.

Though the room was crowded beyond capacity, it felt as if the rebbe was speaking intimately, to each individually, like a father addressing his family. Unconditional love, camaraderie, and the reverence of a kindred spirit infused the air. To the rebbe, the love of Judaism was synonymous with the love of the Jewish people. The unconditional love I felt that night, as a Jew surrounded by fellow Jews, celebrating our shared culture and history, has never left me.

This assignment, without question, redirected the subsequent trajectory of my life, and the moment captured here was the pinnacle. —MARC ASNIN

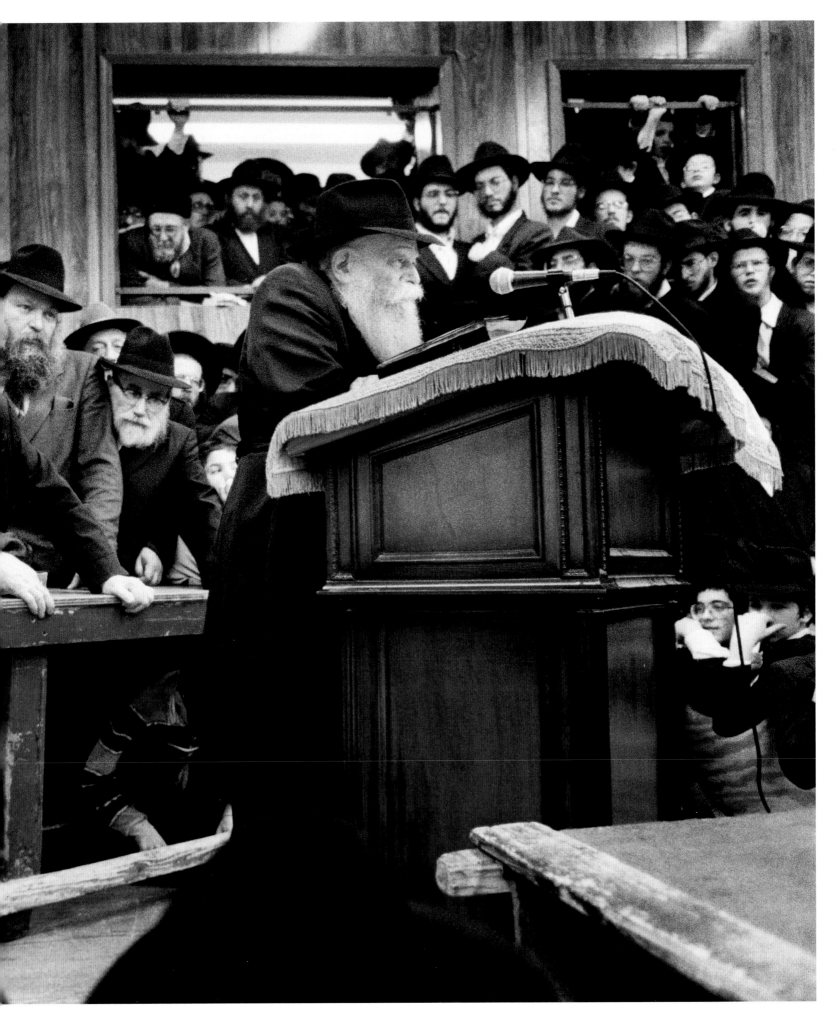

## LARRY TOWELL

A member of the Farabundo Martí National Liberation Front in the town of San José las Flores. From "Out of the Jungle: El Salvador's Guerillas," published February 9, 1992.

Larry Towell reminds us of the technical challenges that were long faced by photojournalists: "In those days, I shot pretty sparingly because I was poor, and film was expensive." He used only three rolls of film—approximately a hundred images—per day, and documented the entire war in El Salvador using one Pentax camera. Larry still shoots film: "Any time I try to shoot digital," he says, "it turns out to be snapshots."

Larry is a photographer who works with "muscular" composition—here the frame is bisected and the balance of the image is wonderfully jarring. —K.R.

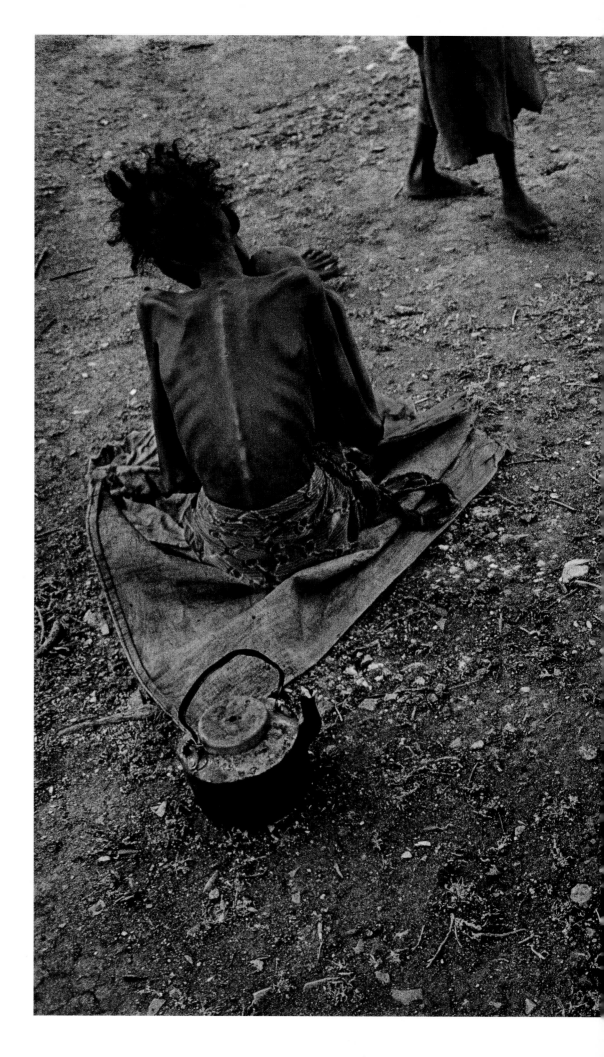

## JAMES NACHTWEY

A Somali woman being transported in a wheelbarrow from a hospital to a feeding center. From "Somalia, 1992: The Casualties," published December 6, 1992.

Jean-Daniel Tauxe, a senior operative with the International Committee of the Red Cross in Somalia at the time this photograph was made, was part of the campaign to bring global media coverage to the country's horrific state of famine. "We needed to find something to turn the tables," Tauxe says. The ICRC invited James Nachtwey to come to Somalia. Tauxe observes that his powerful images in the *Magazine* "brought the immediate attention of the U.S. government, followed by the U.K., France, and the entire world. We enjoyed tremendous support and when months later the UN and UNOSOM . . . came to the rescue we could proudly say that 1.5 million people survived thanks to what is and will remain the largest ICRC operation since World War II. James's pictures made the difference." —K.R.

When the famine started in Somalia, I wanted to become involved in documenting it. The first news cycle of this story had already gone by, and most major publications had already run something on it. But I realized that it was far from over, and that people needed to be reminded. We had to keep the pressure on in terms of public awareness.

So although I couldn't get an assignment from anyone, I decided to go myself. I brought the pictures back and showed them to Warren Hoge. The *Magazine* published an extensive layout, and put one of the photographs on the cover. I found out only years later, from [Jean-Daniel Tauxe], that the publication of those pictures in the *New York Times Magazine* mobilized donors to the extent that the ICRC was able to undertake the largest relief operation since World War II.

The point is that it was really not just about the photographs, but the fact that the *New York Times Magazine* published them. If they had remained unpublished, or poorly published, the result would have been far different. That the work was displayed in such a powerful way by such an illustrious magazine really grabbed people's attention.

So much good photography is just howling in the wind without bold editorship. —JAMES NACHTWEY

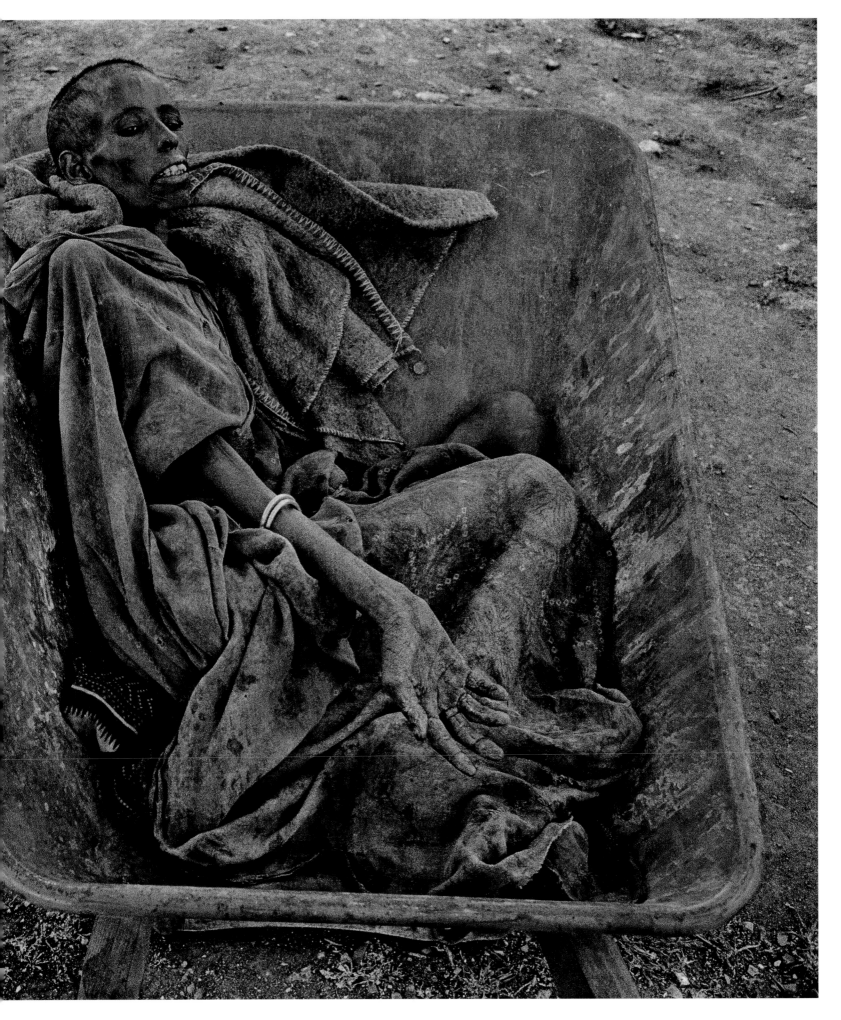

## GUEORGUI PINKHASSOV

Petlyura's artists' squat in Moscow. From "Young Russia's Defiant Decadence," published July 18, 1993.

Gueorgui Pinkhassov says that he doesn't have a particular intention when he is photographing; he is interested in something he doesn't know. When he is shooting, he ignores the action and concentrates on the movement and intersection of purely visual elements—line, form, light. "Don't be afraid to take bad pictures," he says, "because good pictures are the mistakes of the bad pictures."

In this photograph, there are four separate actions that all weave together: one person lifts a cigarette, one tosses a ball, the dog looks on, and the Lenin-like figure drops the flag to the ground. For Pinkhassov, life is really like a tapestry— he's never shooting just one thing, there are often several things happening simultaneously. —K.R.

**MARK PETERSON**

At the Hampton Classic Horse Show, Bridgehampton, New York. From "The Snooty Dame at the Block Party," published October 24, 1993.

Everything was new, and the colors were shouting at me. They sold tickets for a horse show, but the real show was the people in the stands, who were dressed to the nines. I sat down and they looked at me like they had been waiting all day to have their picture taken. I stayed about five minutes, timing my clicks to the jump of the horses. I'm sure they would've been happy for me to stay forever. —MARK PETERSON

## ELLEN BINDER

Cossack cadets at Kadetsky Korpus in Novocherkassk, Russia. From "The Sound of Cossack Thunder," published October 31, 1993.

I moved to Russia in 1991, before the putsch, and shortly thereafter I photographed Cossacks for about a year. Their story was about impotence and anger disguised as racial hatred. My interest in the Cossacks came from stories my grandmother told me of her childhood. She remembered being driven in the middle of the night from a bed she shared with her mother, wrapped in a blanket, and carried to the safety of the next village—fleeing Cossack horsemen with torches.

I went in search of the contemporary reality behind the folklore myth. I also must admit that it was exciting riding horses with the Cossacks, drinking with them, and being welcomed into their homes. (They either didn't realize I was Jewish or thought I was an exception. I didn't ask.)

I found this school in Novocherkassk when I visited the home of a very old Cossack woman; her grandsons were visiting her and they were students at the academy. They were in uniform and I knew the moment I saw them that I had lucked out. It wasn't hard to get in, partly because Russia had not yet become self-conscious and partly because, of course, to be a successful photographer you have to know how to get access. —ELLEN BINDER

## DONNA FERRATO

Beggar on New York City subway. From "The Business of Begging," published April 24, 1994 (cover image).

The subways in New York were flooded with panhandlers, and we set out to have a look at each individual one—to find out who these people were. I felt they were a community, that there were few enough of them that they all, in some way, knew each other. And I wanted to draw the lines between them. I wanted to go into their lives. —ADAM MOSS

This was a classic *Magazine* project. New York's then-mayor, Rudy Giuliani, and Police Commissioner William Bratton were coming down hard on "street nuisances" like beggars. We sent a writer out with Donna Ferrato, and they rode the subways for weeks, making pictures and identifying each beggar they could. In this case, Donna was on the subway when a man dropped to his knees as part of his panhandling routine. She's right there in a crowd.

This is the kind of photograph that is only going to get better with time. —K.R.

## SCOTT THODE

Christy Mirach, eleven, whose mother, Evelyn, was dying of AIDS. At the time of this photograph, Evelyn and Christy were searching for someone to replace Evelyn after her death. From "Christy Picks a Mother," published May 8, 1994.

There were a lot of sad times after my mom died, times when I missed her a lot. Good memories as well—so I guess I could say mixed emotions.

I look back at these pictures and think about how grown-up I am now. I'm twenty-eight years old. The picture represents memories and things that were in my life at the time—what I was going through, my mom being sick, my mom's passing, seeing her go through the stages and everything else. It lets me hold strong to her, and realize that she's still with me, in a sense, even though she's not with me.

With everything I've been through in my life, thinking about it helps me kind of stay strong and focused on where I'm trying to go. —CARMEN ("CHRISTY") MIRACH

## LYLE ASHTON HARRIS

Working mother Mary Ann Moore on her day off after a week of twelve- and thirteen-hour shifts. From "Better Work Than Welfare: But What If There's Neither?," published December 18, 1994.

I can't recall if this was my last session with the subject, Mary Ann Moore. It was, at any rate, worth the wait in that it evokes a humanity of sublime exhaustion that we all can identify with. It is often too easy to project on to "the other" our own notions of difference and "concerned" sympathy, but what enthralls and haunts me about this work is its concerned transcendence in a Caravaggio-esque sense. —LYLE ASHTON HARRIS

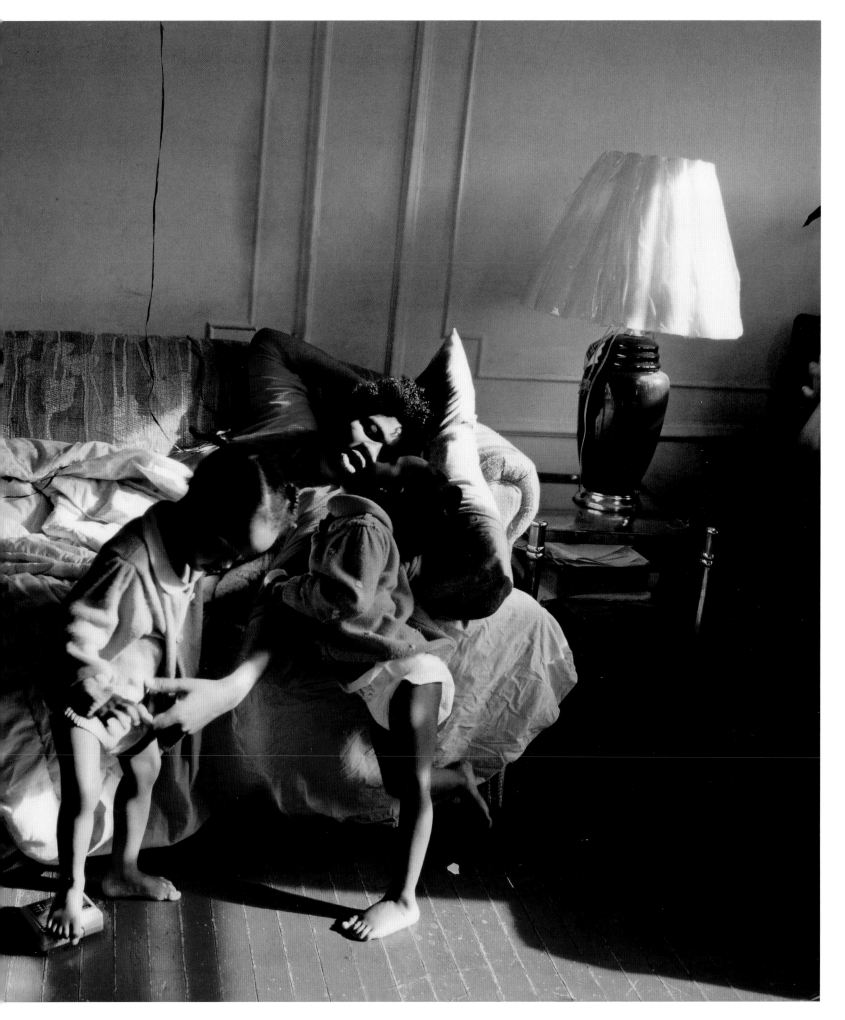

**LEE FRIEDLANDER**

Telemarketer Julie (Yolanda) Cerny in Omaha, Nebraska. From "It's 7 P.M. and 5 Percent of Omaha Is Calling," published December 3, 1995.

I've been interested in working people forever, I think. I'm just there to try to see them.

With the telemarketers project, I went into this office in Omaha and everybody was in a little cubicle—a little bit bigger than a phone booth, but not much bigger—and they were talking to people all day long. There was a sea of cubicles, and that was only one company.

The world makes up my pictures, not me. —LEE FRIEDLANDER

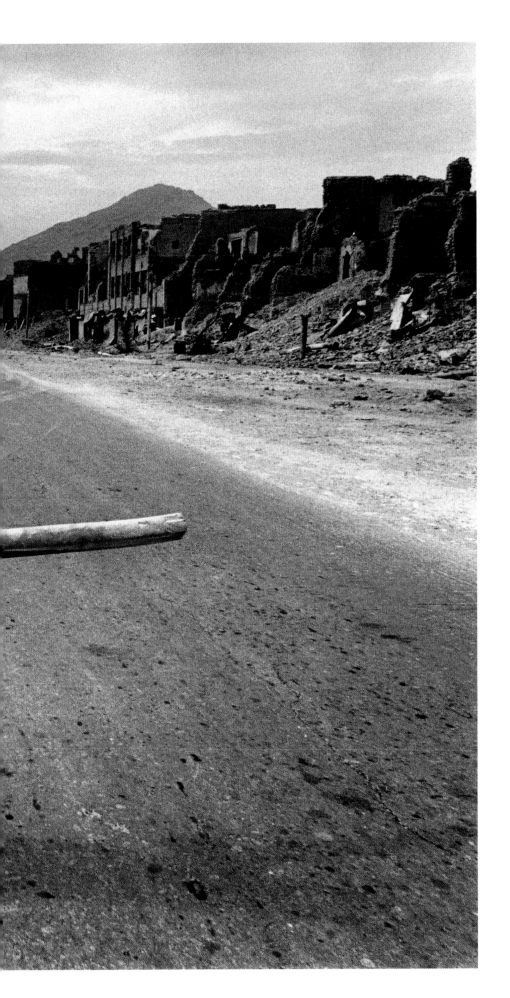

## LAURENT VAN DER STOCKT

A boy in Kabul, Afghanistan, carries firewood to his home, almost two miles away. From "City of Orphans," published April 2, 1995.

In December 1994 Kabul was being torn apart by warring Afghan factions, battles that had been raging since the end of the Russian occupation. Children were the primary victims of this situation. They were often charged with keeping watch for the troops out in the fields, and great numbers of them were seriously wounded by the millions of land mines distributed throughout the country by the Russians. Many of them had been orphaned by the war and were living at the mercy of their needs. They sought to survive by any means possible. Some worked in unhealthy conditions in factories; others were essentially slaves to the Mujahidin. Some hunted for pieces of wood in the rubble of the destroyed city, to be used for heat or cooking, or to be sold by weight at the markets.

This boy, Mamad Unos, takes advantage of a moment of calm during the bombings to walk down the middle of Judde Maiwan—one of Kabul's main thoroughfares—transporting his find, which is bigger and heavier than he is. He is fully adapted to his hostile environment, in which solidarity is such a vital question. —LAURENT VAN DER STOCKT

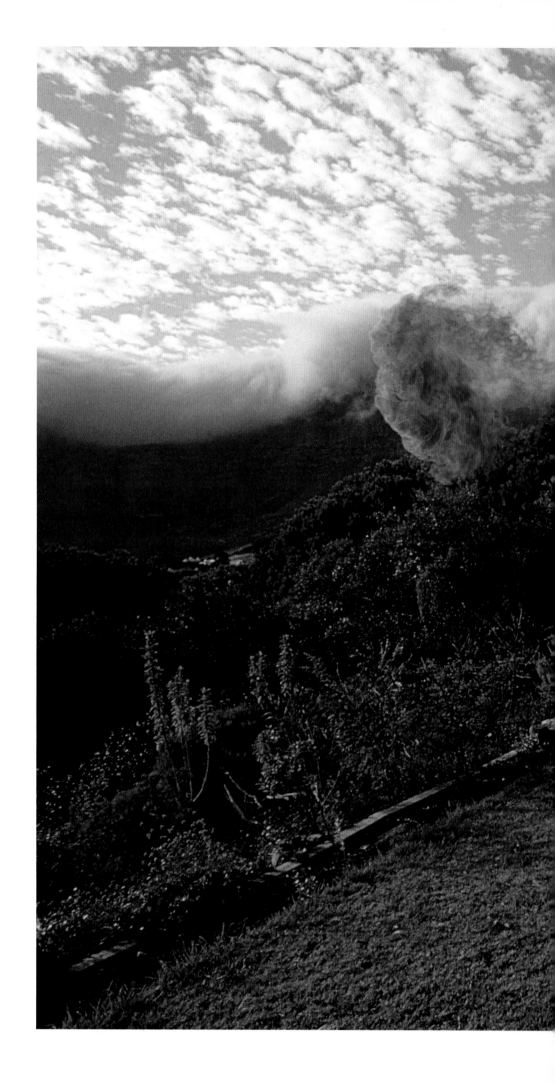

**GUEORGUI PINKHASSOV**

Conceptual artist Beezy Bailey, painted blue and wearing a headdress, in the backyard of his Cape Town mansion. From "Separate and Equal: The Artists of South Africa," published March 27, 1994.

Surprise, unpredictability: these are the main materials of creativity. —GUEORGUI PINKHASSOV

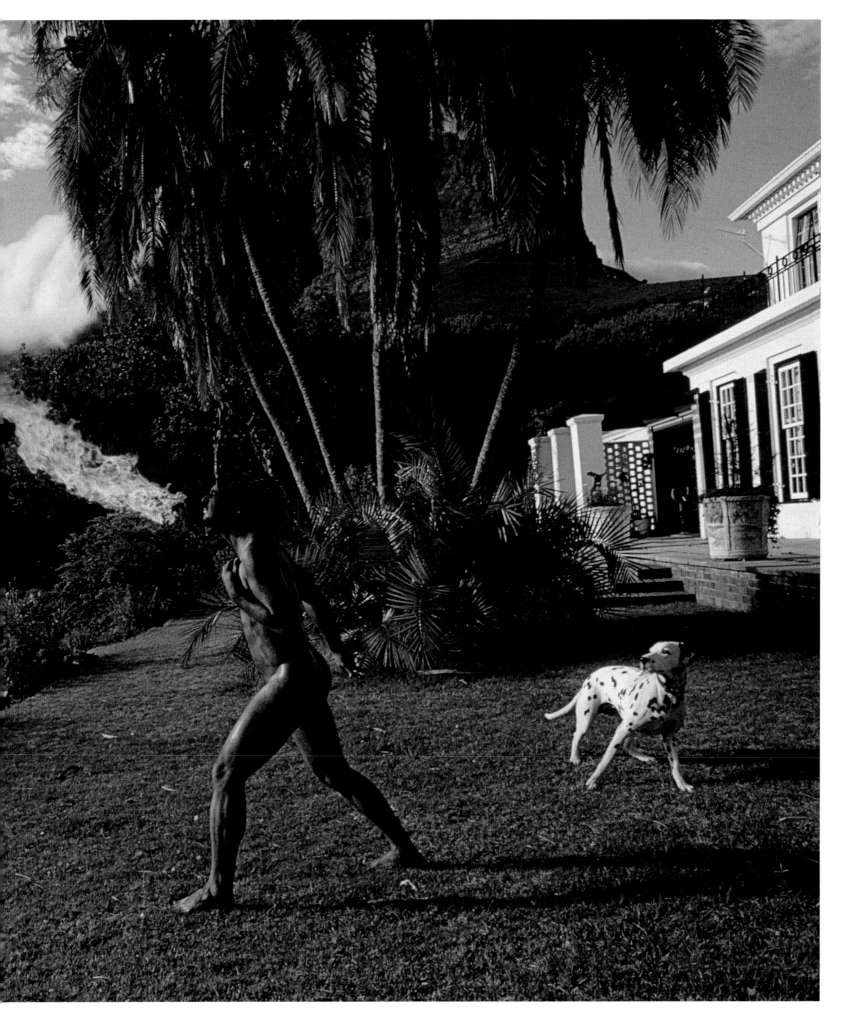

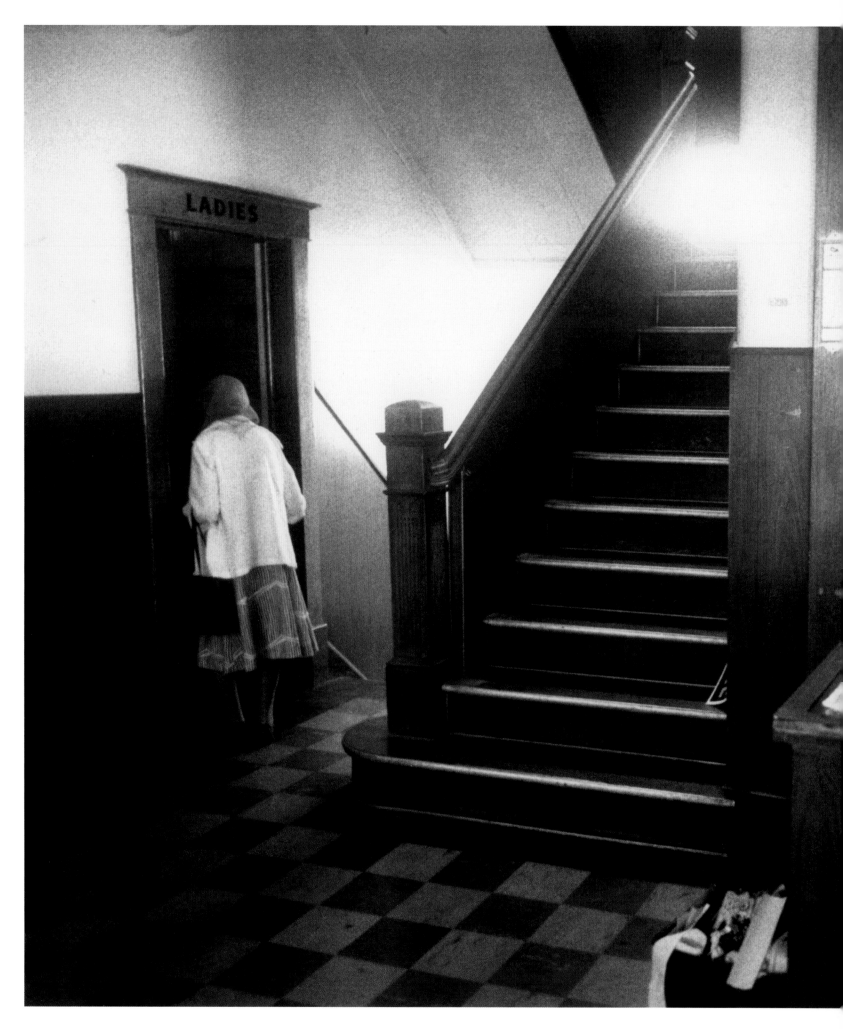

**CHARLES HARBUTT**

Hotel lobby in Fessenden, North Dakota. From "The Reopening of the Frontier," published October 15, 1995.

This picture is a distillation of what was going on in my mind while working on the story.

When I was a kid, the pioneers and the frontier were for me a deep part of the American myth: small towns, farmers, buffalo roaming. . . . The story was about what had become of it all.

I was mostly dealing with ghosts. To see an actual person was rare.

This picture was made in the town of Fessenden (population 625), the county seat of North Dakota's Wells County. There was a café where I noticed this woman having lunch alone, all dressed up. I imagined that this ritual had been part of her life for dozens of years. Later I saw her again in the lobby of this hotel, and suddenly it occurred to me that here was a remnant of all the work and yearning the pioneers had done making a life on the plains. —CHARLES HARBUTT

**LARS TUNBJÖRK**

Louis "Bo" Polk, a venture capitalist, at home in Wyoming. From "Big Boys Will Be Cowboys," published November 19, 1995.

This was my first assignment for the *Magazine*; it was for an issue about wealth in the United States. I visited a number of rich people who had big ranches in the West. The man jumping is Louis "Bo" Polk—a businessman. The trampoline was mostly for his two small children, but he was a very sporty man and loved to jump for exercise. And he loved his cowboy outfit. —LARS TUNBJÖRK

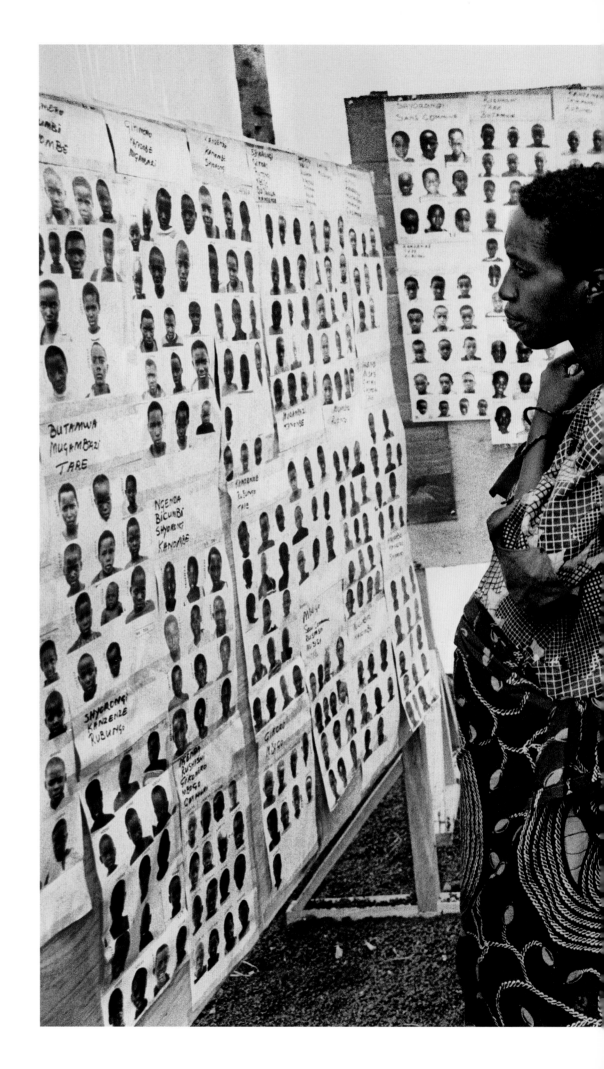

**REZA**

At the Mugunga refugee camp near Goma, Zaire, Rwandans look for photographs of their missing children. From "Lost and Found," published March 24, 1996.

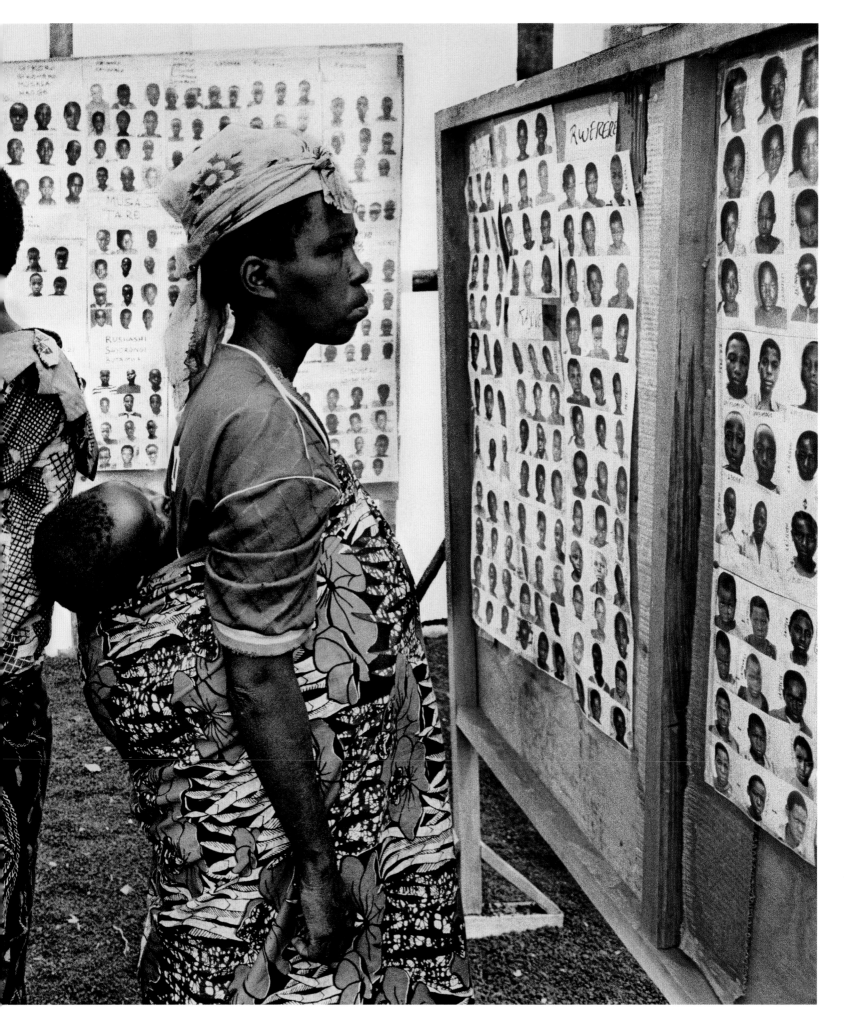

## GILLES PERESS

A house in Vogošca, near Sarajevo, Bosnia-Herzegovina, torched by retreating Serbs the night before the town came under Muslim-Croat control. From "Savage Spite," published April 28, 1996.

I was spending time with a Serb family that was about to leave Vogošca. They were waiting in an apartment, drinking slivovitz. Some were crying. Finally, when the time came, they began to pack a truck to leave the town. As they did, I saw the house across the street burning. As I was shooting that picture, I turned around, and behind me in the shadows, in the ground-floor apartment, was a little old lady who was also looking at the house burning. She wasn't saying a word, but she was crying, reaching out to the sky, silently witnessing the end . . . well in some ways, the end of a life.

Why was the house burning? The Serbs had developed this radical attitude: if they had to move out of that part of the land, they would leave *nothing* behind. It wasn't only that they burned their own homes. They also went into the cemeteries and dug up their ancestors—the grandmother, the grandfather, the uncle. It was the middle of the winter, the ground was soggy, frozen, snowy, and there were these incredible scenes of drunkenness, of coffins bursting open, the juice of death spilling all over the place.

It was an extreme moment of the soul in historical terms. —GILLES PERESS

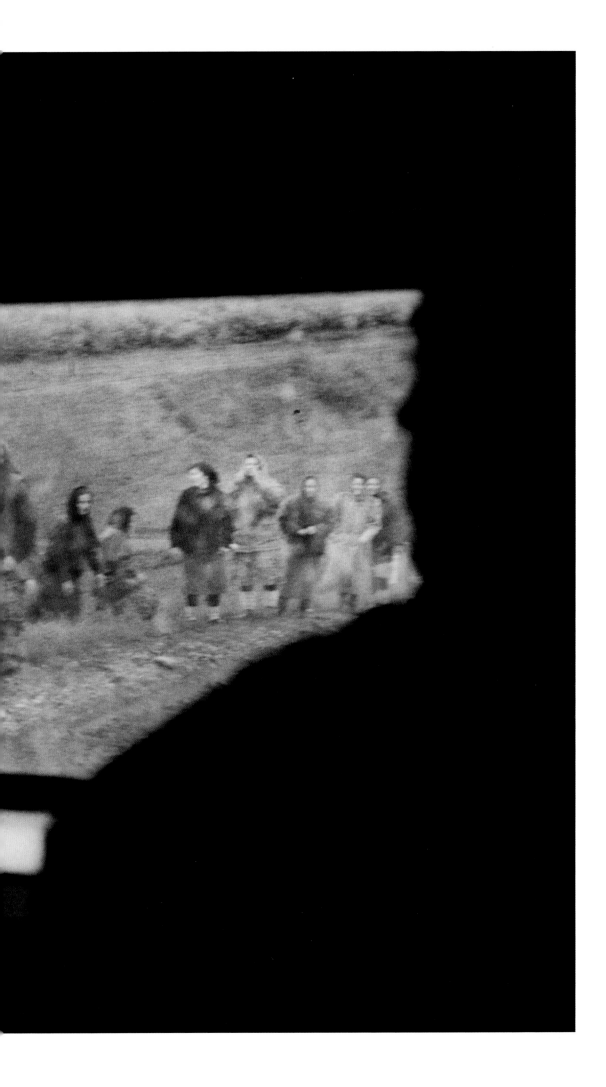

## STANLEY GREENE

The road to Samashki, in Chechnya, where American humanitarian aid-worker Frederick Cuny disappeared in 1995. From "What Happened to Fred Cuny?," published February 25, 1996.

A writer can surmise, but a photographer has to *show* what is the truth. You cannot make it up, you cannot fake it. Trying to do a photo-essay where there is no chance of photographing the person whom the story is about is like trying to solve a detective novel. I had the idea to follow the route of the crime visually, as if I were a detective, but using my camera to show the clues, the crime, the details of the suspected murder—how, where, and why it was done.

Here, I was on the road to Samashki, the same road Fred Cuny must have traveled before he disappeared, looking out of a vehicle just like the one Fred and his fellow travelers were in. I had to show what happened on that road, re-create it in the middle of a war, with real bad guys all around, and towns and villages being destroyed. I was trying to solve a mystery in Chechnya, which had been bombed, where most of the clues to the disappearance are gone. Chechnya, for me at this moment, was invisible. You could not see the death. You could only feel it. —STANLEY GREENE

**LARS TUNBJÖRK**

Office cubicle. From "The Office's Subconscious," published January 18, 1998.

I made this photograph at the beginning of my *Office* project—about office spaces in the United States and Sweden. I hadn't seen many American offices yet, and at home in Sweden we don't have these cubicles. I thought they looked like small prison cells but also beautiful objects. —LARS TUNBJÖRK

## RICHARD BARNES

The shack of Theodore Kaczynski, known as the "Unabomber," was trucked from Montana to a warehouse in Sacramento, California, where it was held as evidence in Kaczynski's trial and continued to be stored after he pleaded guilty. From "Evil's Humble Home," published September 13, 1998.

This was my first assignment for the *Magazine*. I remember getting a call from an assistant asking if I could send my portfolio to New York so they could make a decision. I agreed, and inquired what the assignment was. She informed me she couldn't tell me. I thought this odd but asked her to at least indicate to me what I should include in the portfolio. Her answer was: "Have you ever photographed warehouses?" I got the assignment based on a few images of warehouse-type buildings I'd cobbled together.

I learned that the assignment was to photograph the Unabomber's cabin, which was being held in deep storage in a warehouse in Sacramento on an air-force base, administered by the FBI. It evoked the idea of "architecture on trial": Theodore Kaczynski's tiny home, without heat or running water, had been trucked a thousand miles to demonstrate to a jury that anyone who could live like this for thirty years obviously had to be insane. —RICHARD BARNES

## JOACHIM LADEFOGED

French military helicopters bring humanitarian relief to Kukës, Albania. From "Exodus," published April 25, 1999.

I was shooting in the Albanian border town of Kukës when I learned that the *Magazine* was interested in seeing my work because they were doing a story about the Albanian exodus. So I called them. It was a Wednesday afternoon, and they told me to send my undeveloped film to New York by Friday, so they could have a look and still make their deadline.

I panicked: how do you send thirty rolls of film from an Albanian mountain town in the middle of nowhere to New York within two days? By luck an Albanian friend was able to contact a woman he knew at a travel agency in Tirana; she found someone who was traveling to the United States. It was arranged that I'd be picked up at a hotel in Tirana at seven A.M. the next morning and taken to the airport, where I'd stand at the entrance waiting for this man and ask him to hand-carry my film to Washington. He'd hand it over to a courier service that would bring it to New York, where a lab would make contact sheets and have the film ready for edit by Friday morning.

So now I just had to get down from Kukës to Tirana. I took a taxi and told the driver not to stop for anyone or anything—a lot of press people had had equipment stolen by armed gangs. The ride was the scariest of my life: the driver seemed to have a death wish; he drove like crazy—we made the seven hour drive in five hours! But I made it to the airport the next morning, found the passenger, gave him the bag with the film, and said good-bye. In the end, the *New York Times* ran the pictures over eight pages. —JOACHIM LADEFOGED

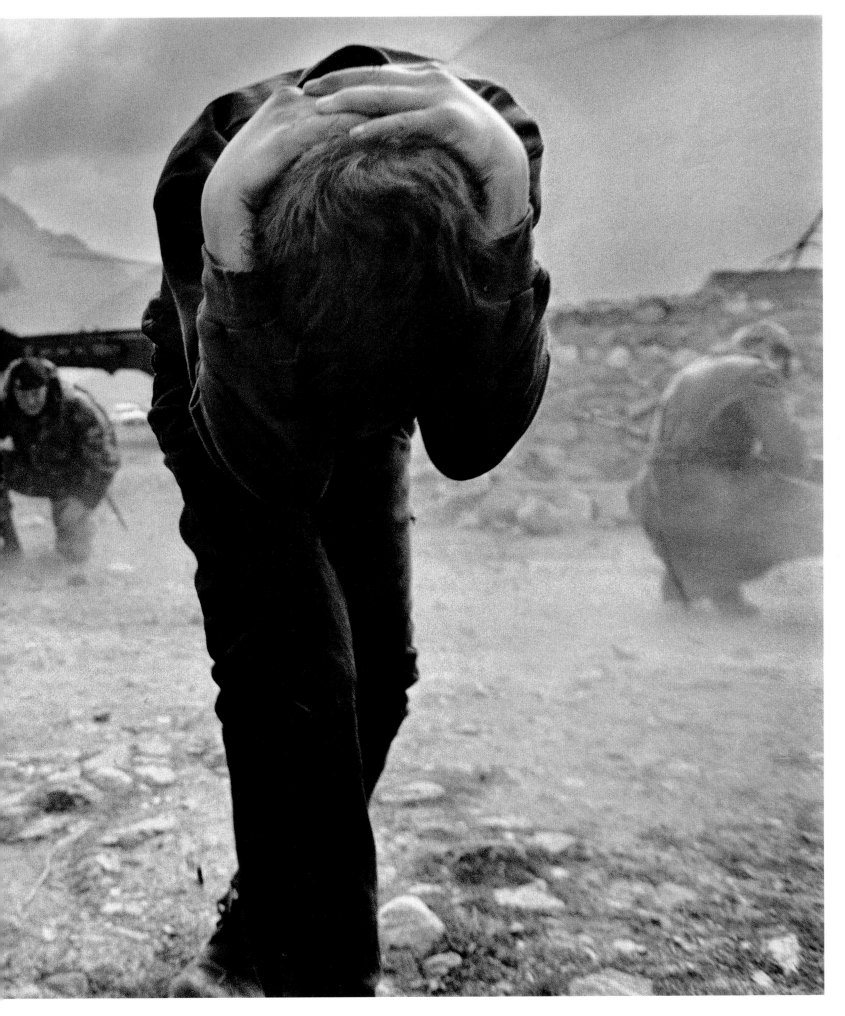

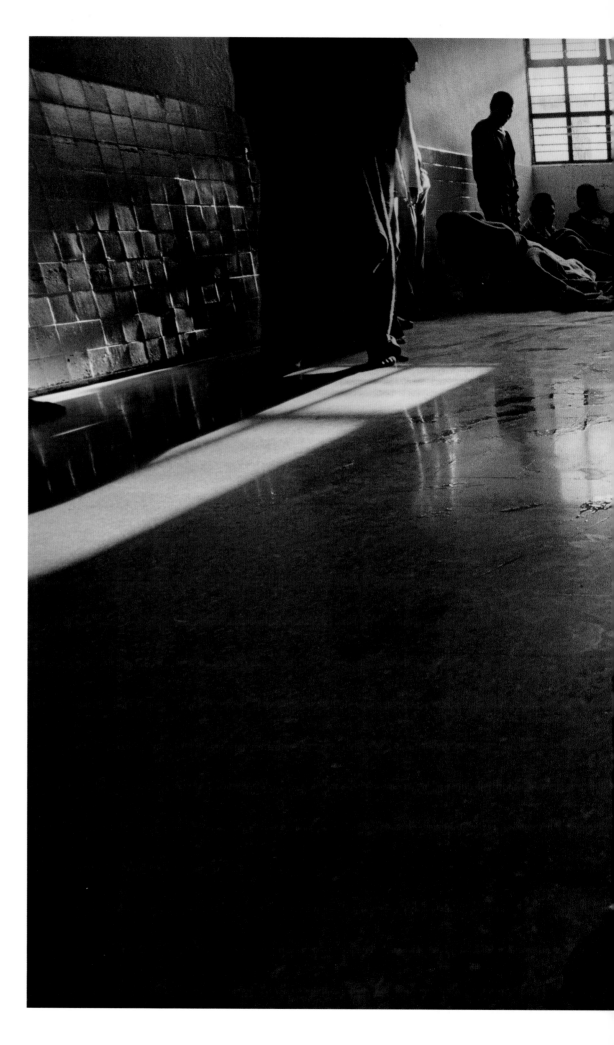

## EUGENE RICHARDS

The Ocaranza hospital for the mentally ill in Hidalgo, Mexico. From "The Global Willowbrook," published January 16, 2000.

From a journalistic point of view, this assignment seemed very clean-cut. The Ocaranza institution in Hidalgo is terrible: go into it and show the bad conditions. So I went to see it with a group of Mexican and U.S. human-rights activists. We just showed up, early one morning, walked in and wandered around. Most everybody was oblivious to us: they were in their own world. They were drugged. Some of them were unconscious on the floor. Occasionally people would turn to study me, and that was a little disconcerting. But it's not a bad thing for a photographer to be made self-conscious by the fact that these are *people*—and this is not necessarily what you should be doing: photographing people who are profoundly sick.

These pictures are sometimes a little bit too much for viewers, emotionally. On the other hand, there was far worse going on in that room. You have to draw the line. I mean, every photographer has a line where it changes over from empathy or sympathy to disgust for its own sake, and it's really hard to know when that is. And you tell yourself that whatever you're showing, as bad as it looks, it isn't nearly as bad as it really was. Do you need to show it all? No. That's just common sense. But you're not telling the complete story. —EUGENE RICHARDS

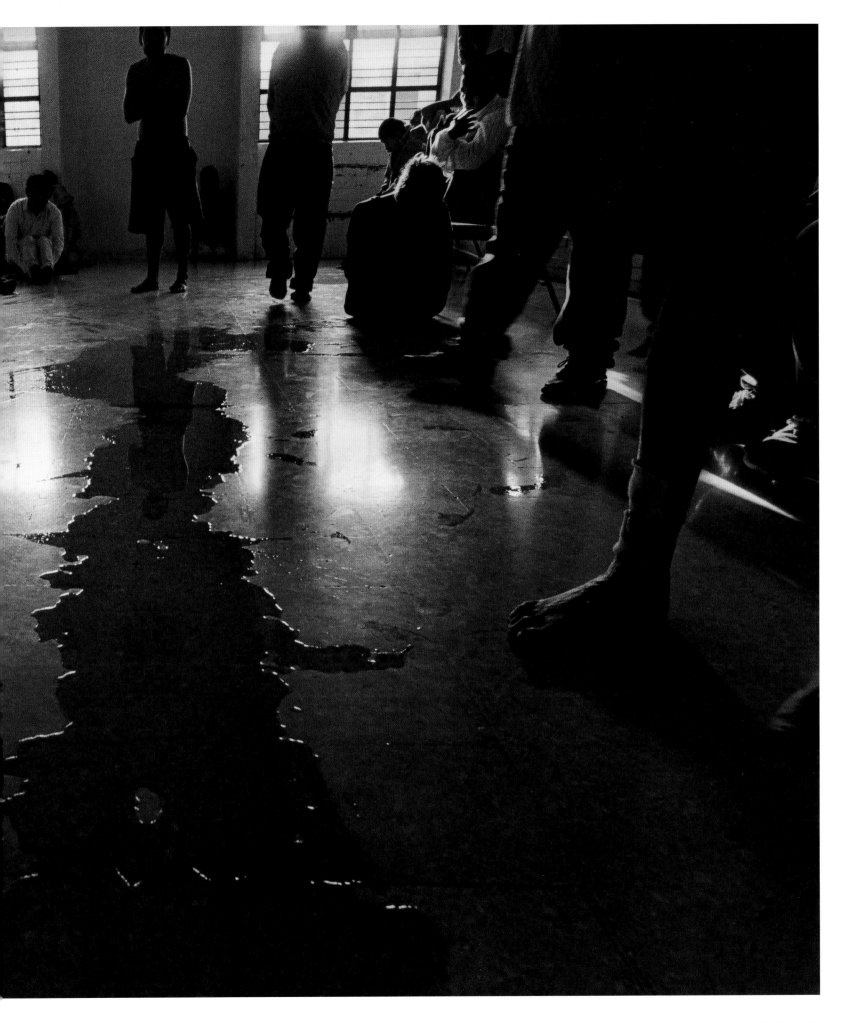

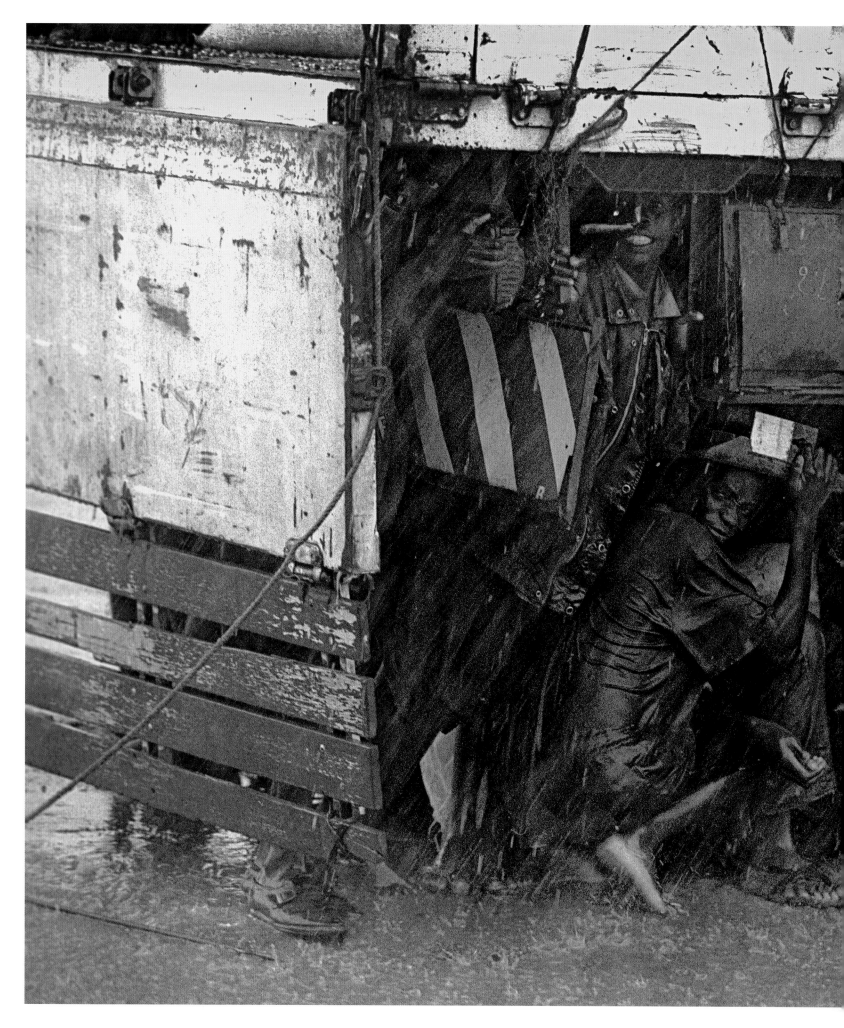

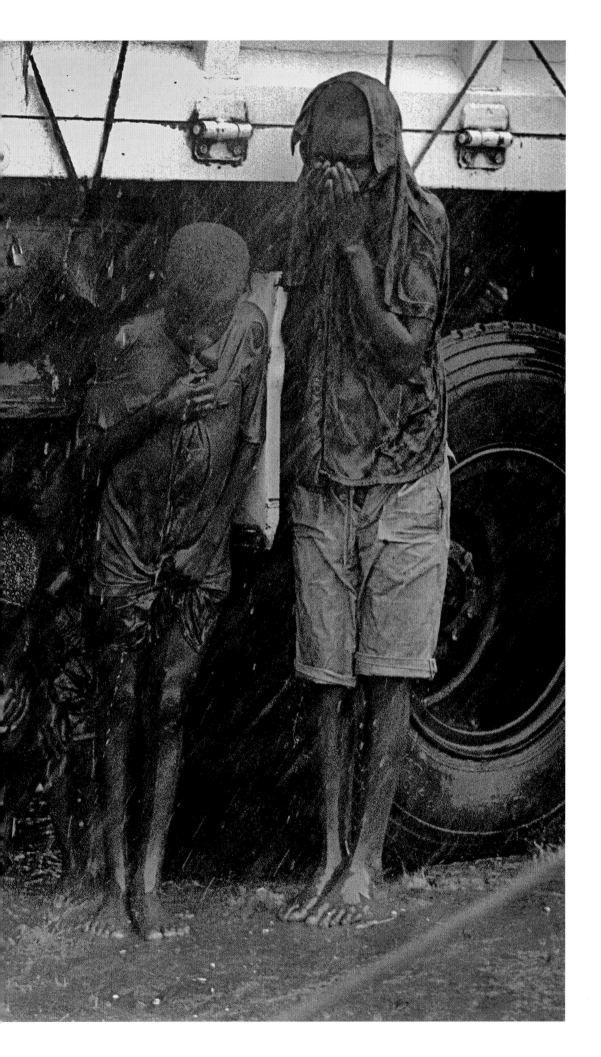

**ETTORE MALANCA**
A rainstorm halts the food line at Kabezi camp in Burundi. From "Ethnic Fencing," published May 21, 2000.

This picture was taken in March 2000 in Burundi, at the Hutu Kabezi camp during a weekly NGO food distribution. A storm came up; the rain was so strong that I could hardly see the dark parts under the truck. Three days later, at a photo lab in Paris, I discovered with emotion this photograph in the contact sheet, and saw that in the dark part of the picture you can see the people's eyes. It was a great moment for me as a photographer. —ETTORE MALANCA

**EDWARD KEATING**

Amarillo, Texas, 1:30 in the morning. From "Asphalt Blues,"
a story about U.S. Route 66, published July 2, 2000.

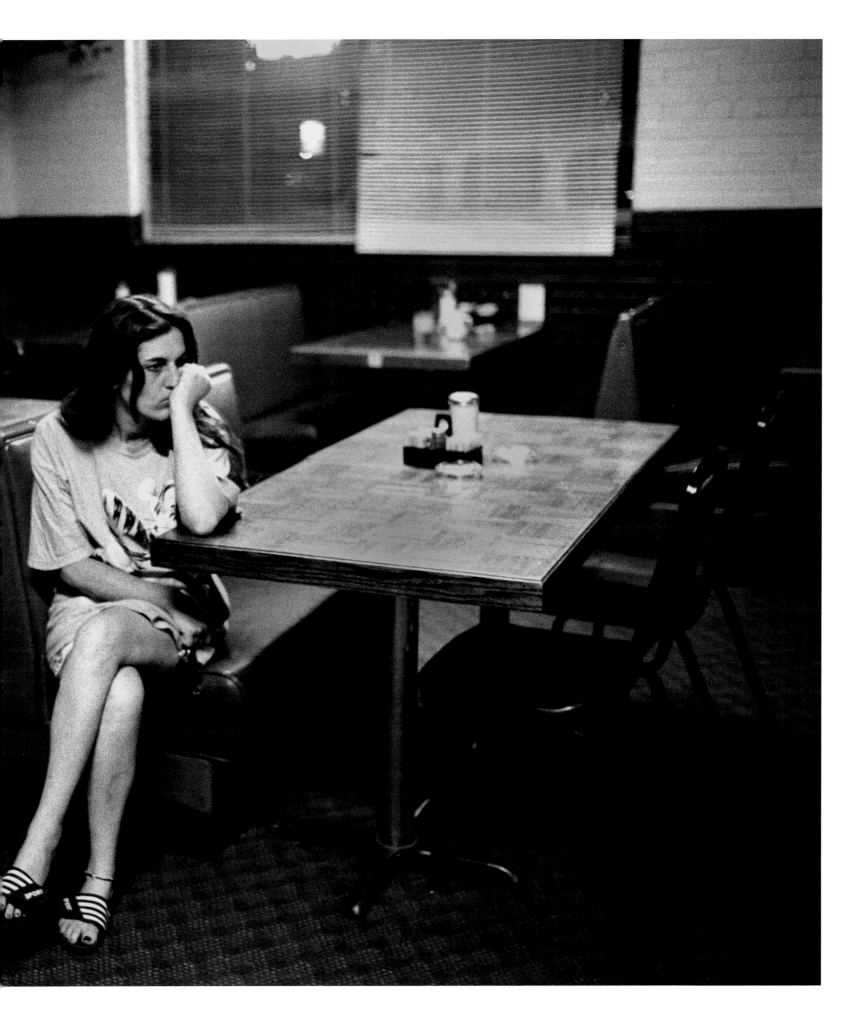

## CHRISTOPHER ANDERSON

Barely afloat on the vessel *Believe in God* with forty-four Haitian migrants, somewhere in the Caribbean. From "America, or Death," published June 18, 2000.

In 1999 I boarded a twenty-five-foot homemade boat called *Believe in God* with forty-four Haitians trying to sail to the United States. The boat, made of scrap wood and nails, had no navigational equipment other than a magnetic compass. The sails were made of stitched canvas. There was no motor.

We were all stuffed into the hold of the boat to conceal us from discovery by Coast Guard and immigration authorities. It was unbearably hot. Everyone was seasick, myself included. Every breath was thick with the smell of sweat and vomit and human waste.

This photo was made when we realized we were sinking. Salt water mixed with vomit was rising up around our shins. I remember the transition from worrying about the possible outcomes of this trip to the acceptance that this was going to be how my life would end. It was the middle of the night but the light of a bright moon poured through the opening to the deck above and fell on the faces in front of me. I had not made many pictures up to this point. David, one of the Haitians, said: "Chris, you'd better start taking pictures because we are going to be dead in an hour." It was not hyperbole; it wasn't melodrama. So I began making pictures.

I have spent much time since thinking about that moment. Why make photographs that no one will see? The only answer I can come up with is tied to an idea that the act of photographing has as much to do with explaining the world to myself as it does with explaining it to someone else. The process of making a photograph was linked to how I understand my world and my experience.

When we were finally rescued, I thought that I had failed miserably at my "job": I had only five rolls of film in total. In my mind, I had blown the story. I couldn't imagine how anything on that film could ever convey anything about the experience, much less tell the story I had been commissioned to tell. —CHRISTOPHER ANDERSON

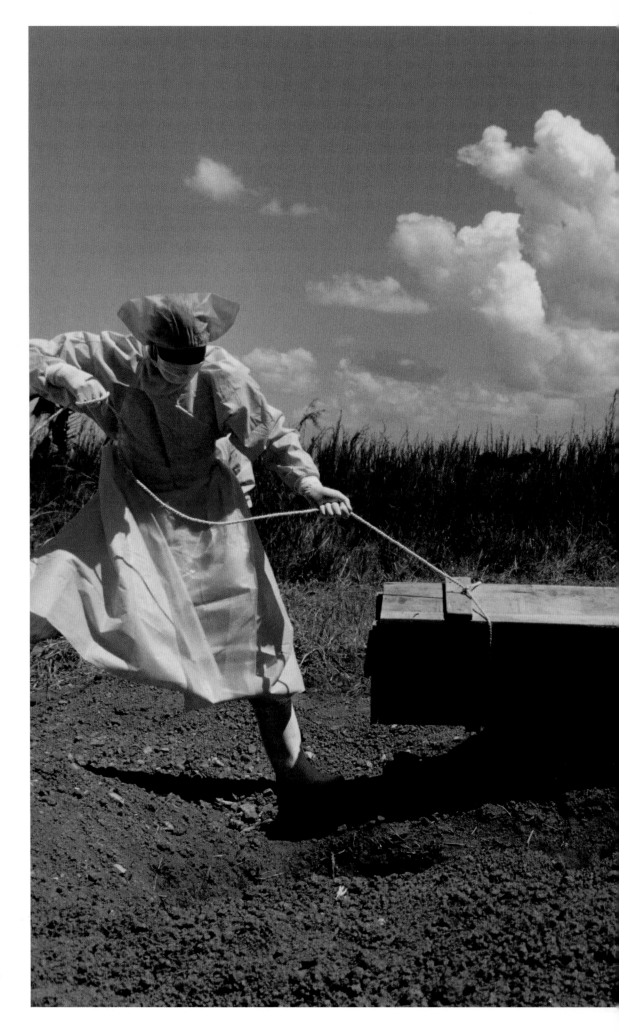

## JODI BIEBER

In African towns such as Gulu, Uganda, Ebola corpses must be buried in quarantined fields. From "Ebola's Shadow," published December 24, 2000.

I have vivid memories of the Ebola crisis. When I arrived in Uganda, the majority of the press was leaving. I had three days to figure out a way to cover this horrific, contagious, and deadly virus. I met local ambulance drivers who were doing the most amazing work in incredibly dangerous situations. It was an unwritten law never to shake anyone's hand, as the virus spread so easily. You always wore safety clothing and shoes and whenever at an Ebola scene you had to constantly be sprayed with a strong detergent called JIK. We went into vulnerable areas were the LRA [Lord's Resistance Army militia] could attack at any time, which made it even more difficult for the ambulance workers. The scenes of death were horrific, and there was no turning back once you were a victim to the virus. —JODI BIEBER

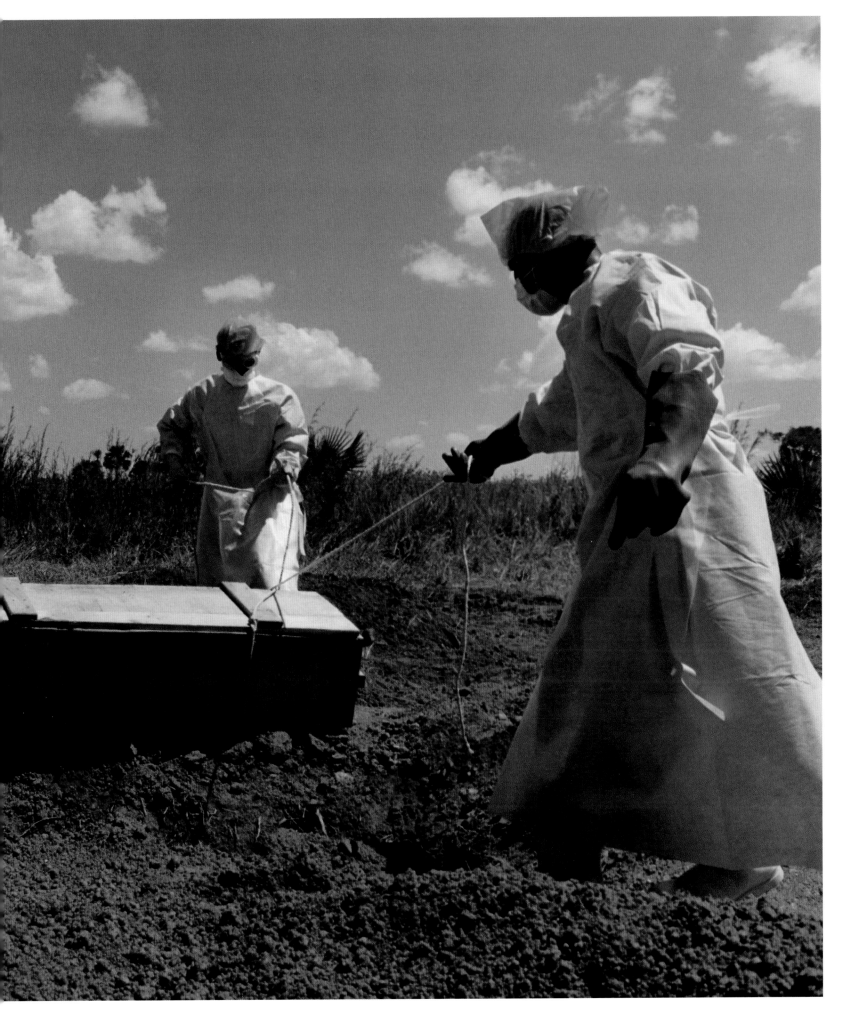

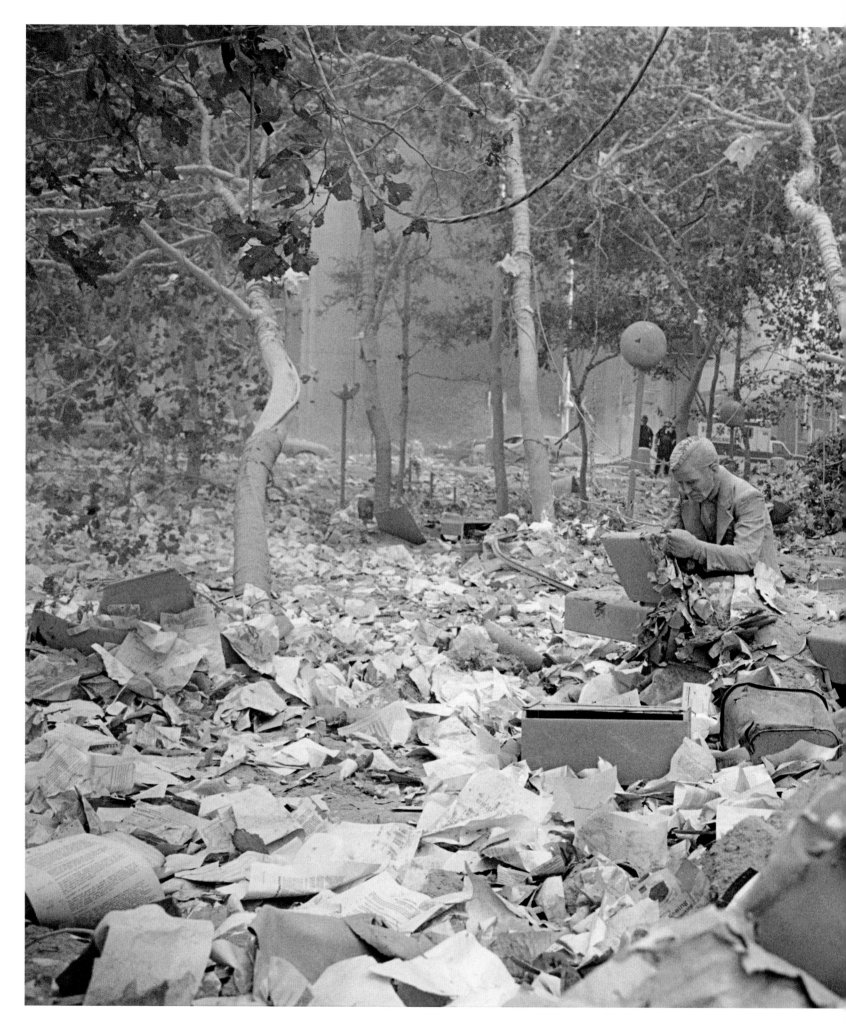

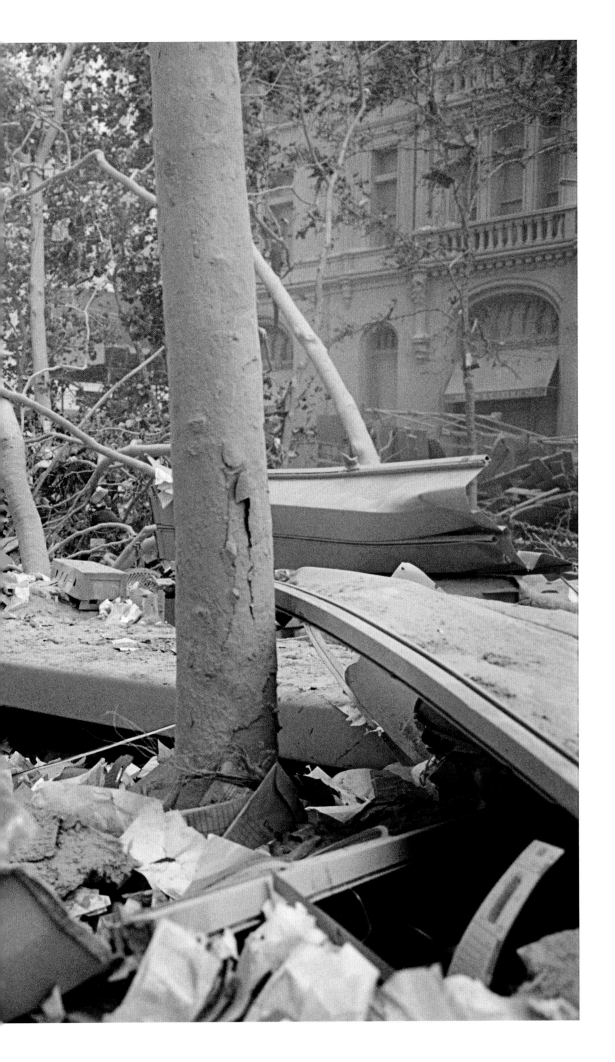

**JEFF MERMELSTEIN**

New York City, September 11, 2001. From "Windows on the World," published September 23, 2001.

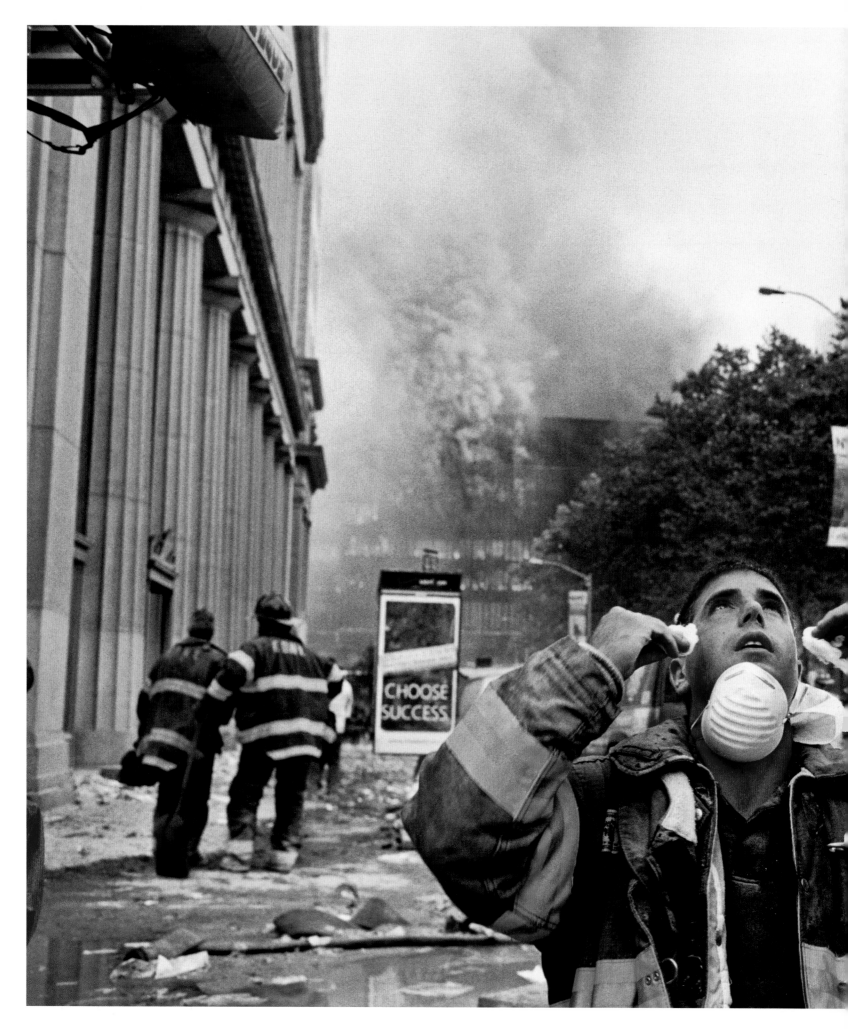

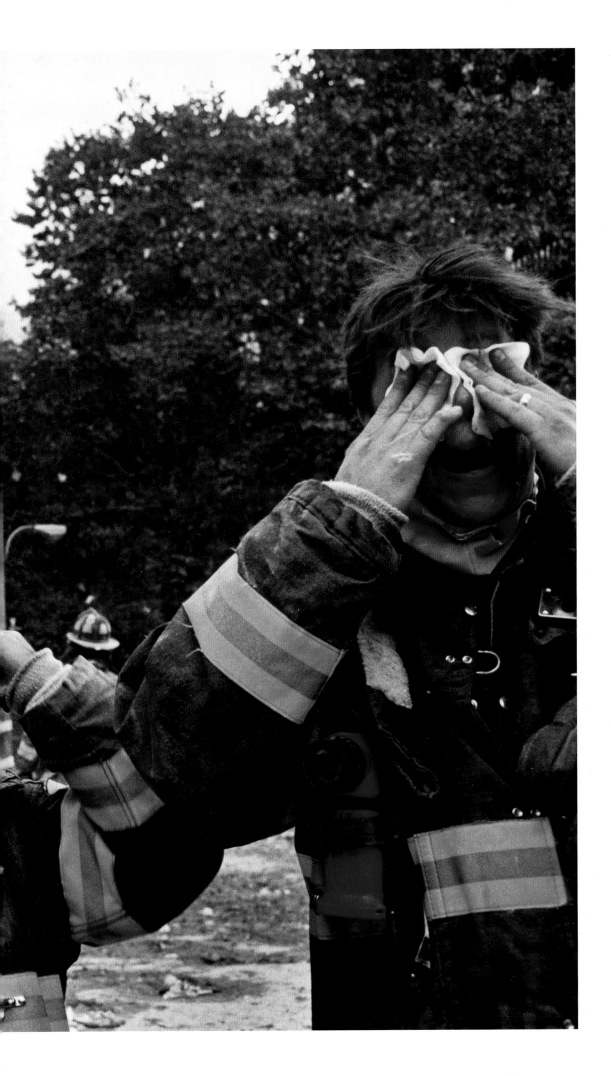

**JEFF MERMELSTEIN**

New York City, September 11, 2001. From "Windows on the World," published September 23, 2001.

I do not have a conscious memory of taking most of these pictures. I was on autopilot the day of the attack. I don't really remember finding the statue covered in debris. And I can barely recall these firefighters who are struggling to clean out their eyes. Though, looking at it now, I can remember exactly how much my own eyes burned from the smoke. —JEFF MERMELSTEIN, 2001

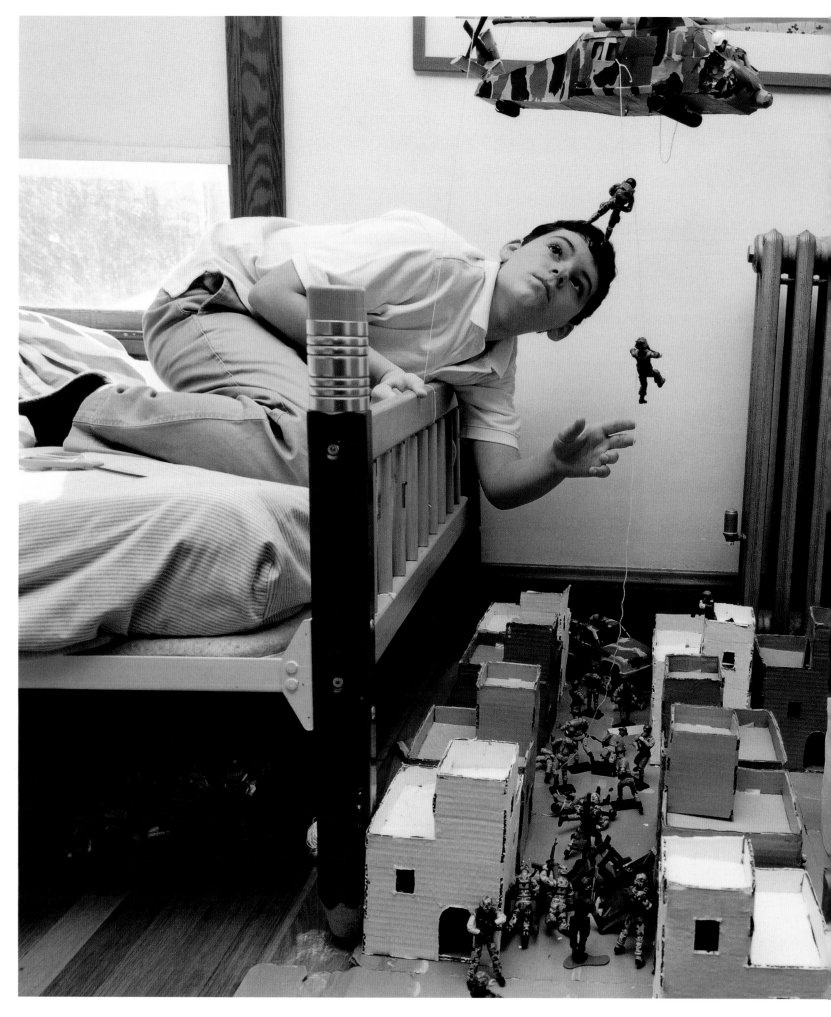

### SAGE SOHIER

Thirteen-year-old Wesley Morgan, Watertown, Massachusetts, with a homemade model of Kandahar, Afghanistan. From "What They Were Thinking," published January 13, 2002.

War has been an interest of mine since I was five or six years old. September 11 was probably the biggest life-changing event in my life—that and the war in Afghanistan. I'd read Tom Clancy novels, I'd played with G.I. Joes, but all of a sudden it was going to be a reality. From 9/11 on, my goal has been to get *out* there.

I'm graduating from Princeton this spring [2011], and I've been taking time off from school to make trips to Iraq and Afghanistan. I've been able to go out with British and U.S. military units and follow them around and take pictures and do interviews. For me it's like a dream come true.

Recently I had the opportunity to go over Afghanistan in a rescue helicopter. As we were flying over Kandahar city, I looked down and realized it looked a lot like the Kandahar of my diorama, however many years ago. Then I realized that I was flying in an AG-60 Gulf—exactly like my little model.

In 2002, when I was thirteen, I said in the *New York Times Magazine* that I wouldn't want to be one of the little people down there in Kandahar. It's kind of funny, because now, in reality, being among those little people has turned out to be my favorite thing in the world. —WESLEY MORGAN

## MASSIMO VITALI

**THIS PAGE AND OPPOSITE:** The Sagamore Hotel, Miami Beach. From "Portfolio: Water's Edge," published May 4, 2003.

My diptychs are of course two separate photographs, so clearly there is a lapse in time between the two images. For me, it is always interesting to see the images as a continuous narrative, and watch how situations have changed and people have moved from one to the other. In the Sagamore diptych, the point that most draws my attention and curiosity is the "couple" in the stairwell in the photograph on the left. Though the man and woman are on different floors, I think they are actually together. He is bare-chested (I assume he's wearing shorts), and she has a drink in her hand. A few seconds later, when the second picture was taken (the photograph on the right), there is no trace whatsoever of either the man or the woman. Where have they gone? Have they used the noise and movement of the party as a cover for a clandestine meeting? I always wonder where they went and what the backstory to their meeting could have been. —MASSIMO VITALI

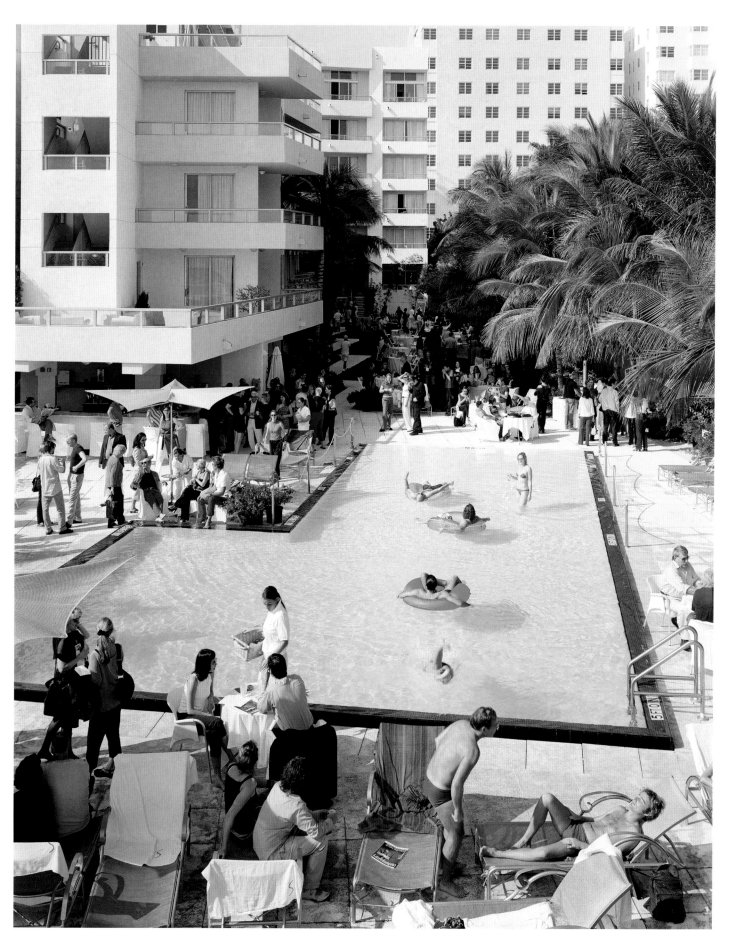

## MITCH EPSTEIN

*Dad's Briefcase,* 2000. From "Closeout," published June 8, 2003.

This picture is from my project *Family Business*, which examined my father's life and the history of my hometown, Holyoke, Massachusetts. The project questions how my father, once one of the most successful members of his community, found himself late in life confronting a major lawsuit and the liquidation of his furniture store.

My father's life symbolized that of a lot men of his generation who believed that if they simply worked hard they would do well. —MITCH EPSTEIN

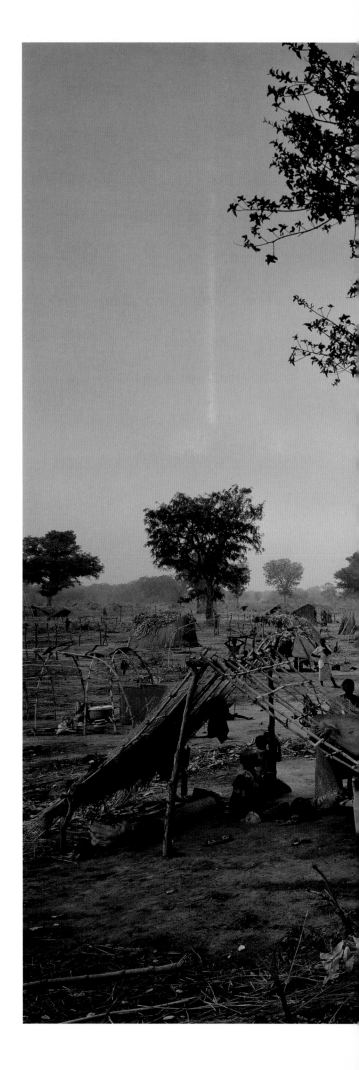

## SIMON NORFOLK

Moro Camp, Chad. From "Displaced Places: Where Refugees Try to Make a Home," published September 21, 2003.

When the war began in Iraq, I had an idea to do a photo essay on refugees who don't make it back to their homes for a long time. We sent Simon to look at a new refugee camp—this one in Chad was only weeks old. He then went to a nine-year-old camp in Chechnya, and another on the Pakistani border that was twenty years old. It was a way of reminding readers how much time refugees can spend as displaced people. —K.R.

So many photographers try to clarify things as they shoot. In my head, it's all clear. It's just drawing a picture in your imagination. If you can tell where the sun will rise/set (and you've got a bit of experience), then you can sit on a hill and "draw" how the light will look when it switches on. Putting a camera in front of that, even a big one like mine, is the easy bit.

I don't feel like I'm taking pictures, I feel like I'm just gathering them in. They're all out there. I know where they'll be; I just have to get out of bed early enough to bring them home. Like lost kittens.

The painter I connect with is Claude Lorrain. In him I see the notion that imperial history repeats; the bullish exuberance of emergence followed by an eventual, inevitable decline and fall: the price owed for all that pride. —SIMON NORFOLK

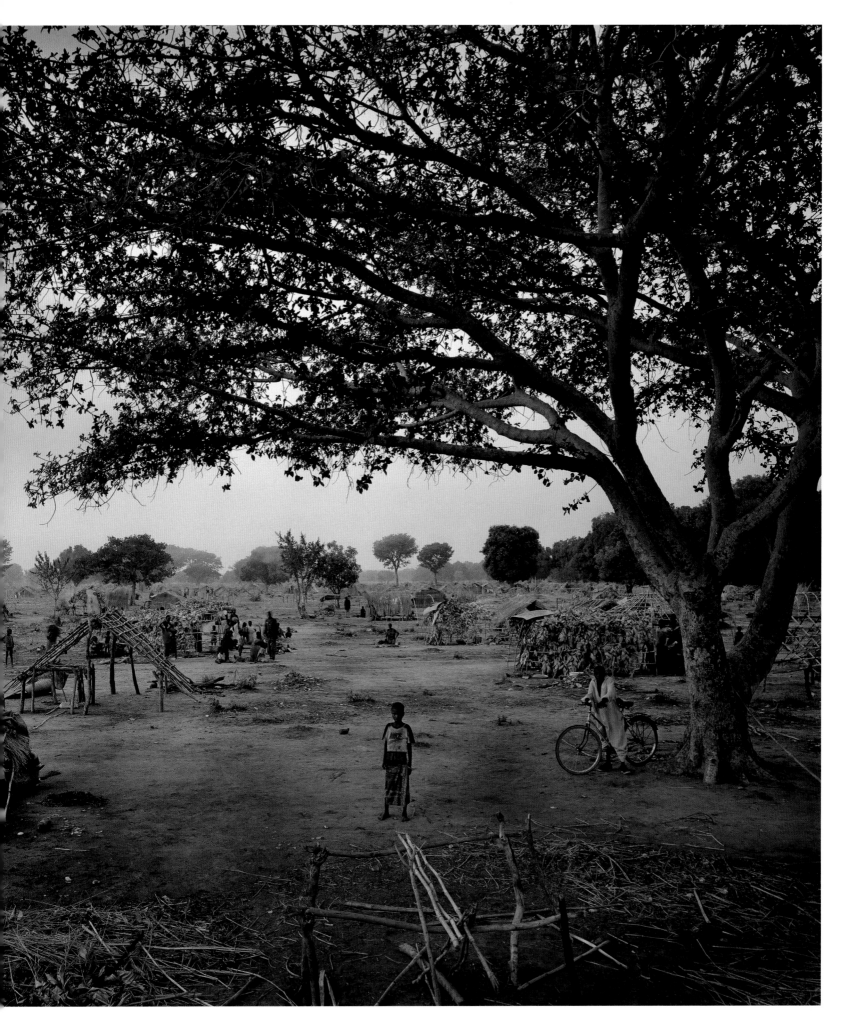

**MITCH EPSTEIN**
Cheshire, Ohio. From "Something in the Air," published February 8, 2004.

In 2003 the *Magazine* assigned me to photograph the remnants of the town of Cheshire, in the Ohio River Valley, near one of the largest coal-fired power plants in the U.S. After residents complained of contamination due to the emissions from the American Electric Power plant, the company bought nearly everybody out and simply erased the town. The Cheshire shoot laid the groundwork for my project *American Power*, which looked at our cultural relationship to energy—how we make it and use it, and its ramifications to our society and the American landscape. —MITCH EPSTEIN

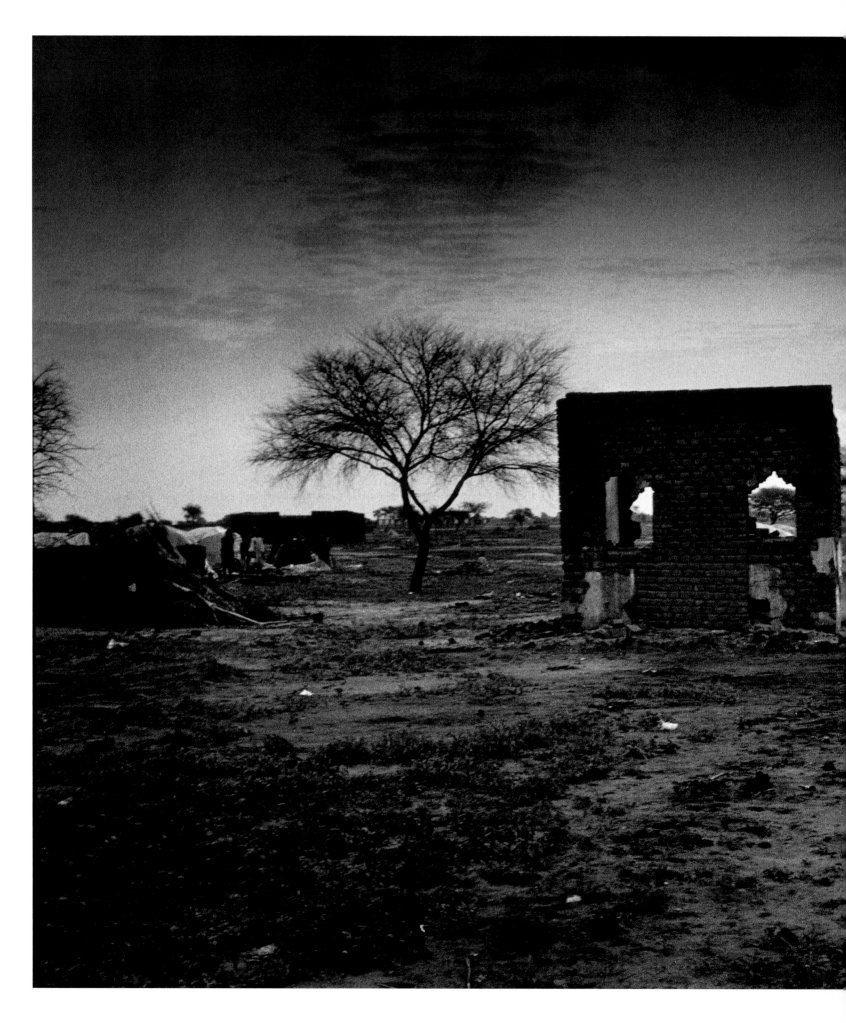

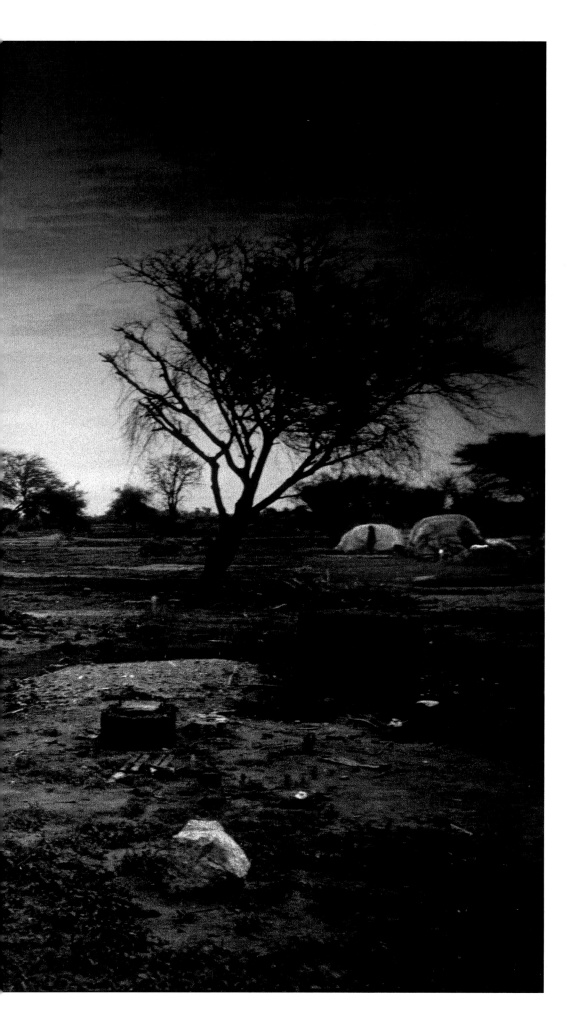

## PAOLO PELLEGRIN

The remnants of a village near Nyala in southern Darfur, from "How Did Darfur Happen?," published October 17, 2004.

It seems always to be nighttime in Paolo Pellegrin's pictures. Black is the dominant color, encroaching like whirling ash. Often his images are sooty, grainy, more akin to charcoal sketches than crisp photographic documents. The blackness bleeds in from the corners of his frames, drowning out the peripheral information so we see only the angry eyes of the wounded survivor on a stretcher in Lebanon or the deadened eyes of the man about to be blindfolded in Iraq—or here, the rubble of a village in southern Darfur.

Paolo has really left behind the tools of the detached documentarian. He has rejected sharp focus and specificity in favor of a shadowy palette. He keeps us in the dark for a reason: this is his way of pointing our attention to moments of light that emerge from the gloom. These moments are the heartbeat of his photographs. —K.R.

We walked around this village until I caught a glimpse of this presence. I was shooting film; I think I shot one frame. It sometimes happens that you just know, and that was the frame. You have a feeling that things are coinciding, and that they operate and work on a number of levels—obviously visual aesthetics, but also content and narrative in terms of the bigger picture. When document and metaphor come together. —PAOLO PELLEGRIN

**MATTHEW PILLSBURY**

The American Museum of Natural History's Rose Center for Earth and Space, New York. From "After Hours," published October 24, 2004.

The Museum of Natural History is magical at night. It's not creepy in the least: most of the lights remain on and it's beautiful seeing the spaces without the usual crowds. (Other museums in this project were actually far creepier, as I went around with only security lighting left on. The wax museum, Madame Tussaud's, was completely terrifying).

After this series for the *Magazine*, I began to focus on photographing museums around the world, including Tate Modern and the Victoria & Albert in London, and the Louvre in Paris. —MATTHEW PILLSBURY

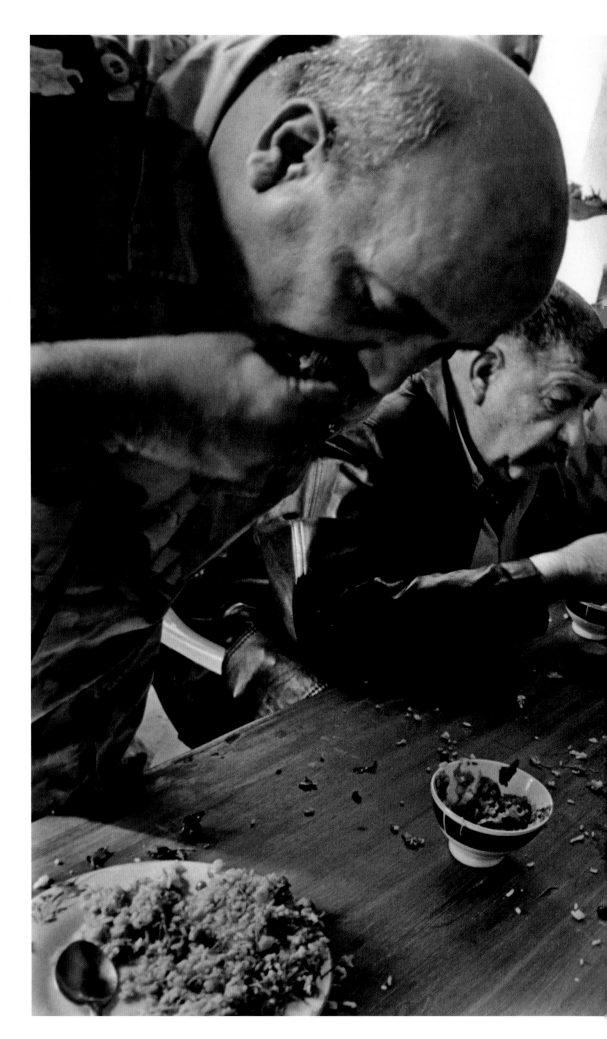

## GILLES PERESS

American adviser James Steele (second from right) and General Adnan Thabit, leader of an Iraqi counterinsurgency force (seated at left), share in a communal lunch at the general's headquarters in Samarra, Iraq. From "Is the War Getting Dirtier? The Way of the Commandoes," published May 1, 2005.

This image was made in Samarra during an operation of the newly formed Iraqi counterinsurgency force that was under the command of a man known as General Adnan. He was a mysterious and a brutish man who was attempting, in a way, to reinsert Sunnis into the political equation by trying to prove that they could help the government by reducing the insurrection in Anbar Province. He was being shadowed by U.S. Special Forces and by a man named Jim Steele, an extremely mysterious character who was on the phone every night with Washington, D.C.

So at this meal—a very traditional meal— were Adnan, his commandoes, members of the Special Forces, and Jim Steele. At times, other guests would come in to negotiate allegiance, and they too would be invited to share in the lamb.

They were all warriors—but warriors with varying levels of trust among them. With the sacrificial lamb in the middle. —GILLES PERESS

I was stunned when I saw this photograph of a warriors' feast, because it was so unlike anything I'd seen from Iraq. Peress translates the intense frenzy of the men into a great, metaphorical, very visceral image. His eyes don't miss anything. —K.R.

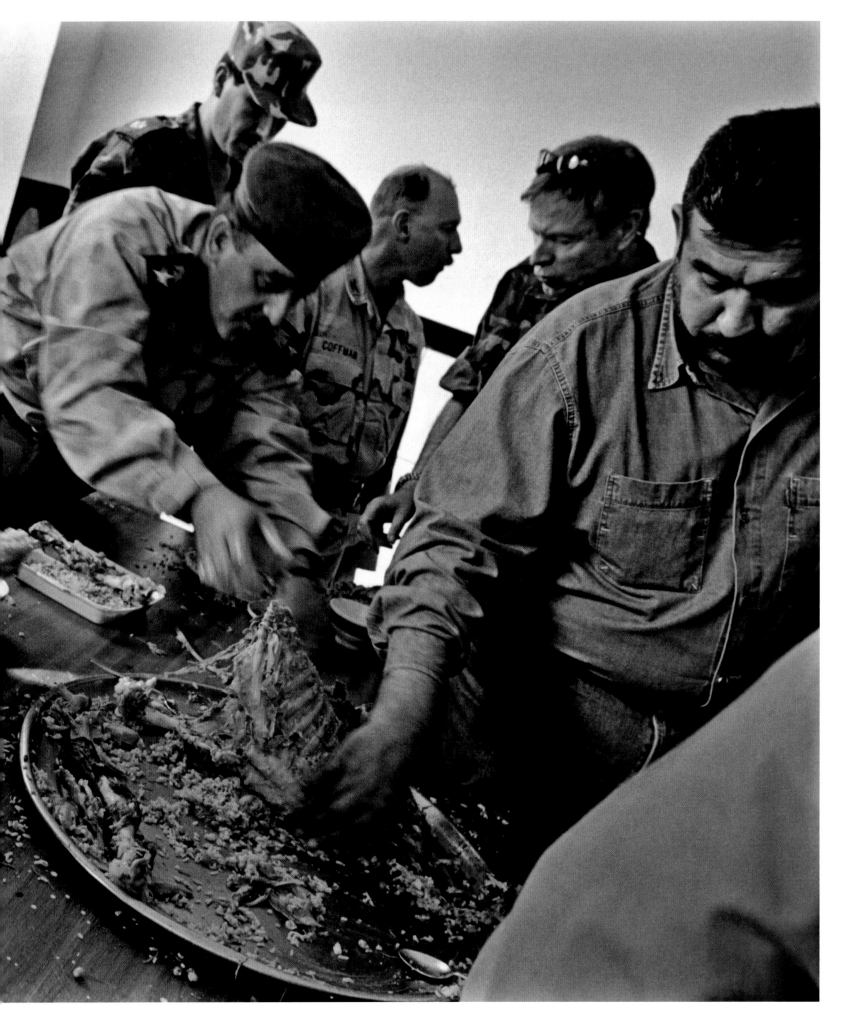

## ABELARDO MORELL

A fragment of scenery from the Metropolitan Opera's 2005 production of Charles Gounod's *Roméo et Juliette*. From "Illusions Backstage: Behind the Scenes at the Metropolitan Opera," published October 30, 2005.

We asked Abelardo Morell what he might be interested in doing for one of the *Magazine*'s "Portfolios"; he was keen to do backstages of theaters, and we ultimately chose New York's Metropolitan Opera. He was interested in the kind of surrealism that happens backstage, which is exactly what this picture shows. —K.R.

A lot of my work has to do with a kind of theatrical rearrangement of the world. So I thought, maybe theater itself could be an interesting subject: not staged theater, but what goes on in the back—the coming-together of all the props and sets. I knew it would be interesting to see the tableaux that exist behind the curtains. And I love the opera. —ABELARDO MORELL

## LYNSEY ADDARIO

In southern Darfur, Janjaweed fighters keep the village of Tama burning to prevent inhabitants from returning. From "Rings of Fire: If Not Peace, Then Justice," published April 2, 2006.

In early November of 2005 I was in southern Darfur, moving around with a group of Nigerian peacekeepers. We learned that in the village of Tama, roughly sixty people had been killed in attacks led by the government and the Janjaweed. Some residents had fled during the violence and had been unable to return to claim and bury their dead.

Over several days, we tried to approach Tama with the peacekeepers and some of the villagers. Each time we tried, shots were fired in our direction from the distance—Janjaweed were still guarding the perimeter of Tama. After a few days of this, we were driving toward the village and saw plumes of smoke in the distance. The Janjaweed had finally left, but they wanted to make certain that there was nothing left for the villagers to return to.

We pulled up, and the peacekeepers got out and walked around the village taking notes. The Tama residents we had brought with us matter-of-factly entered each hut to retrieve what little remained—clay pots, charred cooking utensils, furniture—and then loaded up trucks with their belongings.

They then calmly directed us toward the dead bodies splayed out along the outskirts of the village: people who had been trying to flee. —LYNSEY ADDARIO

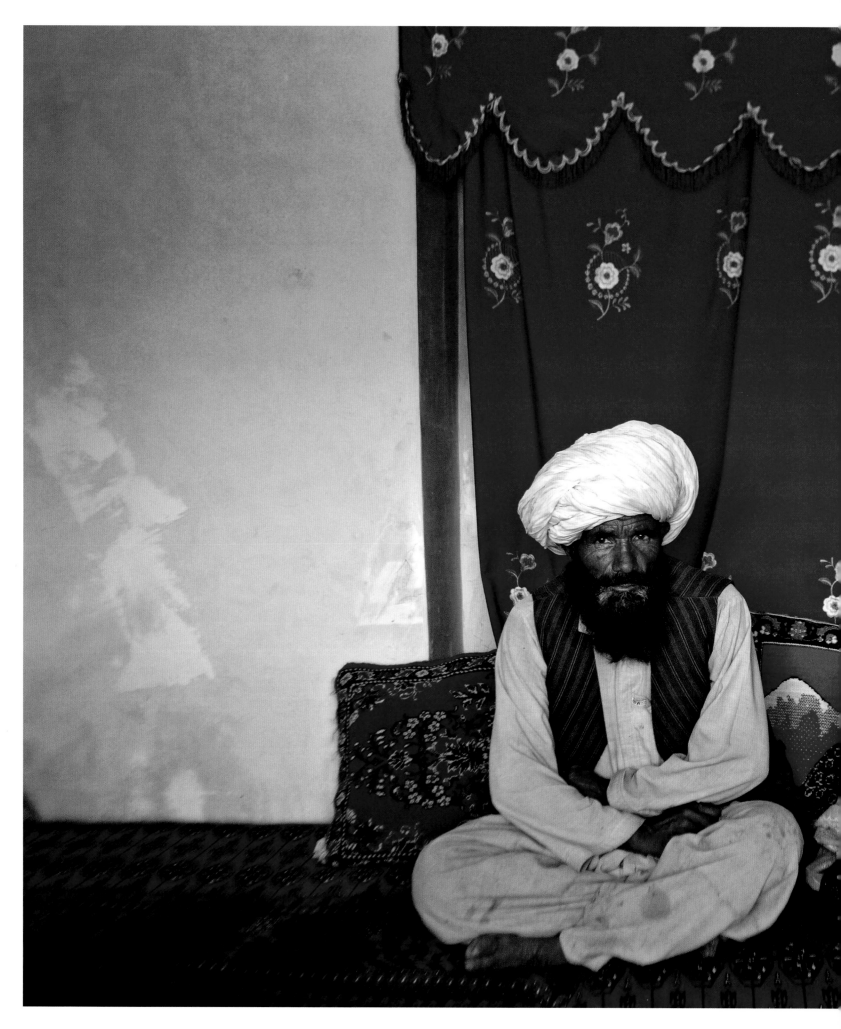

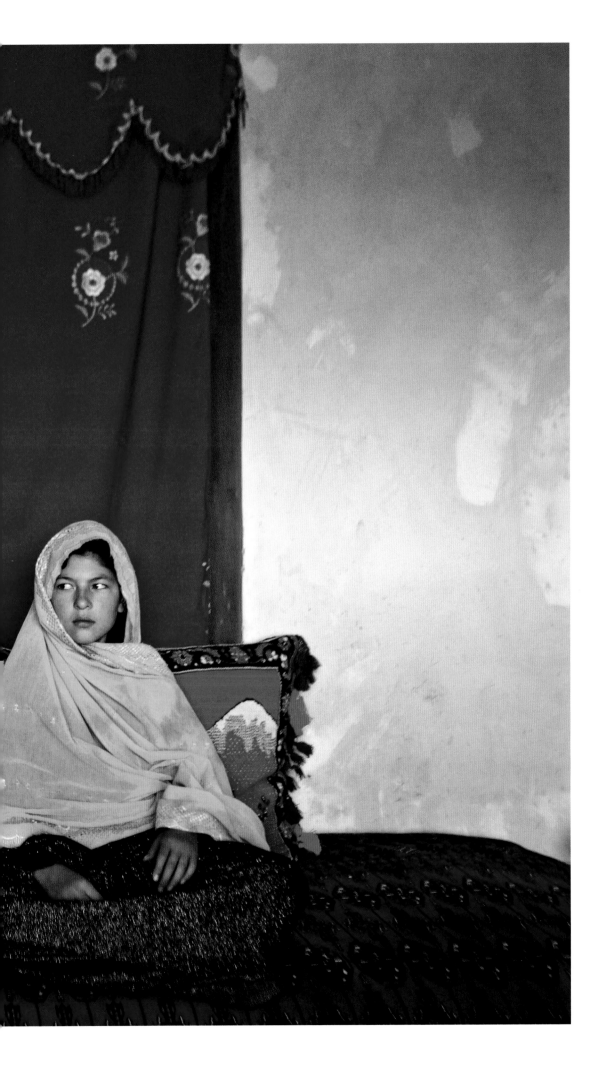

## STEPHANIE SINCLAIR

In Afghanistan, Ghulam Haider, eleven, is betrothed to Faiz Mohammed, forty. She had hoped to be a teacher but was forced to quit her classes when she became engaged. From "The Bride Price," published July 9, 2006.

Stephanie Sinclair has a clear calling with her work, and the lives and rights of women are integral to it. She came to us having begun a report on child brides in Afghanistan, and then we sent her off to continue it as an assignment. She would follow it up two years later with stories on female circumcision among Muslims, and on child brides in the Fundamentalist Church of Jesus Christ of Latter Day Saints. She has been investigating the issue of child marriage around the world for eight years now. Stephanie is a very passionate and driven photographer—and that intersects beautifully with our needs as a news magazine. —K.R.

**EUGENE RICHARDS**

A bed in an abandoned home on Highway 42 near Corinth, North Dakota. From "Not Far from Forsaken," published April 9, 2006.

The thing that makes this image of a forlorn bed in North Dakota is the dusting of snow on the mattress. It's the "discordant note." Without that snow, this would be an ordinary photograph; with it, the picture rises above the expected. Mortality becomes visible. —K.R.

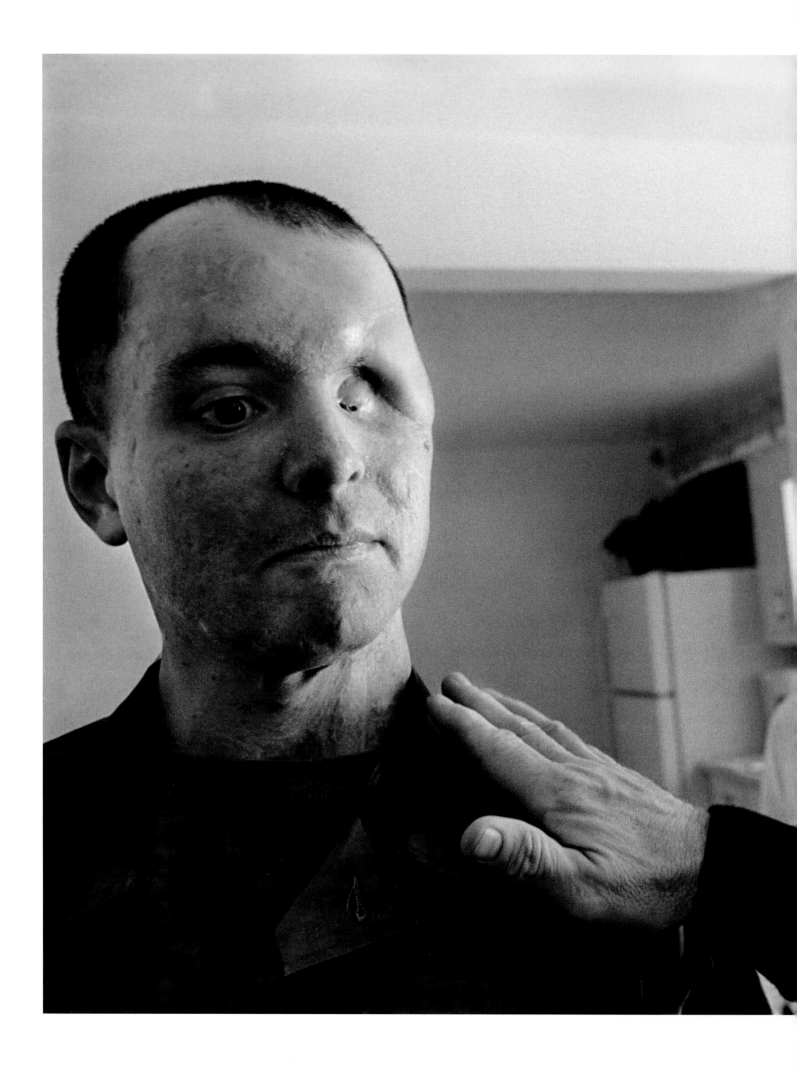

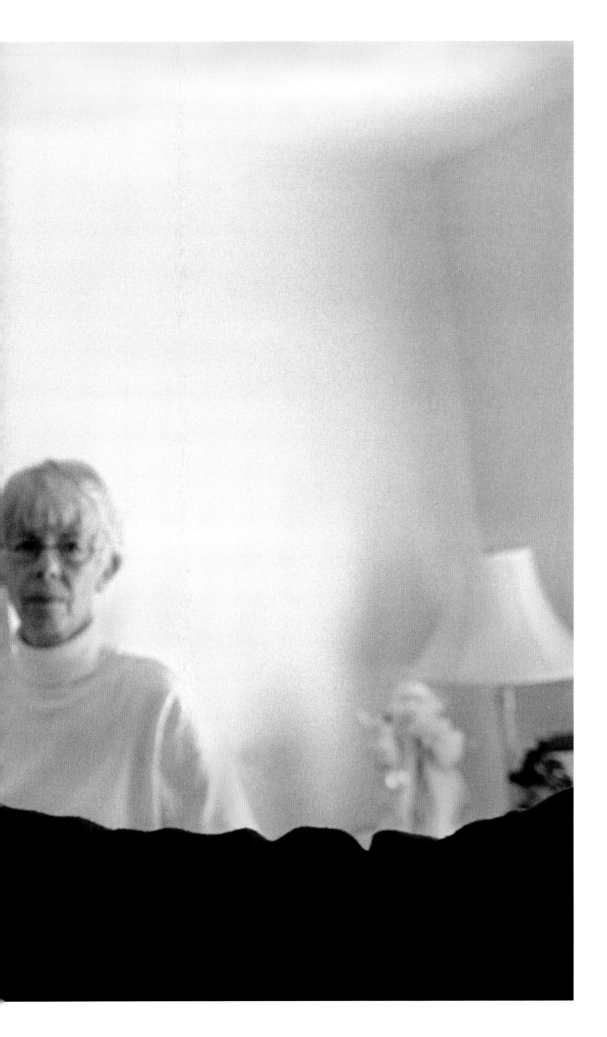

## EUGENE RICHARDS

Paul Statzer was investigating a roadside bombing in Tikrit, Iraq, when a second bomb went off nearby; he lost half of his skull along with part of his front lobe and the left side of his face. From "Bringing It All Back home," published May 28, 2006.

Eugene Richards has the ability to tell a story, or several, in one picture. This is about a soldier and his disfigurement. But it's also a family portrait of three people. Clearly the most obvious and present person is the wounded soldier, but then there is this powerful arm—his father's—reaching in, and the wife and mother looking on warily from the background. It's a moment of intersection with the three of them. A family portrait where you don't see the father's face, yet you can feel what a force he is and what an important part of this soldier's life.

The father's gesture is very ambiguous. Is he encouraging his son with a pat on the shoulder? The arm is rigid; you don't quite know what's going on.

Often in magazine photography, the object is to be *clear*, make your point known. At the same time, great photography is sometimes wonderfully ambiguous. At the *Magazine*, we sometimes talk about the "glue" that keeps readers interested. A complicated photograph, like this one, will keep the reader on the page. You can't just flip by this picture. —K.R.

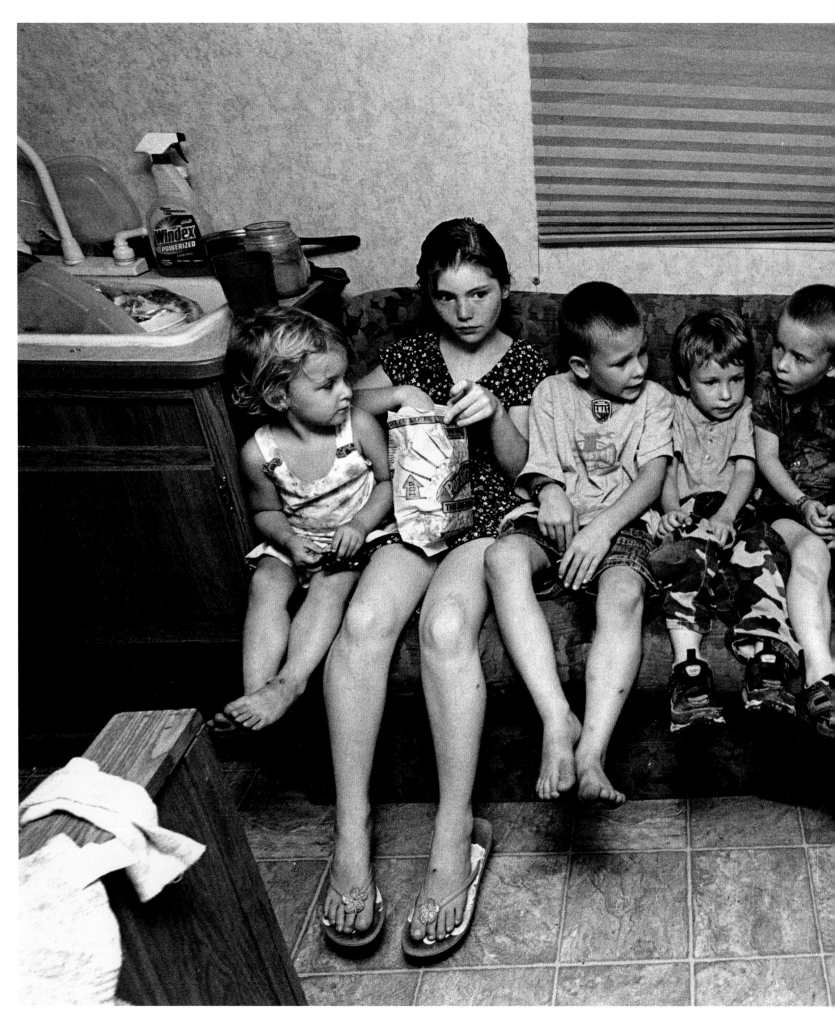

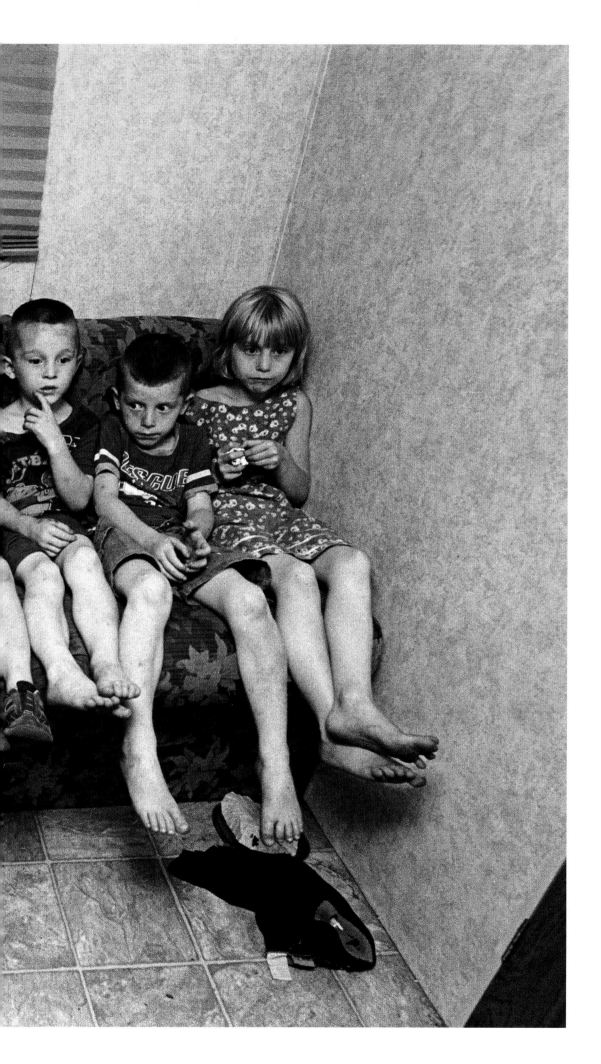

**BRENDA ANN KENNEALLY**

Michaela Ruperts (far right) and siblings and friends wait out a storm in their trailer. From "Children of the Storm: Where Hurricane Katrina, and We, Have Left the Kids," published August 27, 2006.

The Ruperts family lived in a trailer community near New Orleans called Covington. They have four children, and when I visited them they were sharing resources with another family, who had their own three children.

It was a summer day, a year after Hurricane Katrina. There was a storm coming, so everyone gathered in this trailer. It was so tight in there, I was about to leave, but something told me to stay. They ordered pizzas to be delivered in the storm—but there was no room to move, so the parents had the kids line up on this one little place where they could sit and wait for the pizza. I got three frames off, and this is the shot that did it.

These people are pretty tough. They go fishing with alligators at night; they're used to being very close to nature. These kids have never been to a mall. In a way, this is a kind of baseline childhood: childhood distilled to its most basic—or highest—common form. And these nothing moments are the *everything* moments. —BRENDA ANN KENNEALLY

## PAOLO PELLEGRIN

Following a predawn Israeli air raid, some of the residents of Tyre, Lebanon, emerge from their homes to survey the damage. From "Besieged," published September 3, 2006.

In Lebanon, Paolo Pellegrin summed up the violence and horror of the situation by making images that go beyond the immediacy of the events. Here, a group of people gingerly step through the aftermath of a bombing. There are no casualties to be seen. It is a graceful, delicate image that universalizes the tenuous emotions of the civilian population at the moment when they emerge from cover to survey the wreckage and begin reclaiming their ordinary lives. —K.R.

## SIMON NORFOLK

One section of a particle detector in the Large Hadron Collider, the world's largest and highest-energy particle accelerator. From "Where the Protons Will Play: The New Supercollider That Is Poised to Shake Up Physics," published January 14, 2007.

The circularities I was looking for weren't just formal here. When I read about the theoretical physics being studied at this lab, sometimes the ideas seemed like such advanced science, so abstruse, so attenuated, that they ceased to sound like science at all and started to resemble medieval religion—"Dark Matter," "Theories of Everything," etc. Almost as if science had carried out a complete rotation and returned to its roots in primitive hocus-pocus. The caverns being dug under Switzerland were like cathedrals; the lab technicians and theorists were like mendicants; the language of advanced physics a kind of church Latin for our times, intelligible to only the initiated. —SIMON NORFOLK

## HARF ZIMMERMANN

Swimmers in the Hudson River near the lighthouse of Saugerties, New York. From "Just Beneath the Surface," published July 8, 2007.

Harf is a person who works in a very short window of time: it's sunrise and sunset. Imagine the number of sunrises and sunsets this man has seen, because that's the light he uses for his pictures. For the swimmers story, we worked all along the river, early, early in the morning, as the sun was coming up—so he was able to get that really magical light. —KIRA POLLACK

One Tuesday summer morning I had a message on my answering machine, saying that there was an assignment for me—but I would have to be in New York by Thursday. I listened to the message again, thinking I had missed what the assignment was about, but there was nothing. Being in the city the next day wouldn't leave a chance for a callback. But after a minute of thinking, I picked up the phone, canceled everything I had scheduled for the next ten days, called my travel agent, packed my camera, took a shower—and left.

It turned out to be the nicest, most charming and unusual assignment: an eight-page summer piece on swimmers crossing the Hudson River. So I met my "models": great Americans of all ages, open-minded, ready to meet with me in the middle of the night and go into the river even before sunrise, happy to be part of the piece. —HARF ZIMMERMANN

### TODD HEISLER

Cadets entering the cadet mess at West Point's Washington Hall. From "In the Valley of the Shadow," in *The College Issue,* published September 30, 2007.

This image was published with an essay by Elizabeth Samet, a literature professor at West Point Military Academy, about teaching poetry—specifically poetry about war—to cadets who will soon be in the midst of it.

I was looking for images that captured the deep sense of tradition and history of West Point—but that also got into the minds of the cadets. This frame was culled from the hundred or so I filed by Kathy Ryan. There were dozens of dramatic images but there is something slightly different about this one. It doesn't show the drama of the battlefield, the joyful reunions, or the tragic homecomings I witnessed during the Iraq War. This is another part of war: with this image, I can't help thinking about all those soldiers who came before them and those who will come after, and how many of them will continue to shoulder the burden of our wars. —TODD HEISLER

Normally, you might expect pictures made at a military academy to be about order—rows of tables in the mess hall, cadets lined up in perfect geometry—the incredible beauty of order. Here, instead, is a wonderful picture about *disorder*.

As a photo-editor, you sometimes have to be open to the image that defies the story. —K.R.

## STEPHANIE SINCLAIR

A girl cries as she is circumcised. From "A Cutting Tradition: Inside a Female-Circumcision Ceremony for Young Muslim Girls," published January 20, 2008.

With this specific image, I was trying to capture the young girl's emotions—and to some extent my own emotions—while attending this event. I was outraged and horrified, but also felt compelled to make sure I documented the love and pride that the mothers and midwives were experiencing in this moment. —STEPHANIE SINCLAIR

Stephanie Sinclair was on a shoot for another magazine, and she heard about a ceremony of mothers and daughters in Indonesia, in which they routinely perform female circumcision. She went on her own to shoot it. When the other magazine decided not to publish the story, she brought the photographs to me, and we knew immediately we had to run it. —K.R.

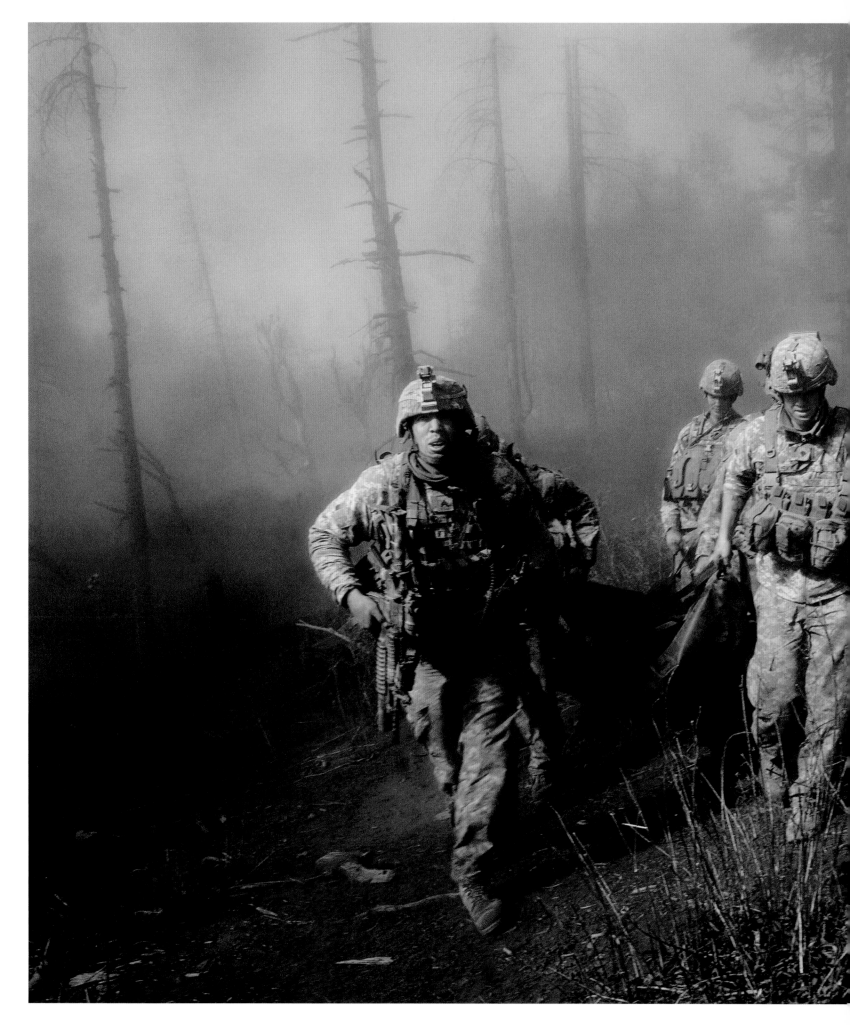

## LYNSEY ADDARIO

U.S. troops carry the body of Staff Sgt. Larry Rougle, who was killed when insurgents ambushed their squad in the Korengal Valley. From "Battle Company Is Out There," published February 24, 2008.

I had been embedded with Battle Company of the 173rd Airborne Brigade Combat Team in Kunar, Afghanistan, for close to two months, as they geared up for a battalion-wide operation to seek out the Taliban and weapons caches.

This photograph was made after the battalion was ambushed one horrible morning. Several men had been wounded in the fight. As the Medevac helicopter swooped in to pick them up, I heard one of the soldiers say: "We have to get the KIA." It hadn't dawned on me that someone had been killed. Then, through the tree stumps and dusty brush, Sgts. John Clinard and Jay Liske and two other soldiers emerged with a body bag. They were weeping as they walked, struggling to balance the physical and emotional weight of the loss of their friend, Staff Sgt. Larry Rougle—so vibrant and tough, and still alive in my brain, chatting through cigarette puffs about how he was going to propose to his girlfriend—now reduced to a black, plastic body bag. —LYNSEY ADDARIO

## STEPHANIE SINCLAIR

LeAnn Jeffs, seventeen (center), and her one-year-old daughter were removed from the Fundamentalist Church of Jesus Christ of Latter-Day Saints' Yearning for Zion Ranch after it was raided by Texas law-enforcement officers in April 2008. From "Children of God," published July 27, 2008.

Stephanie Sinclair proposed a story on child marriage in the United States. Her focus was the Fundamentalist Church of Jesus Christ of Latter-Day Saints. She spent several months researching, laying the groundwork, making inroads, getting to know the people. This was just before Texas law-enforcement officers raided the FLDS ranch in Eldorado, Texas, and removed more than four hundred children who were said to have been sexually, physically, and emotionally abused. (The children were later returned to the ranch.) Sinclair really had foresight. Eventually, through good luck and smarts, she got in, and did a definitive photo-essay on assignment for the *Magazine*. —K.R.

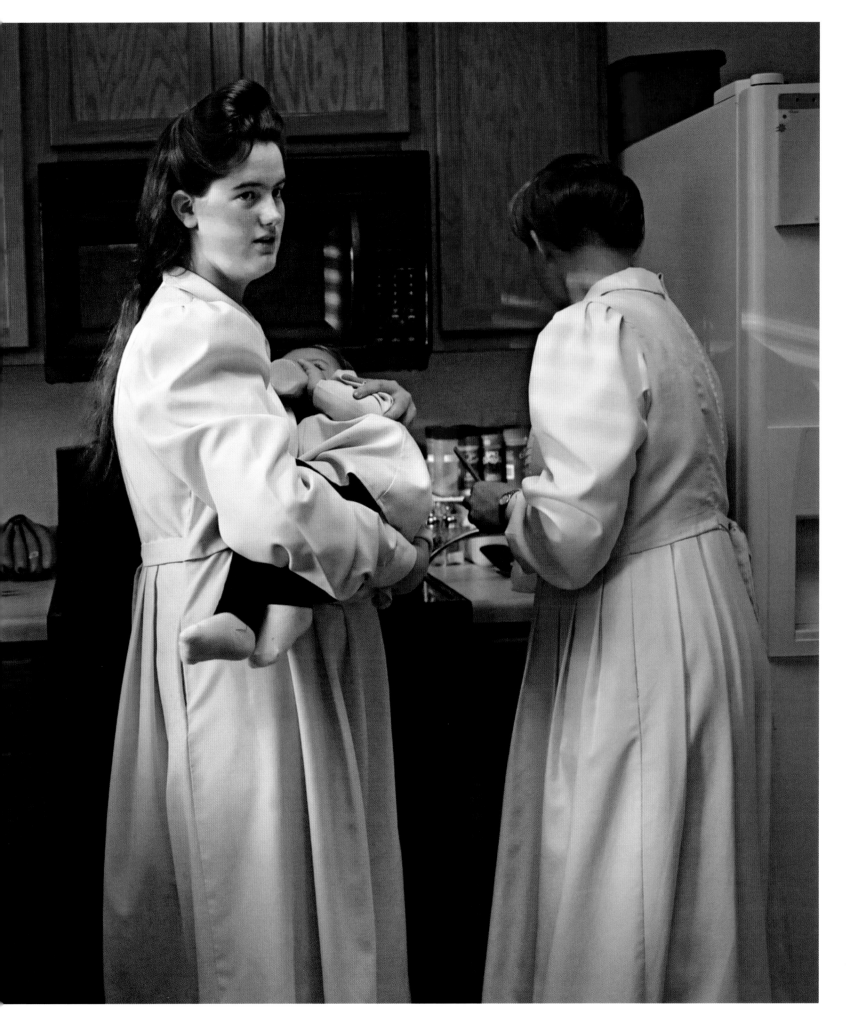

**PETER VAN AGTMAEL**

Marines on patrol en route to Mian Poshteh.
Minutes later, a bomb that was buried in the road
exploded. From "His Long War: Is It Too Late—
Politically and Militarily—for General Stanley
McChrystal to Win in Afghanistan?," published
October 18, 2009.

This is a different kind of war photograph—
a more seasoned image that will have a
different kind of impact on the war-weary
eyes of the public.

This isn't about casualties, violence, or
carnage. It's a combat picture that shows no
combat. Peter van Agtmael brings us a
step back, to reflect on the fragility and
vulnerability of the young men as they
enact the rituals of war—in this case, the
Afghan war. The image is powerful both
because it is an abstraction—these men
become toy soldiers tiptoeing across a
diorama of a battlefield—and because it is a
vivid document of the anticipatory dread
these Marines must be feeling as they step
carefully through a desert landscape that is
surely seething with danger, perhaps under
the watchful eyes of Taliban snipers. You
can feel the silence, pregnant with menace.
By pulling back and framing these heavily
armed soldiers—each weighed down by
heavy packs of gear—as tiny antlike figures
in a vast and barren landscape, van Agtmael
heightens their complete vulnerability. He is
showing us something about the terror of
combat as well as making a comment on the
futility of war. —K.R.

## ASHLEY GILBERTSON

The bedroom of the late Christopher G. Scherer, in East Northport, New York. Scherer was a Marine who was killed in 2007 at the age of twenty-one by a sniper in Iraq. From "The Shrine Down the Hall," published March 21, 2010.

Ashley Gilbertson, who had spent much time in Afghanistan and Iraq, came to us with the idea to photograph late soldiers' bedrooms. It was a heartbreaking project, because often the families keep them as shrines—they don't have the heart to take the rooms apart. And when you look at what's in those rooms, you see absolutely that many of those soldiers were just kids. —K.R.

This is about the dead. It is about *absence*, which is the hardest thing to deal with. The purpose is to present portraits of the fallen—not simply as soldiers, Marines, and airmen, but as sons, daughters, sisters, and brothers.

   This project is my attempt to provide the public with an opportunity to learn, in an apolitical and compassionate manner, about those who have died, and realize that the painful absence felt in each of these bedrooms should not be confined by the walls of the family home, but experienced as a nation. —ASHLEY GILBERTSON

## DAMON WINTER

Michelle Obama watches her husband from backstage as he speaks at the Congressional Black Caucus dinner in September 2009. From "The First Marriage," published November 1, 2009.

We had tried for several weeks to arrange some behind-the-scenes access to any event where both the president and first lady would be together. The staff agreed to let me tag along at the Congressional Black Caucus dinner. After the president took the stage, a staff member pulled out a chair so Michelle Obama could watch her husband deliver his address. It was so dark that I could barely see to focus. Although she had probably heard him speak thousands of times, she was glued to her seat and watched and listened to him from beginning to end. There is almost always an entourage of staff members surrounding both of them, but for just a few minutes, her aides left her alone with this virtual version of her husband for perhaps the first quiet moment they shared that day. Even though they weren't together physically, and I couldn't even see the first lady's face, the connection between them was palpable and real. That little moment was a rare, quiet glimpse into their hectic lives, and was perhaps the most telling image I made during that entire project. —DAMON WINTER

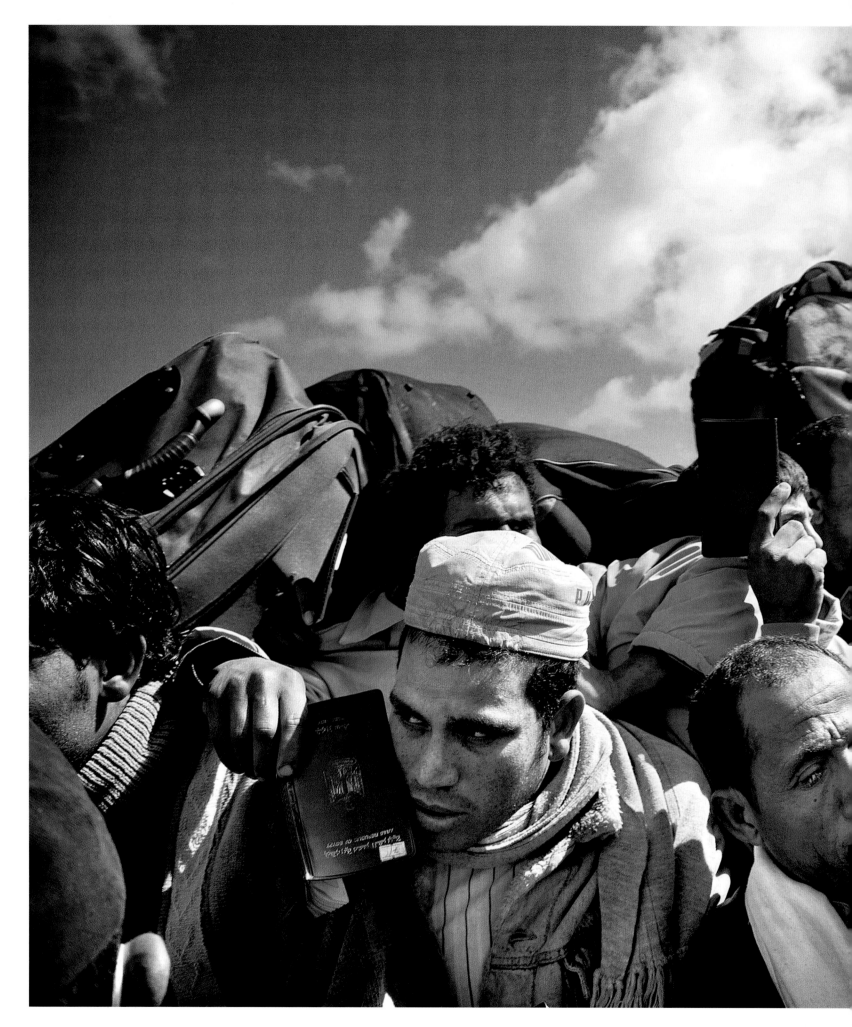

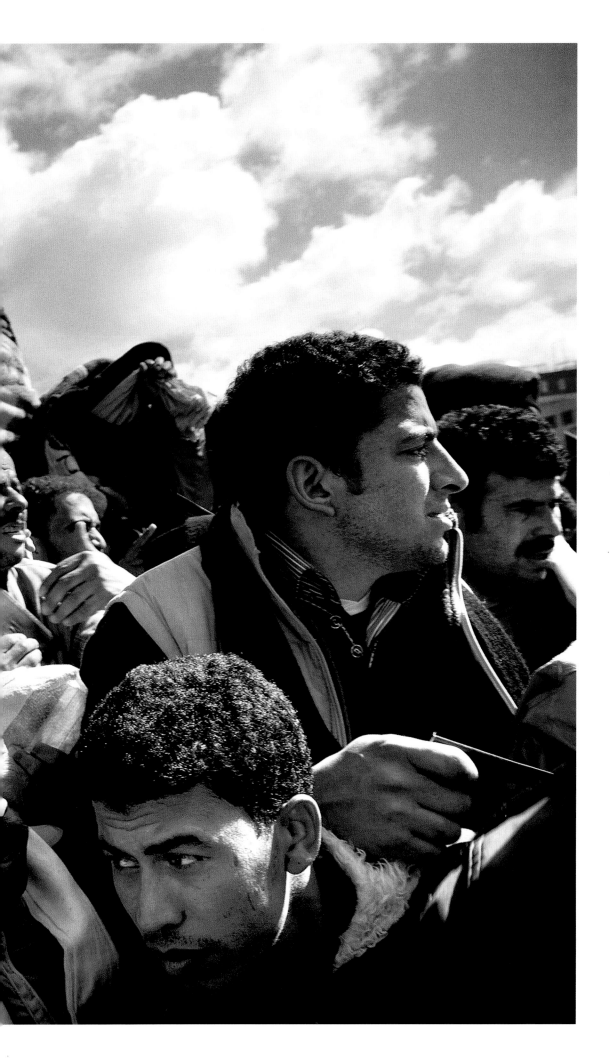

## PAOLO PELLEGRIN

The displaced. From "Scenes from the Libyan Exodus," published March 13, 2011.

Paolo's photograph of the rush of immigrant workers to leave Libya demonstrates the power—and the necessity—of documentary picture-making. There is so much news coming at us today from all over the world, and it can be difficult to keep our minds focused on the actual human beings who are involved, whose lives are at stake. Paolo helps us do that. This picture, like so many of his, enables us to cut out the noise and start to comprehend what's happening to real people in real places. It triggers the empathic response that is the core of our humanity. It is journalism at its finest, and it is beautiful. —HUGO LINDGREN

# photo-illustration

WHEN A COMPLEX CONCEPT is to be represented photographically in the *New York Times Magazine*, the editors must decide what visual mode best serves the need. Sometimes, the answer is photo-illustration: images that are devised, commissioned, and carried out specifically to convey an essential idea. These illustrations frequently end up on the *Magazine*'s cover, where the responsibility of the image is particularly crucial: its message must be crystal clear and so gripping as to stop readers in their tracks and induce them to open the publication to find out more.

Photo-illustrations are among the most collaborative elements of the *Magazine*. With cover images in particular, the editor-in-chief initiates the conversation by indicating what is wanted and what the cover needs to achieve. This is often followed by a vigorous brainstorming process, led by the art director, among members of the photography, editorial, and art departments. Once the parameters of the illustration are decided, the concept is discussed with the designated photographer. Many of these artists will take the kernel of an idea and run with it, formulating their own visual conceit, which is then sent to the *Magazine* for consideration. Or an idea may be fleshed out in the *Magazine*'s offices and the photographer's job is to implement that fully formed concept as persuasively as possible.

Certain photographers are adept at conveying a message in a striking way via the simplest of means: sometimes a single prop or element, photographed to perfection—a plate on a table, a red balloon shaped like an elephant—is all that's needed. Other images could not be made without a vast and complex technical setup, teams of workers, and a full cast of models or performers. The resulting image may be a total fantasy or a subtle heightening of reality (sometimes, indeed, so subtle that the *Magazine* receives letters from readers who have plainly mistaken the illustrations for photographs of reality).

There are those photographers who prefer to have only a cursory read of the text that will run with their images. (As Erwin Olaf puts it: "Sometimes, the more information you have, the more you get confused with your idea. . . . [The photograph] is just *bang*: you have to be able to read it in one second.") There are others, though, who pore over the article to be illustrated at length and study the subject deeply before beginning their work. The process may be clean, immediate, and quickly finished, or hashed out at length, with everyone—the editor-in-chief, photo-editors, art directors, stylists, photographer—going back to the drawing board repeatedly before the *Magazine*'s editor-in-chief gives the final nod to the image. No matter what route it takes to the published page, however, the message of the photo-illustration must always be cogent, strong, and immediately decipherable to the reader.

**DAVID HOCKNEY**
The Brooklyn Bridge. Photographic composite. From
"The Great Bridge and the American Imagination,"
published March 27, 1983 (cover image).

**CINDY SHERMAN**

Mrs. Claus. Outtake from a commissioned piece published December 23, 1990.

For this issue, Cindy Sherman conceived Mrs. Santa Claus, exhausted the day after Christmas. Sherman says she has always responded to the visual paraphernalia of Christmas: holiday plates, cookies, ornaments, and "the mystery of the wrapped package." —K.R.

## TOM SCHIERLITZ

An Aedes aegypti mosquito killed on a full stomach. From "Splat: The Life of Mosquitoes Is Short and Brutal," published August 24, 1997.

The *Magazine* was doing a story about dengue and yellow fever. First they sent me to shoot at a mosquito-research lab, and then to a golf course in a marshy area of Long Island, where people were spraying pesticides with helicopters and sampling the water puddles to see if there was larvae. It was all documentary work.

And then I had an idea: wouldn't it be great to make a crisp *still life* of a mosquito? So we had the National Institutes of Health FedEx boxes of live mosquitos to me—a box every couple of days. There was a whole routine: first you make them bite you, then you put them in the freezer to knock them out, and then you shake them out and photograph them. Everybody in my studio hated me, because everyone got bit at some point by a mosquito. But the ones that were photographed all bit *me*—that's my blood you're looking at.

Funny thing is, because of these photographs, if any magazine in New York wants to show something that's gnarly, gross, slimy, and they need it big and glamorous, it ends up in my studio, most likely. I now have a reputation for taking very strange things and making them look sexy and appetizing. —TOM SCHIERLITZ

## TOM SCHIERLITZ

Goat fetus developing in an artificial uterus. From "Baby in a Box," published May 16, 1999.

This was for a story about a professor of gynecology at Tokyo University who was doing experiments to develop an artificial womb for super-premature babies. I basically went to Tokyo for a single picture, and I had to do some serious negotiating to get it. —TOM SCHIERLITZ

OPPOSITE:
## ANDRES SERRANO

From "Power Suffering: The Lives of the Mystic Saints Offer a Cruel Lesson in Success—And It Still Works Today," published May 16, 1999.

We were running a story about St. Catherine and the dichotomy of power and suffering, and paralleling that with contemporary women. So the thinking was: who better to stitch those two things together than the creator of *Piss Christ*? —JODY QUON

## JOEL-PETER WITKIN

From "The Plague Years: Decimation via the Black Death and AIDS," published September 19, 1999.

In 1999 six *Millennium* issues were produced, each with a theme that marked both a sense of history and the viewpoint of this particular moment in the culture. The fifth of these issues was called "New Eyes"—the story of the millennium re-imagined through the visions of living artists. We selected twenty-two artists and gave them each a milestone moment in the millennium to consider. For Joel-Peter Witkin it was "The Plague Years: Decimation via the Black Death and AIDS." His powerful image juxtaposes the bones of an actual fourteenth-century plague victim with a living sufferer from AIDS, a reminder that the deadly threat remains. —JANET FROELICH

## DOUG AND MIKE STARN

From "Great Leap Forward," published
September 19, 1999.

For the *Magazine*'s issue devoted to
the most important events of the past
millennium, we were asked to choose
from several historical moments
that led to the millennium's defining
characteristics. For our piece, we chose
Marco Polo and the Silk Road. On the
Chinese scroll (which is growing into
the page of the European illuminated
manuscript) is a painted tree limb; it
becomes the Silk Road along which
the Chinese technology comes to
Europe. We chose this as it speaks of
an interconnected world and the transfer
of knowledge and interdependence.
—DOUG AND MIKE STARN

**MIKAKO KOYAMA**

From "Self-Inflicted Wounds: How the Red Cross Came Apart," published December 23, 2001 (cover image).

For this image, I sketched the idea for a cross made of gauze and dipped in red ink. It was a powerful, simple cover idea, but it needed a soft emotionality in order to be effective. Deputy picture-editor Jody Quon showed me the work of Mikako Koyama. There was a vulnerability and translucency about her still-life imagery that suited the project. Prop-stylist Megan Caponetto brought us dozens of gauzes, dipping each in red ink, to extract the perfect weave. Megan's hands were stained red from this exercise. —JANET FROELICH

### THOMAS HANNICH

From "I'd Like to Buy the World a Shelf-Stable Children's Lactic Drink: Coca-Cola Confronts a Global Marketplace That Has Lost Its Thirst for Bubbly Brown Sugar Water," published March 10, 2002.

This shot was one of the most improvised ones I have ever made. It was done in a friend's tiny apartment in Brooklyn. The setup was in the kitchen, and the camera was in the living room. I had to wait until dark to do the final exposure, as I couldn't black out the space properly—very exciting stuff for a still-life photographer! —THOMAS HANNICH

**LENDON FLANAGAN**

From "What If Fat Doesn't Make You Fat?," published July 7, 2002 (cover image).

OPPOSITE:
**DAVID LaCHAPELLE**

From "The Pursuit of Ecstasy: Reflection on the Lure of a Potent Little Pill," published January 21, 2001 (cover image).

**FRED R. CONRAD** CONCEIVED BY PAUL MYODA AND JULIAN LaVERDIERE

*Phantom Towers.* Photo-collage by *The New York Times.* From "Remains of the Day," published September 23, 2001 (cover image).

It's an emotional response more than anything. Those towers are like ghost limbs, we can feel them even though they're not there anymore. —JULIAN LAVERDIERE, 2001

Amazingly, nearly everyone on the staff made it into the office the morning of 9/11, and we watched on the television as the second Tower fell. I remember the instant I went from being a horrified citizen to being a journalist and thought: "This is not just an awful event, it's an historical awful event." Within an instant, everyone in the room realized we would have to throw the issue we'd been working on away and do something else, which we hoped would be meaningful.

We mobilized immediately. The photo-department sent a battery of photographers out and located others who were already in the field, and brought in pictures as quickly as possible. Several walls at the office were plastered with extraordinary photographs; the dissonance of the horror and the art and beauty of those images was inescapable, because the pictures were taped up everywhere you looked. Putting the issue together was terribly moving. And it was one of the most exhilarating journalistic experiences I've ever had.

We made room inside the *Magazine* for every picture we possibly could, and yet we didn't have a cover that seemed like it would last. I remember exactly the moment when I saw it. I came through the office, and Janet Froelich said: "Come here. Now." She showed me what they were working on. It was one of those consensus moments: we saw the Towers as cover of the *Magazine* and we also saw them as something that had to be made real—not just as a picture, but as a fact. —ADAM MOSS

On the morning of 9/11, those of us who were able to get in to the *Times* office gathered to assess the *Magazine*'s ability to respond to the extraordinary events unfolding around us. Adam Moss, the editor of the magazine, asked us to consider what readers would want to see in the *Magazine*, especially on the cover, two weeks after the 11th, when our issue would come out. We had to try to envision, in the rawness of the experience, what people would want to think about and know about two weeks later.

Adam suggested I ask architects and artists to conceive of a memorial—but most people I spoke with were too stunned to even consider it. Then I called Anne Pasternak, the head of [the public-arts organization] Creative Time, who told me about a group of artists who had studios on the ninety-first floor of the North Tower. Two of them, Julian LaVerdiere and Paul Myoda, had been working with ideas reflecting their experience in the Towers. I met with them, and as we reviewed their ideas they quickly conceived of a design in which the Towers could be memorialized by shining two beams up into the heavens from the spot where the Towers had been destroyed.

It was a stunning concept—but we still had to make it work visually. We began looking at images of Lower Manhattan—at sunset, at sunrise, in daylight and evening, and tried to incorporate beams of light into them, but nothing felt real. Then I saw a shot by Fred Conrad, taken from a barge in the Hudson, looking toward the city, showing all of Lower Manhattan—one of the first landscapes to be made of Lower Manhattan after the Towers were gone. It was an early-evening view, with a white beam of light running horizontally through the empty space where the buildings had been. It dawned on me that we could transform that eerie, horizontal beam of light into vertical beams using Photoshop.

We spent most of a night working on this, trying to retain the haunting beauty of Fred's picture while forcing those beams to move vertically through the sky. Adam came to visit us at midnight (there was no sense of day or night that week, you just kept working), took one look at it, and said: "You've got it." The image ran on the *Magazine*'s cover on September 23.

A couple of weeks later, Anne Pasternak and the Municipal Art Society and others began talking about making the project into a real memorial. A year later, those beams were in the sky—actual beams. [Since 2002, each year on the anniversary of September 11, New Yorkers have seen the *Tribute in Light:* twin beams of light shining into the sky from near Ground Zero.] It's thrilling to think about how that whole idea came to pass in such an incredibly condensed period of time. —JANET FROELICH

### RODNEY SMITH

*Superslow Exercise.* From *The Year in Ideas* issue, published December 9, 2001.

The notion of the *Year in Ideas* issues was to chronicle the most innovative concepts, inventions, and ideas of the year, in the form of a kind of encyclopedia: with a hundred or so items arranged alphabetically. I saw it as an illustrated compendium, using images the way they were used at the turn of the last century: each literally illustrating the concept, illuminating its ideas.

Rodney Smith was just right for this. His work wrestles with big ideas in a traditional way, and although he deals with classical motifs and values, there is an enormous irony and humor in his images that make them very contemporary, as well as a beauty that comes from his deep understanding of classical proportion and restraint.

Rodney works with a team—almost like an improv troupe—of stylists, models, and prop makers who contribute ideas and substance to each image. We chose a location, a lovely old seminary in New York that has an almost untouched nineteenth-century gymnasium. Rodney transformed the space using a fog machine and the surreal, outsized props developed by his team. —JANET FROELICH

### OPPOSITE:
### ZACHARY SCOTT (WITH CHRISTOPH NIEMANN, NICHOLAS BLECHMAN, AND BRIAN REA)

*Blackboard Jungle.* From *The Year In Ideas* issue, published December 12, 2004 (cover image).

This was a collaborative effort between the *Magazine* and four artists, three illustrators, and one photographer.

I'm not sure why this cover went viral the way it did, but I'm still seeing advertisements that are too close for comfort. Even a popular burger joint in New York took notice and put two large chalkboards in the dining room that are almost exact duplicates of our cover. I recently had lunch there with Christoph, and he was able to pick out the similarities one by one. —AREM DUPLESSIS

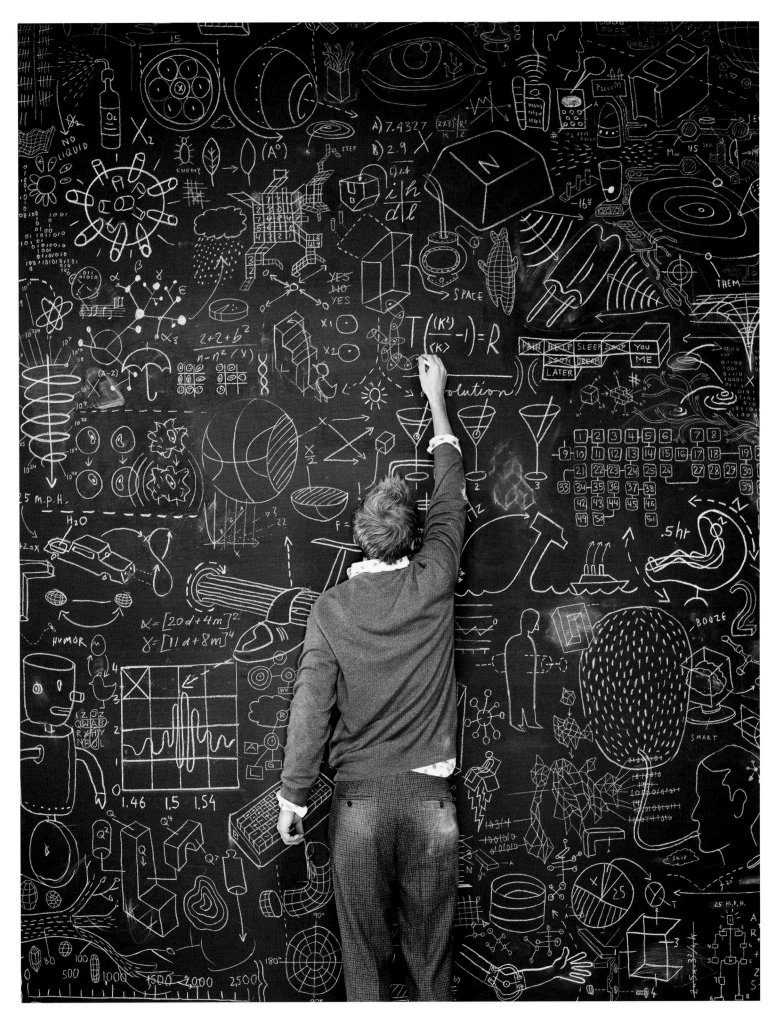

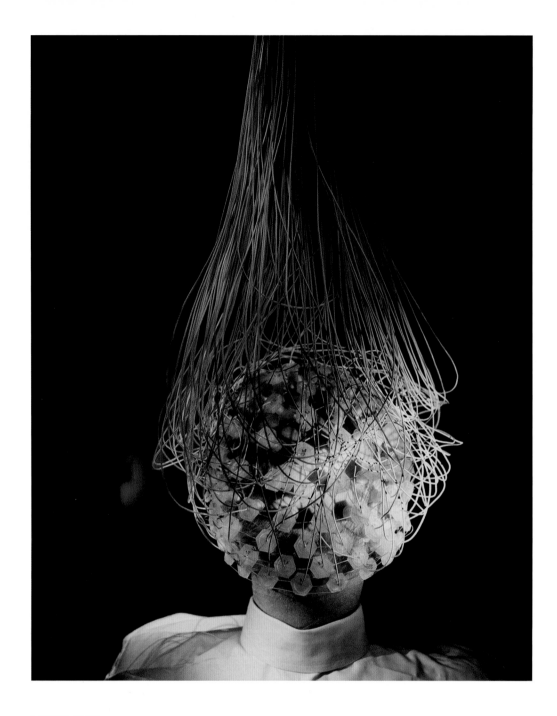

**LARRY FINK**
With this special electrode-studded cap, scientists hope to someday be able to zero in on a "lie zone" in the brain. From "The New Science of Lying," published February 5, 2006 (cover image).

OPPOSITE:
**ANDRES SERRANO** BACKDROP PAINTING BY IRINA MOVMYGA
From "What We Don't Talk About When We Talk About Torture," published June 12, 2005 (cover image).

Just after the Abu Ghraib images came out and were fixed in the public mind, the *Magazine* had the idea to do a story about whether torture is ever justifiable. We wanted to show vignettes about torture and to create them in extremely stylized studio pictures. But sometimes, even in something fictional, it is stronger if you start from a real place. For this shoot, we went so far as to ship in the actual hoods and handcuffs that were used in interrogations of prisoners in Iraq. I asked Serrano to create the images for us, and this one ran on the cover of the *Magazine*. Interestingly, we heard back from some readers who were upset, thinking that these were real scenes of torture. —K.R.

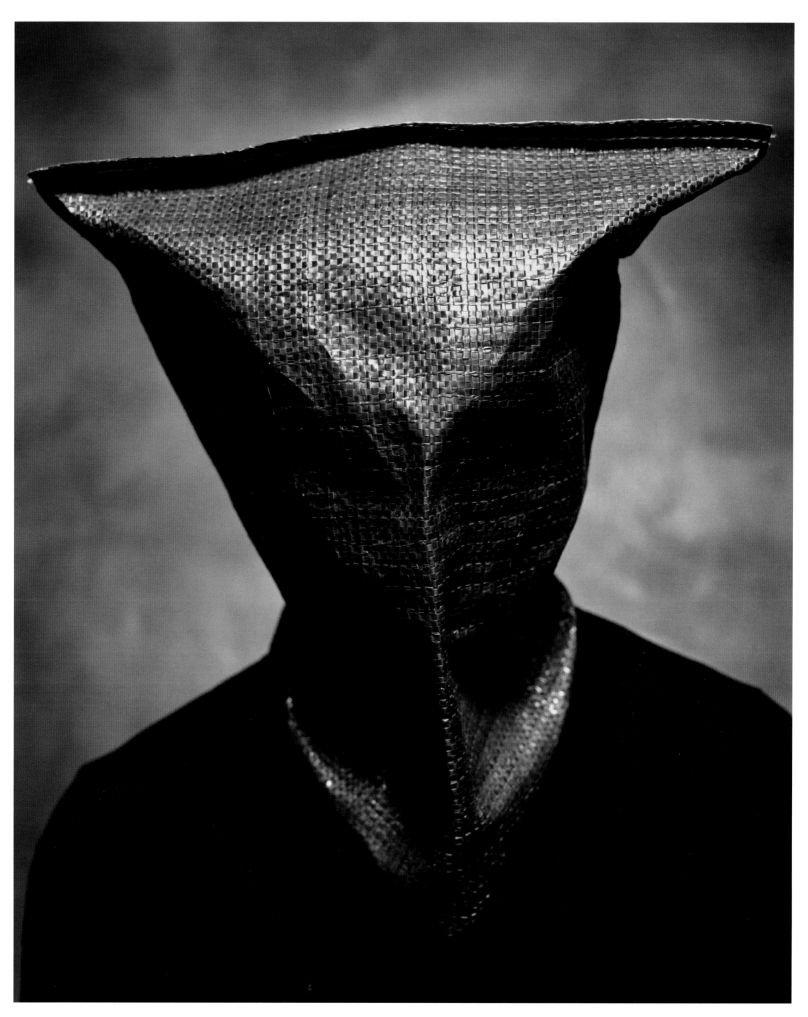

**ERWIN OLAF**

From "You Think I'm a Smart Ass?: The Animal Self." Photo-montage (postproduction by Magic Group NL), published January 22, 2006.

For the *Magazine*'s story on animal emotions, we had the people posing make various emotional expressions for us, so we could look at them when we were photographing the faces of the animals and then manipulate the images to convey the human moods in their faces. So I said to the girl that was playing the part of the lamb's body: "Can you look like you've just lost your lover?" Later, when we photographed the actual lamb, we used her expression and imitated it in the lamb's face. The boy who played a donkey did a very nice expression with his mouth, which we "drew" in Photoshop on the mouth of the donkey. Within the fairy tale, it had to be as real as possible—so I paid attention to the littlest details: the hair on the collar, and so on. That is my philosophy: the tiniest things have the biggest impact. —ERWIN OLAF

This was the first time I assigned Erwin to do a piece for the *Magazine*. It's very exciting to have a "first date" with a photographer—you don't know how the dynamic will work. Our deadline was impossibly tight, but within days he had created these wild pictures. —K.R.

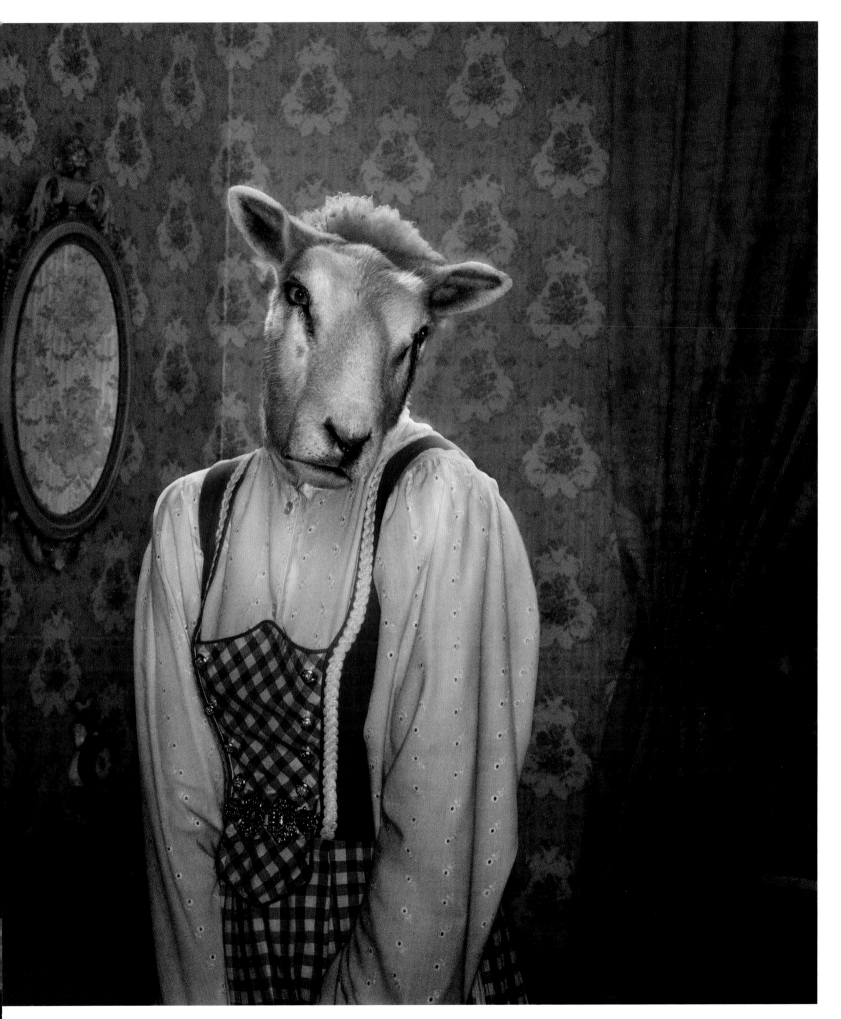

## ANDREW BETTLES

**THIS PAGE AND OPPOSITE:** "Before" and "After" images, from "Fill 'Er Up!: The Latest Wrinkle in Face Lifts," published April 30, 2006.

I remember these balloons very clearly. Occasionally, you get asked to do things you think are straightforward and simple, but when you sit down and actually try to *do* them, it's tricky. To get the wrinkled balloon, we figured out we had to make the air inside the balloon very cold. So we put several inflated balloons in the freezer and kept them there for half an hour or so, after which they looked absolutely fantastic—for about twenty seconds—and then the air inside warmed up and expanded. So we had a dozen balloons slowly warming up and then slowly chilling down. It was tricky.

    The joy of doing some jobs is figuring it out. It's a combination of art and science, and problem-solving, and banging heads against walls, and walking around the street asking people . . . and then it's trial and error, basically. —ANDREW BETTLES

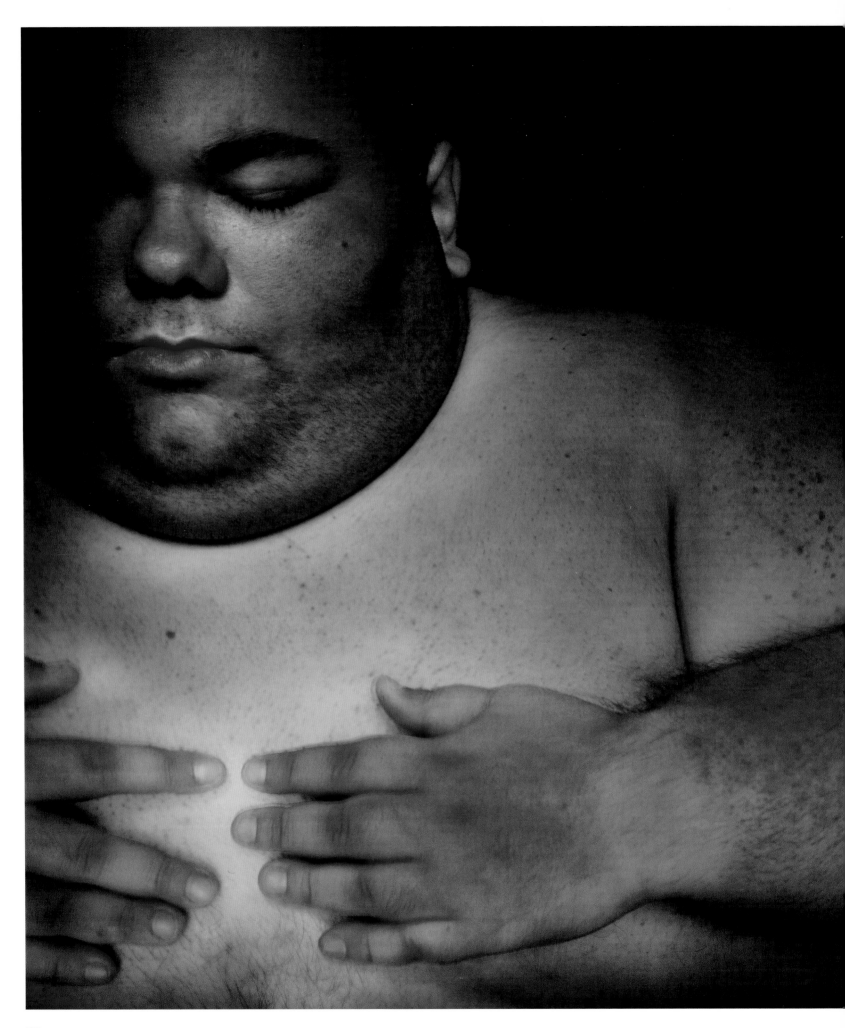

## GARY SCHNEIDER

From "The Fat Virus," published August 13, 2006.

Omar wanted to be an actor. But when he arrived, and realized he was going to be exposed—not entirely naked, only his chest—he started panicking. To put him at ease, I said to him: "Omar, why don't you have lunch, take the limousine, go home, and I'll just tell the *Magazine* that I screwed up?" His response was extraordinary: "I want to be professional. I really want to have this career."

But he was so overwhelmed that after I lay him down, he literally fell asleep . . . I think from anxiety. He slept through the entire shoot. This was the first frame I shot. He was on the floor, and the camera was directly above him.

The lights are out. I crouch around the subject in the dark, and the lens of the camera is open. I have a small flashlight, and I explore the details of my subject with it; literally, the entire surface. And it takes an enormously long time. This portrait of Omar would have taken maybe an hour to set up, and to actually expose, possibly another hour and a half. He wasn't completely motionless: his hands were overlapping each other at first, and as he relaxed, his hands came apart. And that made the picture.

When I'm done, I close the shutter of the camera and tell the subject I'm done, and then we kind of have this relieved giggle together. Then I turn the lights on.

And then we go on to the second frame. —GARY SCHNEIDER

## HORACIO SALINAS

From "Do You Want to Know a Secret?: Washington's Corrupt but Crucial Black Market in Information," published March 25, 2007.

There are certain still-life photographers, like Horacio Salinas, who are great thinkers. You go to them and ask them to come up with an idea. This image was Horacio's idea. The piece was about the trial of Lewis "Scooter" Libby and the trafficking of secret information in the U.S. government. It's such a simple, clean idea: just the Venetian blinds, pinched up slightly. With photo-illustration, often a sharp, simple idea is the best of all. —K.R.

When I was asked to create the illustrations for this piece on cover-ups and the exchange of covert information, I rented every 1950s noir movie I could find and watched them all, back to back, before the shoot. (*Double Indemnity* started it all off.) Venetian blinds just kept showing up as a classic noir piece, so we went with it. —HORACIO SALINAS

### VIK MUNIZ

**THIS PAGE:** Manhole cover. From "City Life in the Second Gilded Age," published October 14, 2007 (cover image).
**OPPOSITE:** From "The Greening of Geopolitics," published April 15, 2007 (cover image).

For our annual "Money Issue," the subject was wealth in New York City. For the cover we wanted something New York–centric, but also representational of wealth. All the obvious things came to mind: the Statue of Liberty, the Brooklyn Bridge, the Guggenheim. In the end, we chose a manhole cover and settled on making it gold-plated.

Vik loved this crazy idea. Our hope was to spray-paint a real manhole cover gold, but the city rejected our request. So we had to improvise by using a mold of an actual manhole cover. The day of the shoot, we collected old discarded cigarettes, dried leaves, and bits of trash to place around the fake cover, which we shot on a street Vik knew. It was very important that it look authentic. —AREM DUPLESSIS

**ANDREW BETTLES**

From "The End of Republican America," published March 30, 2008.

We were looking for a way to illustrate "The End of Republican America." It was Gerry Marzorati who suggested the balloon figures. So we went online, found the balloons, and sent them to Andy Bettles, who did a wonderful series in which the red elephant deflates. Again, it's a clean, simple idea, well-done—sometimes that's all it takes. —K.R.

**STEPHEN WILKES**

From "The Green Mind," published April 19, 2009.

"The Green Mind" idea came out of a real *Magazine* group-think. Design-director Arem Duplessis came up with the concept of the green brain and a profile of a head formed by human bodies. Clinton Cargill, a photo-editor, thought of engaging the Momix troupe to act it out. Christoph Niemann made the drawings that we blew up to scale on set, and wonderful costumes were designed by Phoebe Katzin and Rick Delancey. We asked Stephen Wilkes to shoot it, because he's a great problem solver—and this was a huge technical challenge. It took us two days of shooting to get this. —K.R.

**KENJI AOKI**

From "Thank You for Smoking: Barbecue-Pit Flavor, Minus the Pit," published September 14, 2008.

I have a memory of simply reconciling space and perspective on paper as a child. One line appeared in numerous drawings I made: it was the horizon line.

To me, this photograph represents that relationship between ordinary objects, the world around us, and gravity. —KENJI AOKI

## KATHERINE WOLKOFF
Illustration for Patricia Cornwell's serialized story "At Risk," published January 29, 2006.

These two images (above and opposite) were part of the *Magazine*'s "Sunday Serials": fictional narratives published in serial form over a period of several weeks. We commissioned one artist-photographer to do all the illustrations for a given story. Katherine Wolkoff made the images for Patricia Cornwell's mystery "At Risk"; and Paolo Ventura created miniature tableaux, which he then photographed as illustrations for Michael Connelly's "The Overlook." —K.R.

OPPOSITE:
## PAOLO VENTURA
Illustration for Michael Connelly's serialized story "The Overlook," published September 17, 2006.

I was living in rural Tuscany when I made these maquettes. I had to look everywhere for props. The light in the corner is a Ping-Pong ball; the teacup on the floor is from a kid's dollhouse; the books were cut from the covers of actual books. Most of the things I made myself, because I was in the middle of nowhere and it was hard to find anything but paper and cardboard. I made the paintings myself. The man is made of clay, and I used some fabric and sewed his little sleeve. —PAOLO VENTURA

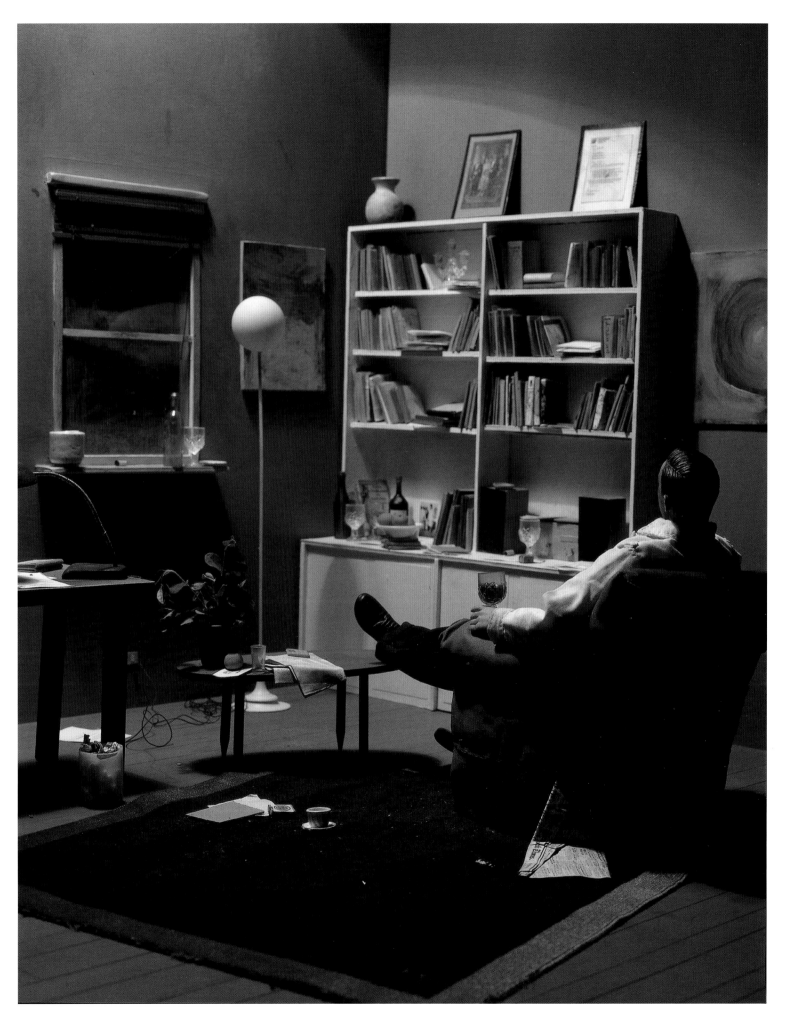

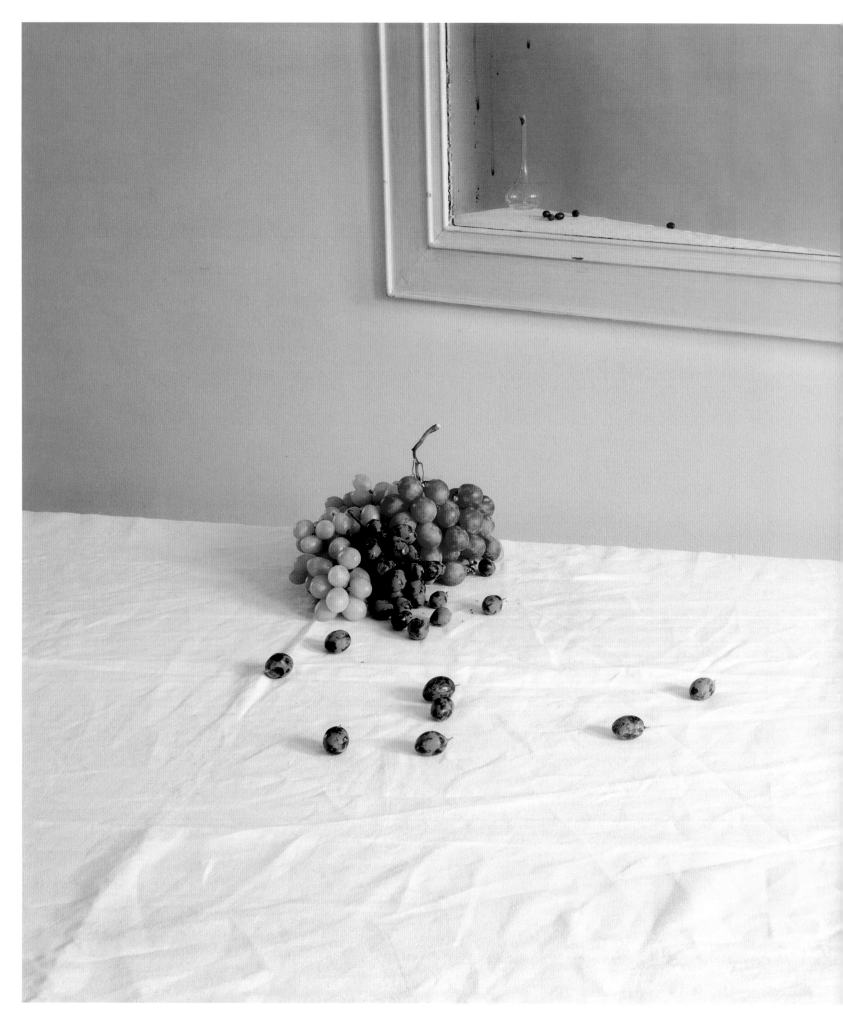

## LAURA LETINSKY

From "The Grapes of Wrath: A Spirit Suitable Only for Defrocked Priests, Grappa Finds Redemption in the Kitchen," published January 6, 2008.

When thinking about how to approach this photograph, I started pretty directly with glasses of grappa, decanters, and foodstuffs that might accompany this end-of-a-luxurious-meal elixir. It's usual for me to start with more and then pare away, until I have only what feels necessary to the picture. —LAURA LETINSKY

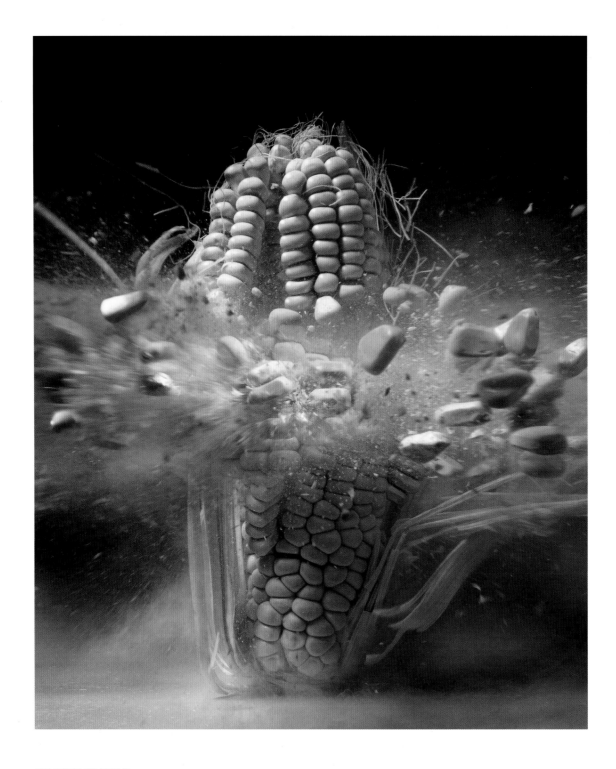

## MARTIN KLIMAS

**THIS PAGE AND OPPOSITE:** From "Food Fights!," published October 12, 2008 (three cover images were created from Klimas's photographs: the two in these pages, and another depicting an exploding apple).

I had seen Martin Klimas's images of exploding vases: incredibly beautiful vases of flowers caught in a moment of sheer exuberant explosion. In fact, I had tacked up a little image of one of them on my bulletin board just as an inspiration-reminder. So when I heard the working title for this piece—"Food Fights!"—I immediately thought we'd get Martin to blow up some food. Sometimes, you just have fun with it. —K.R.

## JEFF KOONS

**THIS PAGE AND OPPOSITE:** From "The Love That Dare Not Squawk Its Name: Inside the Science of Same-Sex Animal Pairings," published April 4, 2010.

To illustrate our story on "gay animals," Gerald Marzorati, the editor of the *Magazine* at the time, came up with the notion of photographing two rabbits (same sex) snuggling on the cover—just in time for Easter.

On the inside pages, we continued the idea by featuring a menagerie of same-sex animal couples: sheep, cats, swans, and Chinese silkie chickens. We thought that Jeff Koons, with his lush color and leering wit, would bring just the right sensibility to the project.

With Jeff and his team, we hunkered down in a photo-studio for two days, building sets with flowers, grass, and bales of hay. We hired an animal wrangler, who brought the animals to the set and patiently worked with them while Jeff shot. Jeff is a perfectionist; he was meticulous with every detail: lighting, camera, set, everything.

These images play with a vernacular that is familiar to many of us from cat calendars and animal postcards. Jeff delivers it straight: they're fun images, but not too over-the-top. —JOANNA MILTER

## HORACIO SALINAS

From "The Thoroughly Wired, Weirdly Obsessive, Rather Narcissistic Life of a Self-Measured Self," published May 2, 2010 (cover image).

One of the things Horacio Salinas does magnificently is take inanimate objects and anthropomorphize them. He has this ability to evoke emotion from these beautiful, eerie, puppet-like figures. Doesn't this thing have a personality? —K.R.

OPPOSITE:
## REINHARD HUNGER MODEL BY SARAH ILLENBERGER

*The Calorie-Restriction Experiment.* From "Putting America's Diet on a Diet," in *The Food Issue,* published October 11, 2009.

We paired Sarah Illenberger with Reinhard Hunger for their first collaboration: his sense of humor, graphic clarity, and bold use of color complemented Sarah's style and made her abacus idea sing. —LUISE STAUSS

## THOMAS DEMAND

The Oval Office. Paper maquette. From "After the Imperial Presidency," published November 9, 2008.

We needed to find a new way to cover the idea of the "imperial presidency." Photo-editor Joanna Milter had the idea to ask Thomas Demand to create and photograph a paper maquette for us. His piece was so perfectly and subtly rendered that, we realized from readers' responses, many people didn't realize it was a model! —K.R.

This assignment came to me, I believe, just three weeks before the issue was to go to press. It was a huge challenge. I realized with some pride that the text that my images were to accompany was relatively abstract—and that it was an important story. I imagined the discussion at the editorial meeting about what kind of image could go alongside such a text. It seemed clear that a straight documentary shot was not right. By asking me, the *Magazine* acknowledged, I think, a quality in my work, which often treads the fine line between fact and fiction, realism and abstraction.

We had to work quickly. I tore images out of many magazines for inspiration. And then I assembled five teams of people, each responsible for different parts of the maquettes: furniture, décor, curtains and carpets, and so on. The pieces are all life-size, and they represent a combination of all the Oval Office incarnations since Gerald Ford's presidency. We worked around the clock, improvising. It was amazing to see that everyone seemed to have an idea of what to do— even though none of the team had ever been anywhere near the White House! —THOMAS DEMAND

## JAMES CASEBERE

From "The Elusive Small-House Utopia," published October 17, 2010.

James Casebere is a strong artist who creates a distinct kind of imagery, and yet he was totally open to the magazine dialogue. For this piece on the "Elusive Small-House Utopia," we asked him to change certain things, to emphasize the little house in the center—we went back and forth a number of times, and he welcomed that. I think this photograph succeeds as an art image in its own right, and it also served our purposes as a photo-illustration. —K.R.

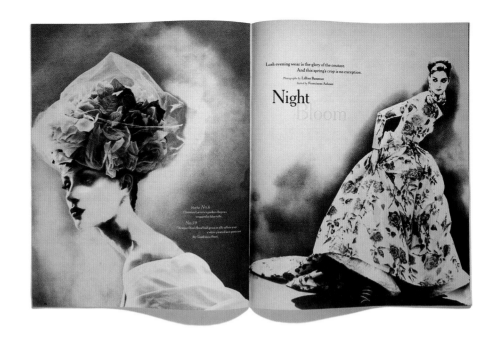

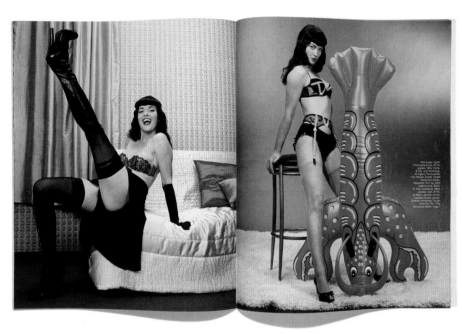

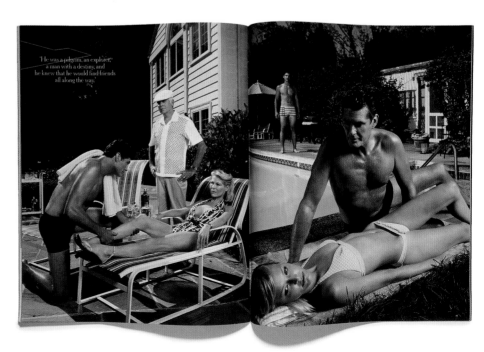

# style

BEAUTY IS ENDLESSLY SEDUCTIVE. The *New York Times Magazine*'s Style pages are driven by it: images that capture the allure of a swanlike neck shimmering with jewels, the pleasing balance of a well-designed spoon, or the charm of a taffeta train draped behind a young woman of otherworldly grace.

Like photo-illustrations, however, images of style are constructions, and as such open to myriad inventive possibilities; as fashion-editor Stefano Tonchi notes: "If you put the right ingredients in the pot, somehow the soufflé will rise." Style is broadly interpreted here, but whether the subject is fashion, food, cutlery, or furniture, beauty is the chief element that unites these photographs. Though it is not always *easy* beauty. (As fashion editor Diana Vreeland famously noted: "Too much good taste can be boring.") Some of the Style images that have appeared in the *Magazine* over the past decades are in fact distinctly gritty, others are eerie, some are shocking, several are playful or even funny. A few of the photographs take readers into the bustling hive behind the scenes of the fashion industry, where hairdressers, seamstresses, and manicurists nervously ready models for their runway struts. Others show us couture sported dashingly by models in their nineties. Also featured are clothes with no model, as well as models with no clothes.

Although the *Magazine* started its life in the late 1800s as a pictorial supplement that included news articles, drama reviews, comics, and a "women's department," Style pages have not always been relegated only to the *Magazine* per se. *T: The New York Times Style Magazine* debuted in 2004; published fifteen times a year, it is currently the *Times*' main channel for fashion photography. (The daily paper began publishing a weekly "House and Home" section in 2002, and a "Style" section in 2005.) But the *Magazine*'s own Style pages have played an important role over the years in enticing readers with elegance, comeliness, and a few surprises—and serving as a reminder of Yves Saint Laurent's dictum: "Fashions fade; style is eternal."

## BRUCE WEBER

Actress and model Brooke Shields. From "Roughing It," published May 20, 1984.

I worked with Bruce Weber for many years—since the beginning. Working with Bruce, you just have to be open to everything. You don't ask any questions. You just say yes, and you never know what's going to happen.

Bruce is less about directing and more about waiting for the natural to happen. Sometimes, though, after shooting a hundred rolls, he'd finally say: "OK, we've got it"—and I'd relax and heave a sigh and move from my pose. And that's when he'd say: "Wait, wait, wait! That's great; don't move!" and then shoot twenty *more* rolls. So I learned never to move once he said we were done. I just stayed in the same position.

We were in Texas for this shoot. I remember there were a lot of cowboys, and Bruce put beds out in the middle of fields—everything sort of seemed incongruous. But the way he put it together, it looked absolutely beautiful and appealing. This portrait was made around the third day of the shoot. We had done a few other scenarios first—on a bed in the field and at a little outdoor market. Then he said: "All right, we need to do a portrait." Just me, without anything else. He wanted to make it more interesting, so he just took the shirt and somebody tied it on my head. And he said: "That's it; that's the photo." —BROOKE SHIELDS

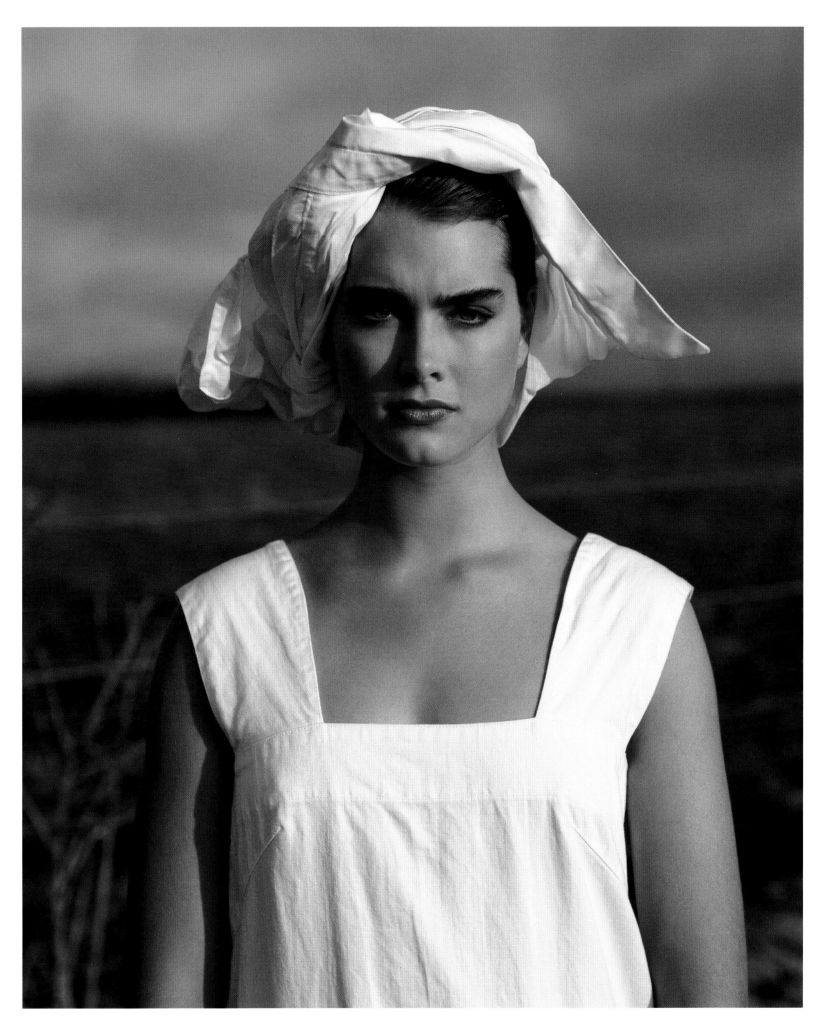

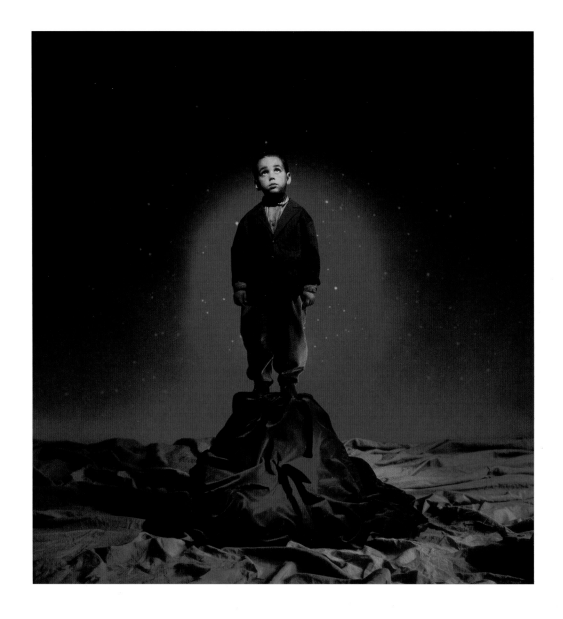

**JOSEF ASTOR**
A little prince searches the sky for his asteroid. From "States of Enchantment," published August 11, 1991.

OPPOSITE:
**STÉPHANE SEDNAOUI**
Evening gown by Geoffrey Beene. From "Tropical Plumage," published February 9, 1992.

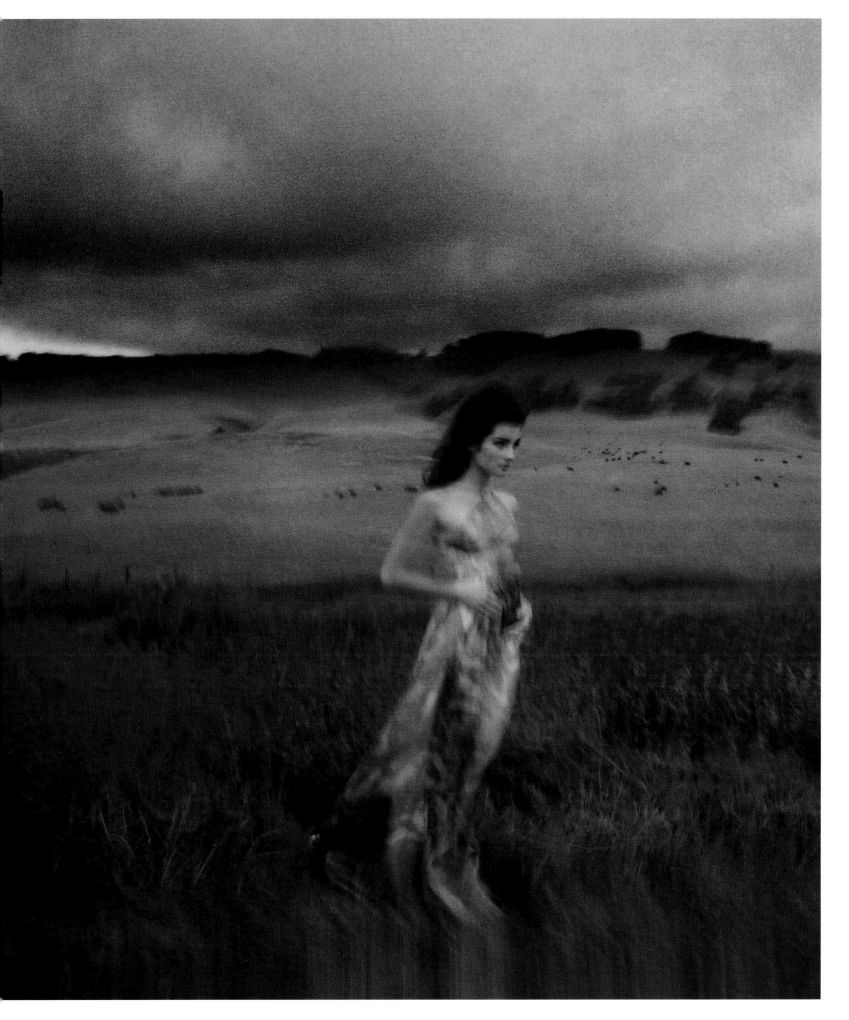

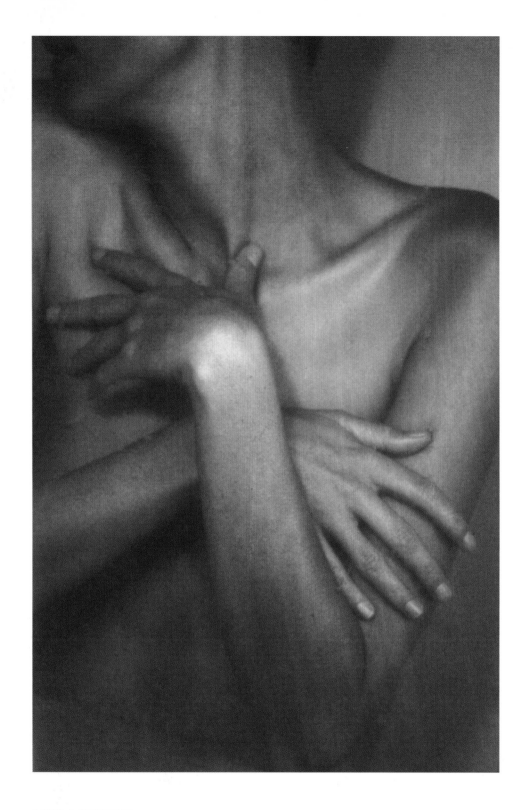

## SHEILA METZNER
**THIS PAGE AND OPPOSITE:** Both photographs from "Body Language," published May 5, 1991.

From the moment I first saw this model, Josie Borain, at a Calvin Klein show, I wanted to photograph her. She was rather androgynous: cropped hair, flat-chested, very beautiful. She was a superb model and could play any role. Nudity was difficult for her—she was a top model at the time, and they just didn't pose nude. (These photographs were for a piece called "Body Language"—focusing on parts of the body, though in fact there was a lot of covering of body parts.) But she trusted me and my work, and she had a terrific sense of humor, which saved the day. —SHEILA METZNER

## SARAH MOON

**THIS PAGE:** Strapless mousseline dress by Bill Blass. **OPPOSITE:** Chiffon dress by Donna Karan. Both photographs from "The Languor of Drapery in the Classical Mode," published April 10, 1994. (Reproduced from prints color-adjusted to the artist's 2011 specifications.)

I can still hear Sarah's voice during this shoot. As she always worked with small Polaroids, the models would have to freeze while posing. She would always count: "One-Mississippi, two-Mississippi," etc. She looked like she was always in a cloud (dreaming), but she knew exactly what she wanted and would go on and on till she came near to her ideal. —FRANS ANKONÉ

## SALLY GALL

At a home in Spring Lake, New York. From "Remembered Rooms," published June 7, 1992.

This picture was for one of my favorite (and oddest) editorial jobs ever—working from literary quotes that evoke the sense of smell or sound in rooms. I was asked to take evocative photos to accompany the quotes—this one was from Sue Grafton's *A is for Alibi*, and mentioned the scents of Lemon Pledge and bourbon. —SALLY GALL

OPPOSITE:
## KURT MARKUS

The marcel wave. From "A Time for Revealing," published May 16, 1993.

This woman wasn't a model—she was pulled out of the hat in Jamaica when our New York models ran into travel complications. Edris Nicholls did her hair, and she did a magnificent job. When I first looked at this woman, I knew she was beautiful, but once Edris had done her hair she was transformed. —KURT MARKUS

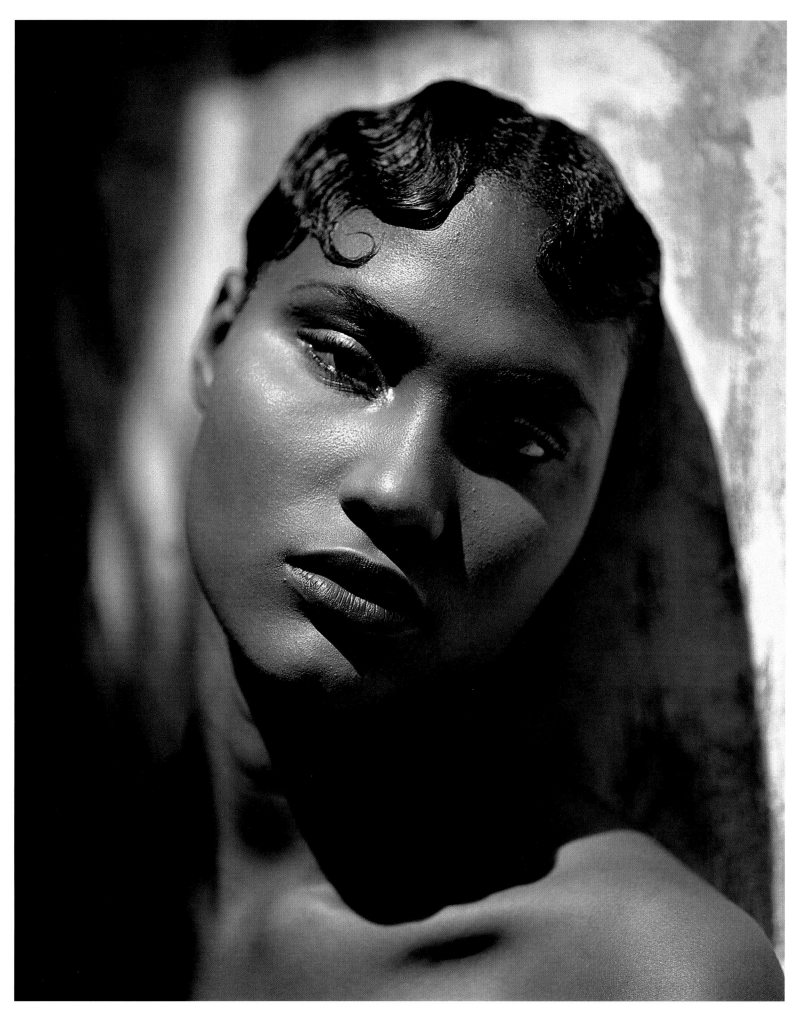

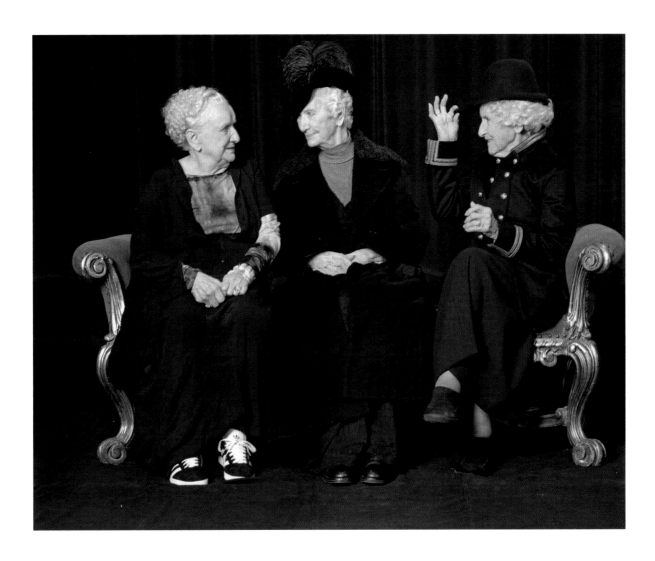

## KURT MARKUS

**LEFT TO RIGHT:** Anna Scott (ninety-two), Marie Carroll (ninety), and Vera Kortemeyer (ninety-one). From "The Look of the Nineties," published September 12, 1993.

For "The Look of the Nineties," I found a group of photogenic elderly people in Omaha, Nebraska. When we had finished the shoot, one of these ladies asked us: "When will this come out?" We told her probably in a few months. The woman paused, smiled, and then deadpanned: "How nice . . . I hope I'm still alive." —KURT MARKUS

OPPOSITE:
## RAYMOND MEIER

Hand-forged sterling spoons by Ted Muehling. From "Curves Ahead," published September 5, 1993.

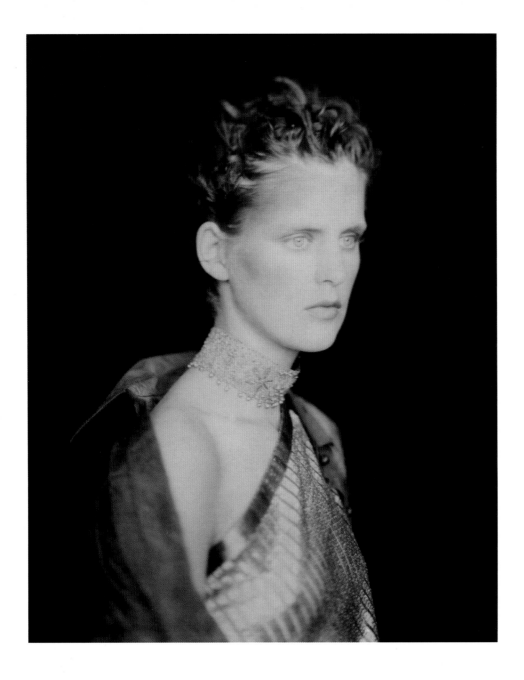

**PAOLO ROVERSI**
Top by Romeo Gigli; crushed organza shirt by Badgley Mischka, and choker by Dries Van Noten. From "Cast in Bronze," published May 8, 1994.

It was always fun to work with Paolo, as we were all involved in the pictures. I remember a pitch-black studio—hairdresser, makeup artist, assistant, and me, all with a flashlight. We would have to shine on a particular part of the model's body, and the model could not move for quite a while. Paolo can always invent amazing effects with lighting. —FRANS ANKONÉ

You can always recognize Paolo's pictures. He always does Paolo Roversi. —STEFANO TONCHI

OPPOSITE:
**DAVID SEIDNER**
*The Debutante.* From "Pentimento," published March 13, 1994.

I lit the studio in the style of the Northern European painters, with the light coming from above to fall on the sitter, the way it would from a studio skylight. —DAVID SEIDNER, 1996

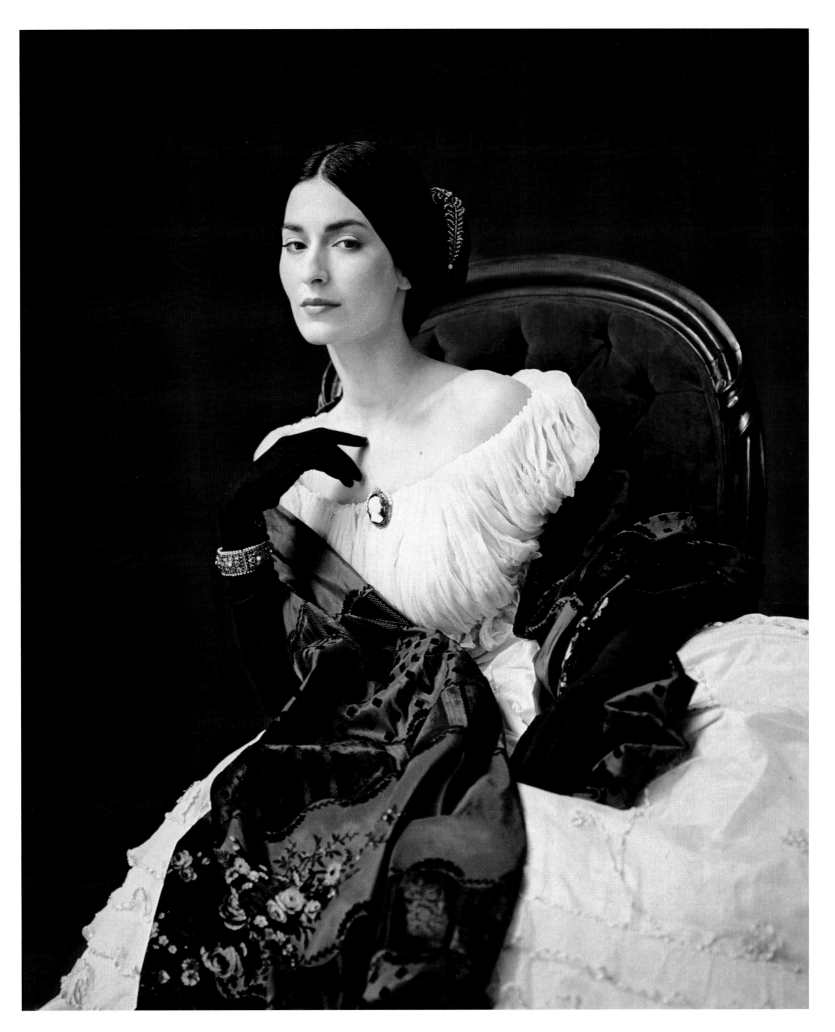

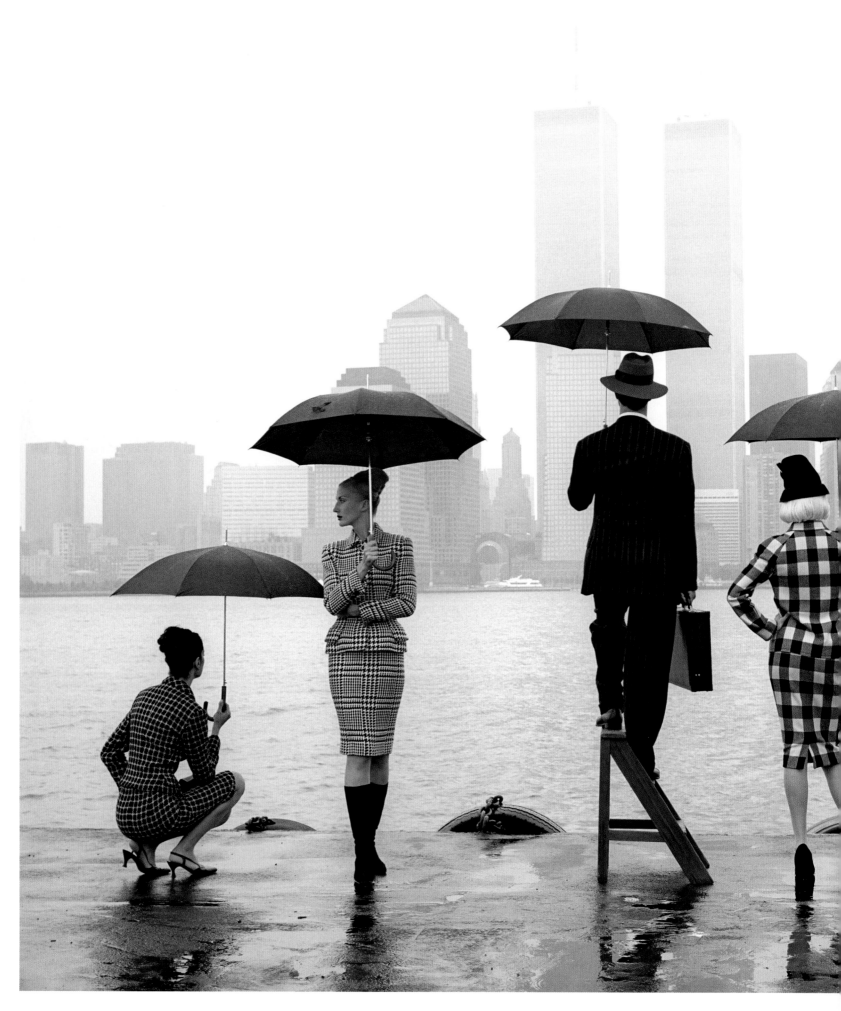

**RODNEY SMITH**

From "Skyline: Check Out the View, Note the New Proportions," published October 29, 1995.

We found a barge that was large enough to put the crew in the middle of the Hudson River. The day of the shoot, it was raining. I remember the art director asking me if we should cancel and reshoot another day. I also remember feeling that shooting that day was fine, and that the rain, rather than a deterrent, was an asset. I have always liked rain. It makes things enigmatic, dimensional, and unresolved.

It took some hours to get the barge in place, and by then it was raining quite hard. We got everyone dressed quickly, positioned the barge, and shot the picture very quickly. I remember that the barge would drift slowly, and I found myself waiting for just the right moment, when the man's hat fell between the Twin Towers. I took a few frames and then the job was done. —RODNEY SMITH

**LAURIE SIMMONS**

Designer Isabel Toledo (right) and her "altered" ego. From "The Perfect Companion," published December 11, 1994.

I'd been doing research at the Vent Haven Museum in Kentucky—the world's only museum dedicated to the art of ventriloquism. For this story I created a "twin" for the designer John Bartlett and a lady companion for Isaac Mizrahi. A dummy was made to look like me, too, and Arnold Scaasi designed two identical blue evening gowns for us. The image of Isabel Toledo and her doppelgänger is my favorite: I love the yellow dresses she designed, and both Isabel and mini-Isabel assumed such regal poses. —LAURIE SIMMONS

OPPOSITE:
**LILLIAN BASSMAN**

Ensemble by John Galliano for Givenchy. From "Night Bloom," published March 31, 1996.

Lillian was already in her eighties when we did this shoot in Paris. The studio was enormous, and she was so small. In every other studio there were tons of people and blaring music. In ours, just a handful, and peace and quiet.

The body language of the models was so different in her days, but Lillian would coach the girls into these amazing poses, from behind the camera. "Longer neck, longer, longer. Put your foot out, more, more." —FRANS ANKONÉ

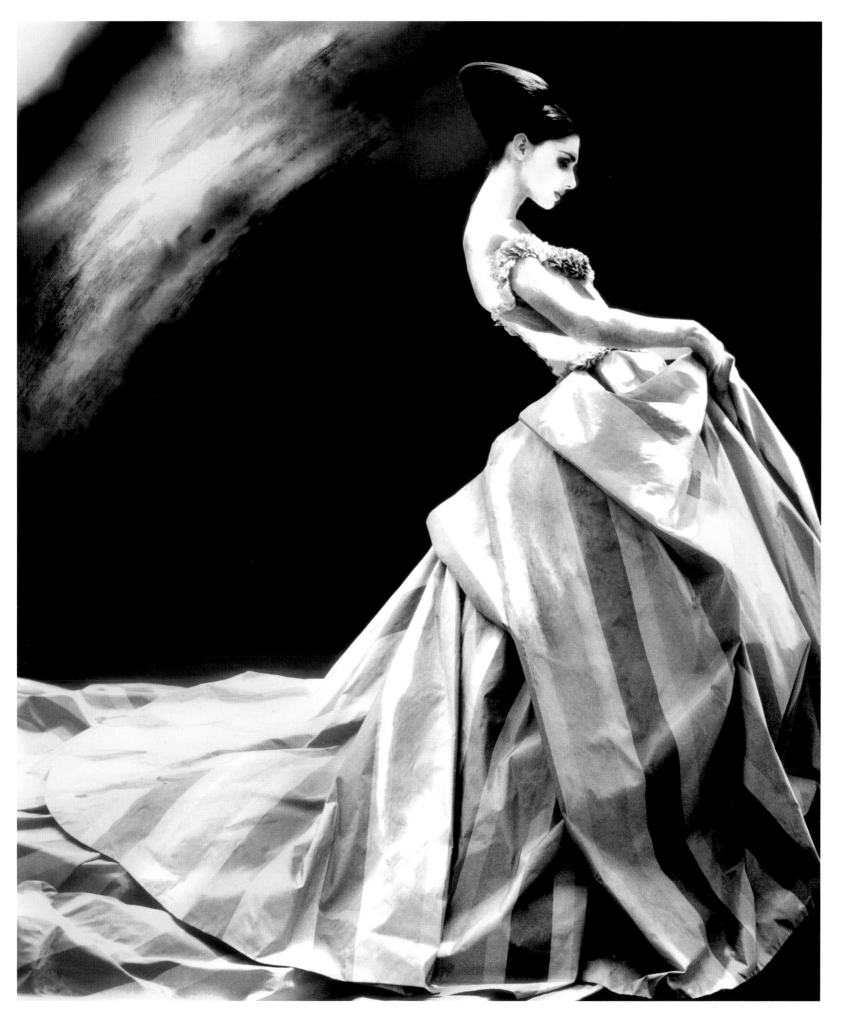

## MATTHEW ROLSTON

Actress Salma Hayek in Elizabethan costume designed by Alexandra Byrne. From "Like a Virgin," published May 16, 1999.

In 1999 the *Magazine* embarked on a yearlong project to celebrate the millennium. Six issues were produced, each with a theme that marked both a sense of history and the viewpoint of this particular moment in the culture. The fourth of these issues was called "Women: The Shadow Story of the Millennium." Its intent was to examine the profound revolution in the status of women through the eyes of historians, novelists, essayists, and photographers. The *Magazine* almost always had a fashion component, and it was particularly appropriate for this issue. This fashion story looked back on sixteenth-century England as exemplified by Queen Elizabeth: Tudor ruffs, epaulets, jeweled wigs, plucked brows. But there is something profoundly contemporary about this Elizabeth, perhaps because it is, after all, a fashion image, shot by the twentieth-century fashion photographer Matthew Rolston. —JANET FROELICH

The concept for this shoot was to look at standards of beauty that were particular to certain eras. This picture was about the high forehead, desirable in Elizabethan times. We wanted to highlight the beauty and strangeness of it.

   We worked with Salma Hayek for a whole series of images; we wanted the same person throughout, to show how differently a woman can appear depending on the conventions of her time. Two other memorable pictures from the series are Salma in a vintage 1950s bullet bra and corset (about the 1950s ideal of a woman's shape), and the photograph of her in *chopines* (platform shoes invented in the 1400s that were so high women needed canes or servants to help them walk). Ours were custom made for the shoot by Christian Louboutin, We did a lot of research for this project. Matthew is an absolute perfectionist. He puts everything he has into everything he does. —ELIZABETH STEWART

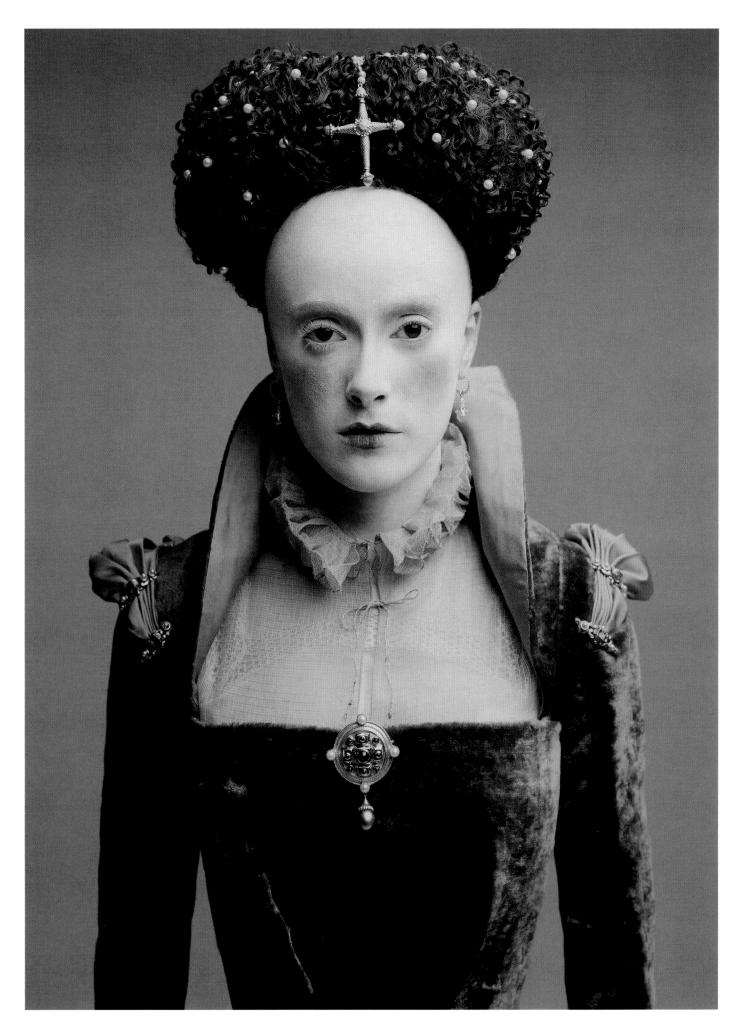

## MARTIN PARR

Favorite foods of Hollywood celebrities. From "The Food," published November 12, 2000.

In rows from top to bottom, starting at the upper left: Ham and eggs at the Griddle Café (Leonardo DiCaprio); Made-to-order gazpacho at Patina (Alicia Silverstone); Grilled chicken delivered to the set of "Baywatch" from Zonedelivered.com (Angelica Bridges); Peanut-butter-and-jam sandwich from Main Street Munchies (*Men on Film* crew); Filet of beef with Stilton cheese, horseradish potatoes, and claret-and-pickled walnut sauce at the Hotel Bel-Air (Sylvester Stallone and Heather Locklear); Sushi without rice at HamaSaku (Warren Beatty); Special "lobster" (made with giant prawns) at Mr. Chow (Billy Wilder); Meatloaf with mashed potatoes, peas, and carrots from Deluxe Catering (*Simone* crew); Chaya steak at Chaya Brasserie (George Clooney, LL Cool J, and Tim Allen); Waffles and cream from Michelson Food Services (*Roswell* crew); One course of the twenty-course, $300-per-person meal at Ginza Sushi-Ko: squid with sea urchin and wasabe; The "Jewish pizza" (Milton Berle).

I am not a celebrity photographer, but I really liked this assignment. In Hollywood—where this tribe is well hidden from its doting public—this is one thing you can not only *see*, but actually *devour*. It is as near to being a famous person as one can be. —MARTIN PARR

## JEFF RIEDEL

Actor David Hasselhoff reinterprets *The Swimmer*. Published November 25, 2001.

We shot over two days, invading one pool after another (as in John Cheever's story, from which the idea came) in the wealthy suburbs of southern Connecticut, coincidentally in many of the same towns where Frank Perry's 1968 film of the story was shot. The piece was styled by Robert Bryan and Mimi Lombardo—this was during the Amy Spindler era in the *Magazine*'s Style pages.

In my mind, David Hasselhoff would play the perfect Neddy Merrill, a successful, handsome, and seemingly virile, narcissistic middle-aged man at the apogee of his mental and spiritual collapse—but who still looks good in a bathing suit. David completely got into the character. The driver we hired to take him from location to location doubled as a valet, carrying his dumbbells around the set so he could pump up his muscles just before stepping in front of the camera. Although we offered to drive David back and forth to New York City, he chose to stay with the team overnight in a hotel. I think he wanted to remain in character for the second day of shooting. He really nailed it.

We shot this just days before September 11, 2001. The scheduled publication date for the story came and went as most of the pages of the *Magazine* were turned over to coverage of the terrorist attacks and related stories. Suddenly "The Swimmer" didn't seem to fit the tone of what was happening. I was beginning to fear that our story would miss its window and not see the light of day, but it did, thankfully.

I was in my darkroom printing something some weeks later and my cell phone rang. "This is Dick Avedon, the photographer"—he called to let me know that he really loved the story and said that he was glad to see people doing something smart with fashion. —JEFF RIEDEL

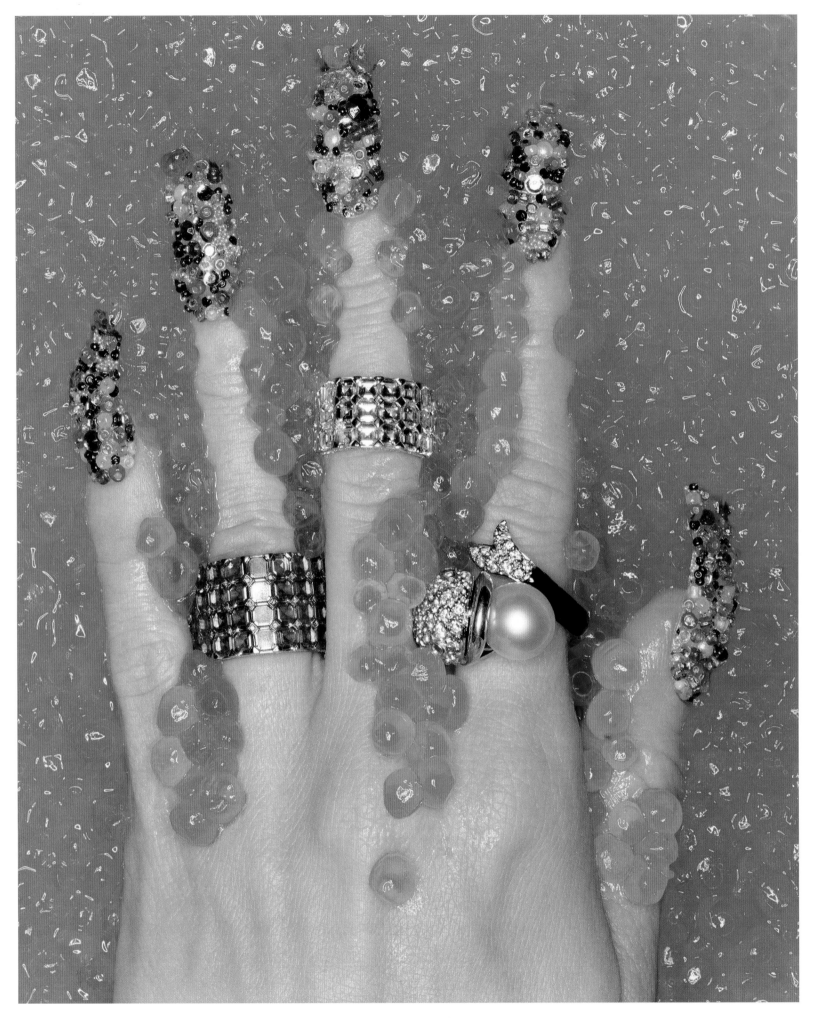

**CARLTON DAVIS**

**THIS PAGE:** Jewelry by Ellagem and Escada. **OPPOSITE:** Rings by Chopard. Both photographs from "You've Got Nails," published February 11, 2001.

## PAOLO ROVERSI
Musician and actress Björk. From "Björk of the North," published August 15, 2004.

It was an interesting combination to have Paolo Roversi shoot Björk. She's usually been photographed by people who are a little bit more aggressive in outlook. We thought it would be interesting to do a portrait of her by someone who has a softer, more romantic feel. She has a strong opinion about how she's seen. She doesn't just want to wear the clothes—she wants them to be part of some larger message. . . . With some people, you want to remake or remodel, but with Björk we really wanted to just help her project an image that she would feel comfortable with and in line with. —ANN CHRISTENSEN

This was one of those situations where, if you put the right ingredients in the pot, somehow the soufflé will rise. You have this very incredible, creative person that is Björk, who likes extravagant clothes—so we gave her freedom to dress up, to transform herself. Then on the other side, you have this very elegant photographer. You can give Roversi anything, and he will transform it into something elegant and personal. —STEFANO TONCHI

## ALFRED SEILAND

**THIS PAGE:** Sundress by Marc Jacobs; chiffon gown by Alexander McQueen, printed silk dress by MaxMara. **OPPOSITE:** Dress by Nicholas Ghesquière for Balenciaga. Both photographs from "Hanging Gardens: When the Bloom Is on the Line," published May 16, 2004.

My first instinct often is to bring in photographers who might not normally be shooting a particular kind of work. There were a lot of beautiful flowered prints that season, which led me to think of Alfred Seiland, an Austrian landscape photographer. I remembered seeing a picture by him of sheets hanging on clotheslines, years before, and that was a direct inspiration. I love the pattern-on-pattern here, and the fact that, even though there's nobody there, the dresses themselves clearly have personality.

These photographs were published in May, which meant we were shooting it in late March or early April. I remember it took some fancy footwork to find blooming flowers that early in the spring. —K.R.

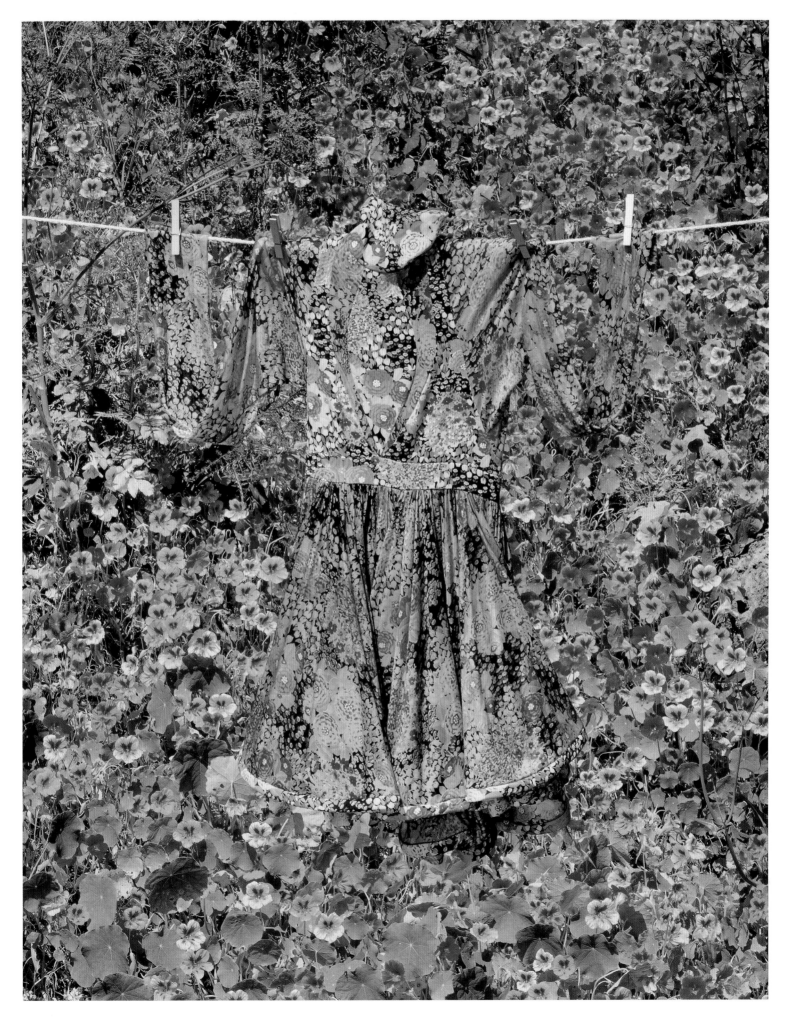

## JEFF KOONS

From "Gretchen Mol: Portfolio by Jeff Koons," published March 12, 2006.

I had always wanted to do something with Jeff Koons, with his obsessions with sex and sexual fetishism, and that 1940s and '50s kind of imagery. He was very specific and precise in the shoot with Gretchen Mol. He re-created each single image from the Bettie Page book—then he subverted them with some weird element of his own. He was the most detail-oriented person I ever met. Oh, my God. —STEFANO TONCHI

I really enjoyed working on the Gretchen Mol shoot. It was a wonderful experience to look back at Bettie Page's original photographs and to try to recapture the authenticity of the setting. When I made this picture of Gretchen on top of a dolphin holding an inflatable monkey, the image was a reference to a shot that Bettie Page had done in almost the same exact setting, holding some type of Raggedy Ann monkey doll. Putting her on the dolphin really gave it a sense of mythology or Darwinism—the small, infantlike monkey is almost Oedipus having sex with his mother, or Gretchen is Aphrodite with her son, Eros. —JEFF KOONS

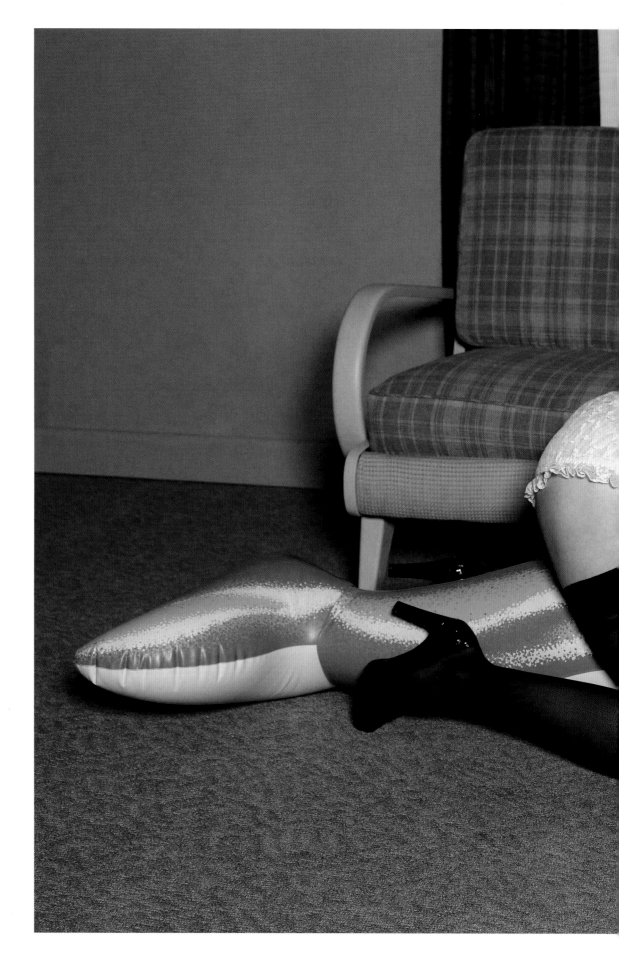

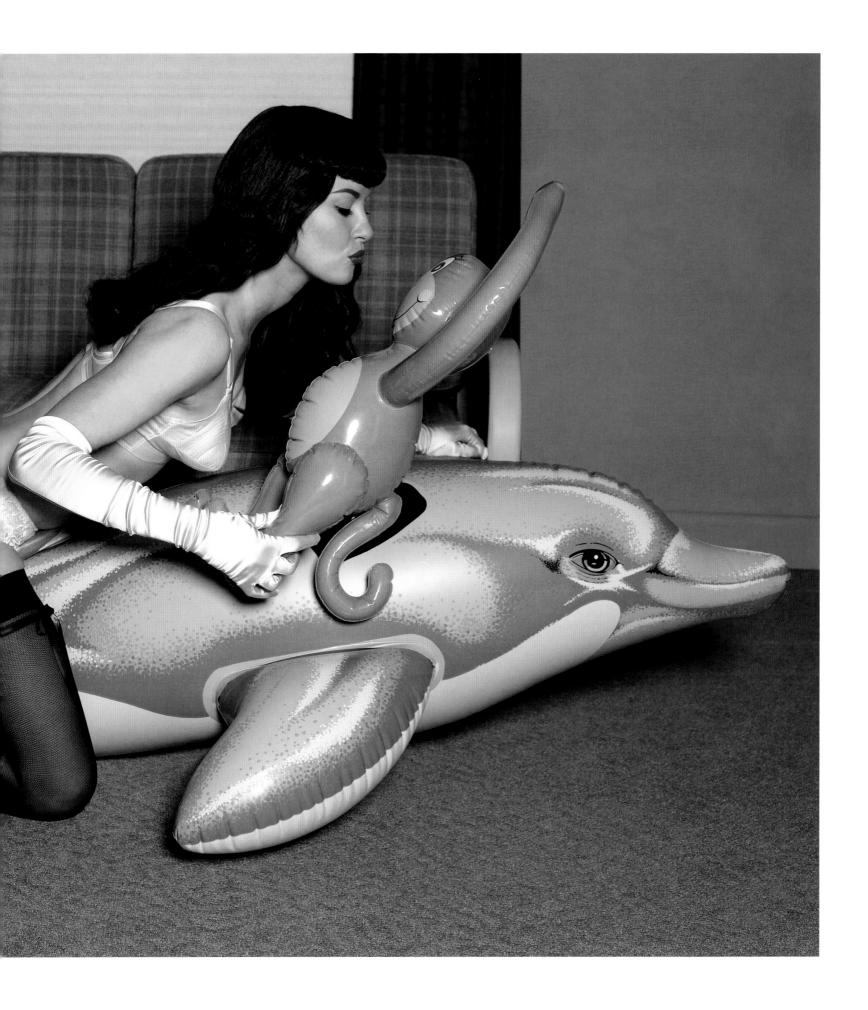

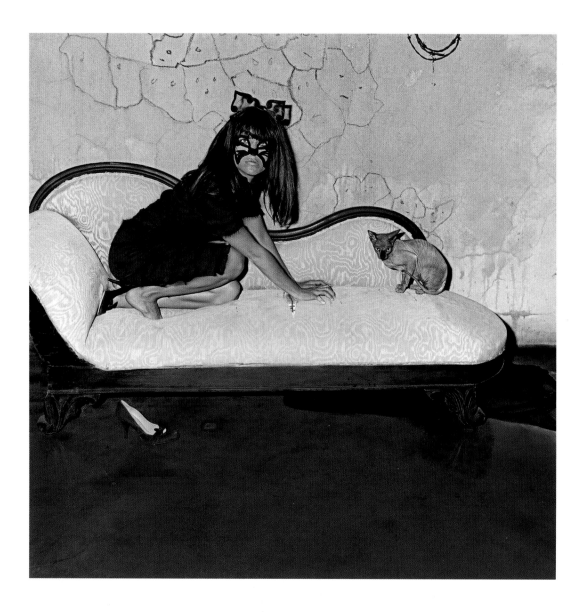

## ROGER BALLEN

**THIS PAGE AND OPPOSITE:** Actress Selma Blair. From "The Selma Blair Witch Project: Fall's Dark Silhouettes Have a Way of Creeping Up on You," published October 30, 2005.

I was surprised when the *New York Times Magazine* called me to do a fashion shoot. I'd never done any fashion photographs in my life—I had no experience in this. But they said: "We'll leave it up to you to figure out what to do." The only things I had to deal with were the actress, Selma Blair, who was superb to work with, and the particular clothes she was to wear. There was no other constraint.

The biggest problem for me initially was to find a place to do the work. We found a giant abandoned psychiatric asylum in upstate New York. The spirit of that place was similar to the type of places I work with in South Africa—on the fringe, on the margin—it had the right emotions for me. So that was a major step forward. Then I wanted animals in the photographs, so the *Magazine* brought in animals and trainers. Some of the props I found in the place, and others I brought in.

I didn't know exactly how I was going to do anything. I never think about a picture before I start it. I try to let my mind just relax, and then when I get there I do it. It's like being an athlete: your mind has to be focused, and when it's ready to go into operation, it works properly.

I was given an award for this project from the Art Directors Club. But I always tell people: I may have won this prestigious award—but I never got another fashion job from it. I guess they didn't like my fashion show! —ROGER BALLEN

Selma Blair understood Roger's pictures, and she wanted to participate in this world he was creating. That was key to the whole shoot. It was a magical combination of subject, photographer, location, stylist, clothes, everything. —KIRA POLLACK

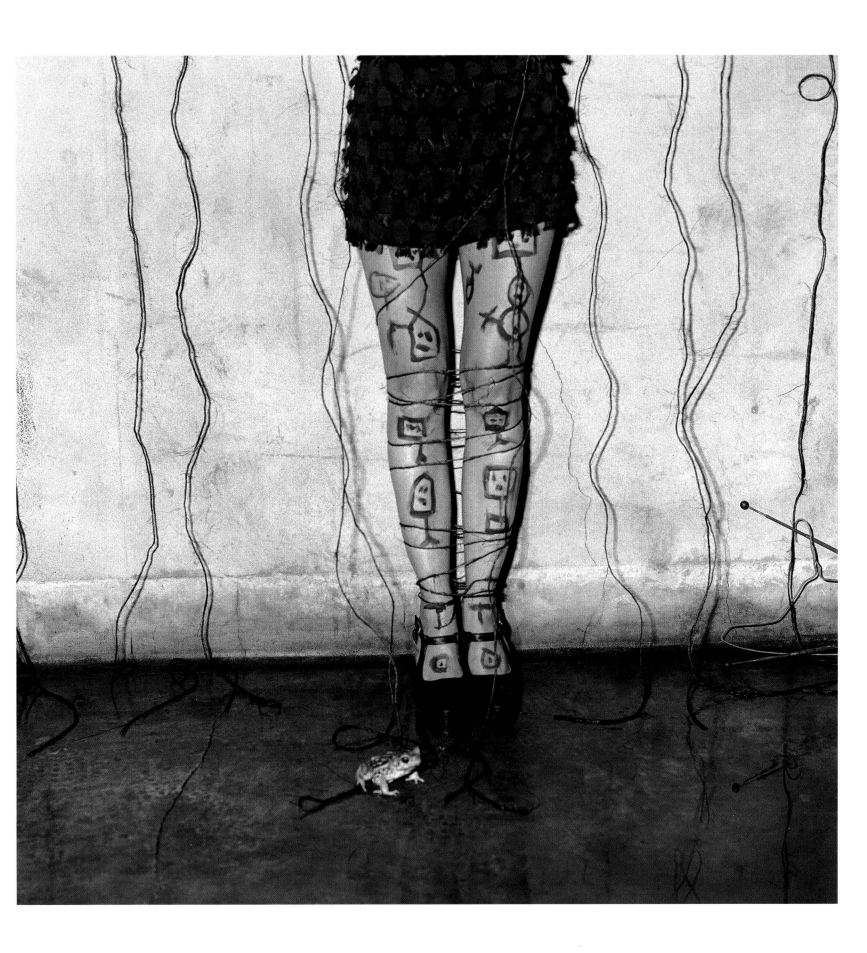

**RICHARD BURBRIDGE**

Ensemble by Gucci. From "Black Magic: Fall's Most Amazing Silhouettes Conjure a Couture Revival," published September 18, 2005.

We were in a season when a lot of designers were channeling Balenciaga, and I wanted to do a shoot that was about that trend. Balenciaga was a designer from another era, but his were very modern clothes and to encounter them back in the 1950s when he was at his heyday must have felt slightly unnerving. I wanted the images to evoke that feeling—elegant and yet somehow twisted. —ALIX BROWNE

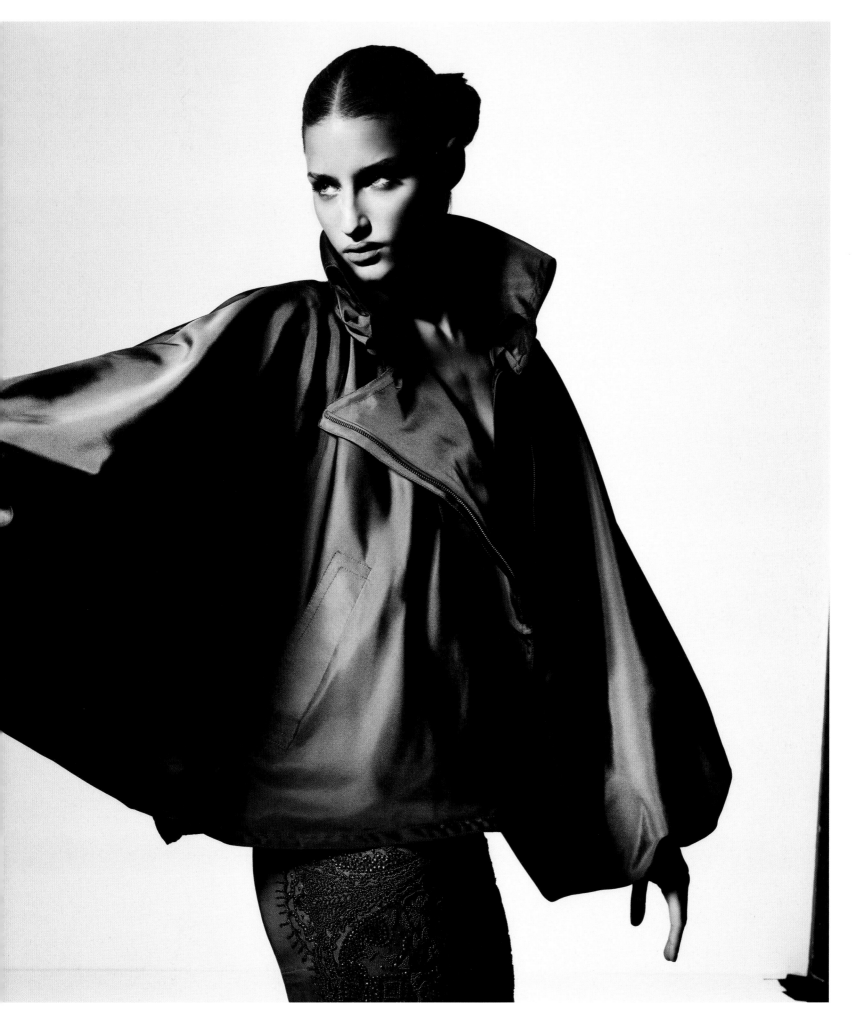

## LEE FRIEDLANDER

**THIS PAGE:** The Dressers; **OPPOSITE:** The Hair Stylists. Both photographs from "Blush, Sweat, and Tears: Peer Behind the Curtain at the New York Fall Collections, and You'll Find the Living Proof that Fashion Is Only About 3 Percent Inspiration," published October 15, 2006.

They're working hard. That's what it boils down to. And I was interested in not just the models, but *all* the people who worked there—the hairdressers, the makeup people. I thought the working people were as interesting as the models, in their own way.

And what they were doing! I've never seen people making themselves up. It seemed funny that they were putting makeup on the models' *feet*, so they could walk down the catwalk and walk back— they were putting makeup on their ankles. And their toes. I was out of my bailiwick, so that stuff interested me. —LEE FRIEDLANDER

## COLLIER SCHORR

Cowboys praying at the Pennsylvania High School Rodeo, Kellettville, Pennsylvania. From "Branded," published June 24, 2007.

There was a real beauty to these guys, playing around with their masculinity, and a certain kind of dandyism within the "dirtiest-prettiest" arena. I was lucky that the guys I met were so ripe to be documented. They really *wanted* to be in pictures. And that's very familiar to me, with subjects that are sort of on the fringe of things. I like to shoot people who aren't overly scrutinized, because they're more excited to be in the picture.

This was a moment of prayer. A cowboy prayer, which is something like: "I'm going to go out there and risk my life, and I may die, and if I do, I'm going to go to heaven and I'm going to be happy because I've done exactly what I wanted to do." —COLLIER SCHORR

**GARETH McCONNELL**

Actor Sam Riley. From "The Life of Riley," published November 18, 2007.

Bruce Pask is a fashion director for the *Magazine*. His twin brother, Scott Pask, is a well-known set designer who works on Broadway shows. I thought it would be wonderful to get the two of them to work on something together. So we all sat down and came up with the idea of "shrunken" set, which he built for the photograph. We invited the actor Sam Riley to pose in this smaller-than-life set. You have to look twice here, the illusion is so effective. —K.R.

## MALICK SIDIBÉ

**THIS PAGE:** Assitan Sidibé in Marni and Christian Lacroix. **OPPOSITE:** Abdoulaye (left) in a suit by Viktor & Rolf and Burberry hat; and Mamoutou in a suit by Dries Van Noten. Both photographs from "Prints and the Revolution," published April 5, 2009.

In the spring season of 2009, there were a lot of mixed prints inspired by West African dress. In fact, a few collections directly referenced Malick's photographs. So I thought: "Why don't we actually try to do a shoot *with* him?" He'd never done a fashion story before. I got his address, and we flew to Mali with two bags of clothes and did the casting right there. In the end, we did eight shots, in twenty-three frames—and we published all eight. —ANDREAS KOKKINO

**SAM TAYLOR-WOOD**

Cousins Eppie Windsor-Clive (left) and India
Windsor-Clive in Dior Haute Couture by John
Galliano evening dresses. From "Social Ties:
A Cast of Haute-Couture Beauties, Bound for
the Ball," published March 11, 2007.

There's a debutante ball that happens
in Paris, for daughters of different kinds
of social creatures, all of a certain
pedigree. We thought: "Wouldn't it be
amazing to shoot them in couture?"
Sam Taylor-Wood, in collaboration with
Gerry Stafford and the stylist Charlotte
Stockdale, was able to wrap her head
around the idea in an interesting way.
These girls were not accustomed to being
photographed, so we decided to *rig* them
into position. There is an incredibly
beautiful photograph by Irving Penn
where you get to see the backside of the
model's head, completely rigged with
cardboard to make her hair look huge. So
we positioned these girls and then rigged
them in place, but left the rigging. The
resulting images were at once classical—
and slightly strange. —ALIX BROWNE

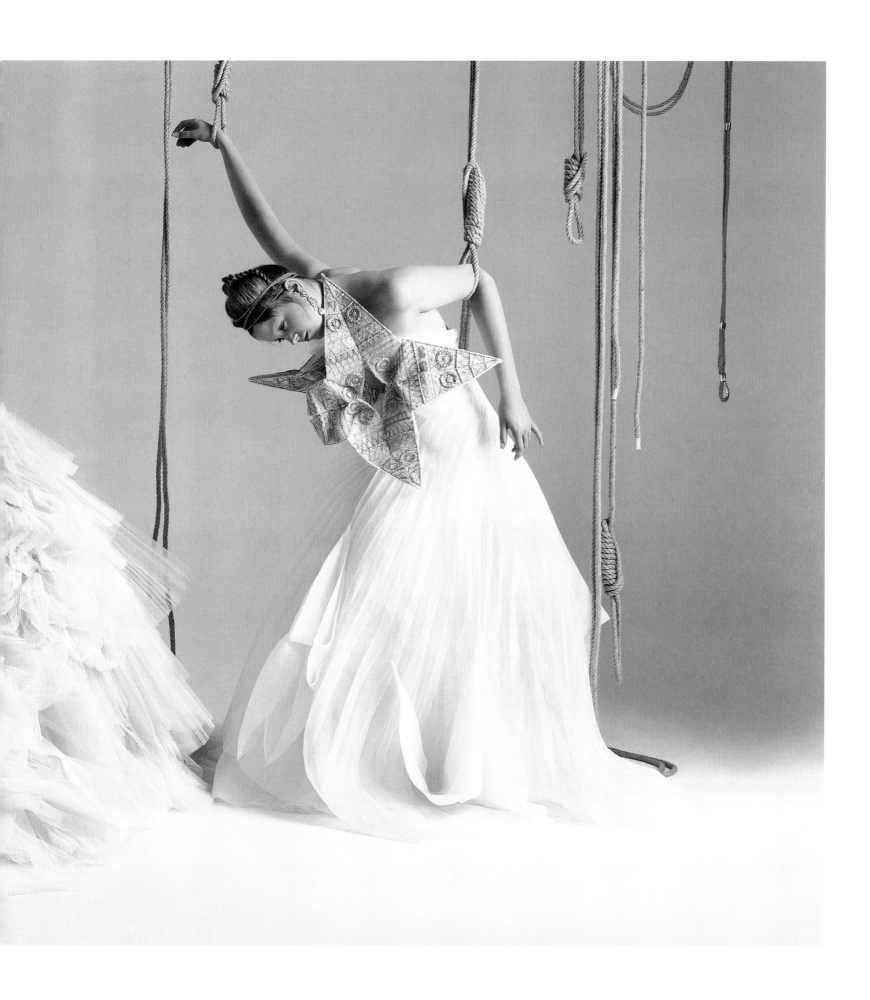

**NAN GOLDIN**

Mariacarla Boscono in a Christian Lacroix
wedding dress. From "The Women: Paris Haute
Couture," published March 16, 2008.

I was not going to send this picture in
because I never in a million years thought
it would be published. Or *could* be
published. I was so surprised that a
photograph was chosen for the *Magazine*
that had all these double entendres, in
relation to pubic hair, menstruation, giving
birth, all these other meanings of what
that detail—that dark-red flower—looked
like in that position on a woman's body.
I was a little afraid even to send something
like this in. I was afraid it was too sexual.
I was afraid it was going to bust me.

It's all the different roles of women,
rolled into one. The Virgin Bride who's lost
her virginity . . . and there are so many other
levels. And it's so funny! —NAN GOLDIN

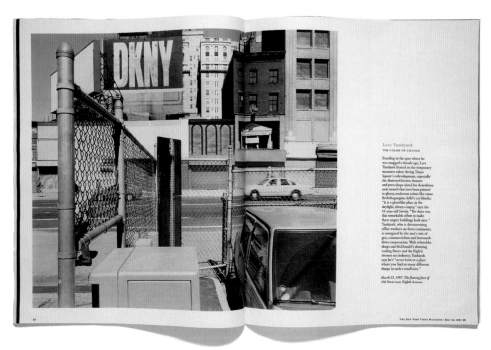

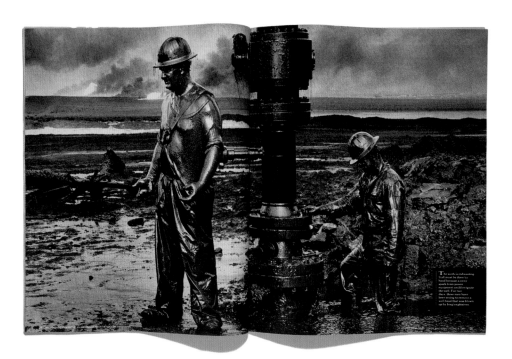

**CLOCKWISE FROM TOP RIGHT:** RYAN McGINLEY, August 8, 2004; SEBASTIÃO SALGADO, June 9, 1991; LARS TUNBJÖRK, May 18, 1997.

# projects

IN 1897 THE RECENTLY LAUNCHED *New York Times Magazine* published a sixteen-page spread of fifty halftone photographs documenting Queen Victoria's Diamond Jubilee. The issue was hugely successful and boosted the new weekly supplement's popularity. Photo-essays appeared regularly over the ensuing century—indeed, the *Magazine*'s reputation as a major engine in the world of journalism was partly built on the inclusion of sequences of hard-hitting, often black-and-white documentary images. In the 1990s Adam Moss, then the *Magazine*'s editor, initiated a photographic "Portfolio" section—a conceptually propelled and commissioned feature that would appear at regular intervals throughout the year. Some of these photo-portfolios played out over an entire issue of the *Magazine*.

The *Magazine*'s photo-essays and photo-portfolios have ranged widely over the years in content and tone, from tough stories on wars, regime changes, and disasters to imaginative artistic tableaux to the purest examples of documentary reportage: investigations into the vicissitudes of ordinary life as it transpires. Sometimes it is the photographer who proposes a project to the *Magazine*, but more commonly the publication's editorial staff will develop a theme and commission one photographer or a team to go out and work within its conceptual guidelines. In all cases, the objective is to convey a powerful story that operates principally or exclusively through images.

In the following pages are selections from eight photo-projects that exhibit some of the varied forms these portfolios have assumed over the years:

1. Gilles Peress's 1980 "A Vision of Iran" brought a new kind of documentary insight to the face of a country undergoing the tumultuous revolution that ushered in the rule of Ayatollah Khomeini.

2. "Times Square," published in 1997, gathered a group of photographers with very different sensibilities to document that colorful but infamously squalid area of the city just before it underwent its irrevocable cleanup.

3. Sebastião Salgado's "The Kuwaiti Inferno" shows harrowing scenes of the scorched land left behind by retreating Iraqi troops in 1991.

4. "Being 13" is an investigation into the complex lives of young people in 1998 America through the eyes of several image makers.

5. Gregory Crewdson's "Dream House," published in 2002, demonstrates the artist's evocative cinematic vision, with a cast of Hollywood celebrities.

6. Photographs by Inez van Lamsweerde and Vinoodh Matadin and by Paolo Pellegrin celebrate film stars featured in the *Magazine*'s "Great Performers" portfolios from 2004 to 2010.

7. "Obama's People," a tour-de-force project by Nadav Kander and key members of the *Magazine* photography and art departments, brought the faces of Barack Obama's new administration to a U.S. public that was eager to meet the incoming team in 2009.

8. Finally, Ryan McGinley's "Olympic Athletes," taken from portfolios published in 2004 and 2010, shows that the body in motion will always be a subject that is new and compelling.

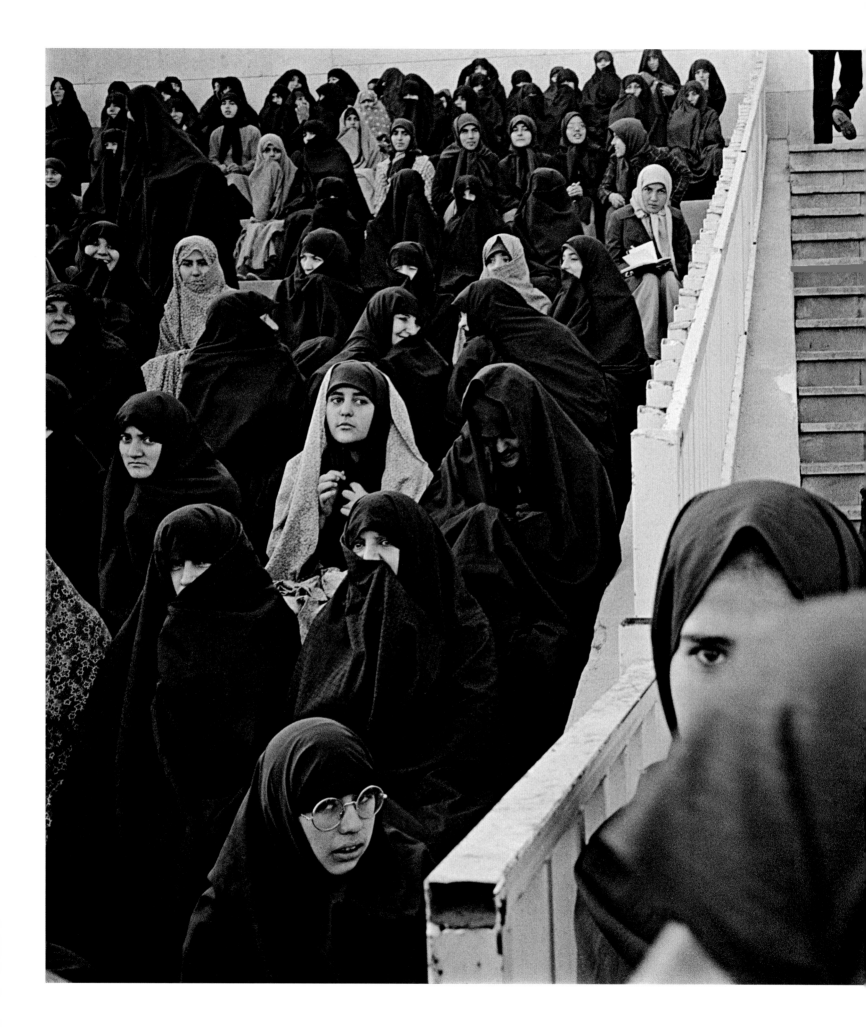

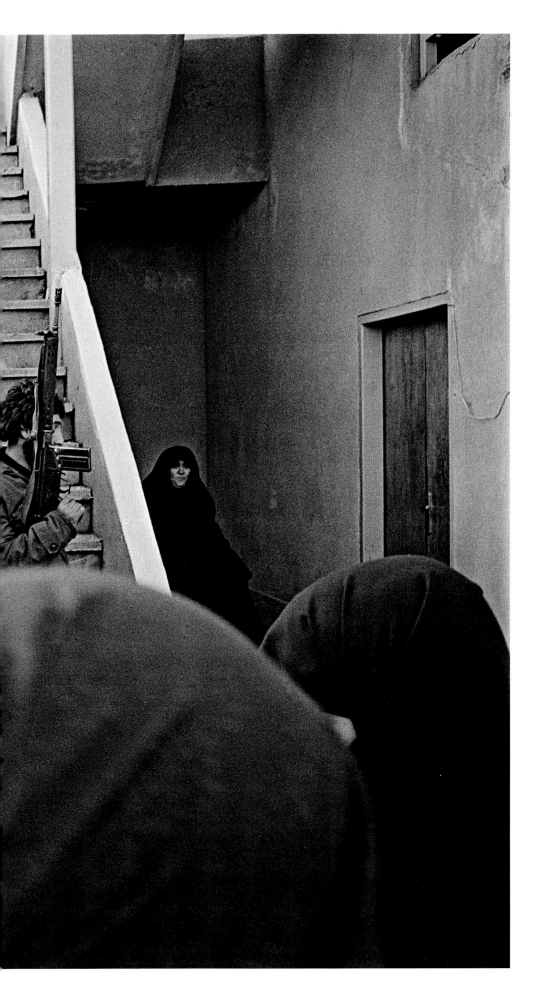

# a vision of iran

published June 1, 1980

In 1980 the human face of Iran was unknown to many Americans, who watched mystified as the country underwent the ruptures of a revolution that ousted the shah, Mohammad Reza Pahlavi, and brought Ayatollah Khomeini to power. Fifty-two U.S. citizens had been held hostage in Tehran since the previous November, and a rescue attempt in April ended in disaster, with the deaths of eight American crewmen and one Iranian civilian. All these events were reported in U.S. newspapers with blaring headlines that were shaping an American awareness of the Iranian people as fanatical, vengeful, frightening—and extremely distant.

Gilles Peress, frustrated with the media's sensationalized reports, traveled to Iran and stayed for five weeks, attempting to see and record something deeper of this place and its people—not only in Tehran, but throughout the country. After his voyage, he brought a carousel of black-and-white slides to Fred Ritchin, the picture editor of the *New York Times Magazine*, with whom Peress had worked before. The work was unlike any photoreportage that had been featured in the *Magazine* or the daily *New York Times* up to that point—photography, after all, was meant to be authoritative and *conclusive*, while Peress's images were subjective and open-ended; they did not provide answers but instead provoked more questions. Ritchin says: "As a picture editor, I was constantly having to defend certain photographic practices, certain kinds of imagery, certain photographers. We were trying to develop new ways of seeing—this was a resistance to conventional thinking at the *Magazine* and at the *Times* in general." Peress's "A Vision of Iran" came out in June 1980; three years later the expanded project was published in book form under the title *Telex Iran: In the Name of the Revolution*.

Peress understood that his work was inciting a new way of looking for viewers. "'Unifocal' images—the staple of what is known as photojournalism—were absolutely *not* what I wanted," he says. "I was fighting to make pictures that were closer to my perception of reality, which was in the making, in struggle, in conflict. . . . I was trying to make pictures that were more like open text, in which the reader has to *participate*—where part of the text is in the reader's brain and requires the reader's efforts."

Peress's "A Vision of Iran" constituted, as Ritchin puts it, "a partial reinvention of the photographic language." It was an unprecedented moment for the role of photography in the *New York Times Magazine*.

Women at a pro-Khomeini demonstration in Tabriz. An armed revolutionary guard (right) provides security.

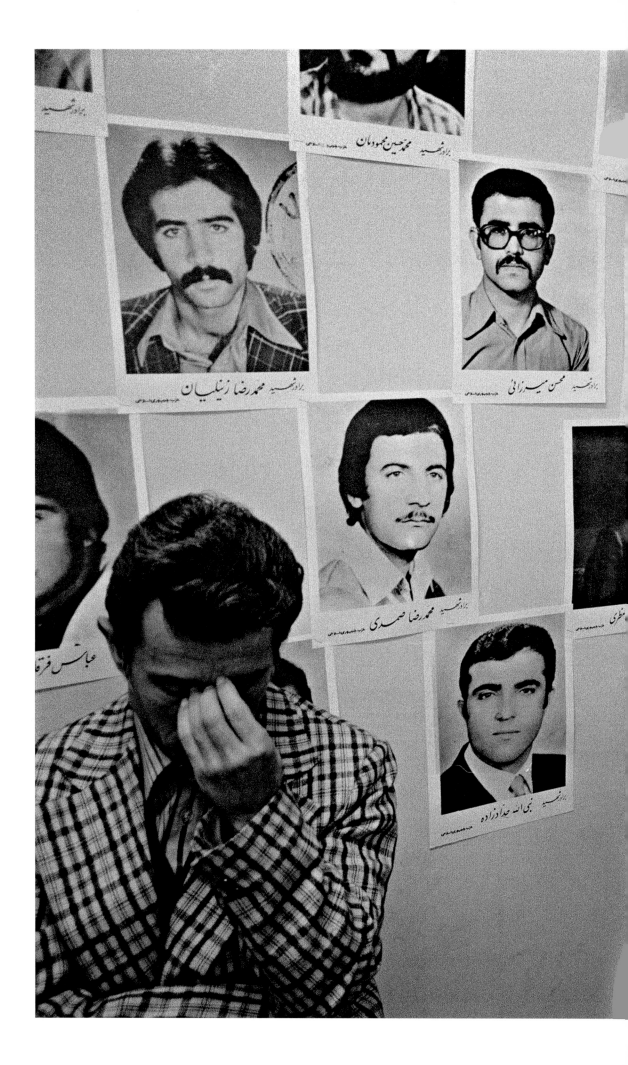

Two agents of Savak, Iran's former secret-police force, facing a press conference at Tehran's Evin prison.

The composition in these images was the result of both an existential and a formal process, which was not weighed upon by the needs of the news or the necessity of having to wire the pictures or ship the film to a paper or magazine. It was in itself and for itself. It was my process of trying to understand the texture of that place, which was in the making. —GILLES PERESS

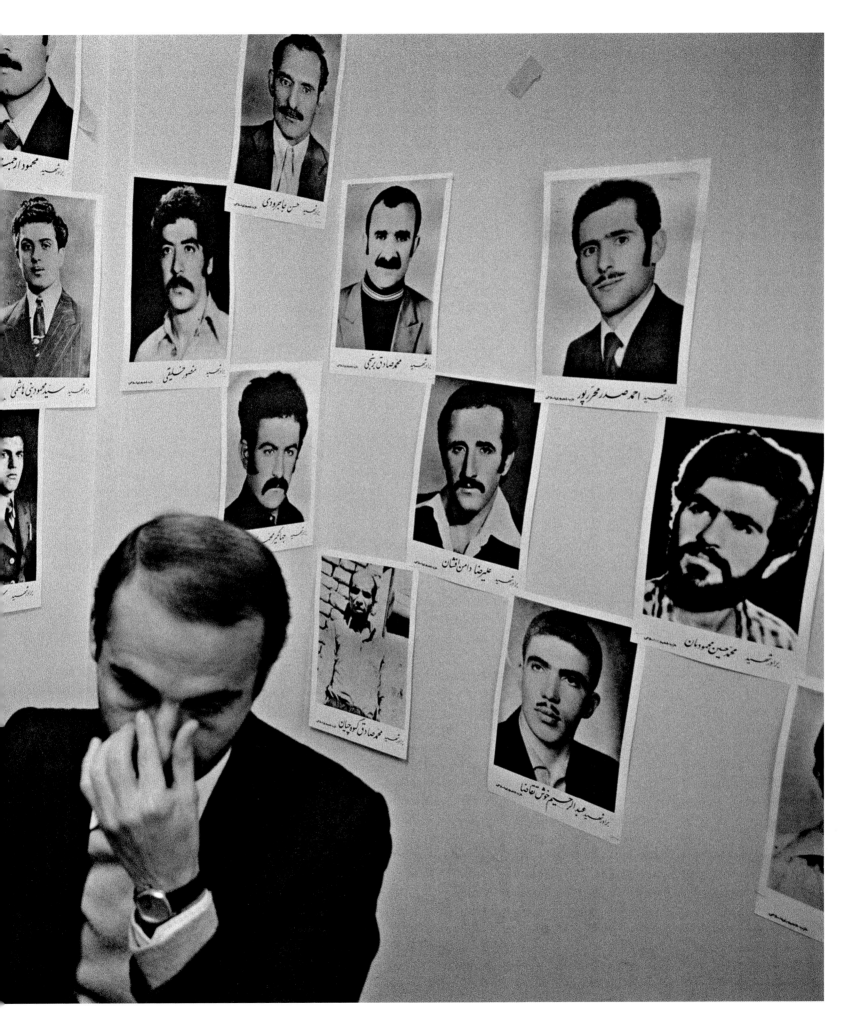

Strollers on a quiet street in Tabriz, against a wall of political slogans.

Peress's photographs are the puzzled, chaotic articulations of a self-avowed outsider looking for explanations in areas where other journalists, confined for months to their on-the-spot positions in front of the American Embassy, were unable to go. In this context the photographs are asserted as questions rather than answers, a strategy in keeping with a growing disbelief that it is possible to present conclusions without involving the reader in the photographer's attempt to understand. The revelation of the image is located in the telling, not just in the evidence of what has been told. —FRED RITCHIN

# VARIOUS ARTISTS
# times square
published May 18, 1997

In 1997 the Times Square neighborhood was on the verge of a massive transformation. Disney Theatrical Productions was finishing the renovation of the New Amsterdam Theatre on 42nd Street—a major catalyst of the change. Many people were overjoyed that this notoriously seedy neighborhood of Manhattan was to be cleaned up, but for a lot of New Yorkers there was a sense of loss and nostalgia for this storied, pulsing center-point of the city.

Formerly "Longacre Square," Times Square was renamed after the *New York Times* in 1904, when the original Times Tower building was under construction. The overhaul of the area would thus have a very tangible impact on the newspaper, whose offices in 1997 were still located at the heart of it. (In 2007 the *Times* moved to its current address at 620 Eighth Avenue, a few steps west of Times Square.) The *New York Times Magazine* decided to organize a photo-project to document the reviled and beloved "old" Times Square before it disappeared.

Kathy Ryan and her team assembled a roster of photographers, each of whom would bring a very different eye and sensibility to the place. She knew it would be an irresistible subject for them. Among the images included in the "Times Square" project were the nine in the following pages, which examine different aspects and moments and moods of the place. Jack Pierson's painterly nighttime vision ran on the cover of the issue. Philip-Lorca diCorcia conveyed the grunge and drama of life on the street. The vibrancy of the neighborhood was captured by Abelardo Morell in a camera obscura image in which the urban signage outside is reflected upside-down in one of the old SRO hotel rooms. Larry Towell spent time at Port Authority Bus Terminal gaining the trust of New York police officers, who showed him a small detention room that seems haunted by the silhouettes of its former visitors. Thomas Demand proved what an icon Times Square was—creating his massage-parlor interior out of paper without ever setting foot in Times Square (though he based his image on photographs from the *Times* morgue). Swedish photographer Lars Tunbjörk brought the clarity of foreign eyes to the once-gritty corner of Eighth Avenue and 42nd Street, discovering its Hopper-esque morning stillness. Chuck Close, though at first reluctant to work on commission, in the end created triumphant portraits of great Broadway actors, including Christopher Plummer and Willem Dafoe. Finally, Annie Leibovitz photographed some of the residents of the neighborhood, including a woman living in an incongruously quiet converted SRO hotel. All the photographers' visions were brought together cohesively to form a landmark portfolio under the leadership of art-director Janet Froelich.

The "Times Square" issue was a pivotal moment in the *Magazine*'s evolution, in which the boundary between art and journalism was elided. The project caught the life and palpable reality of a place that would soon be changed forever.

## JACK PIERSON
The Times Square kaleidoscope, midspin (cover image).

From Jack Pierson, we wanted to get that beautiful, painterly color that was Times Square. He is one of the most sensuous of photographers. This cover was perfect, because it really captured the feel of Times Square: the color, the lights, the blurry, rainy night—it's a cinematic and very poetic image. —K.R.

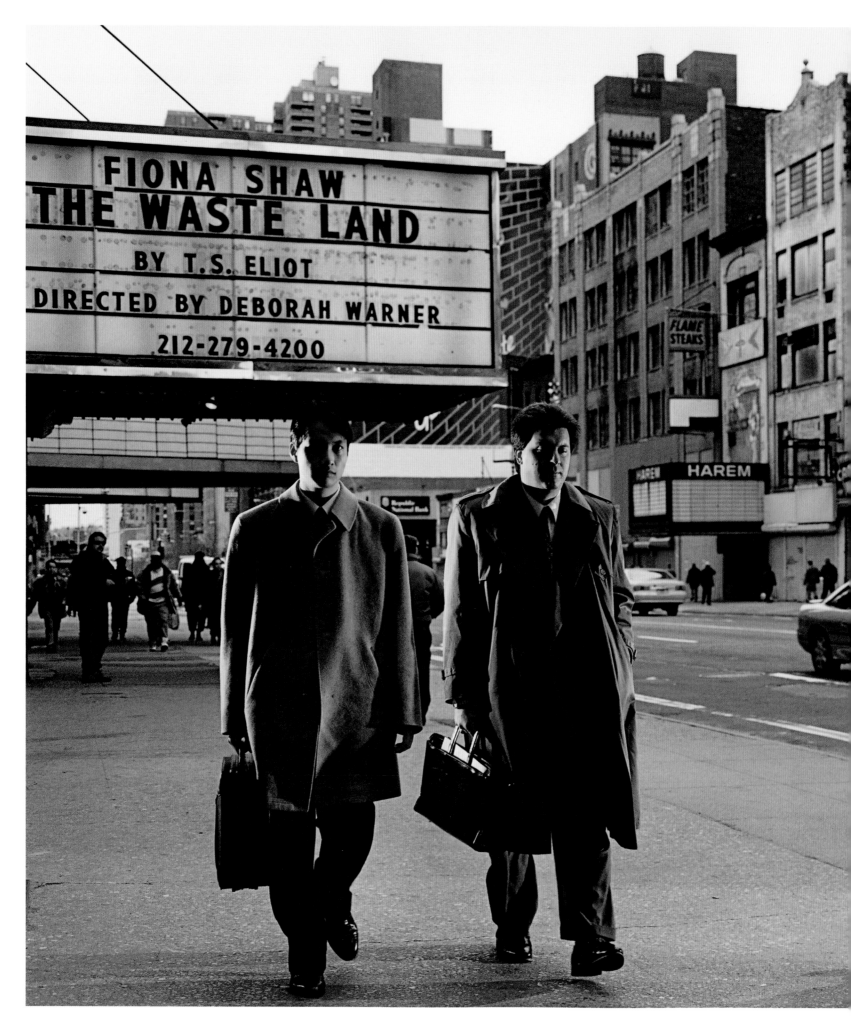

**PHILIP-LORCA diCORCIA**

42nd Street at five P.M., April 4, 1997.

Philip-Lorca diCorcia was already at work on a Times Square project when he was contacted by us for this portfolio. His method for capturing images was outlined in the "Times Square" issue: the photographer "hides several synchronized strobe lights on signs or buildings, places his camera on a tripod and steps aside. . . . This technique allows his subjects no warning that they're being photographed." —K.R.

## ABELARDO MORELL
Broadway, from a room at the Marriott Hotel. Camera obscura photograph.

I wanted somehow to convey in a new way the idea of the dazzling signage of Times Square, and the work of Abelardo Morell came to mind. When I called him and explained what I was hoping for—an image in a hotel room that reflected the signage outside—he said: "I've already been planning that image!" It was absolute synchronicity.

And this was the first photograph that came in after we had assigned the Times Square project. It was an incredible moment, opening the envelope and pulling out Morell's astonishing photograph. I actually began to cry, because I realized that even if nothing else came through in this project, here was a picture for the ages. In the end, of course, everything worked so well. —K.R.

One of the things I appreciated with this assignment was the chance to make a camera obscura picture in a room that looked onto a very complex scene. Times Square really provided that. In fact, it was a little frightening because there was so much activity—I didn't know if it the chaos was going to overwhelm the picture. But it was thrilling, too, to deal with such lively stuff.

For the camera obscura picture, we covered the room's window with black plastic, in which I made a hole about 3/8-inch big to let in light. My usual exposures at the time with sunlight ranged from six to eight hours, but Times Square has a very short window of light entry, because of all the buildings—only an hour or two a day. So this image ended up needing two full days of exposure. It's the longest exposure I've ever made.

I love the paintings of Stuart Davis and Piet Mondrian that look at cities. Cities were seen as these marvelous machines, marvelous organisms, and this project gave me the chance to climb on board that tradition. —ABELARDO MORELL

**LARRY TOWELL**

Holding room at the Port Authority Bus Terminal.

This place radiated the sense of hidden detective work. As one officer told me: "Our job is to hide things." —LARRY TOWELL, 1997

Larry Towell made a wonderful, very classic documentary image at Port Authority. You can see the faint residue of the detainees who sit against that wall night after night. (I sometimes wonder how long it takes viewers to recognize those four ghostly figures.) Photography often challenges perception. I love that this picture requires a stare-down, and then more emerges from it. —K.R.

## THOMAS DEMAND
Massage parlor. Paper maquette.

This image suggests a morally higher viewpoint than the usual massage-parlor client would see—maybe I was making an argument for cleaning up the area of all shady and not-so-presentable parts of life.

The objects depicted here could all have been "actors" in an Edward Hopper painting. The picture is metaphorically loaded, but at the same time, to me, the most trivial place imaginable. That ambivalence is what really got me started. —THOMAS DEMAND

When putting together the list of artists for the "Times Square" project, we were very eager to have a surprising range of photographic genres represented. I contacted Thomas knowing he would never even set foot in Times Square. We pulled images from the *Times* morgue for him to work from. —K.R.

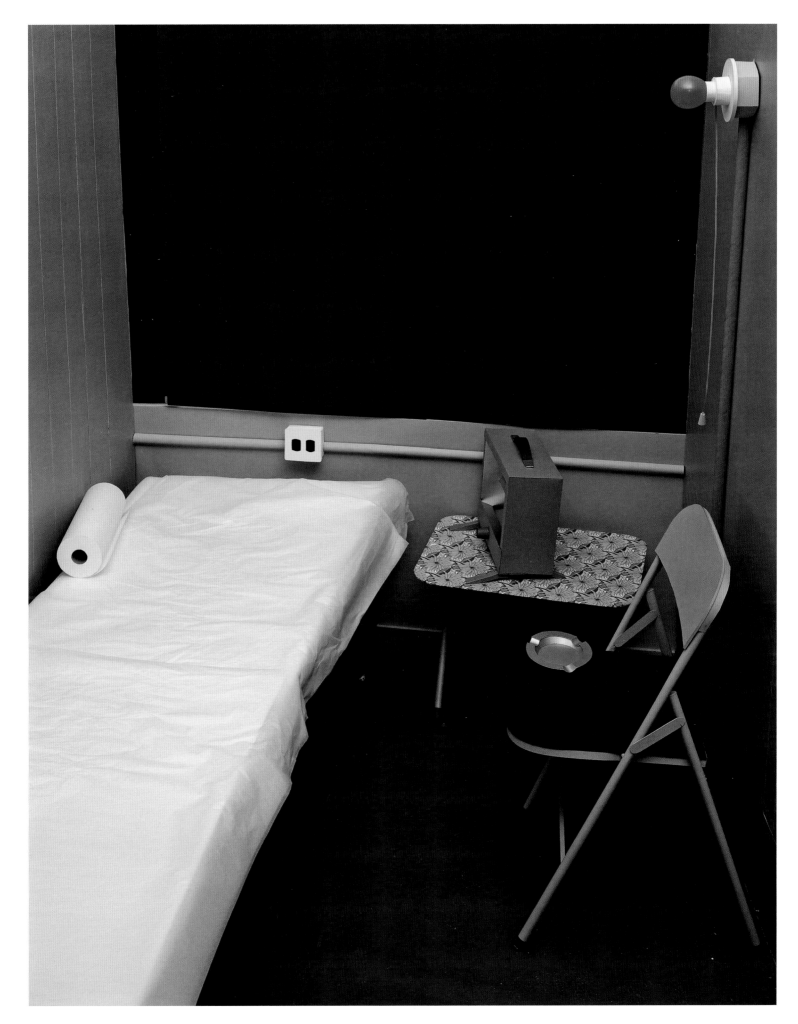

**LARS TUNBJÖRK**

42nd Street and Eighth Avenue.

Forty-second Street at that time was a strange place, with all the abandoned cinemas and porno palaces—like a big empty theater set. I took this picture on a sunny Sunday. I love sunny Sundays in New York: the air is clean, and the light is so crisp and hard. I thought of the paintings of Piet Mondrian when I saw these buildings and the strong colors.

About eight years before I made this photograph, I was robbed a few meters away from the spot. As a naïve tourist, I was walking along 42nd Street late at night. (But the robber didn't find much in my pockets.) —LARS TUNBJÖRK

## CHUCK CLOSE

**THIS PAGE:** Actor Christopher Plummer. **OPPOSITE:** Actor Willem Dafoe. Outtake from commissioned shoot.

For the "Times Square" issue, the *Magazine* asked me to make a portfolio of actors who were performing on Broadway that season.

Christopher Plummer was very tough; he didn't want to be there. He kept going into the back room to reapply makeup. He's a dashing, debonair, matinee-idol kind of guy, and I thought he looked pretty damn good in the photographs. Well, he wasn't happy with them. As I often do, I offered to sign a Polaroid for him, but he refused it!

The thing with Willem Dafoe was very good. I moved to what would later become SoHo in 1967 and I got very involved in the downtown scene—the Wooster Group and all that. Dafoe was a big part of it.

He's such an incredible-looking man. And it's always easier to photograph someone when you have an important relationship with them through their work . . . I sort of felt like we were from the same town—SoHo back then was like a small town in a way—so it was especially nice photographing him.

One of the things that's been very pleasurable about working for the *Magazine* is that it's given me an opportunity to meet people I was really interested in meeting, and in some cases I've continued to see them or have some sort of relationship with them. Often they're real heroes of mine. —CHUCK CLOSE

**ANNIE LEIBOVITZ**

Thereza Feliconio in her apartment at a renovated SRO.

One of the things we wanted to include in this issue was people who were actually living in Times Square.

Annie Leibovitz has a contract with Condé Nast and can't take assignments that might in any way conflict with her work with them. I knew this was a project she'd never get from Condé Nast. And she immediately embraced it.

Sadly, the woman in this image was killed the following year when a piece of scaffolding fell off the new Condé Nast building when it was under construction. —K.R.

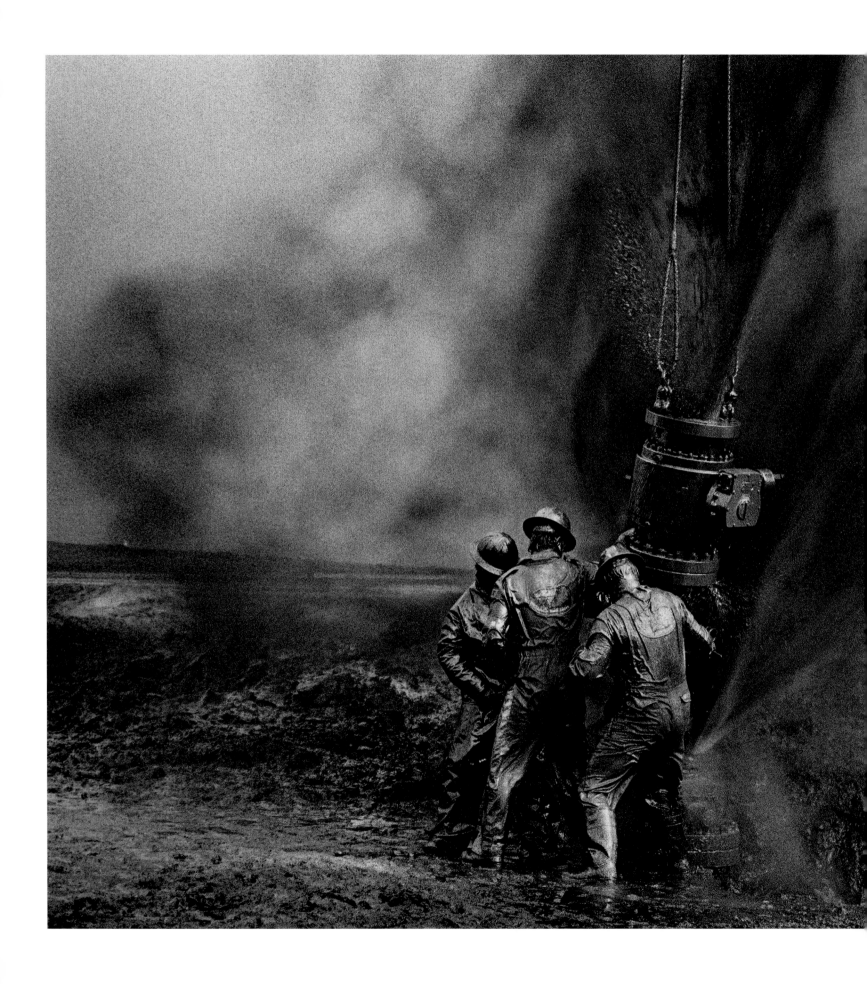

**SEBASTIÃO SALGADO**

# the kuwaiti inferno

published June 9, 1991

Great photo-essays sometimes happen because a photographer anticipates a great story. In early 1991 U.S. troops had invaded the Persian Gulf. Sebastião Salgado called the *Magazine* on the morning of February 24, the day the ground war in Kuwait began. "When they are finished fighting in those oil fields," he said, "they will have trashed that landscape. It will be an extraordinary scene to witness." He wanted to be there to document it.

After a few weeks of furious phone calls—to construction companies in Kuwait, to the Army Corps of Engineers, to the Saudi Ambassador in Washington, D.C., to contractors in Texas—the *Magazine* managed to send Salgado over to the Gulf: by the first week in April, he was at the Saudi-Kuwaiti border, where he had to wait for five tense days before at last obtaining a visa to spend an extended period of time in Kuwait.

What he encountered there was a kind of hell. Hundreds of oil wells had been set afire by retreating Iraqi troops. The fires blazed for more than ten months, throwing heavy smoke into the skies as workers struggled to cap the gushing wells. Salgado stayed in the region for several weeks, and provided the *Magazine* with a visually harrowing, deeply moving story that has the resonance of an epic myth.

"I have done stories in places where wars were going on," the photographer says, "and where there is a danger of being hit by a bullet or stepping on a mine . . . but in fact, danger was not the important point in Kuwait. Danger was secondary. It was *devastation* there."

Workers installing a new wellhead, which enabled them to inject a mixture into the well and "kill" it (cover image).

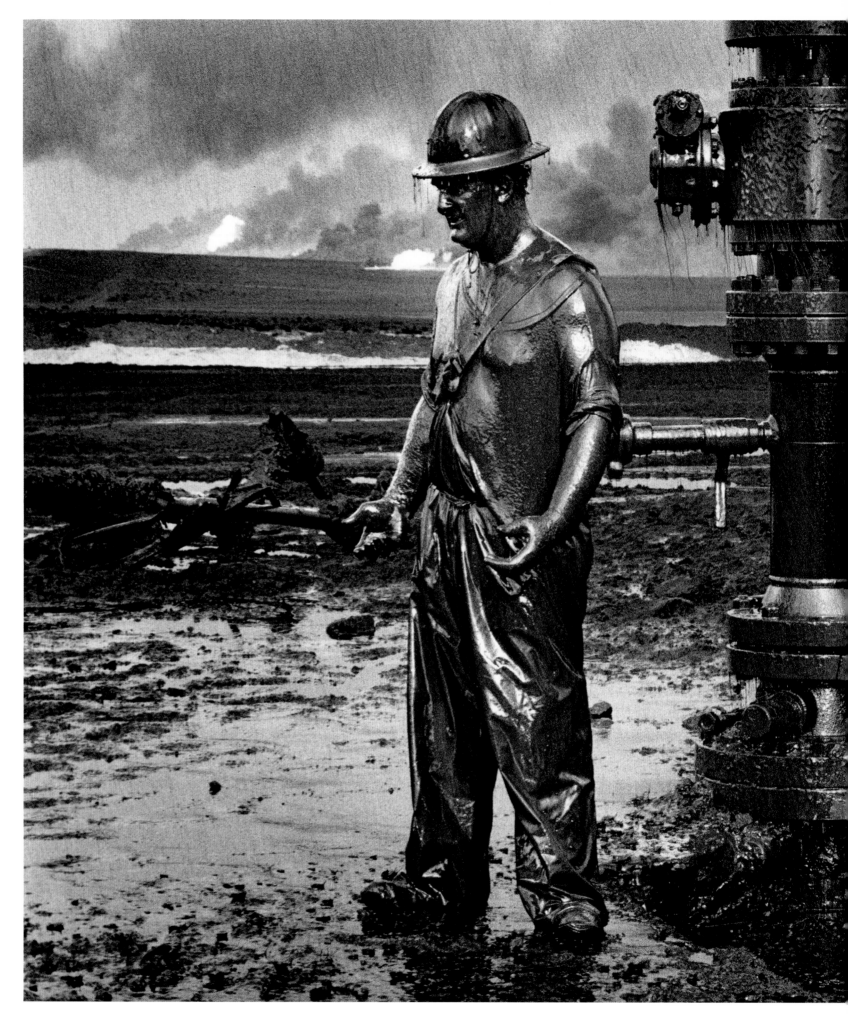

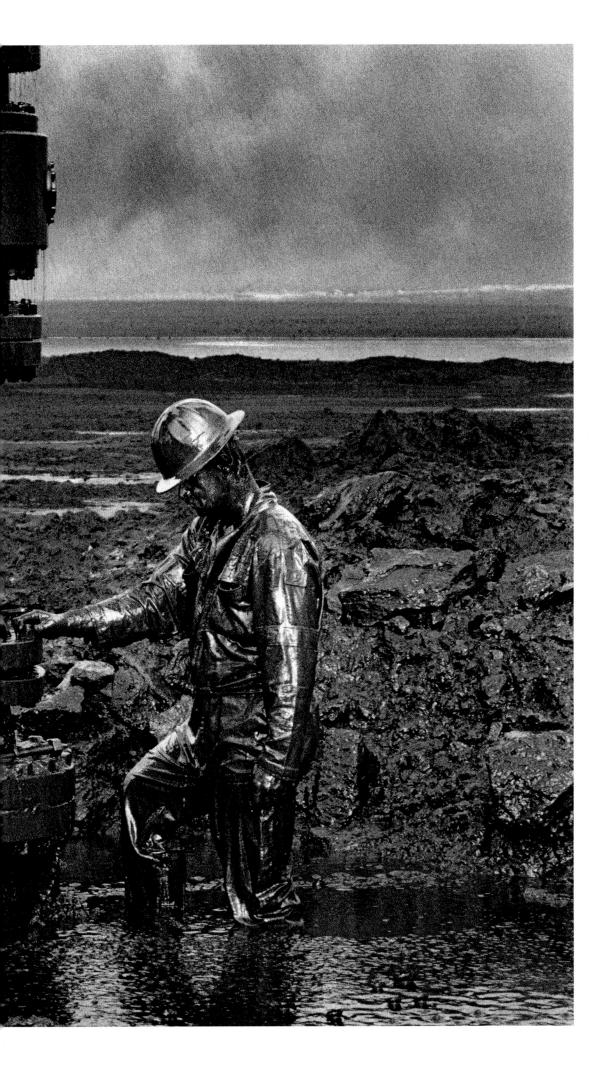

For two days, these men tried to remove a wellhead that had been blown up by Iraqi explosives. The work had to be done by hand: a stray spark from power equipment could re-ignite the well.

I worked in Kuwait for several weeks, and the day I had to leave was very difficult. I wanted to go, but I also had the wish to stay, because I was sure that this was the only time in all my life that I would have the chance to be working in such conditions. —SEBASTIÃO SALGADO

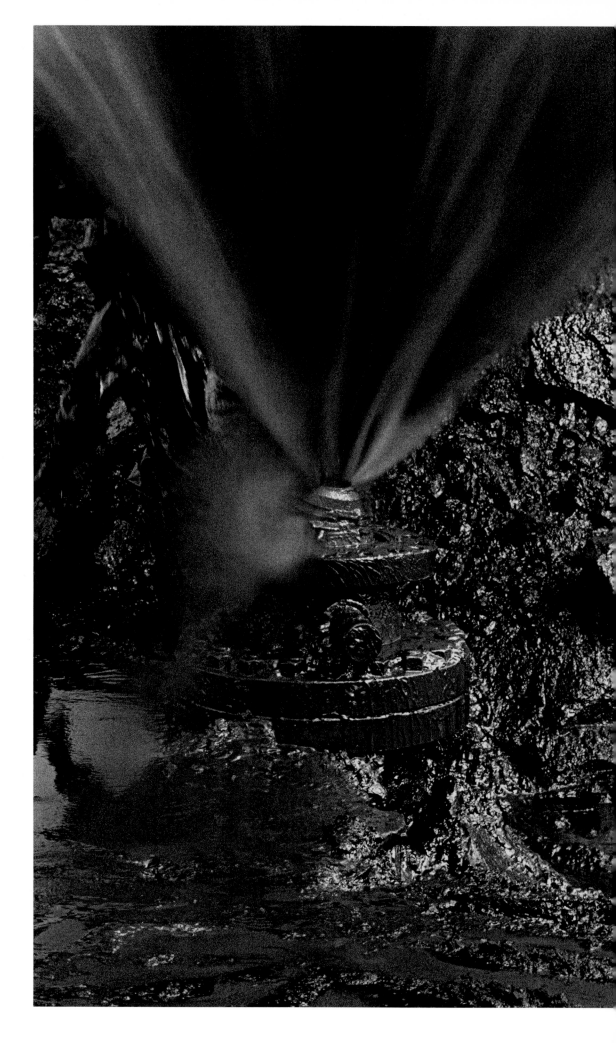

Oil gushing out with a blanket of fumes could be overpowering, as they were for this worker. For those fighting to control the wells, it was a pitched battle.

When you see such pollution, this incredible amount of black, heavy smoke in the sky—there was a light rain of oil, because all the clouds were full of oil—when you see all these fires, and wells burning everywhere . . . it is like being in a huge theater. I had the impression that all this was representation, not real. —SEBASTIÃO SALGADO

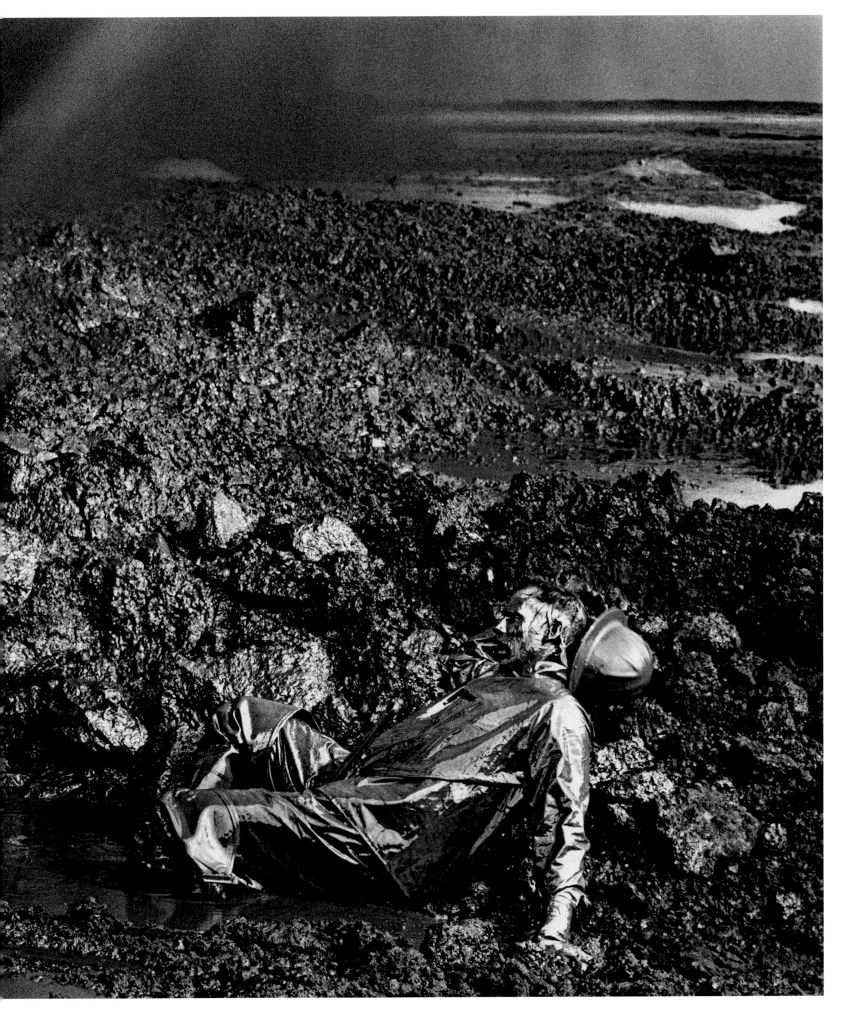

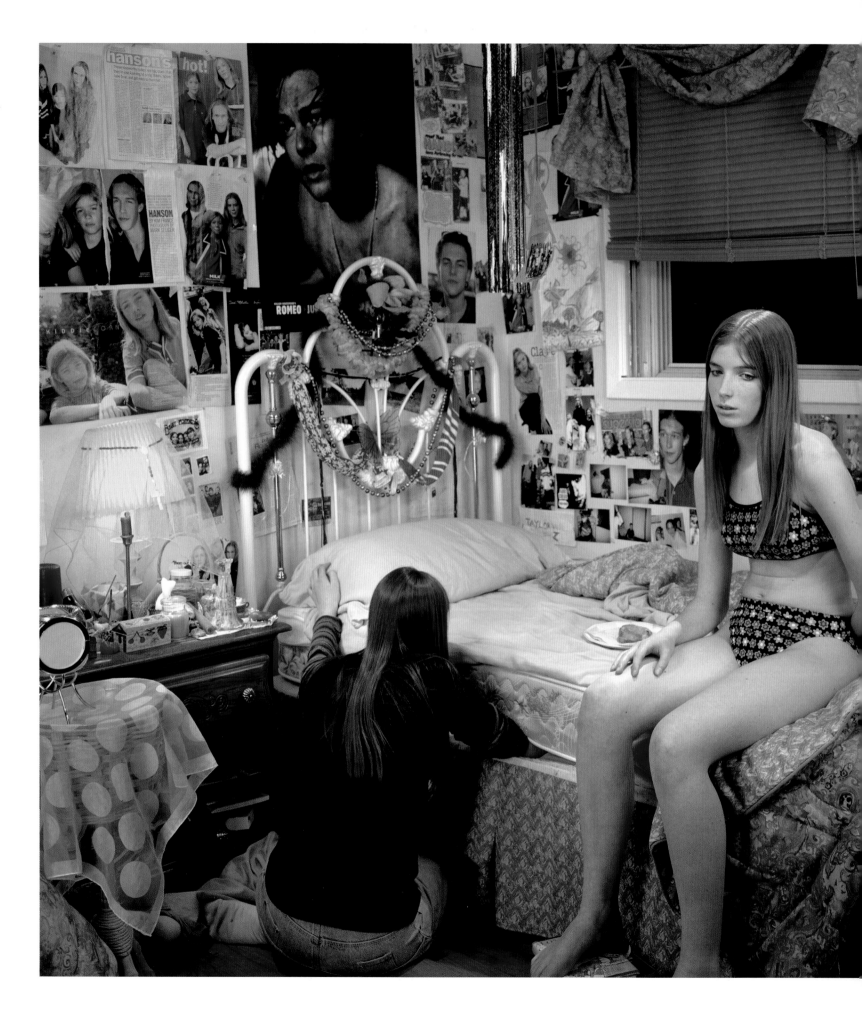

# being 13

published May 17, 1998

In 1998 editor Adam Moss proposed that the *Magazine* devote an entire issue to photographs and stories about the lives of thirteen-year-olds in the United States: their interests and aversions, their hobbies and hangouts, their everyday existence. The project was discussed and planned in the editorial offices of the *Magazine*, and ultimately the photography department sent out a dozen photographers to work on this intriguing assignment.

Among them was Alexei Hay, who scouted out young subjects in New Jersey whose bedroom walls were plastered—like shrines—with posters of rock musicians and movie stars. Lauren Greenfield examined the rituals of primping among girls from an affluent suburban community in Minnesota. And Larry Towell visited a farm in west-central Iowa to spend time with working children who rose before dawn to begin their daily chores. The portfolio also included a section on young business entrepreneurs, and another on Los Angeles gang members—all thirteen years old. In images that seem almost quaint in today's world of mass digital communication, the *Magazine* also looked at a group of girls who were connected to one another by a relatively new electronic vehicle: email.

The "Being 13" project provided a frank slice of life in America at a specific moment in time, giving readers a glimpse at the varied talents and tastes of the coming generation.

**ALEXEI HAY**

Deirdre and Andrea Minissale, twins, Ringwood, New Jersey.

Thirteen is an all-right age, but I'd much rather be fourteen or fifteen. I hate the people in our grade—they're all so boring! People usually think we're older, and we hang out with fifteen-year-olds. They're just so much fun. But thirteen is better than twelve; I hated being twelve, it's too young. At least thirteen has "teen" on the end. —ANDREA MINISSALE, 1998

Everyone in our grade is so immature. Not really the girls, but all of the guys are. All of them are really short, and they act retarded. At dances they won't dance; they think they're too cool to do that. But it is annoying how everyone thinks we're so much older . . . I wish we looked our age. —DEIRDRE MINISSALE, 1998

For this project, we wanted to achieve a balance of points of view—a variety of kids from a range of backgrounds, and a gamut of photographic approaches too. Here Alexei Hay shows kids whose rooms are sanctuaries of pop-culture stuff. —K.R.

**LAUREN GREENFIELD**

Annie Kieren, Hannah Zumberge, and Alli Deckas add the finishing touches, Edina, Minnesota.

Whether you think clothes are important sort of places you in a group. If you think clothes are important and you like being well dressed or you like dressing a certain way, that could put you in a group. Our group sort of has their own kind of fashion. We shop at about six different stores and we all kind of keep up with the trends. The makeup thing sort of puts you in a group, too. Our group tends to wear a lot more makeup than other people. I want to look not generally old but just nice-looking. —HANNAH ZUMBERGE, 1998

Lauren Greenfield has the ability to go straight to the heart of what's going on socially in a situation. Looking at these upper-middle-class girls, you know immediately the story is—clothes, hair, looks—even without hearing from them. —K.R.

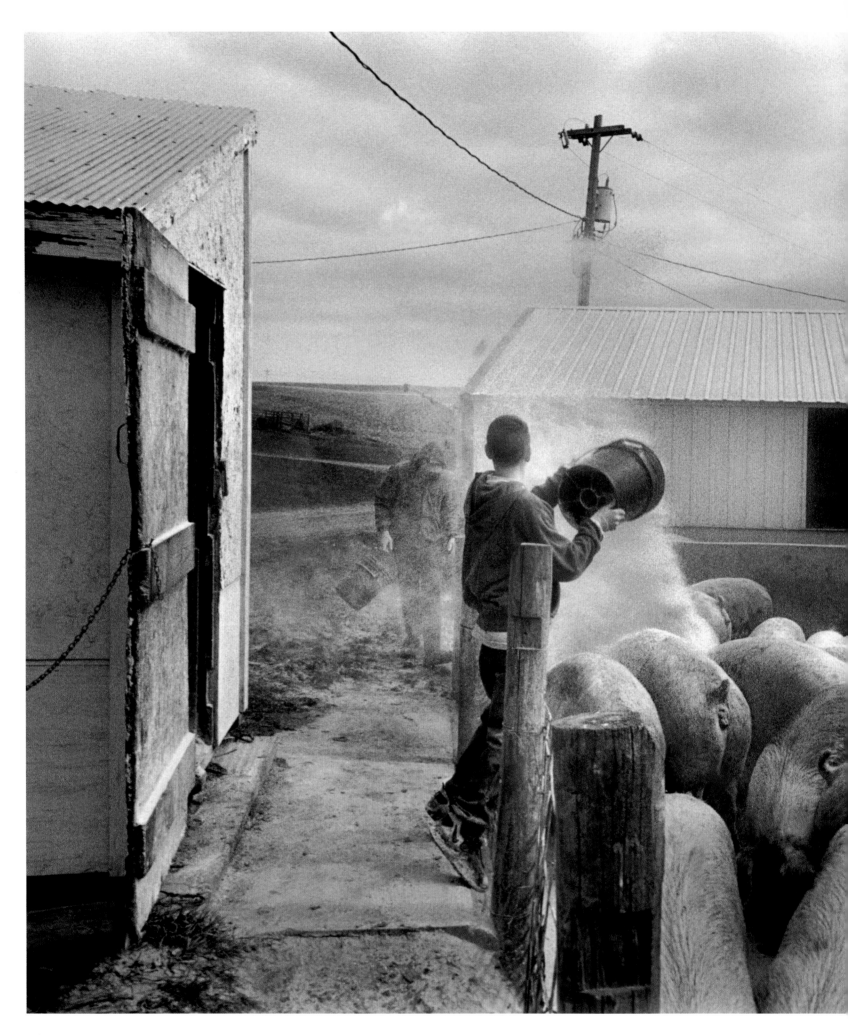

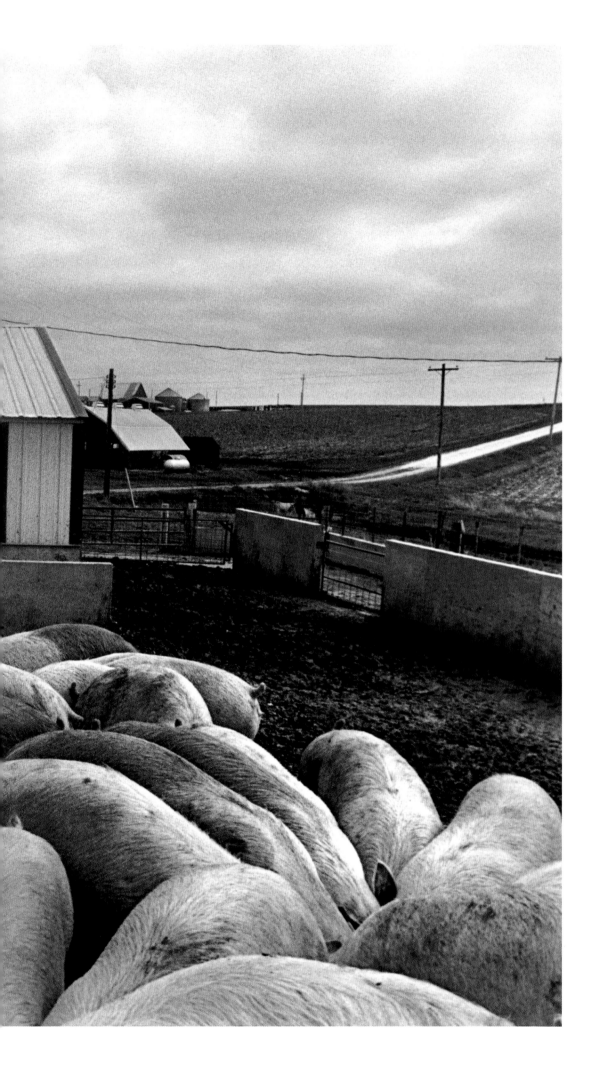

## LARRY TOWELL

Eric Eischeid on his family's farm in west-central Iowa.

I like living in the country because you can be outside all the time and there's always something to do. The bad part is that you have to work so much. You're expected to do a lot of work when you grow up on a farm. Going to church and serving at Mass is important to me because that's the way I was raised. —ERIC EISCHEID, 1998

Larry Towell brought a poetic, photo-journalistic eye to this image of a working farm boy. It was an important element to balance the many styles in this issue. —K.R.

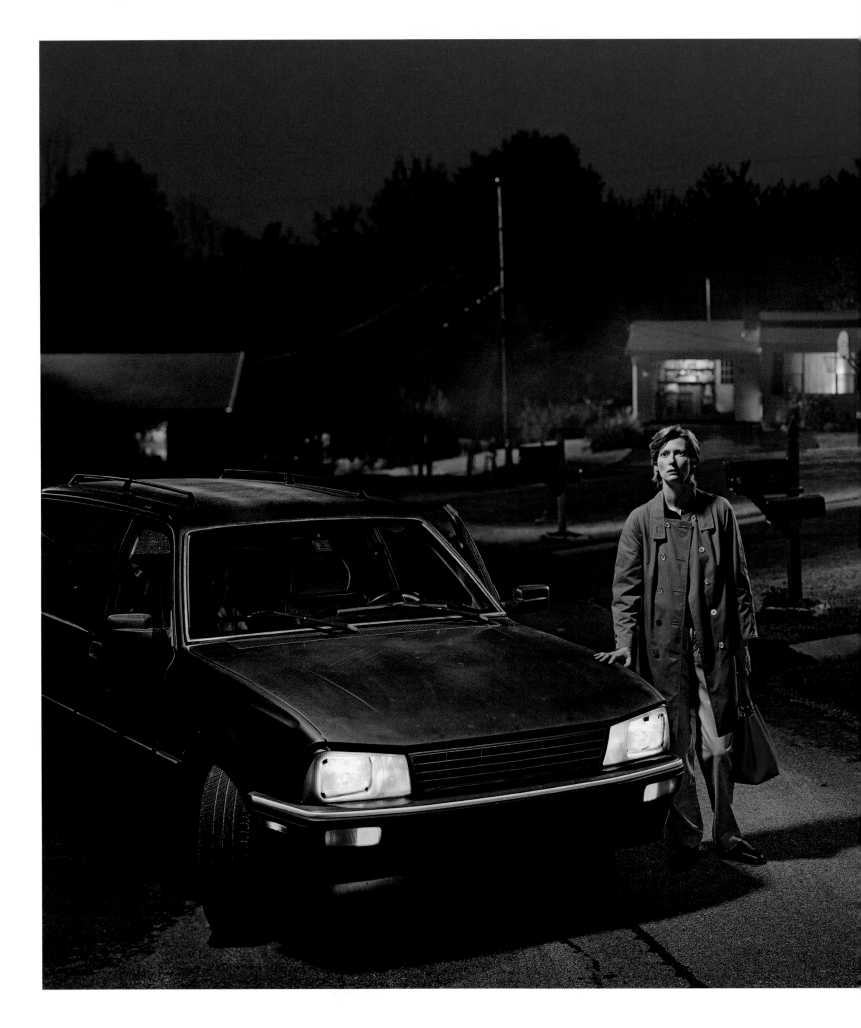

## GREGORY CREWDSON

# dream house

published November 10, 2002

For the project "Dream House," Kathy Ryan ambitiously paired Gregory Crewdson, a well-known art photographer, with a group of eminent film actors. Ultimately, the project functioned both as a series that is very much in keeping with Crewdson's distinctly mysterious sensibility and as an innovative form of celebrity portraiture. Crewdson remarked of the experience: "There was definitely something in each person that I responded to in creating their story . . . I liked the idea of inverting that sense of celebrity, playing off of and defamiliarizing their images."

The actors Tilda Swinton, Gwyneth Paltrow, Philip Seymour Hoffman, Dylan Baker, Julianne Moore, William H. Macy, and Agnes Bruckner all gathered at an uninhabited house that the photographer had discovered in Rutland, Vermont. During the session, Crewdson, who often works much as a film director does, gave very precise instructions to the performers, costuming and positioning them carefully in order to evoke the particular mood he desired for each image. The actors were extremely cooperative—most of them gave a full day to the project (rather than the usual three or four hours a normal shoot requires), and all agreed to travel to Vermont from wherever they were based. Still, Crewdson recalls, it was an unusual session for even the most experienced among them: "They were used to other kinds of narrative that go through time with dialogue and motion. Here, it's all condensed into a single moment, a mute moment, so my basic instruction was, 'Less, less, less,' because you don't need much at all."

Tilda Swinton.

Tilda Swinton really feels like a presence from another place. I wanted to make a picture that captures that sense of her that is absolutely inviting and yet otherworldly. —GREGORY CREWDSON, 2002

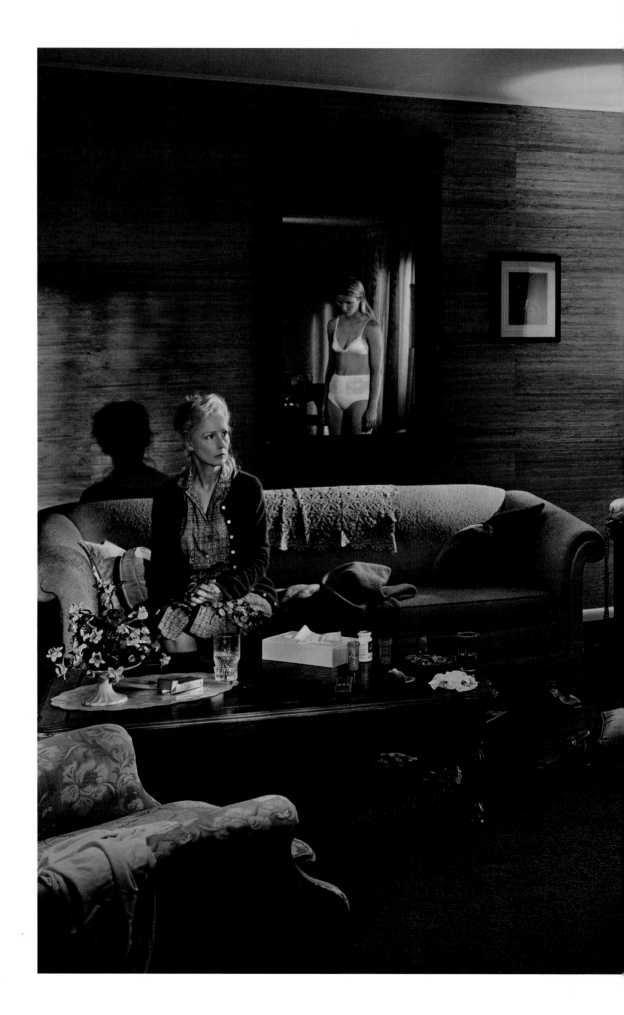

Gwyneth Paltrow.

Gwyneth Paltrow was the first picture we took. I was nervous. She told me: "Whatever you want to do is fine." This is a moment when a mother looks up to see the daughter in this dowdy underwear. I wanted it to be shameful in a sense. —GREGORY CREWDSON, 2002

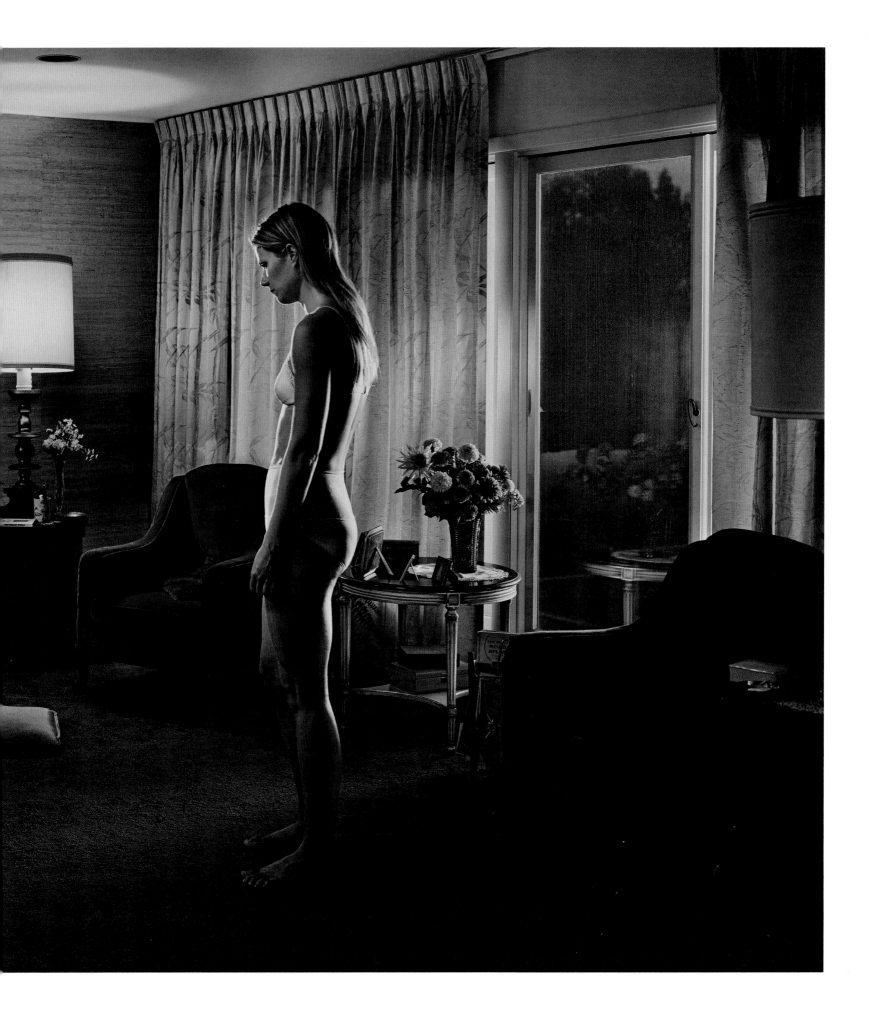

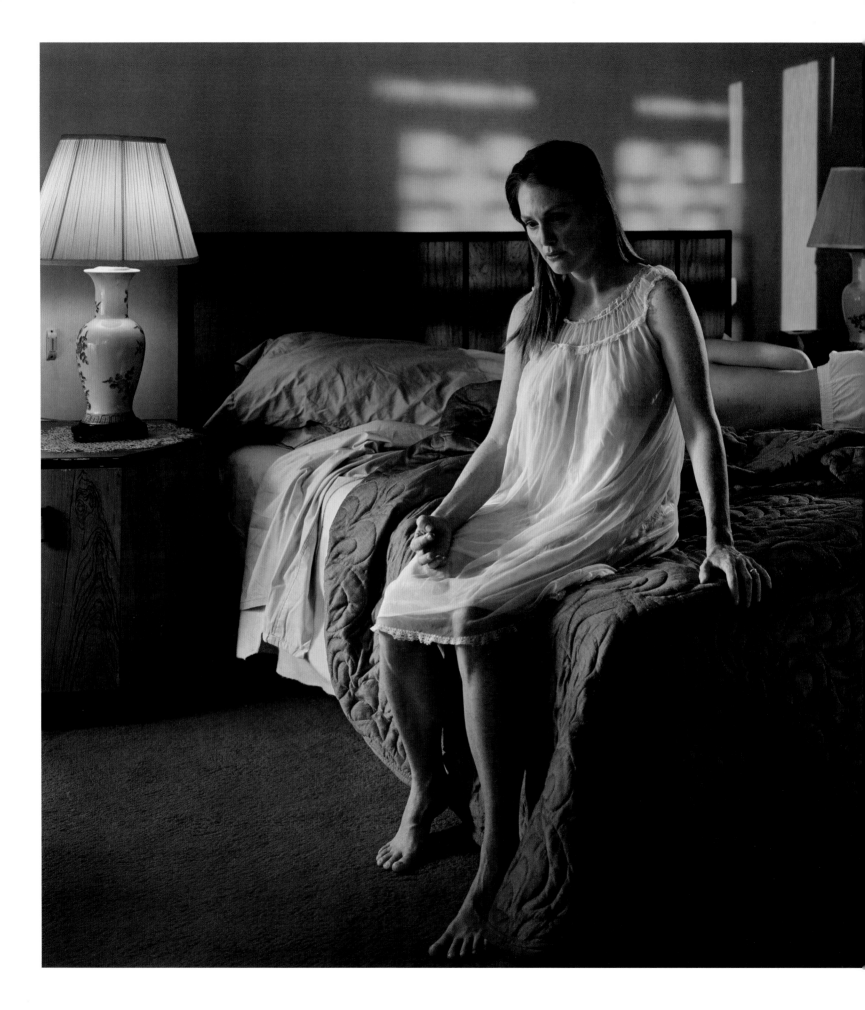

Julianne Moore.

I knew that Julianne Moore had just given birth a few months before. She's looking at her finger, and there's a little droplet of milk on it. This picture is playing off her biography; at the same time, it transcends that. —GREGORY CREWDSON, 2002

William H. Macy.

When I saw William H. Macy, I saw this image: his character's sadness and rage. It's a perfect world that's a failed moment, too. We had a fire truck with firemen spraying water for the rain. It creates this element of nature and cleansing. —GREGORY CREWDSON, 2002

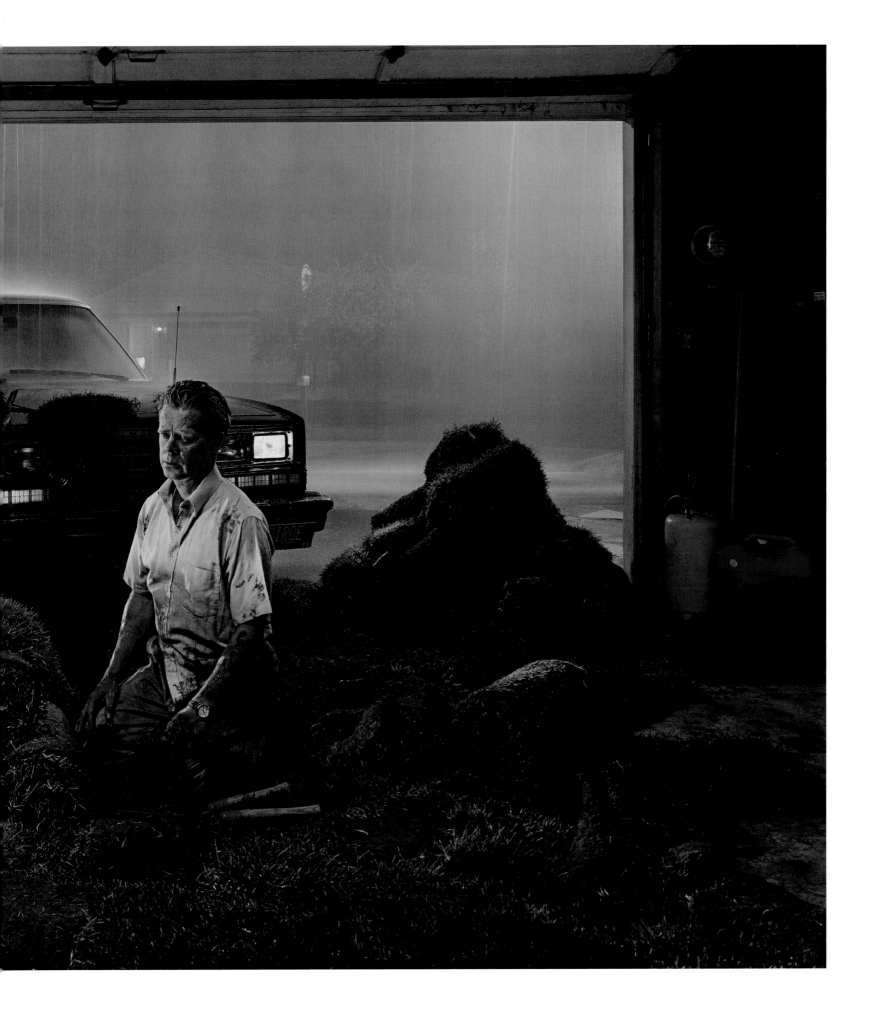

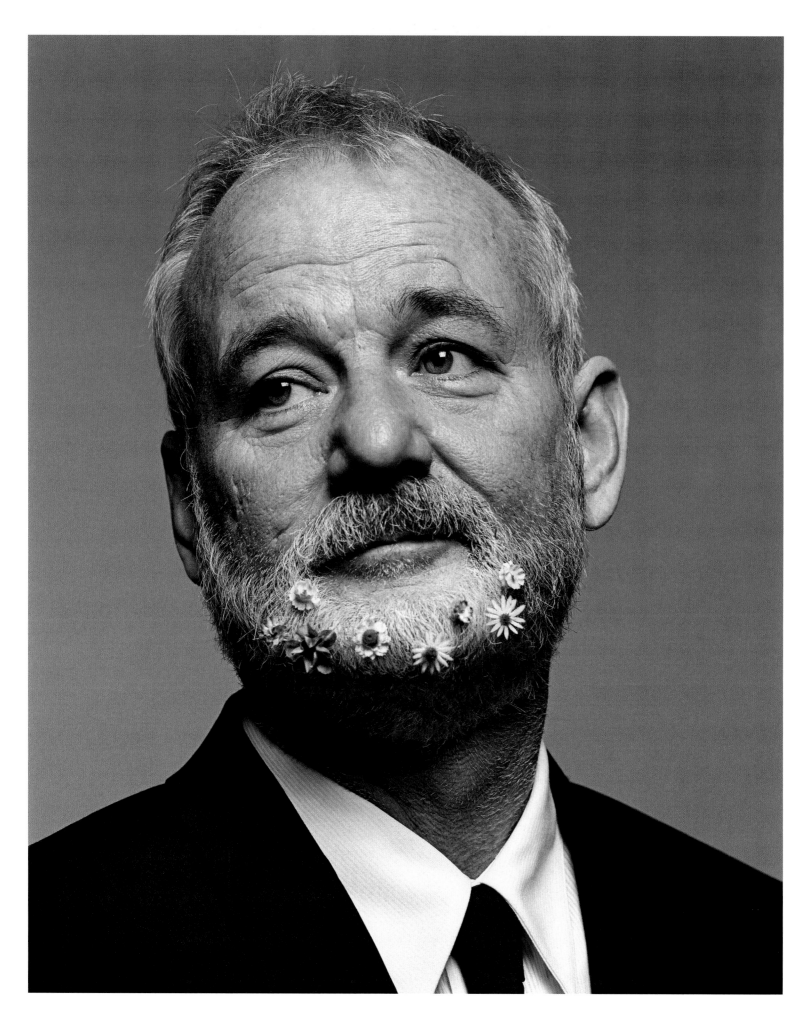

## INEZ VAN LAMSWEERDE AND VINOODH MATADIN, PAOLO PELLEGRIN

# great performers

published 2004–2010

Every year, from 2004 to 2010, the *New York Times Magazine* ran a portfolio of portraits of some of the actors who had given outstanding performances in recent films. These "Great Performers" projects—initiated with writer Lynn Hirschberg—were produced by the creative team of Janet Froelich, Arem Duplessis, Kathy Ryan, Kira Pollack, and Joanna Milter. The first three "Great Performers" projects were undertaken by Inez van Lamsweerde and Vinoodh Matadin; subsequent portfolios have featured work by many talented photographers, including Ryan McGinley, Hellen van Meene, Rineke Dijkstra, Richard Burbridge, and Paolo Pellegrin.

Pellegrin and the duo van Lamsweerde and Matadin make for a particularly interesting contrast, operating as they do in distinctly opposing modes.

Van Lamsweerde and Matadin are maximalists: when they are shooting, they work with a vast amount of gear and a coterie of a dozen or so people—including a lighting assistant, a hair and makeup team, a stylist, a manicurist. This extravagant setup is, in fact, necessary to their work, because their assistants and battery of equipment allow the artists to *craft* their portraits, to sculpt and render images that are deeply consequential in an aesthetic way. With van Lamsweerde and Matadin, a subject may walk into a shoot an ordinary mortal, and within minutes the pair has sussed out what is the most physically beautiful or intriguing thing about the person, and have determined a way to bring that element to the fore in a portrait.

Pellegrin, by contrast, is the consummate minimalist in both visual approach and technical apparatus. A celebrated photojournalist who has spent most of his time covering wars and conflicts, he is utterly pragmatic: working alone, ready to improvise, thinking quickly and moving spontaneously. He doesn't bring in a complex of lights and umbrellas to a shoot—indeed, he is often content with the illumination of a single bulb or natural light on the person in front of his lens. He is a *seeker* of images, who circles his subject until he spots what he wants and then clicks the shutter. This incongruous pairing of a photojournalist who is fully at home in war zones and areas of devastation with the rarefied world of celebrity portraiture might be considered a risky mix. But Pellegrin's very simplicity of mode, combined with his sensitive eye, make for extraordinary and very dramatic portraits.

## INEZ VAN LAMSWEERDE AND VINOODH MATADIN

Bill Murray, after his appearance in *Lost in Translation* (Sofia Coppola, 2003). Published February 29, 2004.

There's a sort of heaviness and lightness about Bill Murray as an actor. So when we were photographing him, I thought: "How do we express that?" The answer came intuitively.

I said to him: "I'm going to put flowers in your beard." And I started putting them in—I didn't discuss it with him, I just did it. I remember him looking at me while I was doing it, and he said: "Does anybody ever ask you *why*?" And I remember replying simply "No"—and that was the end of that. So he just took it, because my reply was very frank, and there was no way around it. I wasn't trying to talk him into anything, so he just went for it and played along. —INEZ VAN LAMSWEERDE

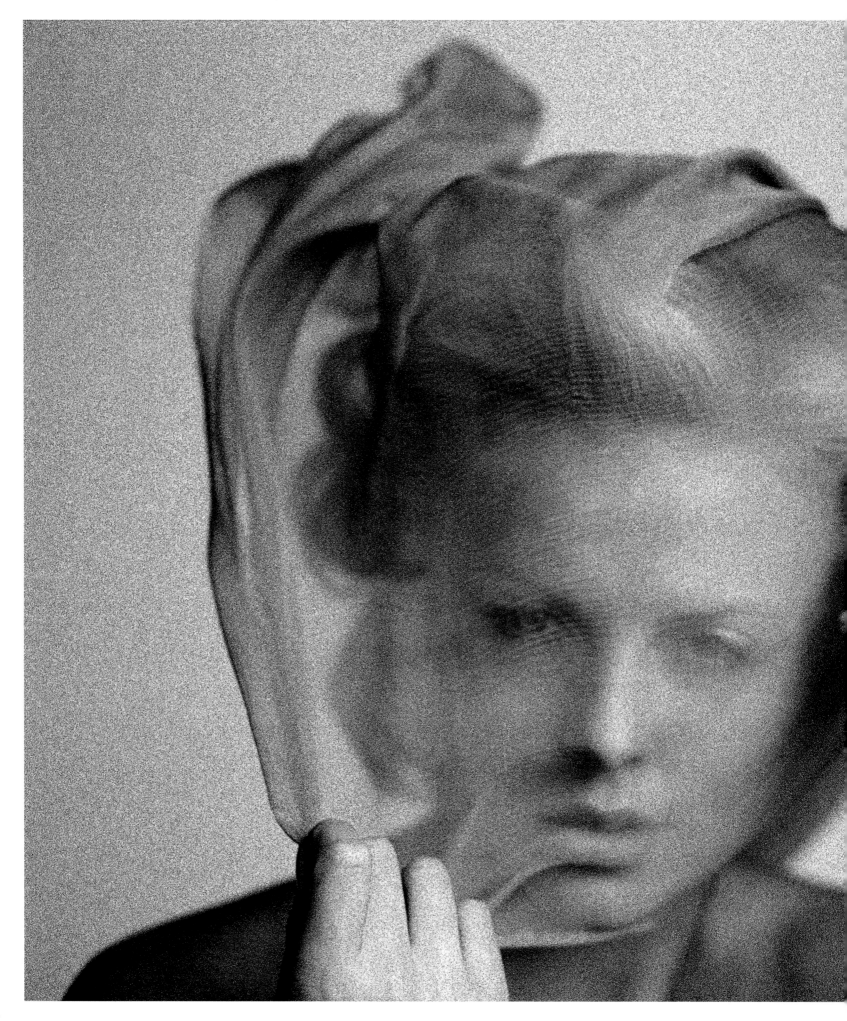

**INEZ VAN LAMSWEERDE AND VINOODH MATADIN**

Charlize Theron, after her appearance in *Monster* (Patty Jenkins, 2003). Published February 29, 2004.

With some of the "Great Performers" portraits, we hadn't yet seen the movies the actors had starred in when we photographed them. With Charlize Theron, we had a vague concept of what that movie *Monster* was about—so we wanted to make an image that was about *hiding* her beauty. That's how we came to the scarf idea. When you use a wind machine, you need to be lucky to capture the right moment, when the scarf is just absolutely at the right place. Also, Charlize is so elegant and knows how to control her body: she knew how to play with the pose and go for it.

I think for her it was probably a welcome alternative to having to sit there with pretty makeup on and perfect hair. That is something we learned while doing these "Great Performers" pictures: actors like to *do* something. They don't like to just be themselves. The more they can step away from who they really are, the better. —INEZ VAN LAMSWEERDE

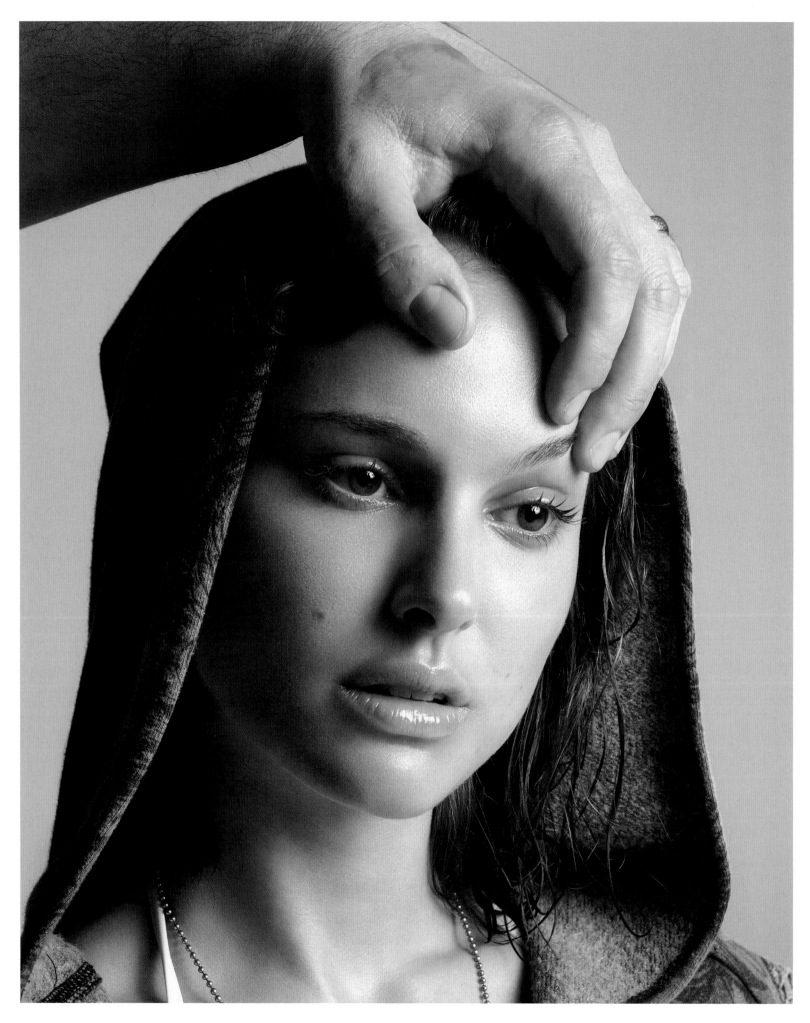

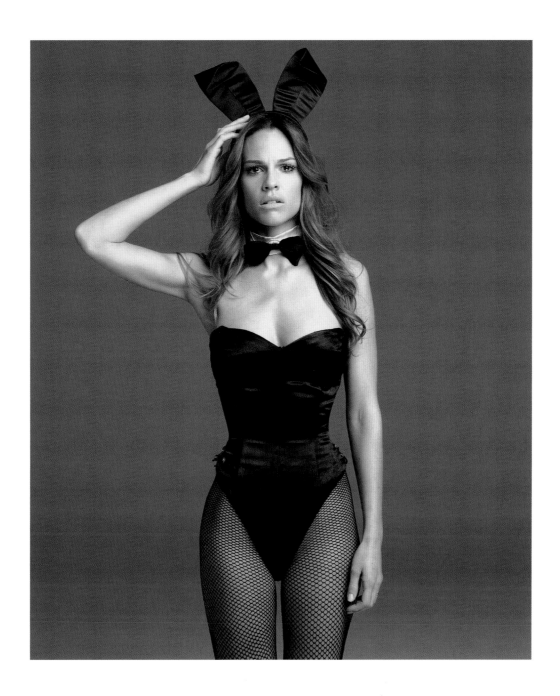

## INEZ VAN LAMSWEERDE AND VINOODH MATADIN

**OPPOSITE:** Natalie Portman, after her appearance in *Closer* (Mike Nichols, 2004). **THIS PAGE:** Hilary Swank, after her appearance in *Million Dollar Baby* (Clint Eastwood, 2004). Both photographs published February 27, 2005.

The portrait of Natalie Portman has to do with religious imagery, which was a very strong presence in Vinoodh's life and mine as we were growing up in Holland. The hood makes a reference to Mary, and the hand is like Hand of God—it could be an Annunciation. She's not looking into the camera. I think if she had, the whole thing would have been different.

With Hillary Swank, we felt that *juxtaposition* was the way to go. She was so strong in *Million Dollar Baby*, and also in *Boys Don't Cry*—we wanted to show her here as vulnerable, in the Playboy bunny outfit. —INEZ VAN LAMSWEERDE

## INEZ VAN LAMSWEERDE AND VINOODH MATADIN

Clint Eastwood, who directed and acted in *Million Dollar Baby* (2004). Published February 27, 2005

The way a face is structured—that strikes me as the thing to focus on, that makes the picture—whether it has a strangeness, or something that's exquisite, or something that's cruel . . . I always look for something with a beauty to it, but at the same time with some other side that might reveal something else.

I try to find that thing. It usually comes to me right away. The moment someone walks in, I see it and I zero in on it.

With Clint Eastwood, we had tested out our smoke machine: it was supposed to produce a little stream of perfect puffs, like a message from God or something. Everything was figured out. Of course, the moment Clint stepped in front of the camera an *avalanche* of smoke came pouring out. We were so scared that he would get angry or freak out, but thank goodness, he just stayed where he was, and we were able to get him like that— emerging from the smoke. It ended up looking (at least in my mind) more like the image of God, in a way, than the other way around, which made for a much stronger picture. —INEZ VAN LAMSWEERDE

Lynn Hirschberg was very instrumental in selecting the actors to be photographed for the "Great Performers" portfolios. We went for a real range of people that we admired—not only people we had to do, but people we wanted to do. I think that made page after page a really interesting editorial mix. —KIRA POLLACK

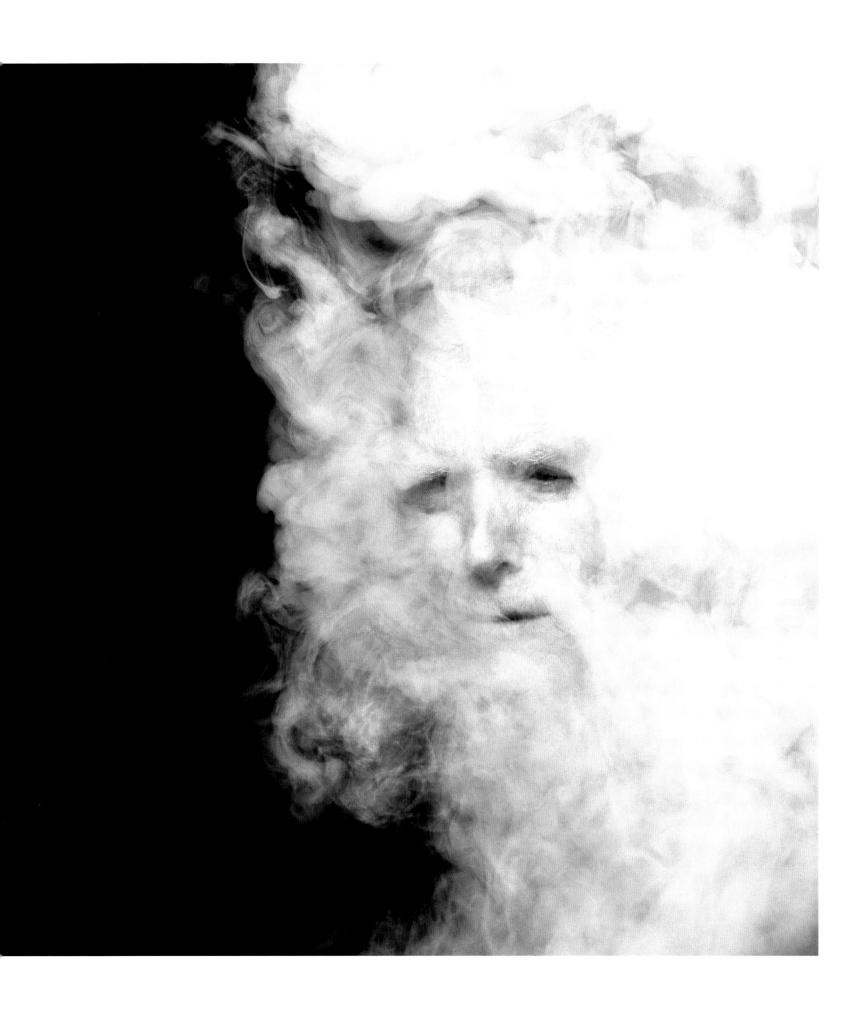

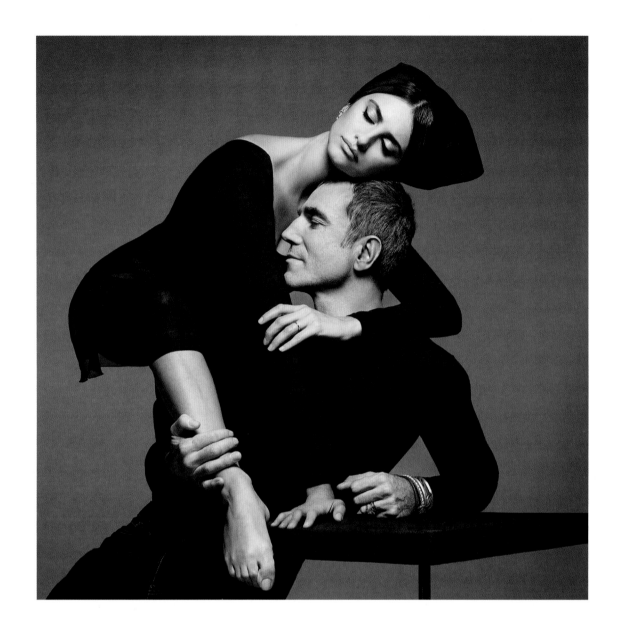

## INEZ VAN LAMSWEERDE AND VINOODH MATADIN

Penélope Cruz and Daniel Day-Lewis, after their appearance in *Nine* (Rob Marshall, 2009). Published February 21, 2010.

We photographed Penélope and Daniel when the film *Nine* had just come out. The movie is so much about performing and dance—we wanted the image to show something happening between their bodies—to make a shape with two bodies that just happened to have the heads of two great actors. So it is a portrait but at the same time there is a graphic shape in the black-and-white that is interesting. It's not just two pairs of shoulders, but an image about the body and about togetherness. —INEZ VAN LAMSWEERDE

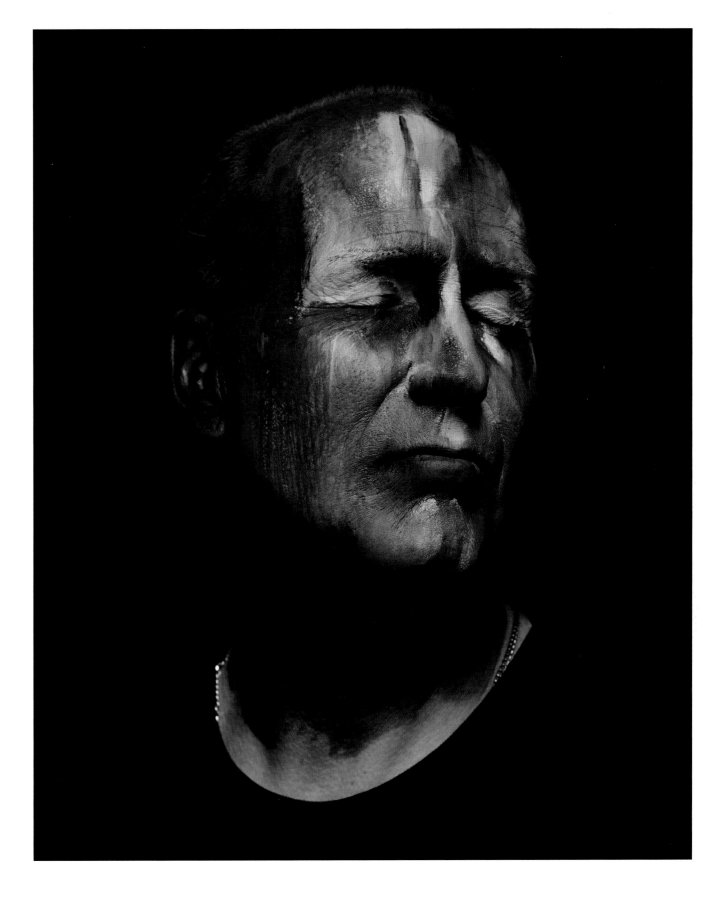

## INEZ VAN LAMSWEERDE AND VINOODH MATADIN
William Hurt, after his appearance in *A History of Violence* (David Cronenberg, 2005). Published February 19, 2006.

For a long time, we had wanted to make an image based on Francis Bacon's painting of the life mask of William Blake. William Hurt has the right face for it—and we felt he would understand it. When we told him what we wanted to do, he said: "Oh, my God: Bacon and that image of Blake! It's everything I love." He got it right away. —INEZ VAN LAMSWEERDE

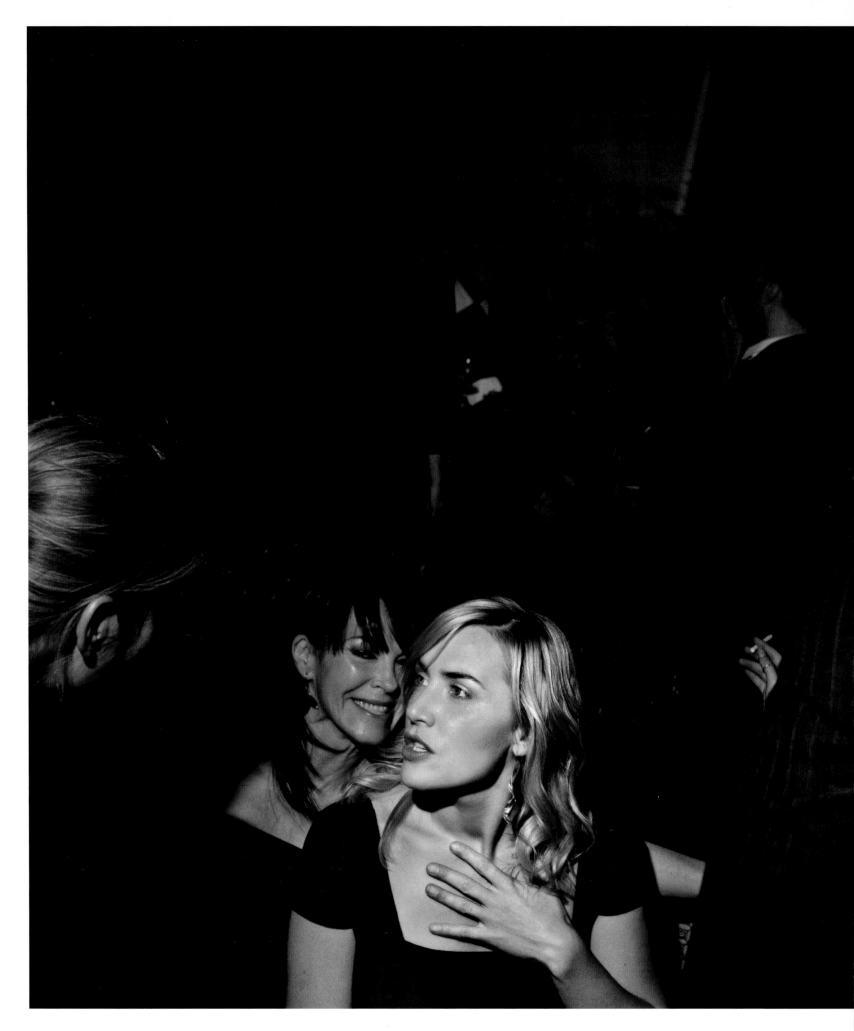

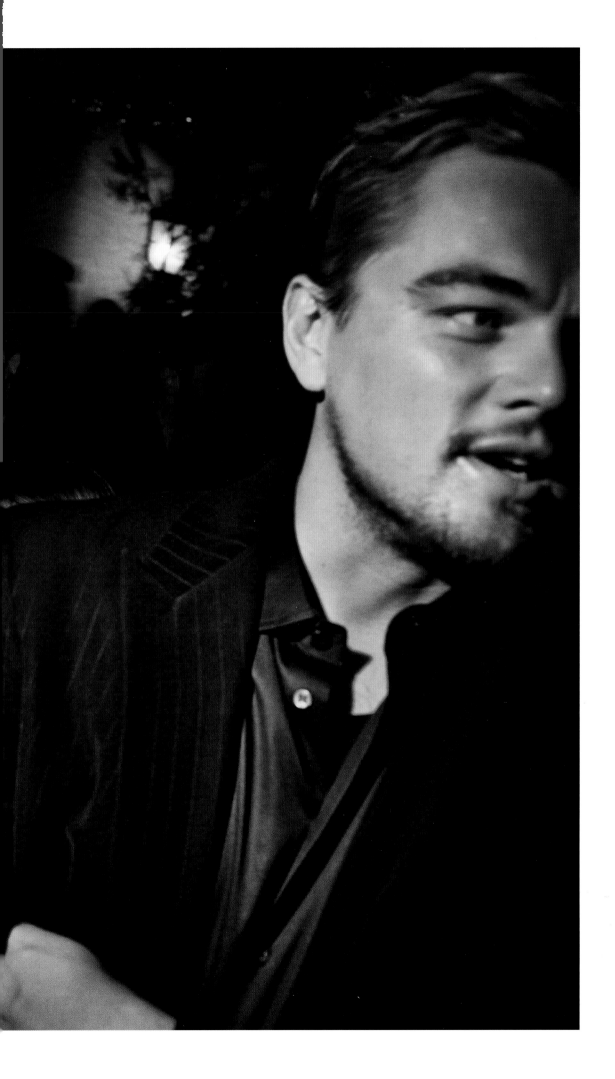

**PAOLO PELLEGRIN**

Kate Winslet and Leonardo DiCaprio (with Winslet's agent Hylda Queally) at the Chateau Marmont, Los Angeles. Winslet starred in *The Reader* (Stephen Daldry, 2008) and performed with DiCaprio in *Revolutionary Road* (Sam Mendes, 2008). Published February 8, 2009.

A party scene is a very unhappy situation for a photographer. In a sense, you are the predator, and you are just waiting for a moment, and you have few elements to work with. You use your skills to get the best possible image from that situation. —PAOLO PELLEGRIN

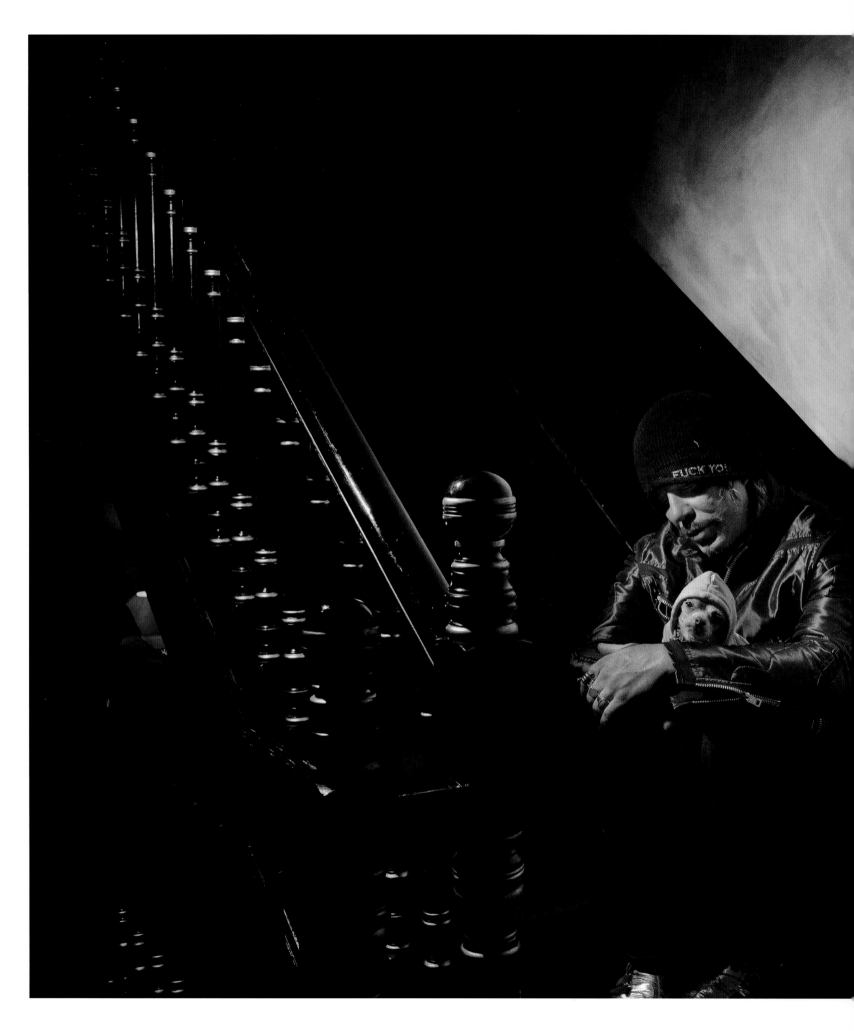

**PAOLO PELLEGRIN**

Mickey Rourke with his dog Loki at Blakes Hotel, London, after Rourke's appearance in *The Wrestler* (Darren Aronofsky, 2008). Published February 8, 2009.

Maybe because of my humanistic background and interests, I am also interested in trying, as much as possible, to unmask these people, or to perceive a different side, which is less known, and also less controlled. These are obviously extremely public people, and extremely talented. They're professionals, and they can put on their public persona and be exactly what we think they are. So the tension and adventure of the "Great Performers" project was to try to have an awareness of this mechanism, and to see if it was possible to dig a little deeper.

Mickey Rourke had a mixture of force and fragility that I found quite irresistible.
—PAOLO PELLEGRIN

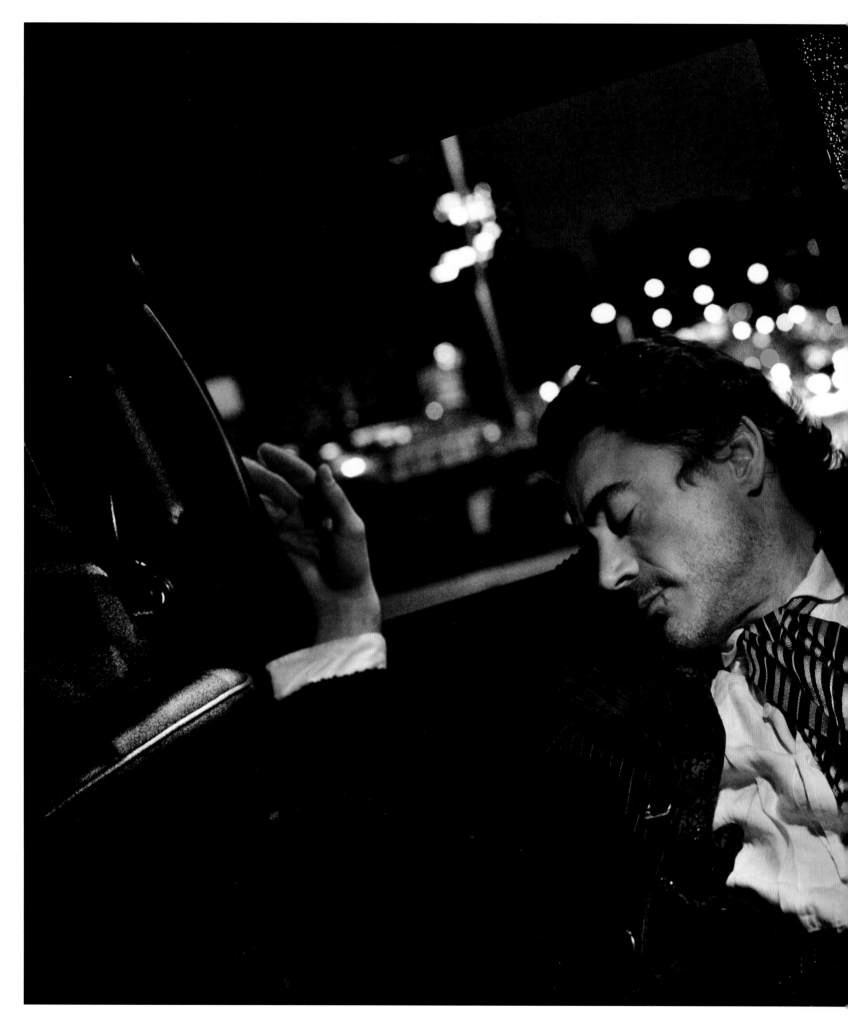

**PAOLO PELLEGRIN**
Robert Downey Jr. in London after a day of shooting
*Sherlock Holmes* (Guy Ritchie, 2009). The actor had
been featured in 2008's *Iron Man* (Jon Favreau) and
*Tropic Thunder* (Ben Stiller). Published February 8,
2009.

Robert and I spent the day together. He is a
very complex, intelligent guy. I think we kind
of connected well, so I ended up spending
much more time with him than originally
planned. This was at the end of the day, and we
were in his car on the way back to his hotel. He
was exhausted. Of course, he knows I'm in the
car—so there is a part of that awareness here—
but there's also another part, which is that I had
entered his space. —PAOLO PELLEGRIN

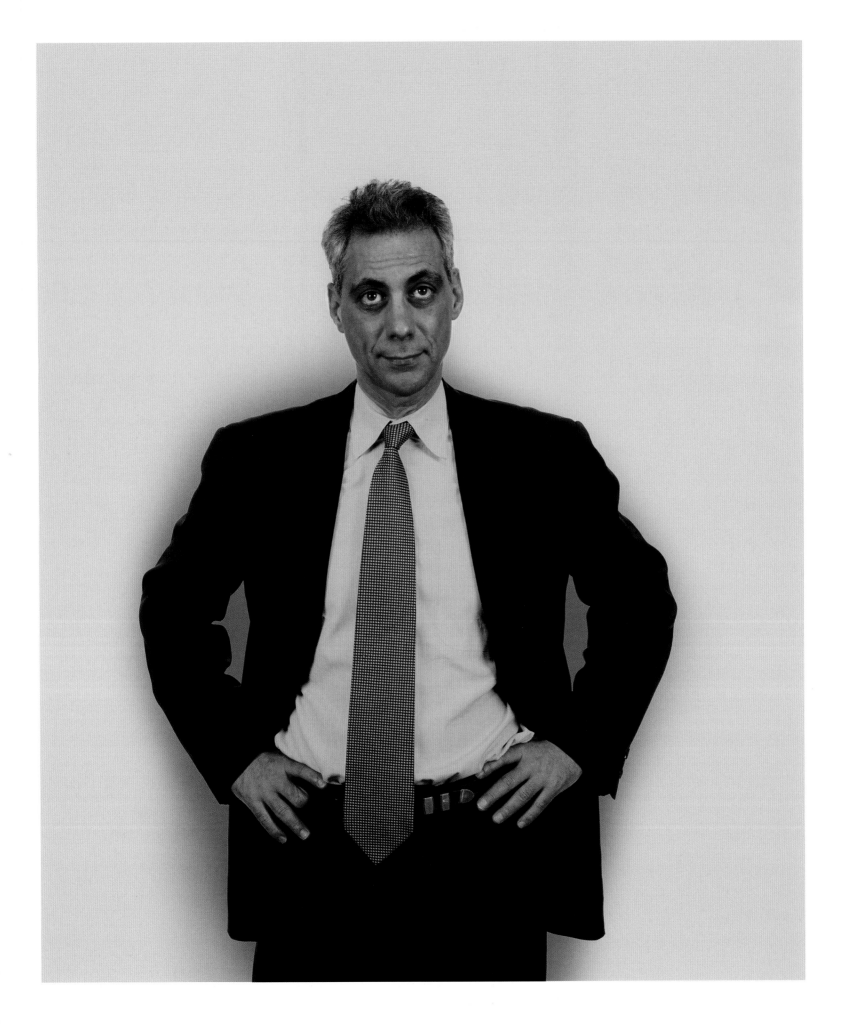

## NADAV KANDER

# obama's people

published January 18, 2009

In the spring of 2008, Gerald Marzorati, the editor of the *Magazine* at the time, envisioned that if Barack Obama were to win the upcoming presidential election, the new team in the White House would likely represent a spectrum of ages, races, and ethnicities unlike that of any previous administration in U.S. history. And he realized that *Times* readers would be very interested to have a look at this new lineup.

The *Magazine* staff began its plans for this photo-project—staff writer Matt Bai would write the text and help establish contact with the many subjects, Nadav Kander would make the portraits, and Kathy Ryan, Kira Pollack, and Stacey Baker of the photography department would scramble to make it happen. Ultimately, design-director Arem Duplessis would conceive and coordinate the overall look and presentation of the project.

However, as with any horserace, the outcome of the election could not be determined beforehand. The *Magazine* staff might guess or project who the winner would be, but they were unable to dive into this formidable project until the results were officially announced on Election Day. This ambitious photo-essay— which ultimately entailed rounding up and photographing no fewer than fifty-two extremely busy people— would thus have to be put together between November and early January (with the usual two-week break in Washington, D.C., for winter holidays) in order to be published before Inauguration Day on January 20, 2009.

The frenzy began in November 2008, just after Election Day. Shoots were organized as quickly as members of the new administration were named. Kander summoned all the dexterity assimilated in his many years as a portrait photographer, sometimes shooting up to thirteen people in a single day. In an effort to personalize each photograph, sitters had been asked to bring in clothes or objects they might have at a White House meeting (Ken Salazar gamely sported a cowboy hat, and Eugene Kang, Obama's young assistant, brought out the notebook in which he kept track of all the president's phone calls and appointments). Some subjects, such as Nancy Pelosi, had sat for many portrait sessions; for others, it was a first experience being photographed this way. Kander was able to size up his subjects quickly and expertly, and to convey them all in a remarkably honest and captivating way.

"Obama's People" was published January 18, 2009, two days before President Obama's inauguration.

Rahm Emanuel, White House Chief of Staff.

We shot the whole thing in thirty-minute time slots. We worked in whatever settings were most convenient for the subjects, so they could just be pulled in for half an hour, and then they were gone. Sometimes it would take Nadav ten minutes to shoot; sometimes twenty. Kathy's role was to be in the editing booth as the pictures were coming in; she was editing as he was shooting.

What was fascinating about this project was (a) the energy of the whole thing—which was just thrilling— and (b) the people in the room where Nadav was photographing didn't even know each other, although they were all part of this new team that was going to be running the country. They had never been on a team together before. And we knew people were curious about that. —KIRA POLLACK

I was so caught up in trying to make a great and enduring body of work that I almost missed what a moment in time I was playing a part in. It was humbling to feel that all my concerns and worries amounted to a pittance compared to what these guys deal with most days. It was a huge honor to be asked to do this portfolio. —NADAV KANDER

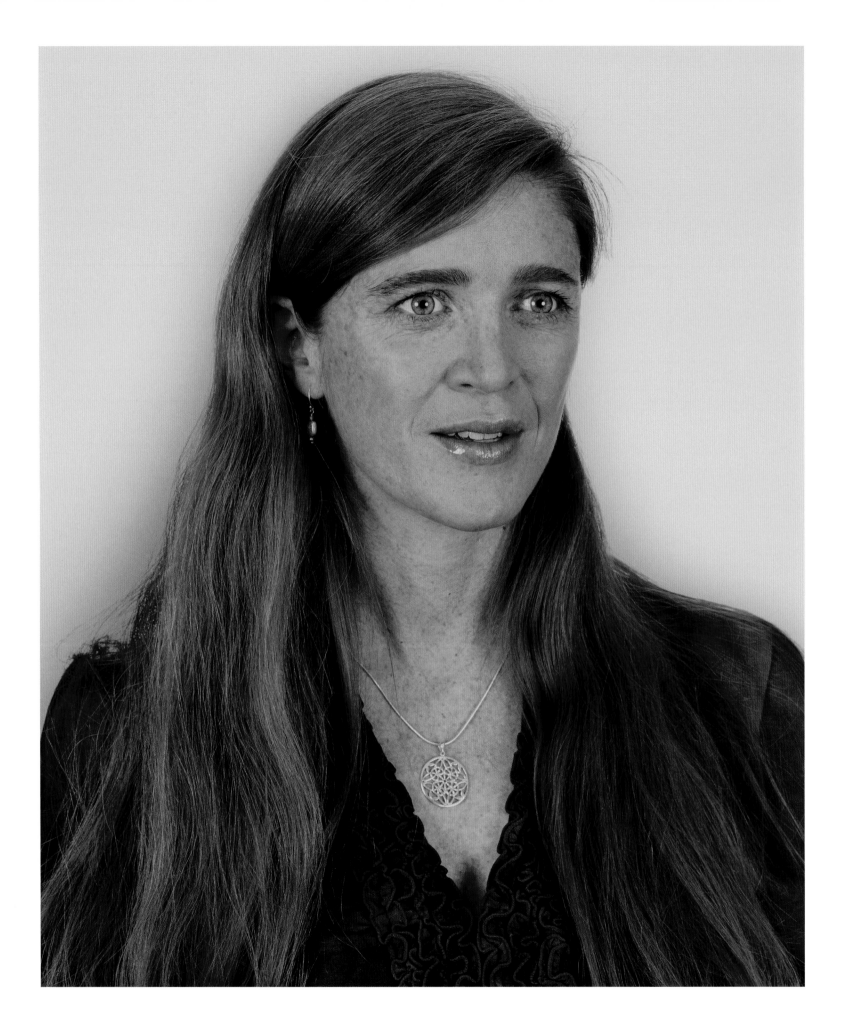

Samantha Power, Adviser.

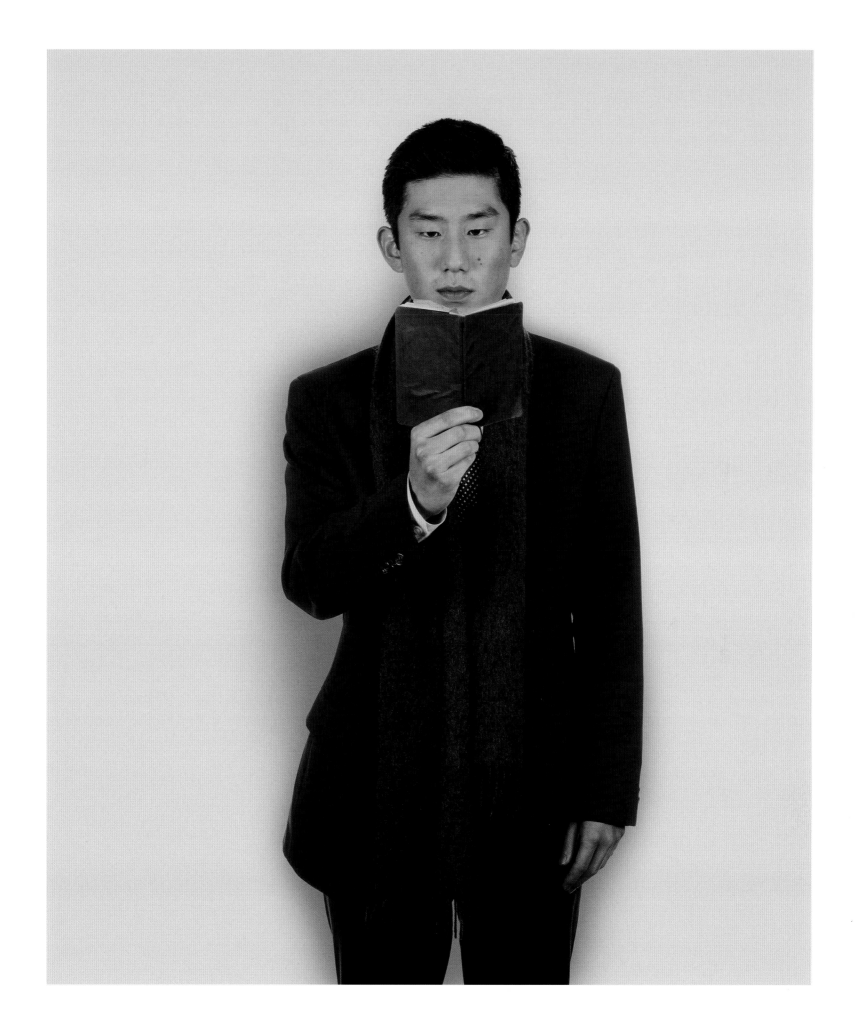

Eugene Kang, Special Assistant to the President.

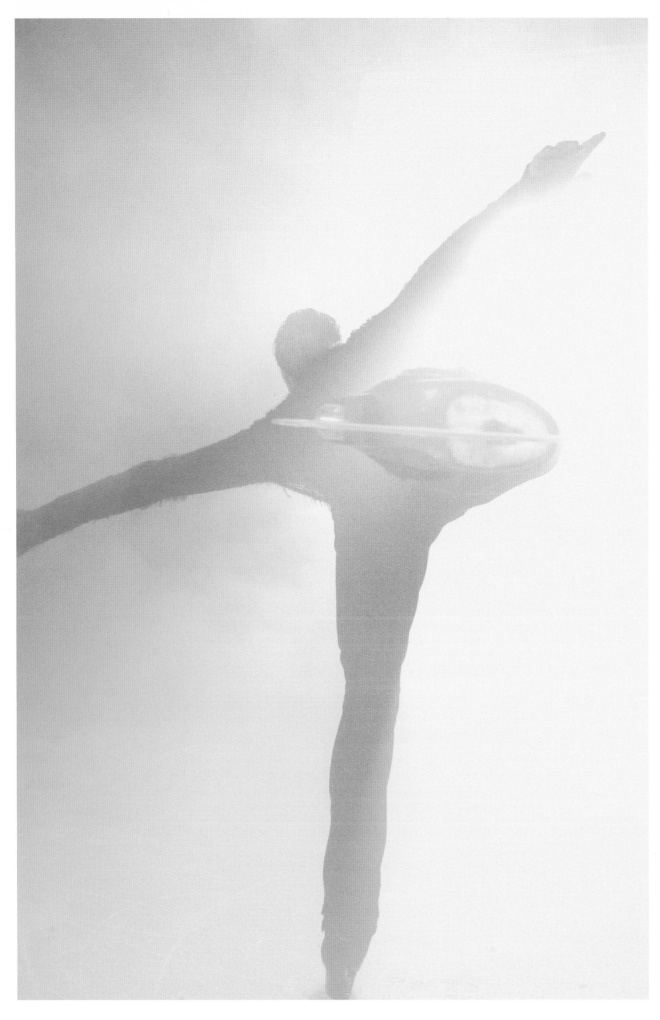

# RYAN McGINLEY

# olympic athletes

published 2004 and 2010

One of the greatest challenges for the *New York Times Magazine* is the constant need to reinvent the familiar. The Olympic Games, for example, take place every two years—winter and summer—and the Olympic athletes are photographed by hordes of image makers. What can a magazine do with athletes that hasn't been done before, that will show them in a new light and tempt readers to look twice?

Ryan McGinley has a unique understanding of the beauty of the human body, and has created two portfolios on athletes for the *Magazine*. A diligent researcher, McGinley has studied the history of photographs of people in motion and spends a great deal of time with his subjects: "When you're shooting athletes, it's a different world," he says. "All they do is eat, breathe, and sleep sports. So they really have no connection with the outside world."

In 2004 Kathy Ryan and Jody Quon visited McGinley at his East Village studio; upon seeing some underwater pictures he had made, Ryan invited him to work with Olympic swimmers. The photographs he produced for the *Magazine* are not standard "sports shots": instead of focusing on physical prowess or speed, they convey the actual sensation of the human body moving through water. In order to achieve this, McGinley entered the water himself and photographed from there—submerged and close to the moving limbs of his subjects. "I could hold my breath after that project for a minute," he says. "I was literally underwater for like two months straight."

During the 2010 Winter Olympics, Gerry Marzorati had the notion to show the athletes in midair. McGinley created a series of photographs of Olympians soaring—skiers, skaters, snowboarders—which was titled simply "Up!" For the shoot (which was coordinated by producer Clinton Cargill), the subjects were dressed in striking avant-garde outfits commissioned especially for this project from designers Laura and Kate Mulleavy of Rodarte. The resulting images are a synthesis of sports photography, style photography, and art. McGinley captured the athletes' dancelike gestures, the peaks of superhuman jumps. Skater Johnny Weir is seen in a midair pirouette against a smoky background "like something out of a children's book," says McGinley. And in an image that ran on the cover of the *Magazine*, skier Emily Cook is upside-down in a spectacular flip, which McGinley says she performed "maybe fifteen times" before he captured this extraordinary moment. "Basically, it was just like she was in the sky," he says. "There was nothing else around. It was like she was floating in the clouds."

Evan Lysacek, 2010 Olympic figure skater. From "Up!," published February 7, 2010.

Shooting Evan Lysacek, I got as close as I could. I remember my assistants saying: "You've got to pull back, man. That guy's ice skate is literally a foot from your head." I thought: "I don't care—I'll take one for the team if I have to, if it gets us a good photo!" And in this photograph, you feel the ice-skate blade going right over the camera—it's just cutting through the film almost. —RYAN McGINLEY

Michael Phelps, 2004 Olympic swimmer. From "Built to Swim: The Making of Michael Phelps," published August 8, 2004.

My initial idea with Michael Phelps was to take him out into the ocean to photograph him. We couldn't do that, but we ended up photographing him in a pool with black walls. That's why this is such an odd picture—it looks like he could be anywhere.

I actually raced him with fins on. It was like: "Let's see how fast he really is." So we raced, and he still beat me, even with fins on! I thought—this guy is just a *machine*. —RYAN McGINLEY

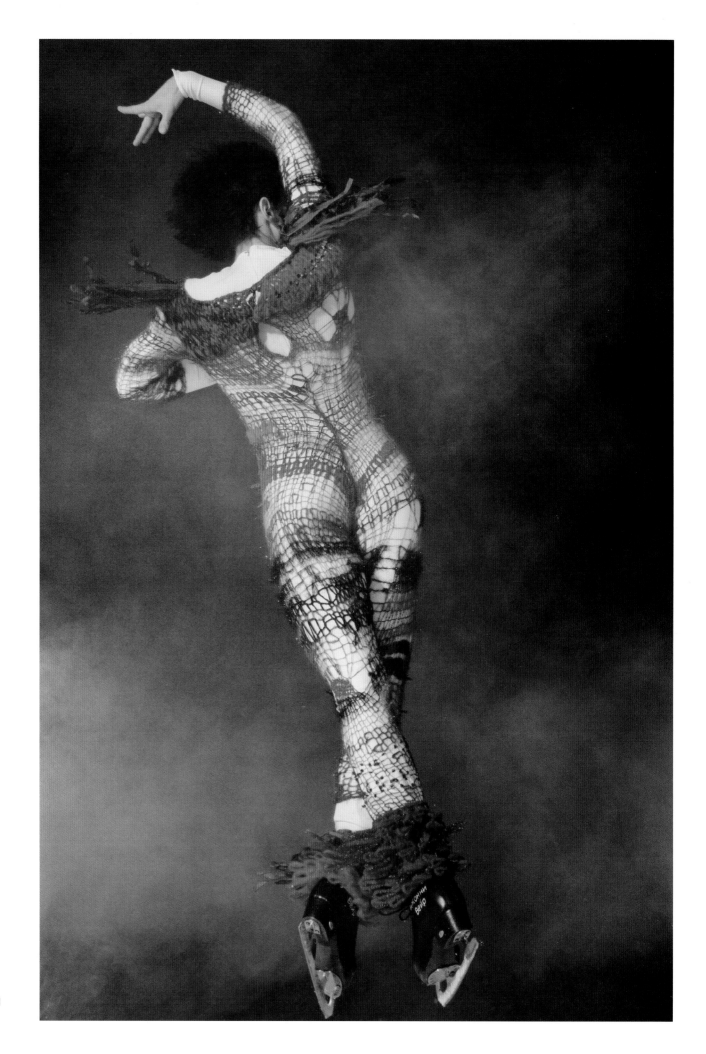

Johnny Weir, 2010
Olympic figure skater.
From "Up!," published
February 7, 2010.

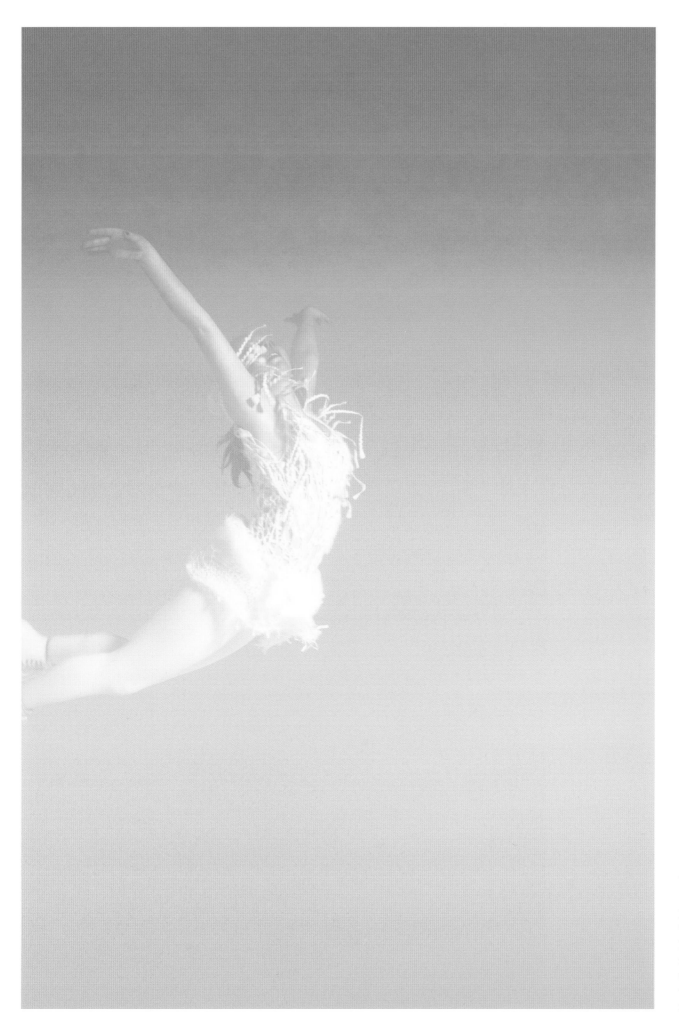

Rachel Flatt, 2010 Olympic figure skater. From "Up!," published February 7, 2010.

Ryan McGinley has that "otherness" of an artist. He has the ability to make lyrical, transcendent images when working on assignment for a magazine. —K.R.

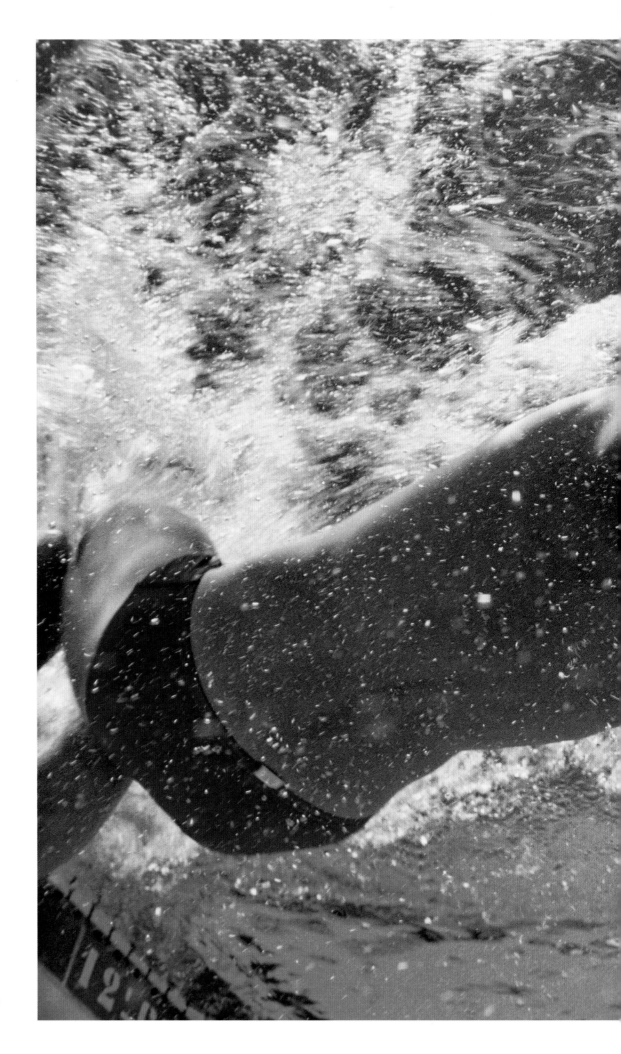

Lenny Krayzelberg, 2004 Olympic swimmer. From
"Everybody in the Pool: Photographs of the United
States Olympic Team," published August 8, 2004.

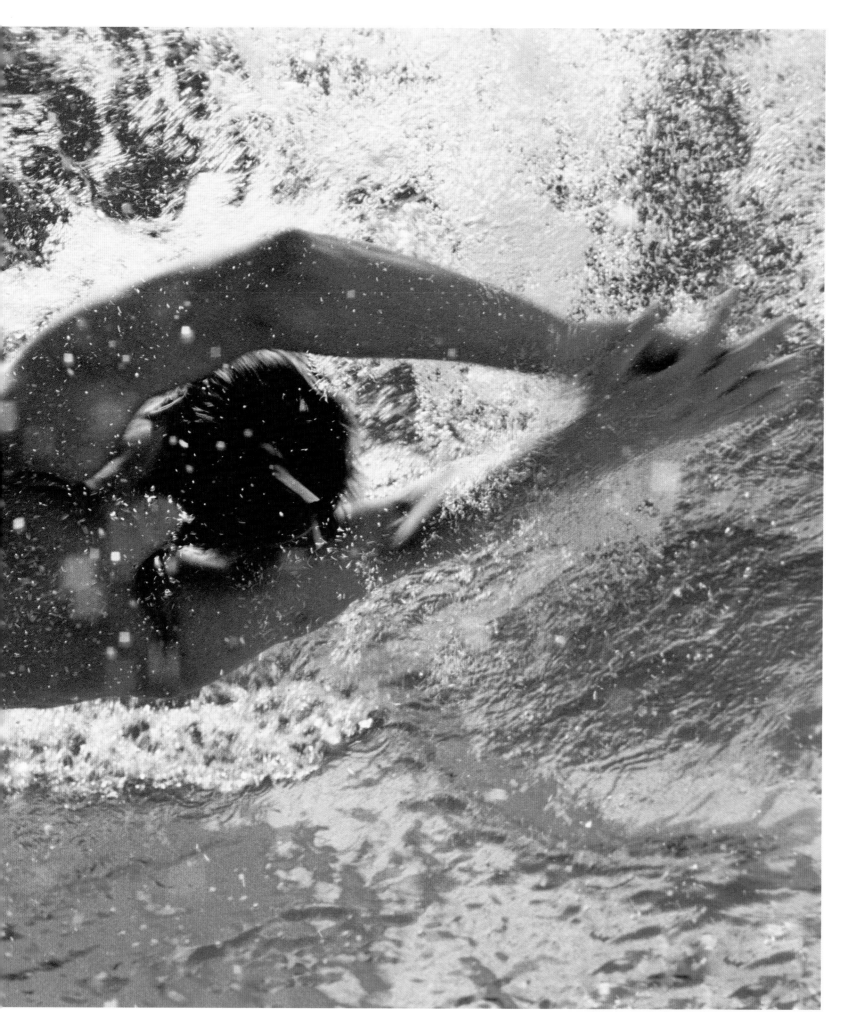

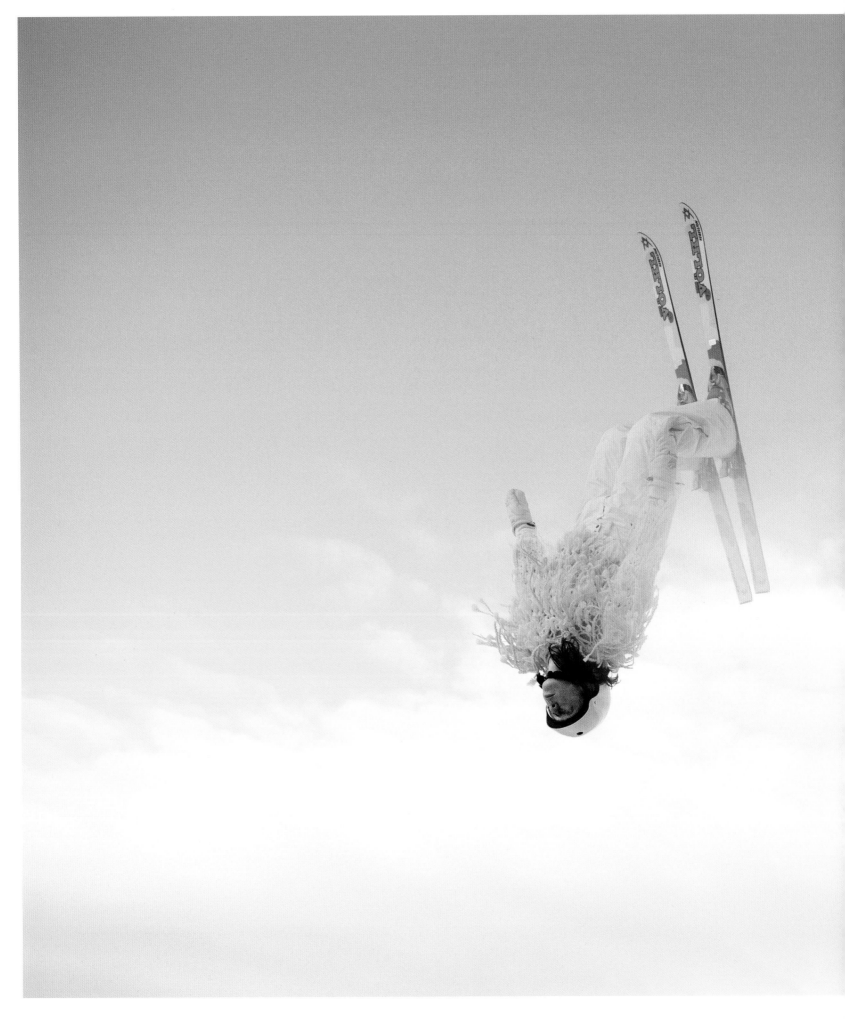

Emily Cook, 2010 Olympic freestyle skier (aerials). From "Up!," published February 7, 2010 (cover image).

It was just fascinating to watch these people do this sport. They literally shoot fifty feet in the air—they're so high up, it's amazing to watch. It's like a dream. It's what I dream about at night. —RYAN McGINLEY

**A** NEW GENERATION OF JUDGES AND OFFICIALS has declared all-out war on the Mafia in Sicily. The battle is being waged in the courts, in the political arena and in the streets of Palermo, Sicily's principal city. Two photographers, Letizia Battaglia from Palermo and Franco Zecchin, a Milanese, in the course of working for a Sicilian daily newspaper, L'Ora, joined the campaign, seeking to inform and educate the public about the Mafia. For the last six years, they have been documenting the violence and corruption synonymous with the Mafia and recording the arduous struggle to make justice, at long last, prevail on the island.

**SICILY AND THE MAFIA**

*Photographs by Letizia Battaglia and Franco Zecchin*

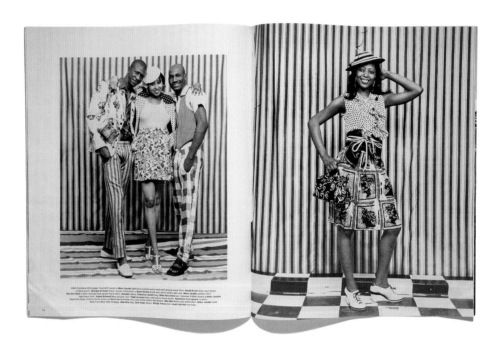

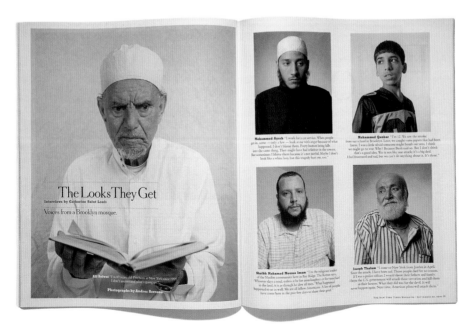

## The Looks They Get

Interviews by Catherine Saint Louis

Voices from a Brooklyn mosque.

*Photographs by Andres Serrano*

**Mohammed Ayesh**

**Mohammed Qanbar**

**Sheikh Mohamed Noman Imam**

**Joseph Thalam**

**TOP TO BOTTOM:** LETIZIA BATTAGLIA AND FRANCO ZECCHIN, May 18, 1986; MALICK SIDBÉ, April 5, 2009; ANDRES SERRANO, September 23, 2001.

# tearsheets

IN THE PRECEDING CHAPTERS OF THIS BOOK, the featured photographs are reproduced at a remove from the editorial framework in which they originally appeared: the *New York Times Magazine* layouts. There, most of them were supported by text and other photographs. The magazine pages were carefully designed and laid out and the typography chosen by designers; the size and sequence of images painstakingly argued over and decided. While each of the images in this volume has an undeniable strength in its singular state, the *Magazine* is a labor of accretion and synthesis: every page, and each element on every page, must function communally, enhancing and enhanced by its surroundings. The creation of that dynamic rhythm is the task of the art director; when the pieces are put together, the published result adds up to more than the sum of its parts.

The following pages, then, contain a selection of *New York Times Magazine* story layouts, reproduced in the context of their original publication and in chronological order, to give readers a sense of how these photographs worked on the page and in relation to other images. The art directors responsible for these layouts are to be credited, beginning with Ruth Ansel, who designed the *Magazine* through the 1970s, and moving forward with Roger Black, Ken Kendrick, and Diana LaGuardia, each of whom made an indelible creative

mark on the publication over the following years. The art director/creative director for the majority of the issues in this volume was Janet Froelich, whose sensibility and substantial talents literally shaped the *Magazine* from 1987 to 2009. Her successor is the *Magazine*'s current design director, Arem Duplessis, who brings to the pages a singularly innovative and elegant vision.

The earliest photo-essay in this volume is Susan Meiselas's seminal 1978 story "National Mutiny in Nicaragua," which marked what is arguably the first use of photography in the *Magazine* as something more than creative illustration: that is, as a powerful journalistic and narrative tool in its own right. Between Meiselas's searing investigation and the most recent layouts featured here—Jeff Koons's 2010 winsome "The Love That Dare Not Squawk Its Name"—are spreads that run a gamut of genres and subjects, from a revolution in hemlines to the very real devastation in New York after 9/11, from natural disasters to iconic baseball players to horrors in Somalia to the Supercollider to the daily lives of thirteen-year-olds, telemarketers, and women in the military.

All these stories and more were *news* in varied incarnations. And the photographs that appeared in the *New York Times Magazine* helped to make that news more comprehensible, more significant, more real to the *Magazine*'s audience.

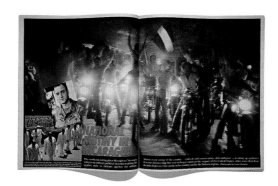

**SUSAN MEISELAS** July 30, 1978

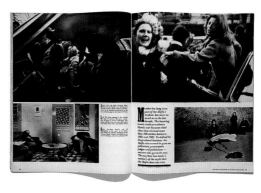

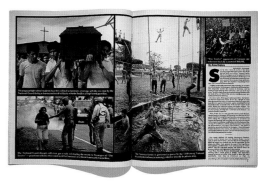

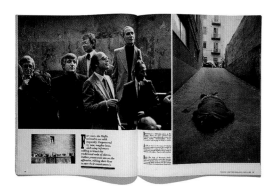

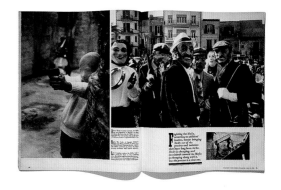

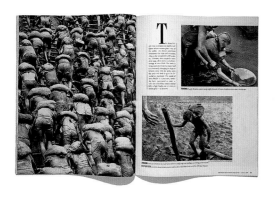

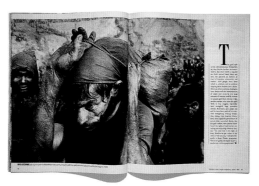

**ANTONIN KRATOCHVIL** April 29, 1990

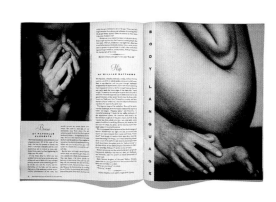

**SHEILA METZNER** May 5, 1991

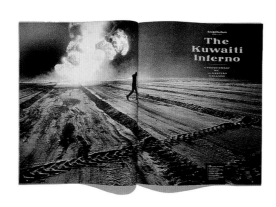

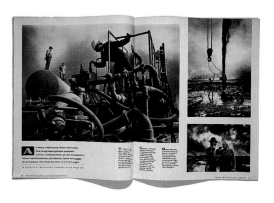

**SEBASTIÃO SALGADO** June 9, 1991

410

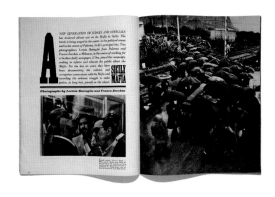

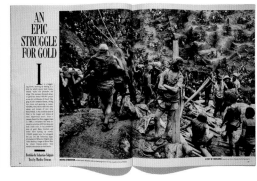

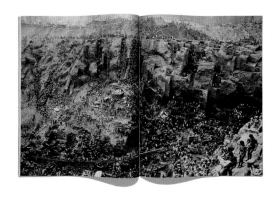

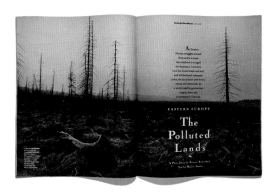
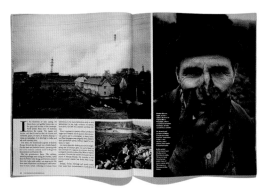
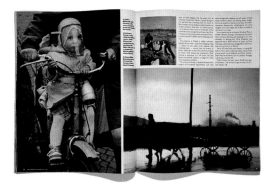

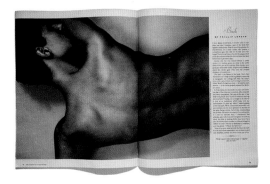
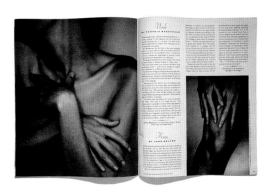

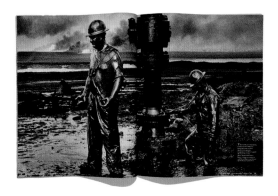
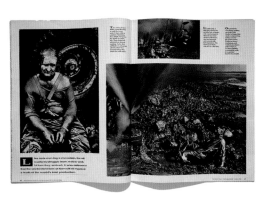

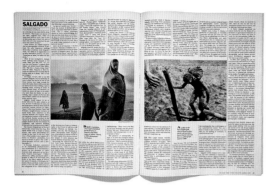

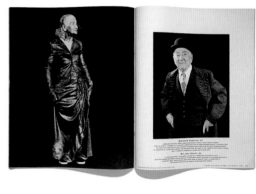

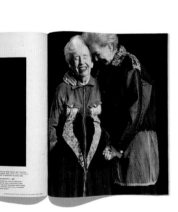

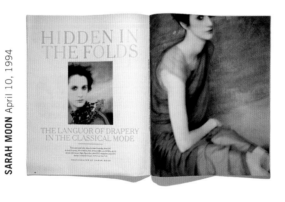

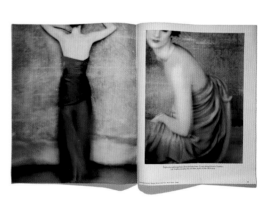

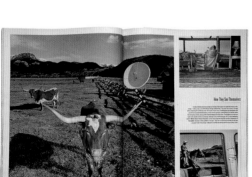

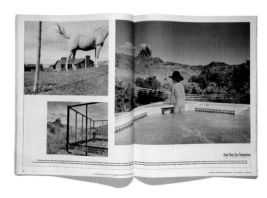

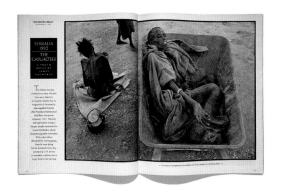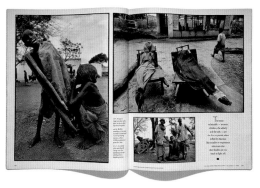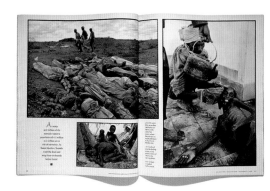

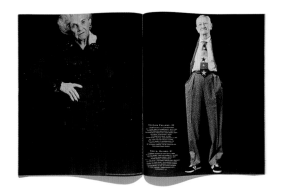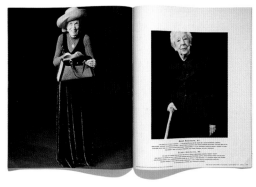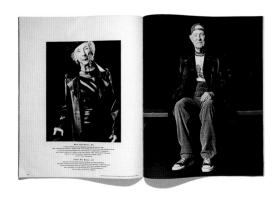

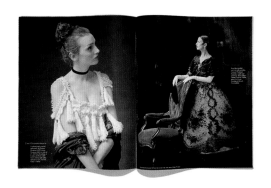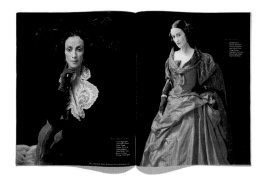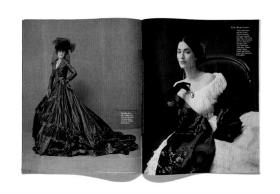

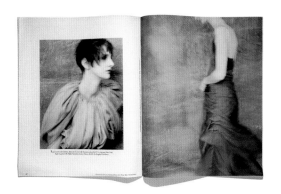

**LARS TUNBJÖRK** November 19, 1995

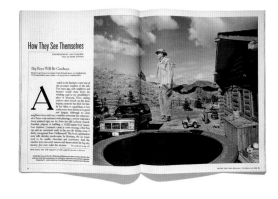

**LEE FRIEDLANDER** December 3, 1995

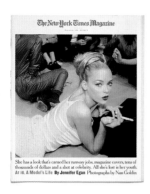
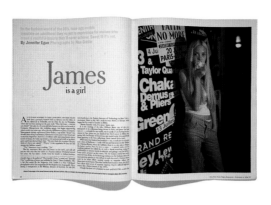
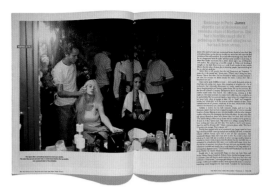

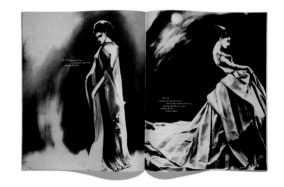

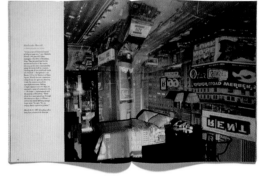

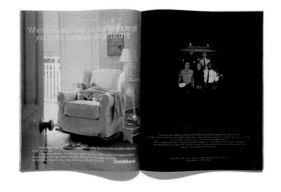
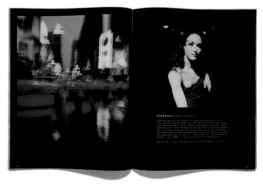

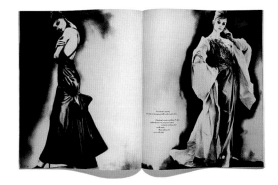

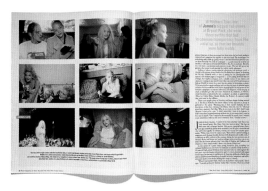

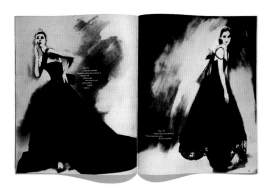

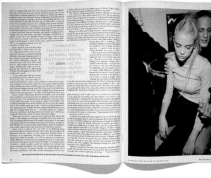

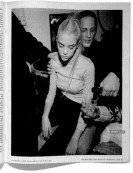

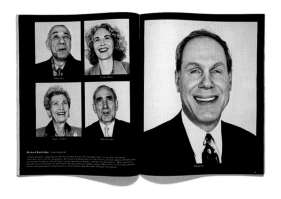

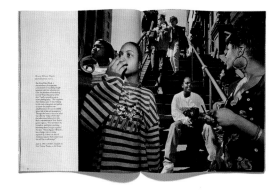

**"TIMES SQUARE"** May 18, 1997

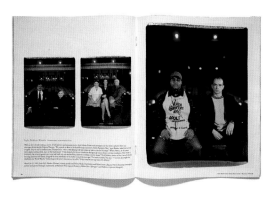

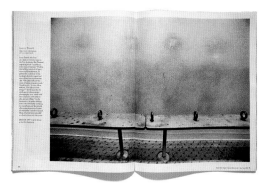

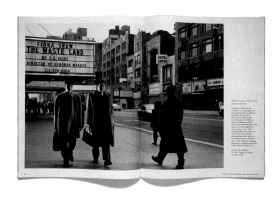

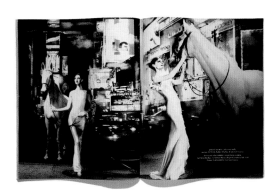

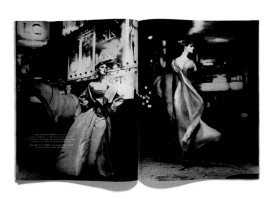

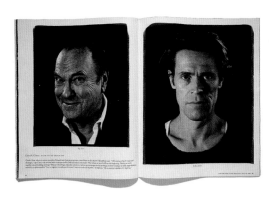

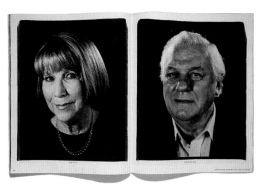

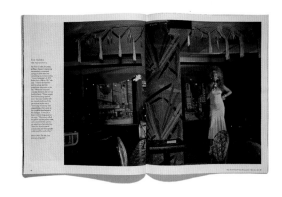

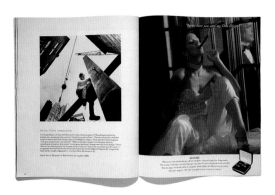

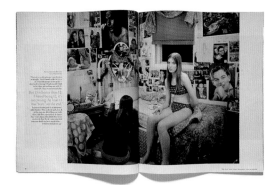

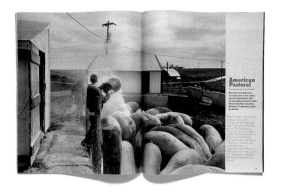

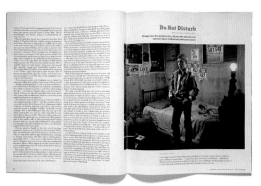

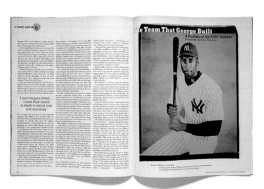

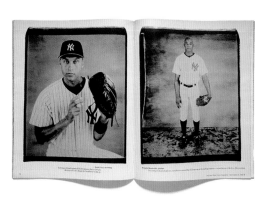

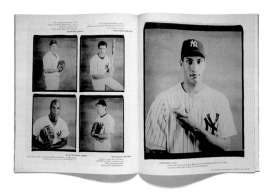

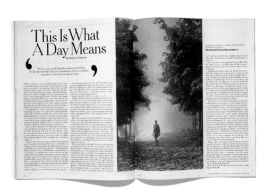

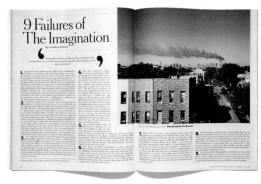

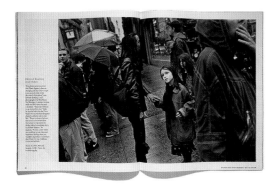

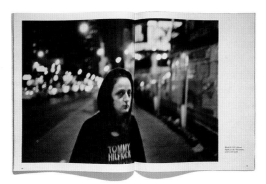

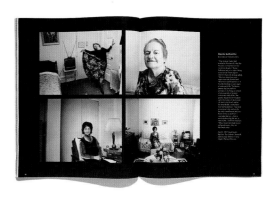

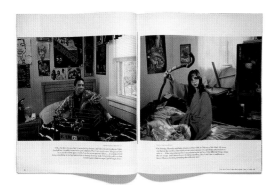

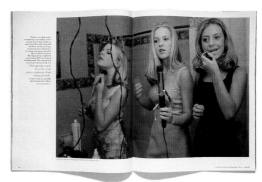

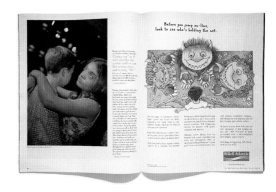

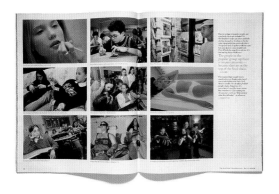

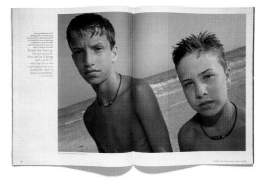

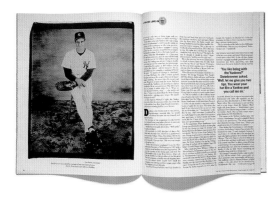

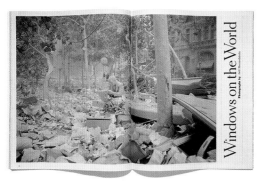

Windows on the World

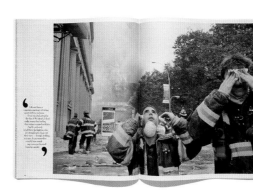

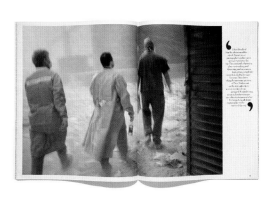

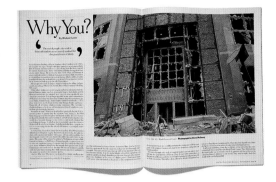

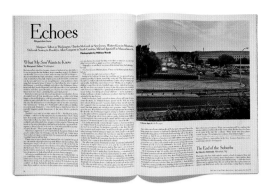

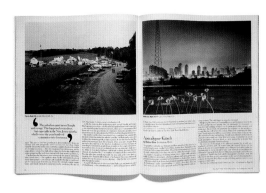

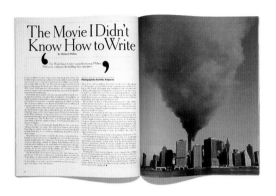

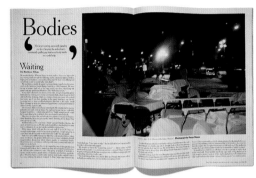

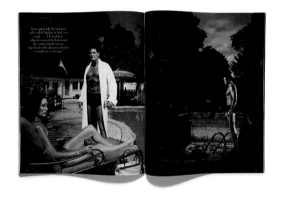

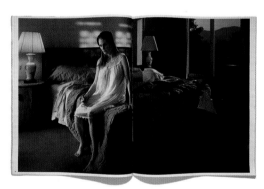

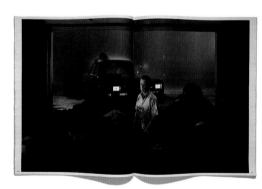

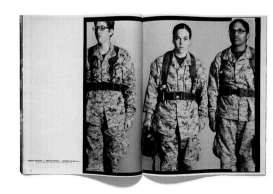

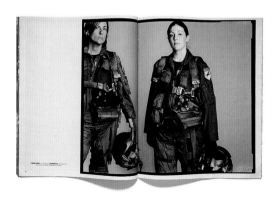

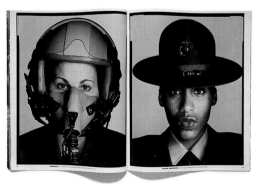

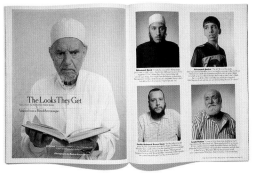

JEFF RIEDEL November 25, 2001

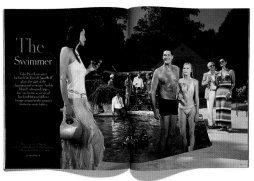

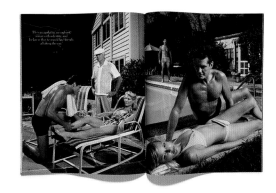

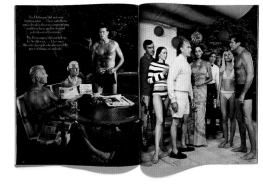

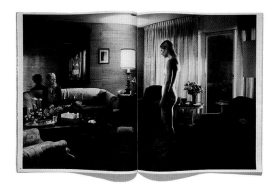

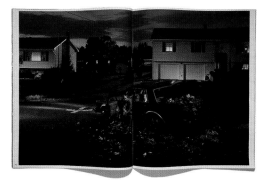

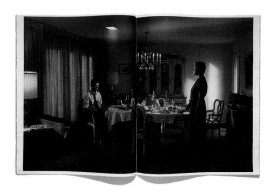

DAN WINTERS February 16, 2003

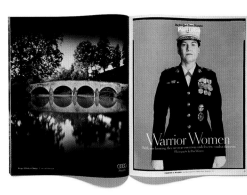

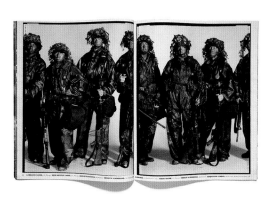

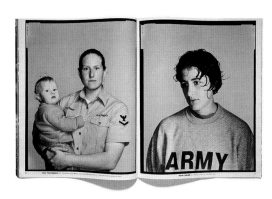

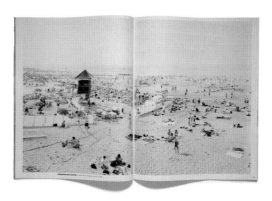

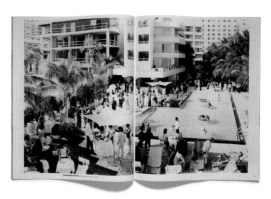

MASSIMO VITALI May 4, 2003

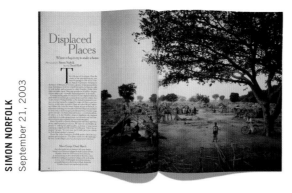

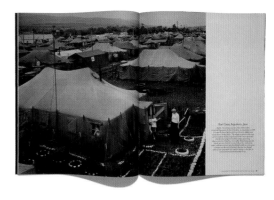

SIMON NORFOLK September 21, 2003

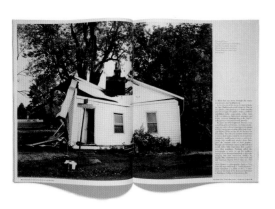

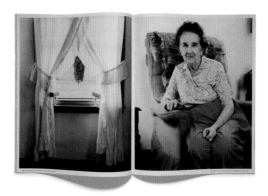

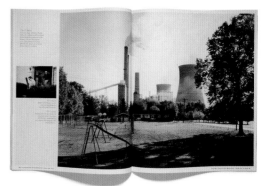

INEZ VAN LAMSWEERDE AND VINOODH MATADIN February 29, 2004

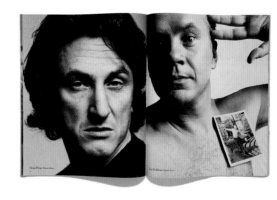

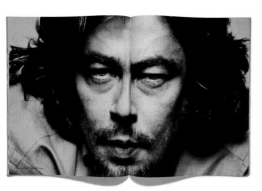

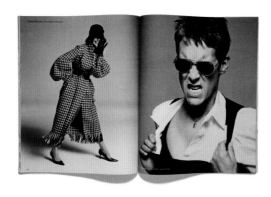

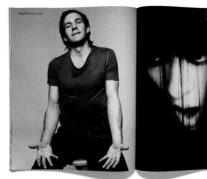

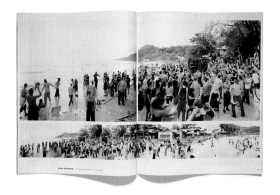

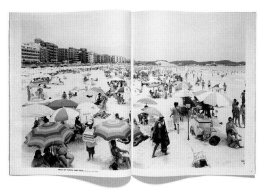

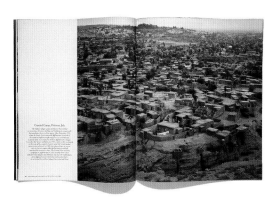

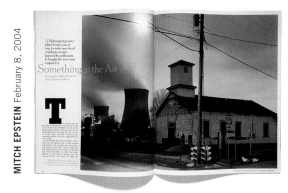

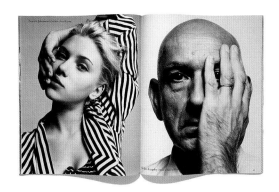

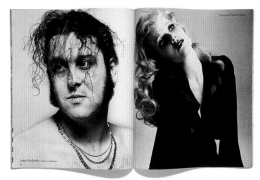

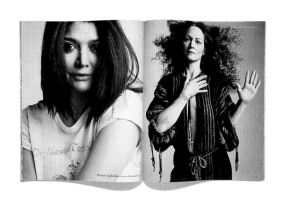

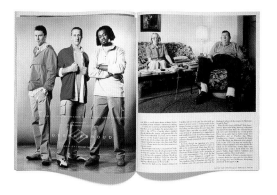

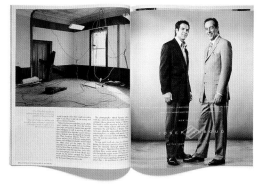

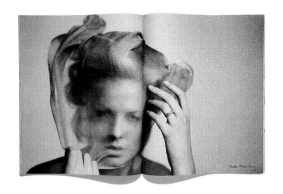

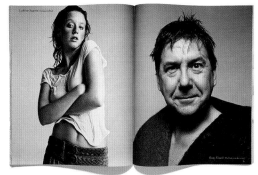

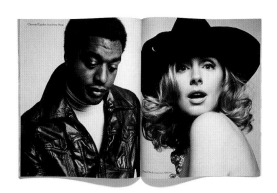

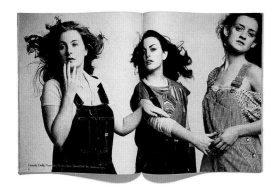

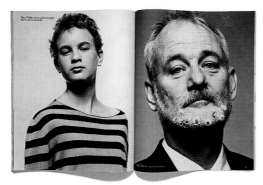

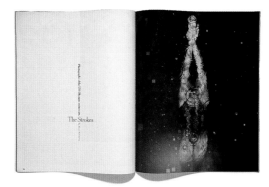

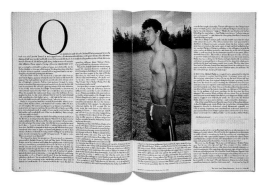

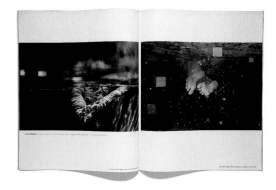

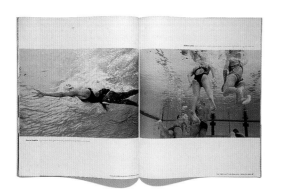

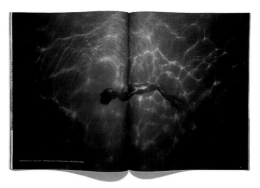

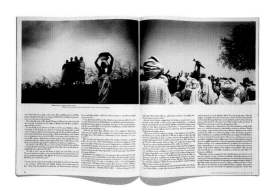

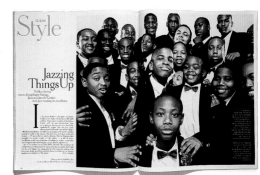

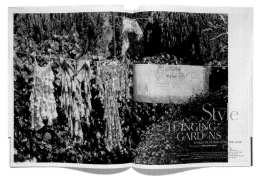
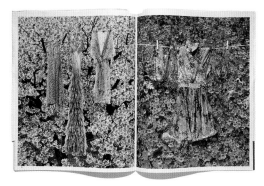

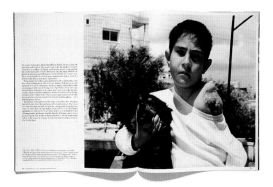

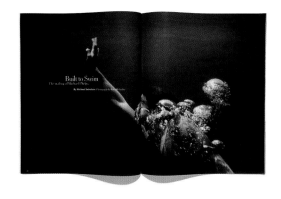

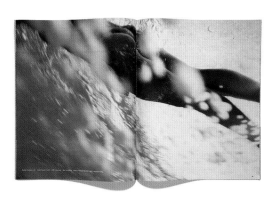
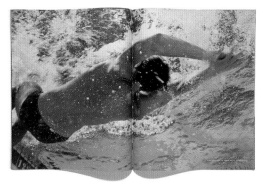

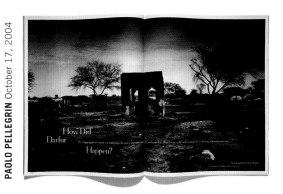
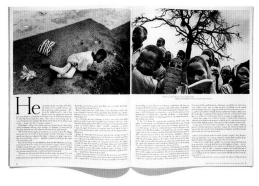
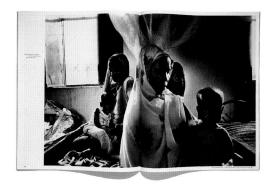

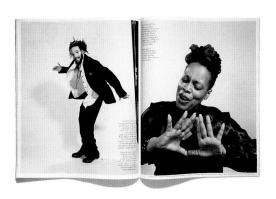
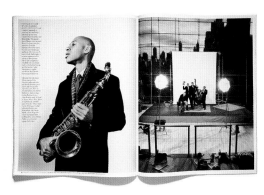

**GILLES PERESS** May 1, 2005

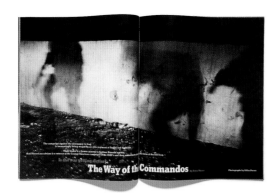

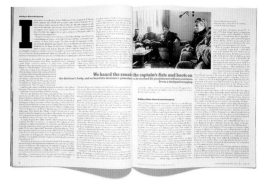

**ANDRES SERRANO** June 12, 2005

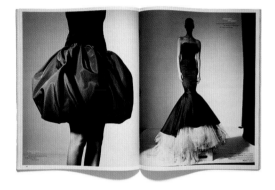

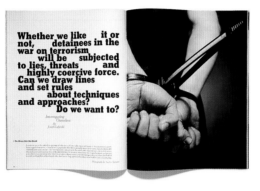

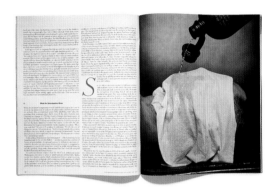

**ABELARDO MORELL**
October 30, 2005

**ROGER BALLEN** October 30, 2005

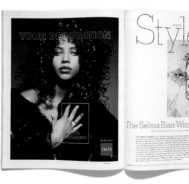

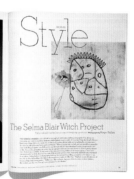

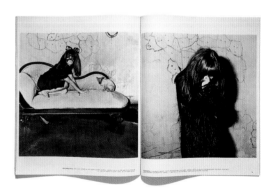

**TARYN SIMON** November 27, 2005

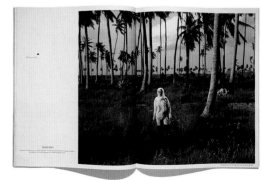

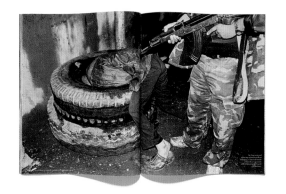

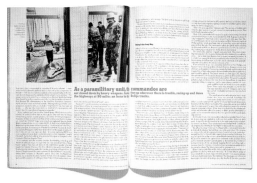

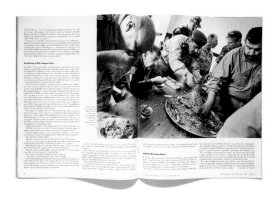

**RICHARD BURBRIDGE**
September 18, 2005

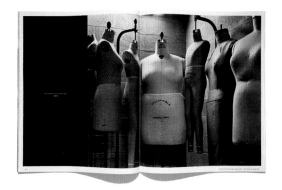

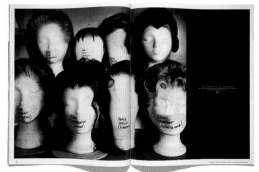

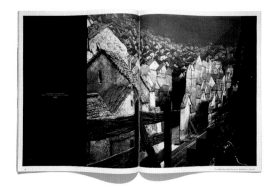

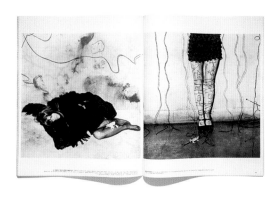

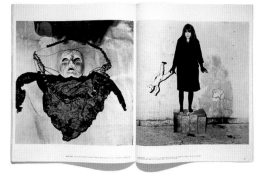

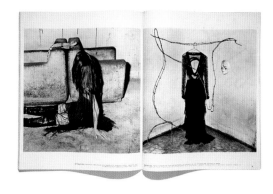

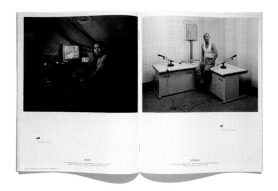

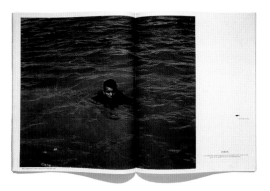

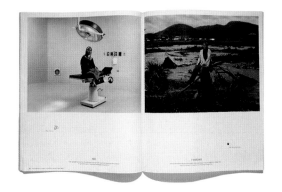

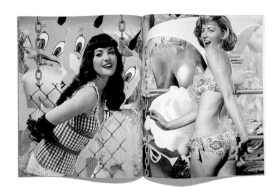

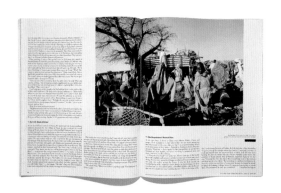

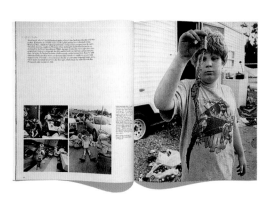

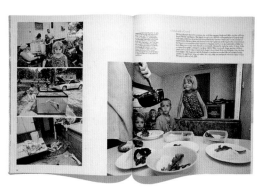

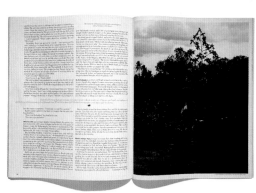

**LYNSEY ADDARIO** April 2, 2006

**BRENDA ANN KENNEALLY**
August 27, 2006

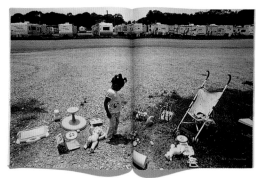

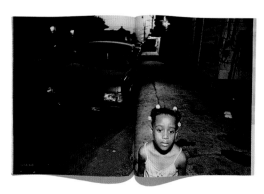

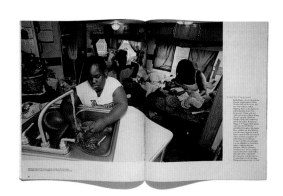

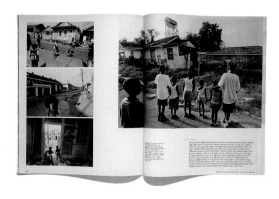

For three years, the people of Darfur have been attacked, abused and killed.

The international community has denounced these actions as genocide but has failed to stop them.

Now Luis Moreno-Ocampo and the International Criminal Court are building a case against the perpetrators.

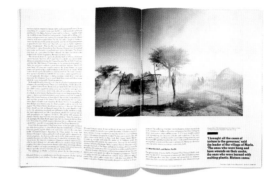

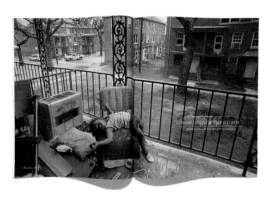

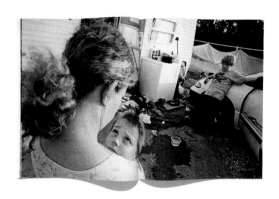

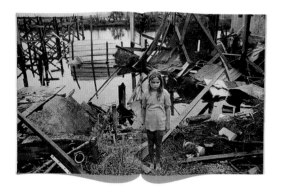

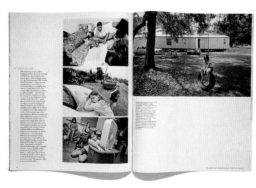

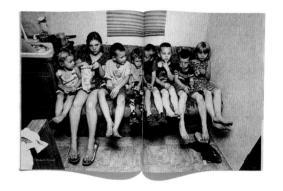

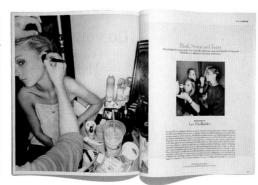

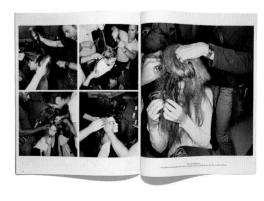

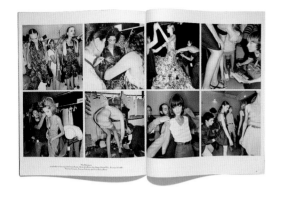

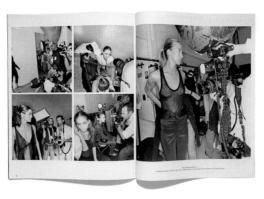

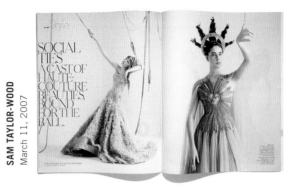

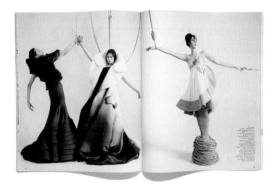

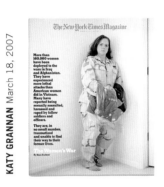

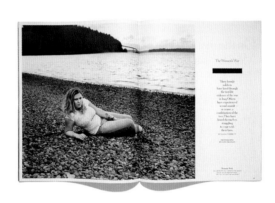

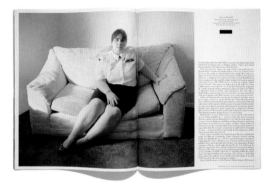

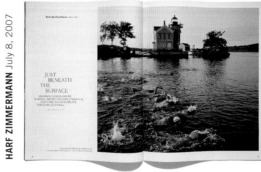

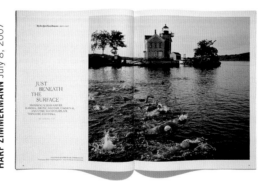

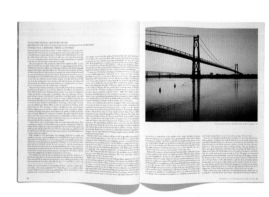

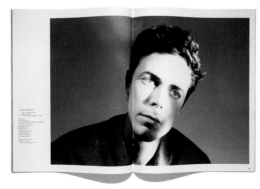

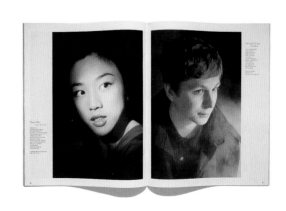

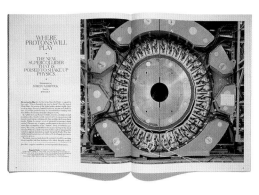

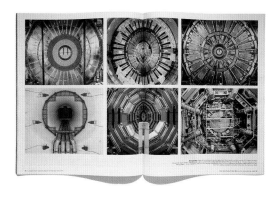

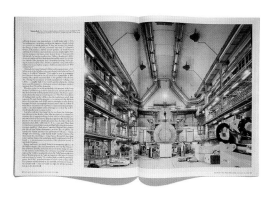

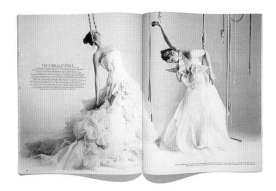

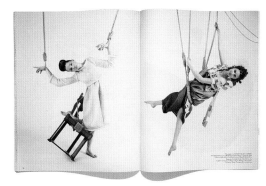

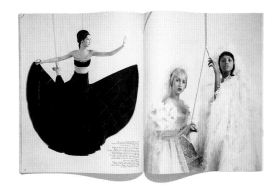

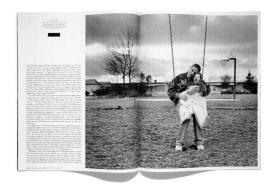

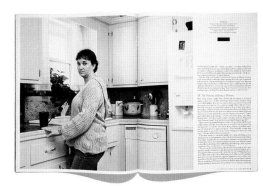

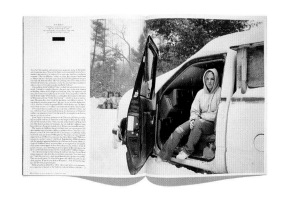

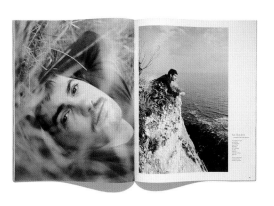

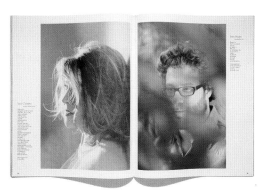

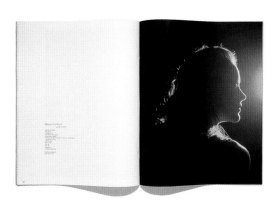

SIMON NORFOLK January 14, 2007

RYAN McGINLEY February 10, 2008

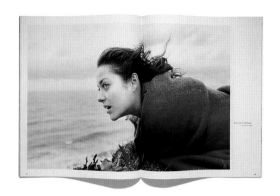

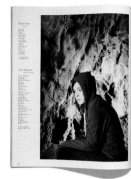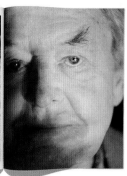

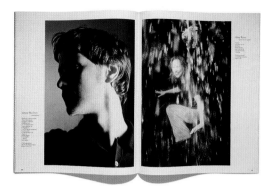

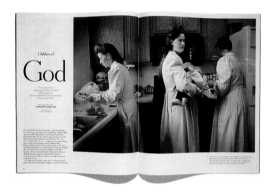

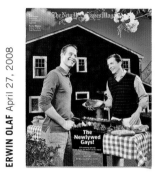

ERWIN OLAF April 27, 2008

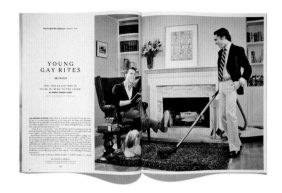

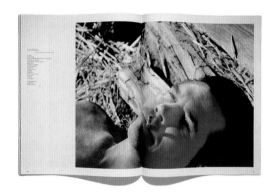

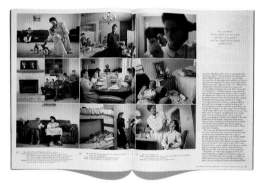

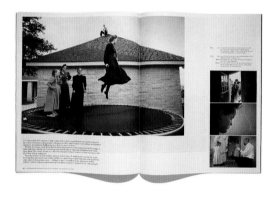

NADAV KANDER January 18, 2009

# OBAMA'S PEOPLE

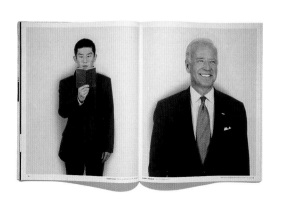

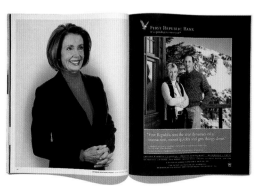

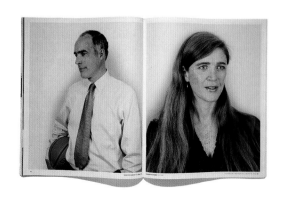

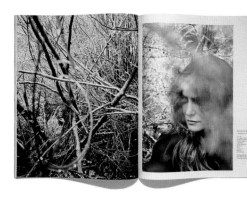
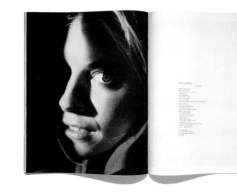

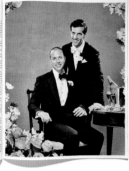

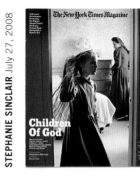

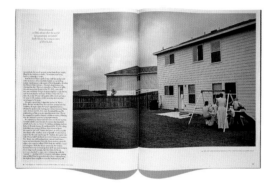
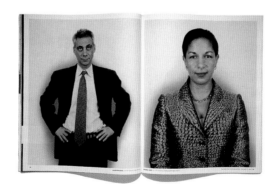

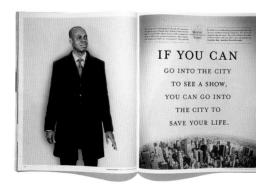

WE INVEST YOUR MONEY
RIGHT ALONGSIDE OURS.
NEEDLESS TO SAY,
YOU BENEFIT FROM SOME
VERY CAREFUL THINKING.

'S
PEOPLE

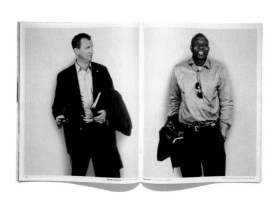
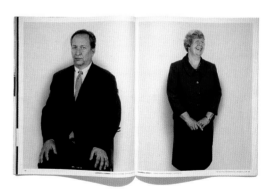

IF YOU CAN

GO INTO THE CITY
TO SEE A SHOW,
YOU CAN GO INTO
THE CITY TO
SAVE YOUR LIFE.

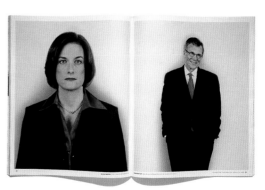

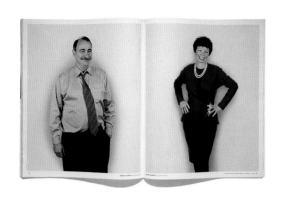
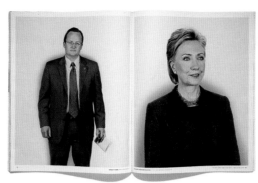

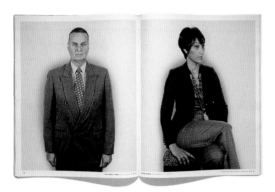
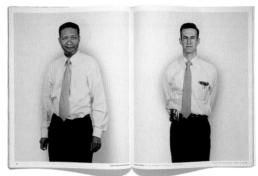

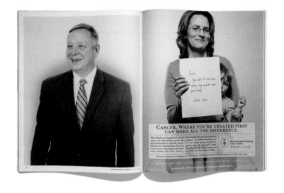

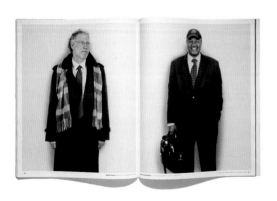
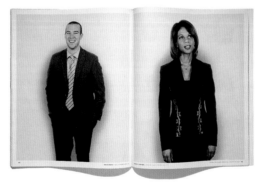
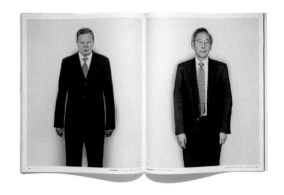

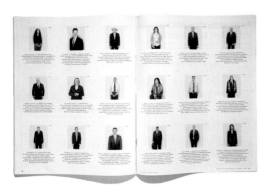

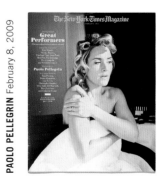

**PAOLO PELLEGRIN** February 8, 2009

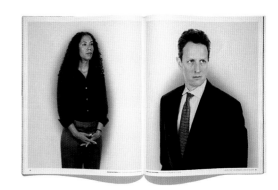

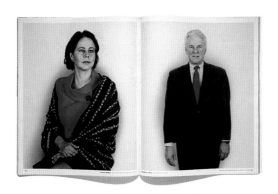

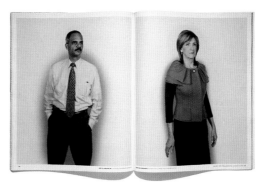

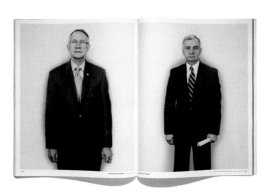

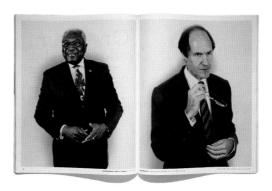

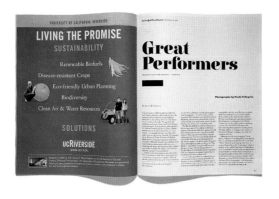

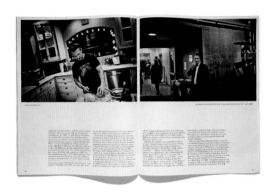

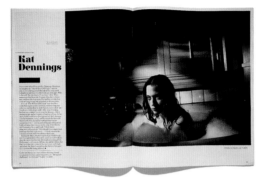

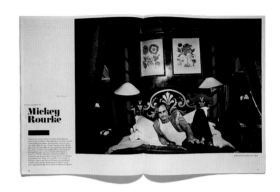

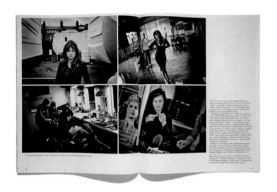

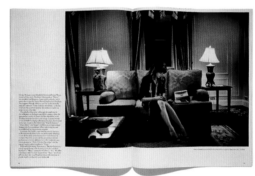

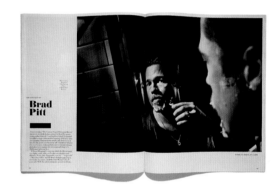

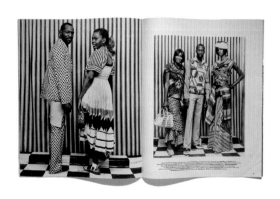

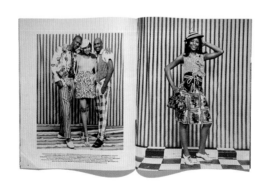

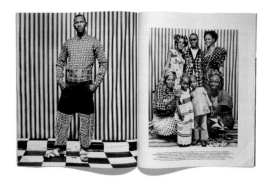

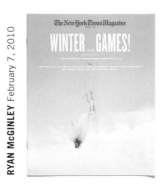

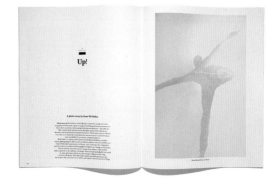

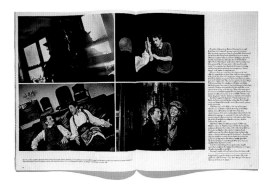

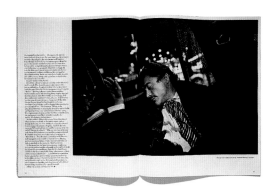

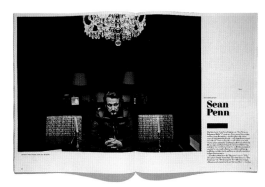

Sean Penn

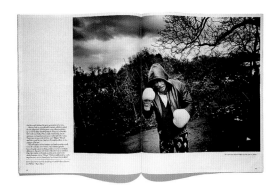

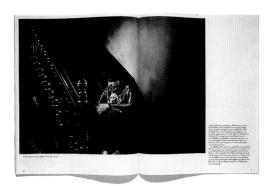

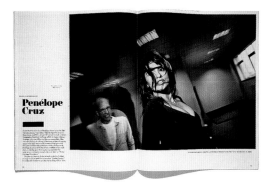

Penélope Cruz

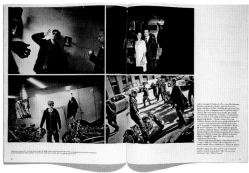

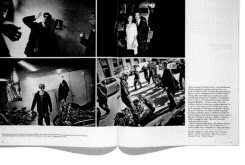

MALICK SIDIBÉ April 5, 2009

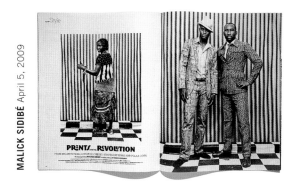

PRINTS and the REVOLUTION

STEPHEN WILKES April 19, 2009

The New York Times Magazine

THE GREEN MIND

WHY ISN'T THE BRAIN GREEN?

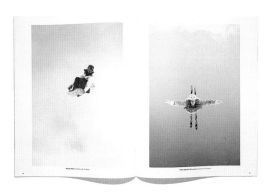

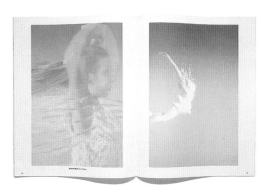

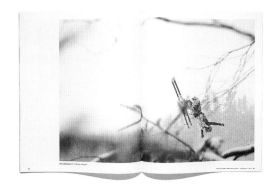

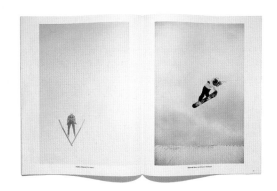

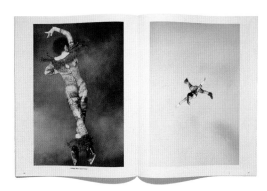

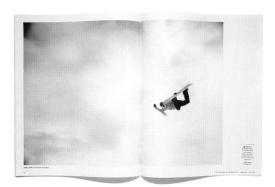

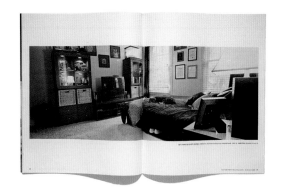

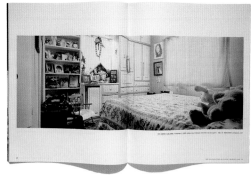

**JEFF KOONS** April 4, 2010

436

**ASHLEY GILBERTSON**
March 21, 2010

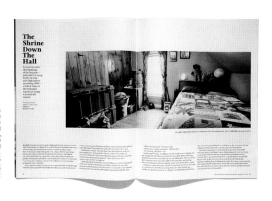

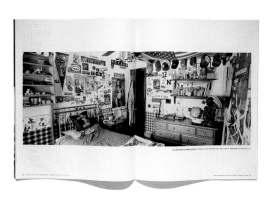

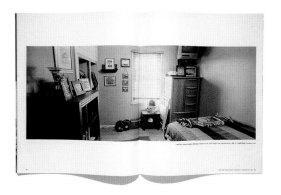

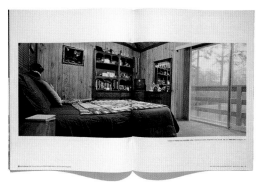

*new york times magazine* staff:
the visual team

Principal editors, art directors, photo-editors, designers, and style editors of the *Magazine* in the period covered by this volume (1978–2011). Many are quoted in the preceding pages.

**EDITORS**

Edward Klein (1977–87)

James Greenfield (1987–90)

Warren Hoge (1991–92)

Jack Rosenthal (1993–98)

Adam Moss (1998–2003)

Gerald Marzorati (2003–10)

Hugo Lindgren (2010–present)

**PICTURE EDITORS/PHOTO-EDITORS/ DIRECTOR OF PHOTOGRAPHY**

Fred Ritchin (1978–82)

Mark Bussell (1982–84)

Peter Howe (1984–87)

Kathy Ryan (1987–present)

**ART DIRECTORS/DESIGN DIRECTORS/ CREATIVE DIRECTOR**

Ruth Ansel (1973–82)

Roger Black (1982–83)

Ken Kendrick (1982–86)

Diana LaGuardia (1986–88)

Janet Froelich (1986–2009)

Arem Duplessis (2004–present)

**FASHION DIRECTORS**

Carrie Donovan (1977–93)

Holly Brubach  (1994–98)

Amy Spindler (1998–2003)

Stefano Tonchi  (Style Editor of *New York Times Magazine*, 2003–4; Editor of *T: The New York Times Style Magazine*, 2004–10)

**MEMBERS OF THE PHOTOGRAPHY DEPARTMENT***

Virginia Avent

Stacey Baker

Maggie Berkvist

Ruth Block

Clinton Cargill

David Carthas

Courtenay Clinton

Cavan Farrell

Steve Fine

Scott Hall

Sarah Harbutt

Leora Kahn

Selma Kalousek

Masood Kamandy

Evan Kriss

Leonor Mamanna

Joanna Milter

Michael O'Keefe

Justin O'Neill

Marvin Orellana

Jennifer Pastore

Kira Pollack

Gabrielle Plucknette

Jody Quon

Judith Puckett-Rinella

Lala Herrera Salas

Lonnie Schlein

Peter Schleissner

Luise Stauss

Nancy Weinstock

**MEMBERS OF THE ART DEPARTMENT**

Todd Albertson

Ian Allen

Lindsay Ballant

Catherine Gilmore-Barnes

Larry Barth

Caleb Bennett

Gail Bichler

Jody Churchfield

Charlie Churchward

Lamar Clark

Emily Crawford

Joele Cuyler

Sarah Cwynar

Kristina DiMatteo

Chris Dixon

Andrea Fella

John Fulbrook

Jeff Glendenning

Hilary Greenbaum

Holly Gressley

Leo Jung

Leslie Kwok

Erika Lee

Claude Martel

Kevin McPhee

Julia Moburg

Lisa Naftolin

Lucas Quigley

Audrey Razgaitis

Petra Reichenbach

Josef Reyes

Kathi Rota

Nancy Harris Rouemy

Richard Samperi

Tina Strasberg

Robert Vargas

Michael Valenti

Steve Vickery

Drea Zlanabitnig

**FASHION EDITORS, STYLISTS, AND RESEARCHERS****

Robert Bryan

Frans Ankoné

Rona Berg

Beat Bolliger

Tina Bossidy

Alix Browne

Anne Christensen

Polly Hamilton

Andreas Kokkino

Mimi Lombardo

Joe McKenna

Jeffrey W. Miller

Bruce Pask

Patrizia Roversi

Andrea Skinner

Elizabeth Stewart

Charlotte Stockdale

Barbara Turk

*List includes names of freelance contributors to the *Magazine*.

**Only those fashion editors and researchers whose work is reflected in this volume are listed.

# acknowledgments

I WILL BE FOREVER GRATEFUL to the hugely talented Peter Howe for bringing me to the *New York Times Magazine*, an extraordinary place to work. I was also fortunate to work with the visionary art-directors Ken Kendrick and Diana LaGuardia, who took over the *Magazine*'s art direction with flair when Ken left. I would never have arrived at this amazing magazine if Eliane Laffont had not given me my first job in photography at the Sygma Photo News Agency. Thanks, Eliane! I am also grateful to Jean-François Leroy, for his belief in photojournalism.

With the arrival of Fred Ritchin in 1978, photography in the *New York Times Magazine* began a new era. Fred saw the potential for the *Magazine* to become a showcase for sophisticated and game-changing photography that would challenge and provoke. He fought, alongside art-director Ruth Ansel, to make it happen. In 1982 Mark Bussell became the photo-editor, and continued the evolution by adding more fine editorial portraiture to the mix. He was followed two years later by Peter Howe, who continued to build on this foundation by filling the *Magazine*'s pages with landmark documentary photography. I am thankful to all these people for their groundbreaking work.

I am deeply grateful to and in awe of Janet Froelich, the legendary art director whose vision and artistry have defined the look of the *New York Times Magazine* for two decades, during which she led us through a period of thrilling creativity and rigorous editorial problem-solving. It was exciting to work alongside her and watch as she raised the photography to greater heights by presenting it in elegant and journalistically powerful layouts. I will always cherish the brainstorming and assigning sessions we had. Throughout the five-and-a-half-year gestation of this book, Janet periodically joined us to offer insights and guidance, for which we are very appreciative.

I am also extremely thankful to the amazing Arem Duplessis for his inspiring design, boundless creativity, and the joy he brings to the art direction of this magazine. Thanks also for the stunning typography he designed for the cover of this book.

I am grateful for Warren Hoge's belief in strong photojournalism when he was editor of the *Magazine*. I am indebted to Jack Rosenthal for all the times he gave us great stories with huge photographic potential to assign when he was the editor. He greatly expanded the role of photography in the *Magazine* by committing more pages—and special issues—to it. Adam Moss has been a gigantic force in my photographic life. I am grateful to him for teaching me that magazine photographs have to succeed on all counts. Color, composition, and artistry matter, but they must be in sync with the larger mission of the *Magazine*. His singular vision of what makes successful magazine photography continues to shape my decision making to this day. Once, in exasperation, Adam accused me of being a "visualist"—perhaps the best compliment I ever received. How many photo-editors are lucky enough to have a onetime art writer as their editor? That was Gerald Marzorati, my editor for six years. He is a photo-editor's dream, whose love of photography and brilliant story ideas launched many powerful photoessays. Now, I am blessed to be working with Hugo Lindgren, who has brought a burst of energy and excitement to the *Magazine* and has ignited another reinvention of the publication that presents new photographic challenges. Thanks also to Arthur Ochs Sulzberger Jr. and Bill Keller for their leadership.

Now for the Dream Team. For a quarter of a century, this *Magazine* has had the best photography department in the business. There have been four astoundingly talented deputy photo-editors in the past twenty-plus years. First the amazing Steve Fine, followed by Sarah Harbutt, who has a sharp vision and passionate belief in documentary photography. Then Jody Quon, the ever-elegant picture editor whose dozen years at the *Magazine* were crucial to its visual signature. She was followed by Kira Pollack, whose enthusiasm for cultural subjects, keen eye for talent, and energy made so many of the big production numbers possible. Joanna Milter is now carrying the torch, coming up with original visual ideas and bringing them to life, no matter how ambitious.

The energy and commitment that the members of the photography department—

Stacey Baker, Clinton Cargill, Marvin Orellana, and Luise Stauss—bring to their work is awe inspiring. Thank you all for your spirit of adventure, great ideas, and love of pictures. You are the most devoted crew imaginable. I am indebted to all of you for the brilliant work you do and grateful for the grand time we have doing it.

Many, many thanks to all the wonderful designers, story editors, writers, and other *Times* staff members whose work and ideas have contributed to the photography and layouts in the *Magazine* during the years covered in this book.

When Melissa Harris and Lesley Martin asked if I would do a book on the photography in the *New York Times Magazine* five and a half years ago, I had no idea what a huge undertaking it would be while putting out a weekly magazine. During the first five years, I worked closely with Melissa, fine-tuning the selection of photographs I had chosen from over 1,700 issues of the *Magazine*, and figuring out the architecture of the book. I am thankful for the wisdom, sweeping knowledge of photography, and moral support she brought to these pleasurable editing sessions.

Once the photographs had been chosen, she brought in the fabulous Diana Stoll as the text editor. Her keen ear and elegant editing brought the voices throughout this book to life. I am very grateful for her work.

Throughout the entire process, the wonderful Stacey Baker assisted in countless ways. Marvin Orellana was a crucial member of the team, always there to coordinate the handling of the imagery, communication with the photographers, and innumerable other contributions large and small. Monica Stromdahl did a terrific job of tracking down the many vintage magazines that were missing from our archives. Gabrielle Plucknette pitched in during the final months when we needed some last-minute help, as did Luise Stauss. Kate Pastorek did a great job of coordinating all the photographic material on Aperture's side. Francesca Richer and Inger-Lise McMillan started the design of the book, which was ultimately taken over and finalized by Emily Lessard. I am very grateful to them, and especially to Emily, for the beautiful way they have displayed the images of so many photographers working within so many genres. It was no small challenge. Others who deserve thanks at Aperture include Matthew Harvey, who oversaw the book's production; Paula Kupfer, Jenny Goldberg, and Nima Etemadi, who helped gather images and information; and a battery of talented work scholars who assisted in countless ways: Amelia Lang, Andrea Chlad, Julia Barber, Tessa Basore, Carolyn Deuschle, Simone Eissrich, Allegra Fisher, Alex Freedman, Christopher Kissock, Ed Lessard, Daisy Lumley, Benedikt Reichenbach, Faye Robson, Gem Salsberg, Suzy Shaheen. I am grateful too to Ted Panken, who heroically transcribed dozens of interviews for this volume.

When Chris Boot took over the directorship of Aperture he steered the book toward the finish line. His powerful belief in the importance of this volume, insistence that it had to get done, and genius at book making gave it the shaping and focus it needed to come to a finish. I am very grateful for his support in the home stretch. None of this would have come to anything without Lesley Martin's fierce discipline and passion for the project, particularly in the final six months. I was fortunate to see up close why she is one of the best in the business. I am also deeply indebted to my brother Morgan Ryan, as always, for his brilliant editing of my galloping prose and the courage he gives me.

I am thankful to my parents for encouraging a love of art in us, and to my other siblings, Maureen, Rosemary, Matthew, and Beth, for their support.

Most of all, endless thanks and lots of love to my husband, Scott, and daughter, Sylvie, for their boundless creativity and encouragement throughout this project, and always.

Finally, the biggest thanks of all go to the extraordinary photographers whose unforgettable pictures fill this book. Your faith in the power of photography and remarkable creativity never cease to amaze me. It is a privilege to work with you. Thank you for making the *New York Times Magazine* the great publication it is. —K.R.

image credits

# index of photographers

authors' bios

KATHY RYAN, the Director of Photography at the *New York Times Magazine*, has worked with the publication for more than twenty-five years; in that time, the *Magazine* has been recognized with numerous photography awards. Ryan received the 1997 Picture Editor of the Year Award at the Visa pour l'Image photojournalism festival in Perpignan, France; a Lucie Award for Picture Editor of the Year in 2003; and a lifetime achievement award from the Griffin Museum of Photography, Winchester, Massachusetts. In 2008 she was a co-curator of the inaugural New York Photo Festival, and in the following year organized the exhibitions *Prune: Abstracting Reality* for FOAM Museum in Amsterdam and *Dutch Seen* for the Museum of the City of New York and FOAM. Ryan lectures widely and serves as a mentor and thesis advisor at New York's School of Visual Arts. A pioneer in combining fine-art photography and photojournalism in the pages of the *Magazine*, she has also recently been commissioning videos for the *New York Times* website.

GERALD MARZORATI is an Assistant Managing Editor of the *New York Times*. He was the Editor of the *New York Times Magazine* from 2003 to 2010. Before joining the *Times* in 1994, he worked as an editor at the *New Yorker*, *Harper's Magazine*, and the *SoHo Weekly News*.

Editors: Melissa Harris, Lesley A. Martin, Diana C. Stoll
Editorial Assistants: Kate Pastorek, Paula Kupfer, Nima Etemadi
Chapter texts by Diana C. Stoll
Transcriber: Ted Panken
Design: Aperture Foundation
Design Director: Emily Lessard
Designers: Francesca Richer, Inger-Lise McMillan
Design consultation: Janet Froelich, Arem Duplessis
Production: Matthew Harvey
Work Scholars: Amelia Lang, Andrea Chlad, Julia Barber, Tessa Basore, Carolyn Deuschle,
Simone Eissrich, Allegra Fisher, Alex Freedman, Christopher Kissock, Ed Lessard,
Daisy Lumley, Benedikt Reichenbach, Faye Robson, Gem Salsberg, Suzy Shaheen

The staff for this book at Aperture Foundation includes:
Chris Boot, *Executive Director*; Mary Colman St. John, *Chief Financial and Administrative
Officer*; Jenny Goldberg, *Associate Editor*; Susan Ciccotti, *Senior Text Editor, Books*;
Anna Carnick, *Assistant Editor*; Kellie McLaughlin, *Director of Sales and Marketing*;
Paul Colarusso, *Sales and Rights Manager*; Linda Truesdale, *Director of Development*

The publication of this book has been made possible, in part, by the generous support of
the National Endowment for the Arts and Roddy Gonsalves and Paul Pincus.

**ART WORKS.**
arts.gov

First edition
Printed by Graphicom in Italy
10  9  8  7  6  5  4  3  2  1

Library of Congress Control Number: 2011906166
ISBN 978-1-59711-146-1

Aperture Foundation books are available in North America through:
D.A.P./Distributed Art Publishers
155 Sixth Avenue, 2nd Floor
New York, N.Y. 10013
Phone: (212) 627-1999
Fax: (212) 627-9484

Aperture Foundation books are distributed outside North America by:
Thames & Hudson
181A High Holborn
London WC1V 7QX
United Kingdom
Phone: + 44 20 7845 5000
Fax: + 44 20 7845 5055
Email: sales@thameshudson.co.uk

**aperture**foundation
547 West 27th Street
New York, N.Y. 10001
www.aperture.org

Aperture, a not-for-profit founded in 1952 as "common ground for the
advancement of photography," provides a forum for the photo community
to connect with the most inspiring work, the sharpest ideas, and with
each other—in print, in person, and online.